Roman Copies of Greek Sculpture

Roman Copies of Greek Sculpture: The Problem of the Originals

Brunilde Sismondo Ridgway

*Jerome Lectures
Fifteenth Series*

Ann Arbor

The University of Michigan Press

Copyright © by The University of Michigan 1984
All rights reserved
Published in the United States of America by
The University of Michigan Press and simultaneously
in Rexdale, Canada, by John Wiley & Sons of Canada, Limited
Manufactured in the United States of America

Library of Congress Cataloging in Publication Data
Ridgway, Brunilde Sismondo, 1929–
 Roman copies of Greek sculpture.
 (Jerome lectures; 15th ser.)
 Bibliography: p.
 Includes index.
 1. Sculpture, Greek—Copying. 2. Sculpture, Roman.
I. Title. II. Series.
NB94.R54 1984 733′.3 83–17124
ISBN 0–472–10038–6

Preface

The basic theories expressed in this book were presented in oral form in the course of four lectures as part of the Thomas Spencer Jerome Series. They were delivered in October, 1981, at the University of Michigan at Ann Arbor, Michigan, and again in March, 1982, at the American Academy in Rome, Italy. It was for me a great honor to be asked to deliver these lectures, and I am deeply grateful to those who gave me the opportunity.

In my text, I have tried to follow as closely as possible the sequence of arguments as presented in the lectures themselves, although the greater flexibility afforded by the written version has allowed me to expand some topics, add more examples, provide supporting references. Conversely, the limitations of printing have prevented me from providing a number of illustrations equal to that of the slides which accompanied the lectures. Yet I have tried to retain as much as feasible the conversational tone of my presentation, and I have cited as many monuments, trusting in the visual memory of my informed readers. (The notes to my text were last updated in February, 1983.)

My research was made possible by a sabbatical year granted by Bryn Mawr College, by the stipend provided by the Jerome Lectureship Committee, and by a generous grant from the American Council of Learned Societies, which allowed for some traveling in Italy, Switzerland, and the United States. To all these sponsoring institutions I wish to express my deep gratitude. My special thanks go also to my two academic hosts—the University of Michigan and the Academy in Rome—which could not have extended to me a more generous, gracious, and stimulating hospitality. From April 15 to May 15 I was also able to enjoy residence at the Villa Massenzia of Bryn Mawr College, in Rome; its idyllic atmosphere proved particularly conducive to the completion of my basic text.

It is virtually impossible to remember all those who have contributed inspiration, provided stimulating discussion, triggered ideas, and in general helped my research and the preparation of this book. At Bryn Mawr College, all my students should be acknowledged, but special assistance and scholarly criticism were offered by Katherine Dohan, Kim Hartswick, Liane Houghtalin, Michael Toumazou, and most specifically my colleague Gloria F. Pinney. At Ann Arbor I particularly wish to thank Elaine Gazda, who

was my safety valve after each lecture, and my former student and friend MaryAnn Eaverly, who made sure that every detail was perfect—including the corsage for the football game. Among the many Michigan friends, old and new, I can only name Ted Buttrey, John D'Arms, John Humphrey, John Pedley, and Margaret Root for exceptional kindness and academic stimulation, but many more should by right be mentioned in these pages—virtually every one with whom I came in contact during my Ann Arbor stay and who in many different ways all managed to enrich my Michigan experience.

In Rome, Carl Nylander's friendly presence at each lecture provided much needed encouragment, Sophie Consagra and Lionel Casson made me feel welcome and privileged. Archaeological, philological, and art historical ammunitions were kindly provided by Elizabeth Bartman, Malcolm Bell, Amanda Claridge, Bernard Frischer, Ruth Gais, Jon Van de Grift, Ronald Lacy, James McGregor, and especially John Van Sickle. During my second stay in Rome, Filippo Coarelli and Eugenio La Rocca greatly helped me with their publications and, the latter, by showing me the material in the Capitoline Museums.

Other scholars were helpful in different ways and from different locations. Evelyn B. Harrison provided bibliography and informative comments; Maria Teresa Marabini Moevs gave me a preview of her theories on the Ambrakian Muses and lent me the use of her photographs; Licia Vlad Borrelli and H. Anne Weis supplied helpful references; Paul Zanker listened to my theories during a meeting in Princeton, New Jersey, and gave me the benefit of his opinion. Last but not least, although more removed in time, I wish to thank Charles K. Williams who, in 1980, gave me the opportunity to study the sculpture from Corinth, thus allowing me a precious insight into the life of a Greek city of the Roman period. To Peter Kuniholm I am indebted for bringing to my attention the marvelous Herakles by Jason Seley, to Samuel Dornsife for lending me slides of his restoration of the San Francisco Plantation in New Orleans. Janer Belson helped type my text, with good will and intelligence.

My greatest debt, as ever, is to those who provide emotional balance to my life: Conrad, Eric, Kevin, Christopher, and, especially, Pete.

Contents

Abbreviations

Citation of bibliographical references for periodicals and standard works follows the guidelines and abbreviations set forth in *AJA* 82 (1978): 3–10 and *AJA* 84 (1980): 3. I have also used the following:

Abgüsse: Ch. von Hees–Landwehr, *Griechische Meisterwerke in römischen Abgüssen—Der Fund von Baia—Zur Technik antiken Kopisten* (Freiburg im Breisgau, 1982), Exhibition held March 20 to May 10, 1982.

Agora Guide: The Athenian Agora: A Guide to the Excavation and Museum, American School of Classical Studies at Athens (ASCSA) 3d ed. (Princeton, 1976).

Agora 3: The Athenian Agora, vol. 3. R. E. Wycherley, *Literary and Epigraphical Testimonia,* ASCSA (Princeton, 1957).

Agora 11: The Athenian Agora, vol. 11. E. B. Harrison, *Archaic and Archaistic Sculpture,* ASCSA (Princeton, 1965).

Agora 14: The Athenian Agora, vol. 14. H. A. Thompson and R. E. Wycherley, *The Agora of Athens: The History, Shape and Uses of an Ancient City Center,* ASCSA (Princeton, 1972).

Andreae, "Antisthenes": B. Andreae, "Antisthenes Philosophos Phyromachos Epoiei," in *Eikones—Studien zum griechischen und römischen Bildnis* (= Festschrift H. Jucker, *AntK BH* 12 [1980]) pp. 40–48.

Arnold, *Polykletnachfolge:* D. Arnold, *Die Polykletnachfolge (JdI EH* 25 [1969]).

Becatti, *Arte e gusto:* G. Becatti, *Arte e gusto negli scrittori latini* (Florence, 1951).

Becatti, "Letture pliniane": G. Becatti, "Letture pliniane: le opere d'arte nei *Monumenta Asini Pollionis* e negli *Horti Serviliani,*" in *Studi in onore di A. Calderini e R. Paribeni* (Milan, n.d., ca. 1960?), vol. 3, pp. 199–210.

Becatti, "Roma di Tiberio": G. Becatti, "Opere d'arte greca nella Roma di Tiberio," *ArchCl* 25–26 (1973–74) : 18–53.

Bieber, *Copies:* M. Bieber, *Ancient Copies: Contributions to the History of Greek and Roman Art* (New York, 1977).

Blanck, *Wiederverwendung:* H. Blanck, *Wiederverwendung alter Statuen als Ehrendenkmäler bei Griechen und Römern* (Rome, 1969).

Bol, *Olympia:* P. Bol, *Grossplastik aus Bronze in Olympia (OlForsch* 9 [1978]).

Brown, "Questions": B. Brown, "Questions about the Late Hellenistic Period," in *Art Studies for an Editor: 25 Essays in Memory of Milton S. Fox* (New York, 1975), pp. 25–41.

Coarelli, "Complesso pompeiano": F. Coarelli, "Il complesso pompeiano del Campo Marzio e la sua decorazione scultorea," *RendPontAcc* 44 (1971–72): 99–122.

Coarelli, "Cultura figurativa": F. Coarelli, "Arte ellenistica

e arte romana: la cultura figurativa a Roma nel II e I secolo a.c.," in *Caratteri dell'ellenismo nelle urne etrusche* (*Prospettiva Suppl.* 1 [Florence/Siena, 1977]), pp. 35–40.

Coarelli, "Grande donario': F. Coarelli, "Il Grande Donario' di Attalo I," in *I Galli e l'Italia,* 2d ed. (Rome, 1979), pp. 231–34.

Coarelli, "Roma 150–50 a.c.": F. Coarelli, "Architettura e arti figurative in Roma: 150–50 a.c.," in *Hellenismus in Mittelitalien (q.v.),* pp. 21–32, discussion pp. 32–37.
 By F. Coarelli see also "L'Ara di Domizio Enobarbo e la cultura artistica in Roma nel II secolo a.c.," *DialAr* 2 (1968): 302–68; and "Classe dirigente romana e arti figurative," *DialAr* 4–5 (1971): 241–65.

Coulson, "Reliability": "The Reliability of Pliny's Chapters on Greek and Roman Sculpture," *ClW* 69.6 (March, 1976): 361–72.

Daltrop, *Il Gruppo mironiano:* G. Daltrop, *Il gruppo mironiano di Atena e Marsia nei Musei Vaticani,* Monumenti Musei e Gallerie Pontificie (Città del Vaticano, 1980).

Dontas, "Artemis": G. Dontas, "La Grande Artémis du Pirée: une oeuvre d'Euphranor," *AntK* 25 (1982): 15–34.

EntrHardt: Le Classicisme à Rome aux Iers siecles avant et après J.-C. (= *Entretiens Hardt,* vol. 25 [Geneva, 1978, publ. 1979]).

Ephesos, Führer: A. Bammer, R. Fleischer, D. Knibbe, *Ephesos—Führer durch das Archäologische Museum in Selçuk-Ephesos* (Vienna, 1974).

Frel, *Getty Portraits:* J. Frel, *Greek Portraits in the J. Paul Getty Museum* (Malibu, California, 1981).

Fuchs, *Vorbilder:* W. Fuchs, *Die Vorbilder der Neuattischen Reliefs* (*JdI EH* 20 [Berlin, 1959]).

Gros, "Les Statues": P. Gros, "Les statues de Syracuse et les 'Dieux' de Tarente (La classe politique romaine devant l'art grec à la fin du IIIe siecle a. J.-C.)," *REL* 57 (1979): 85–114.

Gros, "Vie et mort": P. Gros, 'Vie et mort de l'art hellénistique selon Vitruve et Pline," *REL* 56 (1978): 289–313.

Gualandi, "Sculture di Rodi": G. Gualandi, "Sculture di Rodi," *ASAtene* 54, n.s. 38 (1976, publ. 1979): 7–259.

Guerrini, "Motivo iconografico": L. Guerrini, "Ricerche stilistiche intorno a un motivo iconografico," *ASAtene* 37–38 (1959–60): 403–19.

Gulaki, "Nikedarstellungen": A. Gulaki, "Klassische und klassizistische Nikedarstellungen. Untersuchungen zur Typologie und zum Bedeutungswandel bewegter Figuren" (diss., Bonn, 1980).

Haskell and Penny, *Taste:* F. Haskell and N. Penny, *Taste and the Antique—The Lure of Classical Sculpture 1500–1900* (New Haven and London, 1981).

Hellenismus in Mittelitalien: Hellenismus in Mittelitalien—Colloquium 5–9 Juni, 1974 (= *AbhGött,* Philologisch-historische Klasse, 3d ser., vol. 97 [1976]).

Hölscher, "Die Nike": T. Hölscher, "Die Nike der Messenier und Naupaktier in Olympia," *JdI* 89 (1974): 70–111.

Inan, *Side:* J. Inan, *Roman Sculpture in Side* (Ankara, 1975).

Inan and Jones, "Bronzetorso": J. Inan and C. P. Jones, "Der Bronzetorso im Burdur-Museum aus Bubon und der Bronzekopf im J.-Paul-Getty-Museum," *IstMitt* 27–28 (1977–78): 267–96.

Karouzou, *Guide:* S. Karouzou, National Archaeological Museum, *Collection of Sculpture—A Catalogue* (Athens, 1968; Greek ed., 1967).

Kron, *Phylenheroen:* U. Kron, *Die Zehn attischen Phylenheroen* (=*AthMitt BH* 5 [Berlin, 1975]).

Kruse, *Weibliche Gewandstatuen:* H.-J. Kruse, *Römische weibliche Gewandstatuen des zweiten Jahrhunderts n. Ch.* (Göttingen, 1968, publ. 1975).

La Rocca, "Un frammento": E. La Rocca, "L'Apollo 'qui citharam . . . tenet' di Timarchides: un frammento dal tempio di Apollo in circo," *Bollettino dei Musei Comunali di Roma* 23, no. 1–4 (1977): 16–33.

Lauter, *Chronologie:* H. Lauter, *Zur Chronologie römischer Kopien nach Originalen des V Jahrhunderts v.Ch.* (Bonn, 1966).

Lauter, "Die Koren": H. Lauter, "Die Koren der Erechtheion," *AntP* 16 (Berlin, 1976).

Lindner, "Giebelgruppe": R. Lindner, "Die Giebelgruppe von Eleusis mit dem Raub der Persephone," *JdI* 97 (1982): 303–400.

Linfert, *Kunstzentren:* A. Linfert, *Kunstzentren hellenistischer Zeit: Studien an weiblichen Gewandfiguren* (Wiesbaden, 1976).

Lippold, *Handbuch:* W. Otto, *Handbuch der Archäologie im Rahmen des Handbuchs der Altertumswissenschaft,* vol. 6: 3.1, G. Lippold, *Die griechische Plastik* (Munich, 1950).

Lippold, *KuU:* G. Lippold, *Kopien und Umbildungen griechischer Statuen* (Munich, 1923).

Lorenz, *Polyklet:* Th. Lorenz, *Polyklet* (Wiesbaden, 1972).

Lullies and Hirmer, *Greek Sculpture:* R. Lullies and M. Hirmer, *Greek Sculpture,* enlarged ed. (New York, 1960).

Marcadé, *Au Musée:* J. Marcadé, *Au Musée de Delos* (Paris, 1970).

Marcadé, *Signatures:* J. Marcadé, *Recueil des signatures de sculpteurs grecs,* vol. 1 (Paris, 1953), vol. 2 (Paris, 1957).

Munich Catalogue: B. Vierneisel-Schlörb, *Klassische Skulpturen des 5. und 4. Jahrhunderts v. Chr.,* Glyptothek München, Katalog der Skulpturen, vol. 2 (Munich, 1979).

Museo Nazionale Romano: A. Giuliano, ed., et al., Museo Nazionale Romano, *Le sculture,* vol. 1.1 (Rome, 1979).

Palagia, *Euphranor:* O. Palagia, *Euphranor* (Monumenta Graeca et Romana III, Leiden, 1980).

Palagia, "Personification": O. Palagia, "A Colossal Statue of a Personification from the Agora of Athens," *Hesperia* 51 (1982): 99–113.

Pape, "Kriegsbeute": M. Pape, "Griechische Kunstwerke aus Kriegsbeute und ihre öffentliche Aufstellung in Rom—von der Eroberung von Syrakus bis in augusteische Zeit" (diss., Hamburg, 1975).

Paribeni, "Sculture originali greche": E. Paribeni, "Considerazioni sulle sculture originali greche di Roma," in *La Magna Grecia e Roma nell'età arcaica,* Atti 8° Congresso di Studi sulla Magna Grecia, 1968 (Naples, 1969), pp. 83–89.

Pekáry, "Statuen": Th. Pekáry, "Statuen in kleinasiatische Inschriften," in *Studien zur Religion und Kultur Kleinasiens* (Festschrift für F. K. Dörner) vol. 2 (Leiden, 1978), pp. 724–44.

Pemberton, "Corinthian bronzes": E. G. Pemberton, "The Attribution of Corinthian Bronzes," *Hesperia* 50 (1981): 101–11.

Philipp and Koenigs, "Basen": H. Philipp and W. Koenigs, "Zu den Basen des L. Mummius in Olympia," *AthMitt* 97 (1979): 193–216.

Pollitt, *Art of Greece:* J. J. Pollitt, *The Art of Greece 1400–31 B.C.*, Sources and Documents in the History of Art Series (Englewood Cliffs, N.J., 1965).

Pollitt, *Art of Rome:* J. J. Pollitt, *The Art of Rome c. 753 B.C.–337 A.D.*, Sources and Documents in the History of Art Series (Englewood Cliffs, N.J., 1966).

Pollitt, "Impact": J. J. Pollitt, "The Impact of Greek Art on Rome," *TAPA* 108 (1978): 155–74.

Preisshofen/Zanker, "Reflex": F. Preisshofen and P. Zanker, "Reflex einer eklektischen Kunstanschauung beim *Auctor ad Herennium,*" *DialAr* 4–5 (1970–71): 100–19.

Richter, *MMACat:* G. M. A. Richter, *Catalogue of Greek Sculptures in the Metropolitan Museum of Art,* Metropolitan Museum of Art, New York (Oxford and Cambridge, Mass., 1954).

Richter, *Portraits:* G. M. A. Richter, *The Portraits of the Greeks,* 3 vols. (London, 1965) and *Suppl.* (London, 1972).

Ridgway, *Archaic Style:* B. S. Ridgway, *The Archaic Style in Greek Sculpture* (Princeton, 1977).

Ridgway, "Corinth": B. S. Ridgway, "Sculpture from Corinth," *Hesperia* 50 (1981): 422–48.

Ridgway, *Fifth Century Styles:* B. S. Ridgway, *Fifth Century Styles in Greek Sculpture* (Princeton, 1981).

Ridgway, *Severe Style:* B. S. Ridgway, *The Severe Style in Greek Sculpture* (Princeton, 1970).

Robertson, *Shorter History:* M. Robertson, *A Shorter History of Greek Art* (Cambridge, 1981).

Schwingenstein, *Figurenausstattung:* Ch. Schwingenstein, *Die Figurenausstattung des griechische Theatergebäudes* (Münchener Archäologische Studien 8, Munich, 1977).

Stewart, *Attika:* A. F. Stewart, *Attika: Studies in Athenian Sculpture of the Hellenistic Age* (*JHS Suppl.* 14 [1979]).

Strocka, "Variante": V. M. Strocka, "Variante, Wiederholung und Serie in der griechischen Bildhauerei," *JdI* 94 (1979): 143–73.

Strong, "Museums": D. E. Strong, "Roman Museums" in *Archaeological Theory and Practice,* Essays presented to W. F. Grimes (London and New York, 1973), pp. 247–64.

Trillmich, "Bemerkungen": W. Trillmich, "Bemerkungen zur Erforschung der römische Idealplastik," *JdI* 88 (1973): 247–82.

Trillmich, "Jünglingsstatue": W. Trillmich, "Eine Jünglingsstatue in Cartagena und Überlegungen zur Kopienkritik," *MadMitt* 20 (1979): 339–60.

Vermeule, *Sculpture and Taste:* C. C. Vermeule III, *Greek Sculpture and Roman Taste: The Purpose and Setting of Graeco-Roman Art in Italy and the Greek Imperial East,* Jerome Lectures Twelfth Series (Ann Arbor, Mich., 1977).

Vogelpohl, "Niobiden": Ch. Vogelpohl, "Die Niobiden vom Thron des Zeus in Olympia. Zur Arbeitsweise römischer Kopisten," *JdI* 95 (1980): 197–226.

Ward-Perkins, "Marble Trade": J. Ward-Perkins, "The Marble Trade and Its Organization: Evidence from Nicomedia," *MAAR* 36 (1980): 325–38; cf. also, by same author, "Nicomedia and the Marble Trade," *BSR* 58, n.s. 35 (1980): 23–69.

Waurick, "Kunstraub": G. Waurick, "Kunstraub der Römer: Untersuchungen zu seinen Anfängen anhand der Inschriften," *Jahrbuch des Römisch-Germanischen Zentralmuseums Mainz* 22 (1975) (= Festschrift für H.-J. Hundt, pt. 2), pp. 1–46.

Weber, "Amazonen": M. Weber, "Die Amazonen von Ephesos," *JdI* 91 (1976): 28–96.

Wünsche, "Idealplastik": R. Wünsche, "Der Jungling vom Magdalensberg: Studien zur römische Idealplastik," *Festschrift für Luitpold Dussler* (Munich and Berlin, 1972), pp. 45–80.

Zanker, "Funktion": P. Zanker, "Zur Funktion und Bedeutung griechischer Skulptur in der Römerzeit," in *Entr-Hardt (q.v.)*, pp. 283–306.

Zanker, *Klassizistische Statuen:* P. Zanker, *Klassizistische Statuen. Studien zur Veranderung des Kunstgeschmacks in der römische Kaiserzeit* (Mainz, 1974).

Zevi, "Iscrizioni": F. Zevi, "Iscrizioni con firme di artisti greci," *RendPontAcc* 42 (1969–70): 110–16.

Zevi, "Ostia repubblicana": F. Zevi, "Monumenti e aspetti culturali di Ostia repubblicana," in *Hellenismus in Mittelitalien (q.v.)*, pp. 52–63.

Of interest, although not cited in my work, is A. H. Griffiths, "Temple Treasures: A Study based on the Works of Cicero and the *Fasti* of Ovid" (Ph.D. diss., U. of Pennsylvania, Philadelphia, 1943).

I was not able to consult H. Jucker, *Das Verhältnis der Römer zur bildenden Kunst der Griechen* (Frankfort, 1950), but its contents are summarized in Becatti, *Arte e gusto*, pp. 499–500.

Introduction

The basic ideas expressed in this book were developed through years of studying, teaching, and looking at ancient sculpture, but the primary impulse for expressing them came through the invitation to deliver the Thomas Spencer Jerome Lecturers at the University of Michigan at Ann Arbor and at the American Academy in Rome.

Since the guidelines for Jerome Lecturers specify that the topic should be concerned with Roman art, yet Greek sculpture is the only field in which I can claim some competence, my only recourse was to select a subject tangential to both Greek and Roman sculpture: the problem of copies.

To identify lost Greek masterpieces, preserved for us solely in the descriptions of the ancient authors and in the Roman replicas, has been a major task of ancient art historians since Furtwängler's days. Yet to make attributions to various masters, or even to recognize and assess stylistic trends correctly, had always seemed to me a most difficult proposition. From my very first writings, beginning with a study of the so-called Lysippan Jason, I have attempted to distinguish between classical and classicizing, severe and severizing, archaic and archaizing or archaistic. Inevitably, my theories have met with opposition on detail, but the intent has usually been considered valid, and useful when properly carried out. Archaistic as a trend had long been isolated and recognized as chronologically different from archaic. But classicizing as a style is only at present being thoroughly explored, and severizing, as a newly coined term, is just beginning to find its way into publications other than my own, although individual instances of the style had been identified from time to time and properly described since long ago.

Our approach to Greek and Roman sculpture had been heavily tinted by romantic conceptions about artists, and by a thoroughly modern understanding of creative originality which was projected back into the classical past without proper consideration for its different social and economic conditions. Hellenistic and Roman sources, reflecting the changing structures of their own times, had helped to cloud our perception, all the more so since we were already inclined to think in terms of artistic personalities and individual genius. Thus Pliny, Lucian, and eventually Pausanias had been used as veritable texts to be illustrated through

systematic investigation in our museums, on the firm belief that all masterpieces by the Greek sculptors should have been copied and thus preserved by their Roman followers. That the classical Greeks themselves made no distinction between artist and artisan, between what we call major and minor arts, was not sufficiently taken into account; and Roman creativity was automatically discounted because no major names could be isolated through contemporary sources.

This approach to Roman copies has produced useful results; the identification of Myron's Diskobolos, of Polykleitos' Doryphoros, of Praxiteles' Knidia are undoubted conquests for human knowledge. But extrapolations from these attributions and extension of identifications have produced discordant results, with no basic agreement on most points. The attempt to "recognize" a famous Greek prototype in Roman copies has often been made on insufficient premises, some of which, if subjected to careful scrutiny, would prove already invalidated by subsequent discoveries or greater understanding. In addition, an even greater danger is inherent in the fact that a tentative attribution, if frequently repeated, loses its uncertainty and becomes acquired datum, to be endlessly cited in support of further attributions and arguments.

To be sure, a new wind is blowing both in Greek and Roman studies. In the former, suffice to read the lucid introduction by Filippo Coarelli to *Artisti e artigiani in Grecia: Guida storica e critica* (Universale Laterza 577 [Rome/Bari, 1980])—a useful collection of articles highlighting various positions on social and artistic conditions in the ancient world. Nikolaus Himmelmann has also alerted us to the historical bias inherent in our romantic conception of the classical past and the golden age it stands for. (*Utopische Vergangenheit: Archäologie und moderne Kultur* [Berlin, 1976]. An Italian translation, *Utopia del Passato,* with lengthy introduction by S. Settis, has also been published [Bari, 1981].) The book has been considered too specifically focused on German, rather than on universal, positions; yet German archaeological studies have for many decades set the direction of our research and the tone of our thinking, so that Himmelmann's comments truly apply to a much wider sphere.

As for Roman studies, a new generation of German and Italian archaeologists are, on the one hand, discovering and identifying the sculptural creations of the Romans; on the other, they are striving for a better understanding of the phenomenon of sculptural reproduction throughout the ancient world. What used to be taken for granted—the mechanical copying of Greek originals, the importance of the great names, the nature of cult statues—is now open to question, and if no final solution is forthcoming, a great stride forward has at least been made through the perception of the problems and the identification of questions to be asked.

The present generation of scholars is however not unanimously behind these new directions. Archaeology has become a complex discipline, with so many ramifications and such a growing volume of both discoveries and published theories, that its separation from art history is increasingly marked. Thus art historians in general still teach along the lines of the great masters, while many (not all) archaeologists (or rather, ancient-art historians) have left them behind. Undergraduate curricula in American universities still offer surveys of art that—covering enormous spans of time within a semester—find it simpler and more manageable to concentrate on supreme Greek achievements and on a few artistic giants—or at least on those whom the past generations have fabricated for them. Even specialized publications of the last decade can still focus on reconstructing the oeuvre of single masters, despite the enormous discrepancy between the vast number of both carvers and carvings from antiquity and the paucity and slant of our sources.

In thinking about the problem of Greek originals and Roman copies, I had long been frustrated by the scarce reliability of our attributions and by the wide disagreement among scholars. It seemed obvious to me that the "old method" had been tried to its limit and now was the time for a new approach. The Jerome Lectures gave me the opportunity to try to reverse the familiar process: instead of looking at the Roman copies to reconstruct the Greek prototype behind them, why not attempt to locate the originals themselves, to determine their accessibility for copying? To be sure, this question had already been asked by Lippold fifty years ago, but we could ask it again in the light of new knowledge. This approach however required that not only statuary in Greece be considered, but also those sculptures that had been taken to Italy by the Romans—and a direct consequence of it was the need to determine what the Romans had taken and why.

From the reasons behind taking to the reasons behind copying the step was a short one. Given my previous position of skepticism about our ability to recognize the styles of the major masters, I had been warned that my inquiry might force me to admit the opposite of what I had so far believed and written. I therefore confess to facing such new research with some trepidation. To my surprise I discovered that my findings—as unbiased and objective as I could consciously make them—confirmed in large part what I had suspected: the Romans did not copy prototypes exclusively, or even primarily, because of their creators, and their opinion of the *nomina nobilia* did not correspond to our own.

Another facet of my preliminary investigation was the role played by religion in sculptural production, both in terms of subject matter for monuments and in

the specific sense of permitting or prohibiting mechanical copying. Initial research seemed to show that major sanctuaries either did not admit or did not interest copyists, while civic areas and their monuments were accessible for reproduction. At the conclusion of my work I have to admit that my distinction between closed and open sanctuaries cannot always be maintained, although it can almost always be defended or the exception explained. In some cases I can only argue *e silentio,* but the availability of definite evidence from certain areas leads me to believe that comparable proof could have been found for the others, had it existed.

In the course of my investigation I became increasingly aware that the very core of our beliefs needed reconsideration: mechanical copying, as we understand it in modern terms, probably did not exist nor was it conceivable in antiquity. This is not to say that transference of measurements from a model to a block of marble, or casting and recasting, were not practiced. But I agree with Amanda Claridge that "copying, in the sense of an attempt to reproduce in form, style and execution the work of a given artist, so that the reproduction may stand in the place of the original work as an exact replica for the education and instruction of the viewer, is only with reservations to be accredited to the Classical world" (personal letter, April, 1982). As a consequence, faithfulness to a model was not imperative or even desirable, and accuracy was a matter of degrees, since the prototype was not truly copied but rather rethought in contemporary forms and with a different content. More than ever before I came to realize that the so-called replicas were instead adaptations, imitations, variations on certain themes and styles, and, above all, were intensely Roman despite their apparent Greek formulas and iconography. My task became as much a question of establishing Roman originality as that of determining its relationship to Greek art.

In doing so I was certainly fulfilling the spirit, if not the letter, of the Jerome Series. The founder of the lectureship was moved by his deep conviction that the Romans, living in such splendid natural surroundings, could not have been as "bad" as historians depicted them. He therefore wanted to revindicate Roman reputation, through his own writings and those of all future Jerome lecturers. I have emerged from my research with a much deeper understanding and appreciation for Roman art—but what about my audiences?

My lectures, both at Ann Arbor and in Rome, were received with mixed feelings. The reaction to the speaker as an individual, to me as a person, was invariably cordial, warm, most pleasant. Not necessarily or not always so the reaction to my theories. Perhaps the most supportive were the philologists, the students of Greek and Latin literature, who had long been struggling with similar problems of imitation and emulation. It is their language which has provided the terminology for our new conception of Roman sculpture. To many of them, my most daring concepts seemed not only acceptable but at times even obvious. Yet John Van Sickle warned me: "inevitably, as you succeed in working out a new status for the world of plastic art commissioned by Romans, as you establish the ways in which significantly (even programmatically) they select and mingle diverse styles and iconographic types in new syntheses, you are going to provoke lively interest from students of literature in search of comparative points. . . . At the same time you are engaged in a cultural-historical operation directed against a long tradition of reductive thinking about such matters: again, parallel problem in literary studies" (personal letter, March 1982).

Archaeological reaction was split. Some listeners responded with incredulity, others took some of my assertions for granted. The younger Italian scholars, I found, speak my language when it comes to recognizing how widely the Romans of the Late Republican period had been exposed to Greek art through bona fide commissions, rather than solely through war booty. Some art historians, of all nationalities, and whether concerned with ancient or with later art, could readily accept that concepts of imitations and adaptations carried no indictment against creativity and high quality.

Others, however, responded emotionally to my underlying attempt to undermine their faith in traditional attributions, to minimize the impact of the great masters on the Roman clientele. Invariably there was disagreement or objections on specific evaluations of situations or of single pieces. From the start I must stress that I am by no means sure of every suggestion I make, that I propose to point to a direction for future research rather than to provide new and unquestionable solutions. If some of my listeners were critical of individual points, I welcomed their doubts even when I could not share them; but of the validity of the approach I am totally convinced and I hope to have made at least a superficial breach into the solid wall of traditional opposition.

I am aware that my stylistic analyses err heavily on the side of skepticism, that I question and challenge the Greek origin of almost all major sculptural works, that I may tend to underestimate the appeal of the Greek masterpieces for the Romans. On the other hand, and given the stalemate in our studies largely reached by the traditional approach, a *tabula rasa* mentality seems almost a prerequisite for confronting those very same works so long known and studied, if new insights are to be derived from them. After an initial work of destruction and elimination, the painstaking task of rebuilding can begin, but the new struc-

tures shall not be firm if the foundations for each have not been tested and reexamined according to the new perspective.

The undertaking is formidable, and I could certainly not carry it out within the compass of the Jerome Lectures. But through the latter I have perceived what could be a feasible method for future students: tabulation of all replicas of a certain type should be combined with (or even preceded by) tabulation of all sculptural finds from specific areas and sites. With the aid of the computer meaningful patterns of distribution could emerge, that may aid in pinpointing workshops, centers of diffusion, and regional preferences. I can no longer hope to tackle this program, but I trust that the younger students will accept the challenge and take the lead.

1 The Greek Evidence

Between 447 and 438 B.C. Pheidias created his famed gold and ivory statue of Athena for the Parthenon. The Parthenos stood approximately thirty feet high and on her outstretched hand held a Nike of life-size proportions (six feet). Literary descriptions tell us of the rich decoration on the monument, from the Centauromachy carved on the Athena's sandals to the Gigantomachy and Amazonomachy on her shield, the snake coiled inside it, the elaborate helmet, the spear, the frieze on the base. Yet all that remains today are marble copies in statuette format (plate 1), made in much later times, which convey but a pale echo of the impact the original chryselephantine figure must have made on the viewer, towering aloof and glittering in the semidarkness of the temple. The small replicas do not even agree among themselves in the various details, and only a patient work of "textual" collation and criticism allows those modern reconstructions that purport to capture the original appearance of the Parthenos.[1]

Differences between original and copy are even more striking when only the medium has changed — usually from bronze (plate 2) to marble (plate 3)—but no major reduction in size is involved from one to the other, so that a faithful replica could be obtained without compression or simplification. It is then apparent to what an extent the marble work must rely on extra supports: tree trunk along the leg to strengthen the fragile ankles, struts sprouting from thighs and shoulders to brace raised arms, accessories brought closer to various parts of the body to form a marble continuum as contrasted with the static freedom of objects in bronze.

Under these circumstances, it is perhaps understandable that works in marble made during the Roman period have been viewed by modern art historians with a certain amount of condescension, not as statuary in their own right but only as reflections of lost prototypes of Greek art, presumably by great masters since they were copied. In the standard terms of most handbooks on ancient sculpture, the Greeks only produced originals in single versions, which are now lost, mostly because the majority were in bronze and the precious metal was then melted down intentionally or destroyed in conflagrations.[2] The Romans, who wished to own such masterpieces of Greek art but could ill afford them, or could not all possess the same

single original, had them reproduced in cheaper media and multiple versions for the embellishment of their villas. Therefore, although the oeuvre of some major Greek masters would be entirely unknown to us were it not for the Roman copies, such replicas are seen only as a necessary evil to be endured *faute de mieux;* they are studied primarily to recapture their prototypes to which they are inevitably considered inferior. A certain emotionalism is thus part and parcel of all such studies,[3] whereby every Greek original is always hailed as a superior work, and conversely any sculpture of quality is automatically considered Greek rather than Roman.

Pejorative connotations are inherent in the very terminology. Words such as *copy, imitation, reproduction, replica* imply a lack of originality and of artistic input. Yet this assumption is made only in the case of Greek versus Roman sculpture. That famous Renaissance masters copied works from the antique is acknowledged without stigma, and artists of all periods, down to the neoclassical movement of the early nineteenth century, drew inspiration from Graeco-Roman works without being accused of lack of creativity.[4] A partial answer to our automatic reaction has been supplied by Lippold[5]: in the case of Renaissance or later masters we know what prototypes they "copied," while for the Roman works we often lack knowledge of both the names of their makers and of the Greek models they used. We thus take it for granted that such models were major statuary and attribute them to Greek masters who are known to us only through the literary sources—artists who are just names, and works merely listed by titles. In the process, besides having become largely dependent on Roman marbles for our understanding of Greek sculpture—a truly dangerous procedure—we have also virtually fallen into the trap of believing that the Romans, who were quite capable of creating superb portraits, elaborate sarcophagi and complex historical reliefs, were unable to produce statuary in the round unless they copied it from Greek prototypes.

To be sure, in recent years a new current has asserted itself in Graeco-Roman studies, and scholars have attempted to give the Romans[6] more credit for inventiveness and independence. If Margarete Bieber, although purporting to look at Roman copies as expression of their times, could still stress a negative element—the "mistakes" their carvers made in reproducing Greek dress—as a criterion for identification, other students of ancient sculpture—Andreas Linfert, V. M. Strocka, Walter Trillmich, Raimund Wünsche, Paul Zanker—have been trying to isolate specific Roman traits and preferences which would enable us to distinguish between a Roman copy and a Roman creation.[7] The task is immense and proportionately hard. The groundwork was laid down by Lippold as

early as 1923, and every facet of the problem is at least identified in his pioneering *Kopien und Umbildungen.* I cannot even hope to do as much within the compass of this book, which must therefore be understood more as a prolegomenon to a study of Greek and Roman originals than as a thorough investigation with definite conclusions.

I believe, however, that certain positions are worth summarizing and stressing, and that even circumstantial evidence, when cumulative, can carry conviction. In particular, I shall defend three points.

1. The Greeks themselves often produced sculpture in more than one example; they "copied" at the same or at a different scale, as primary or as secondary offering,[8] and "quoted" earlier monuments.
2. The Romans were not always copying from a specific Greek prototype when producing sculpture in the round.
3. The Romans copied—and collected—selectively, according to criteria different from those we now attribute to them.

The definition "Roman" given either to a master or to a work of art should be understood to refer to the historic period during which the work was made or the master lived, and/or to the nationality of the patron who commissioned the work.

Greek Copies

If the term *copy* is understood to mean the mechanical and exact duplication of a piece of sculpture in all its details and exact dimensions, then very few items, whether Greek or Roman, qualify for the title. If, however, what is meant is the reproduction of a work to such an extent that its similarity to the prototype is easily recognizable and, at least in the intention of the maker, the two pieces can be considered the same, then the Greeks themselves "copied" from the very beginnings of stone carving, in the sixth century B.C.

Several scholars have drawn lists of examples, from which a few monuments can usefully be recalled here to identify the various forms and purposes of such duplications.[9] In the case of Dermys and Kittylos (plate 4), for instance, or of "Kleobis and Biton," the sculptor's intention was clearly iconographic: to identify the subjects as brothers or even as twins, and it is this concept of relationship which finds expression in the similarity. Although a recent study of proportions has revealed subtle differences between the two Delphic kouroi, to all intents and purposes they were carved as equal, and only the refinements of modern technology—but not the naked eye—can readily detect the dissimilarities.[10]

Similarity of a different nature is demanded by the

function of architectural sculpture, where karyatids have to match or mirror each other, and lion-head water spouts must repeat the same pattern endlessly along the eaves of a temple roof. In such instances, the intentional and fairly accurate duplication of a three-dimensional model can be taken for granted. A recent study by Nikolaus Himmelmann has shown that the practice is documented in building accounts, and that no special creativity is attached to the making of the prototype, to judge by the remuneration of the various workers.[11] Thus copying techniques can be shown to have existed among the archaic and classical Greeks and to have allowed the reproduction of a given work even when it had the complexity, for example, of the equestrian groups used as lateral akroteria for the Marasà temple at South Italian Lokroi. In the fourth century, guardian lions often confronted each other (plates 5 and 6), or servant figures mourned in mirror image, at the edges of elaborate funerary monuments.

A different technique is involved in the copying of relief work. Here the initial composition is so akin to drawing that duplication may have involved the use of nothing more elaborate than sketches or pattern books. A striking example has been provided by the discovery in the Kerameikos of a late-sixth-century base (plate 7) that on one fragmentary face displays a ball-playing scene. The preserved figures are remarkably similar to those on the so-called Ball-Players Base in the Athens National Museum (plate 8); only a few details vary, such as the long hair or the beards of some of the men depicted on the recent find. That the latter is earlier than the National Museum base is suggested by the fact that the ball-playing scene occupies its main face, flanked by animal compositions on either side. The National Museum base relegates the ball players to one side and displays other competitions, athletic or otherwise, on its main face and on the second side. This subordination seems to imply a diminution of novelty or of importance for the ball-playing composition, therefore a later date which is supported by stylistic elements; but the fact remains that the workshop producing either or both bases must have made use of a model to obtain such a close correspondence.[12]

The players are seen from different angles, including from the back, and with their limbs variously foreshortened, thus reflecting contemporary experimentation in Attic vase paintings by the Pioneers. Could the prototype for such low relief have been provided by a painted scene? Although no certainty is possible, some scholars postulate pattern books and models also for vase painters[13]; be that as it may, close contacts must have existed in the Kerameikos between the carvers' and the potters' workshops.

The chronological interval between the two ball-players bases is likely to have been fairly short. A greater one may have intervened between the two versions of the Telemachos relief commemorating the cult of Asklepios in Athens: fragments from the second version show iconographic and stylistic changes that imply different dates, albeit still within the Greek period.[14] Some reliefs are known, however, to have been set up in duplicate from the start. The practice is attested for decrees, which had to be displayed in more than one location, but some honorary monuments may have had the same function.[15] This duplication has been documented, for instance, for the Paralos relief, honoring both the hero and the homonymous trireme.[16]

Another, and more startling, example is a relief known from a fragmentary replica in Ostia and a complete panel in Turkey, both dated ca. 460–450 B.C. Strocka, who has published the latter, stresses the correspondence of dimensions as significant in establishing the works as part of a series, by which term he means the contemporary production of two or more examples of the same model, at equal scale and identical composition.[17] Although this definition applies also to the architectural sculpture mentioned above, the low relief of this specific example involves a different technique which puts it in the same class as drawing and painting, and may have relied on outline patterns rather than on three-dimensional models.[18]

Sketches must be assumed whenever considerable geographical distance exists between the monument used as model and its "quotation" on another monument. It is not so surprising, in fact, to find the famous Tyrannicides by Kritios and Nesiotes (plate 10) depicted in relief, both low and high, on the Elgin Throne, for instance, or on architectural friezes in Athens (such as those of the Nike Temple or the Hephaisteion); nor is their appearance so surprising on Attic black-figure and red-figure vases. But that their poses (plate 11) should be repeated on the metopes (plate 12) from Temple E at Selinus, in Sicily, is indeed remarkable,[19] and the same applies to the repetition of some Athenian motifs on the friezes of Lycian Gjölbaschi-Trysa, perhaps executed by Greeks. Similarly, quotations from the Parthenon pediments occur on the Bassai frieze, while the Frenzied Maenad by Skopas was probably echoed by one of the Amazons on the Mausoleum frieze, at Halikarnassos.

The "Skopasian" Maenad probably,[20] but the Tyrannicides certainly, are examples of statuary in the round being translated by more or less contemporary carvers into two-dimensional form. The same can be said for the Doryphoros by Polykleitos (plates 13 and 14), which is echoed on the Parthenon frieze, on a relief from Argos, and especially on several gravestones (plate 15).[21] These last form a category of their own, since their very nature lends itself to repetition with minimal variation and within standard composi-

tional format. We expect seriation and imitation in the relatively "mass-produced" stelai of the fourth century, but more surprising is the recently published gravestone from Nea Kallikrateia in the Chalkidike, which in general style and compositional details—the linear hair, the turn of the overfold at the waist—is remarkably close to the famous "Girl with Doves" in the Metropolitan Museum and must come from the same Parian workshop (ca. 450–430 B.C.). Even within the fourth century, the high quality of the Ilissos stele had prompted suggestions that only a major artist could have produced such a masterpiece, perhaps for a single special occasion—a suggestion apparently abetted by a mediocre imitation also from Athens. But J. Frel has been able to identify several male heads so similar to the old father on the Ilissos stele that no doubt exists as to their provenience from comparable gravestones made in the same workshop. The chances that a famous sculptor is responsible for this production appear therefore remote.[22]

All previously mentioned examples of duplication were attested through preserved evidence. In other instances, however, only inference is possible although compelling in nature: that is, only one member of the supposed double is known, but the existence of the other can be attested through the literary sources or is demanded by the nature of the evidence. A case in point is the well-known Penelope (plate 16) found by modern excavators in the ruins of the "Treasury" on the Apadana at Persepolis, where the sculpture had been buried since Alexander the Great destroyed the Persian capital in 330 B.C. Yet the figure of this mourning woman is known not only through reproductions in vase paintings and gems, but also from a relief which in all probability dates from the Greek period, and from at least two replicas (plate 17) in the round made in Roman times. Decorative terra-cotta reliefs, the so-called Campana plaques, provide additional information on how the Romans could have composed a group by juxtaposing separate elements, or even by creating some to be added to those already in existence.[23] Yet what could the Romans have copied if the original Penelope lay buried in Persepolis since the late fourth century B.C.?

A suggestion that the Greeks may have originally produced two virtually identical and contemporary replicas of the Penelope (a sort of female Kleobis and Biton) is supported by literary sources which often mention duplicate dedications: the bronze bull set up by the Korkyrans at Delphi and at Olympia, for instance (Paus. 10.9.2), or the athletic portrait of Cheimon at Argos and at Olympia (Paus. 6.9.3). Athletes may have often commemorated their agonistic victories by setting up monuments both in their home town and at the sanctuary where the contest took place. To what an extent these double offerings resembled each

other we can no longer tell, but the assumption of close imitation is plausible.[24]

Another class of Greek copies is represented by cult images. These were reproduced, perhaps on a different scale and medium, for religious as well as for commercial reasons. A fragmentary torso of the fifth century B.C. seems to lean against a tree trunk and has prompted the suggestion that it copies the Aphrodite in the Gardens by Alkamenes. The torso was found at Daphni, near Athens, where a sanctuary of Aphrodite has been excavated. Its connection with the cult center in Athens is shown by the existence of a frieze of Erotes carrying religious paraphernalia, of which fragments have been recovered both near the Athenian Akropolis and at Daphni.[25] Given these similarities, the reproduction of the cult image becomes more credible, perhaps to stress that the Daphni sanctuary was a branch of the main shrine in Athens.

Pausanias, writing so late in the Roman period, cannot always be believed, nor does he often tell us the dates of the possible duplications. But fourth-century-B.C. Xenophon should make a more attendable source when he writes that he had the Temple of Artemis at Ephesos—as well as the cult image itself—reproduced in smaller scale, as a private shrine, for his estate in Elis, at Skyllous (*Anab.* 5.3.12). And we know that several temples of Athena had imitations of the Pheidian Parthenos (at Antioch, Priene, Notion) as their cult images, presumably to share in the fame of the fifth-century original.

Perhaps the most interesting category of copies, of which excavations are making us increasingly aware, is that of the reproductions of divine images as marble statuettes which were offered at sanctuaries, probably by visiting worshipers. Recent studies have demonstrated the Cretan provenience of the so-called Grimani figures now in Venice, made during the fifth and fourth centuries B.C. after original cult statues of Demeter and Kore. Similar votive deposits have been found at Knossos and Kos, and their publication is forthcoming. Whether or not these statuettes are faithful reproductions of the large-scale sculptures is of secondary importance; of primary significance is the fact that they were made within the Greek period, probably within the same century, if not even the same decade, as their prototypes.[26] Within the same category should fall the statuette of Apollo signed by Chairestratos of Rhamnous and found at Delphi, which reproduces the fourth-century Apollo Kitharoidos in Athens.[27] The same early Hellenistic master made a life-size statue of Themis for Rhamnous which seems to be a fairly close imitation of the colossal torso excavated in the Athenian Agora in front of the Royal Stoa. In this case the imitation may have been made for iconographic purposes, or as a learned quotation from a famous monument.[28]

Such is the nature also of the colossal Athena Parthenos found within the Pergamene Library. Here the statue could not have had true cultic function, and must have served as inspiration, not in her capacity of armed goddess protectress of a city, but in that of patroness of wisdom and learning, as appropriate to the scholarly environment.[29] Although her size, at one-third of the original, places this reproduction well above the many replicas at small scale, this Parthenos, for all the detail of her carved pedestal, should still be considered a simplified version, not a true copy. In addition, her maker has altered the fifth-century style in accordance with the artistic trends of his own period, the second century B.C. Many other statues from Pergamon, although echoing classical modes, have recently been labelled as Hellenistic classicizing creations, difficult to define because on the one hand they are newly conceived, but on the other they incorporate elements of true copying and citations of classical works, to express a meaning of their own.[30]

Roman Copies

The first undoubted example of a copy after a specific original, for which mechanical means were used and exact measurements secured, is the Diadoumenos (plate 18) from the house in Delos which is now called after the statue. The building was probably destroyed in 88 or in 69 B.C., the two major historical events which reduced the island to ruins. The statue is therefore likely to be earlier, ca. 100 B.C.[31] What makes it important for the history of copying is that casts were made of portions of its body to serve as guidelines for the integration of a highly fragmentary replica of the Diadoumenos (plate 19) acquired by the Metropolitan Museum, and they proved to be perfectly scaled to fit this second copy without further adjustments, despite the obvious difference in time between the two replicas. Among the original fragments in New York, in fact, a palm-shaped tree trunk parallels similar supports in statues erected by Herodes Atticus for his exedra at Olympia. Since this fountain complex was finished by A.D. 150, approximately two and one-half centuries separate the Delian from the New York Diadoumenos, and their exact correspondence of measurements can only be explained in terms of accurate and mechanical copying from the same model.[32]

The date of other early copies can be approximately ascertained through their sealed contexts, since they were found as part of two famous wrecks. One, near the Aegean island of Antikythera, has been dated around 80 B.C. on the basis of various items in its cargo, including amphoras, pottery, glass, and a complex astronomical instrument.[33] The other sank off the coast of Tunisia and is known as the Mahdia shipwreck; it should be somewhat earlier than the Anti-

kythera wreck, but still fall within the first half of the first century B.C.

The Antikythera cargo of statues was not homogeneous; in particular, the bronzes are thought to include an original fourth-century piece, the so-called Antikythera Youth (plate 20) in the Athens National Museum, and several other impressive figures, such as the "Philosopher" and his companions, probably to be dated within the first half of the second century B.C. It is primarily because of these bronzes that Bol, in publishing the sculptures from the wreck, opted for the interpretation that the ship carried material looted from Delos and was en route to Italy when it foundered. Other scholars have accepted the bronzes as "second hand," but have seen the marbles as commercial products intended specifically for the Roman market. The value of the wreck, it has been pointed out, would then consist in the "proof that baroque mythological groups in the round and on a monumental scale, existed not only in the experiments of major artists by this time, but even in derivative second-line production."[34] Be that as it may, among the marbles on the ship we find a replica of the Odysseus known as part of the "Theft of the Palladion" group from reliefs on Roman sarcophagi and, in the round, from the Sperlonga grotto. We find also a replica of the Hermes Richelieu type (plate 21), and new fragments have been added, after Bol's publication, to copies of the Knidia (plate 22) and of the Herakles Farnese (see plate 99).[35] This last statue, sadly damaged by its underwater sojourn, is nonetheless important to show that the overmuscular rendering of the type cannot be attributed to exuberant Roman copyists, as some authors claim, but was already current at the time of the wreck, on a scale close to that of the original.[36]

If the Antikythera boat seems to have carried a mixed cargo, no doubt exists about the basic homogeneity of the shipment rescued off the coast of Tunisia. The total Mahdia cargo was meant for the commercial market, and it included not only large-scale statuary in bronze and marble, but also architectural members, such as columns and capitals, items of furniture, and statuettes which have been convincingly explained as *oscilla* meant for a Roman impluvium or peristyle. Only a head of Niobe has been considered a true copy among the marbles recovered from the wreck[37]—the others were thought to be free versions. Fragments of two large marble vases, however, can still be identified, despite their water damage, as belonging to the same types as the Borghese krater in the Louvre and another in Pisa. The Sperlonga finds, moreover, have revealed that one more piece, a child-satyr (plate 23) from the wreck, has not one but three parallels at Sperlonga (plate 24),[38] here transformed into human children playfully arranged around a pool and in the act of splashing water onto the passerby, thus explain-

ing the peculiar and misunderstood gesture of the mutilated figure from the wreck. Since the ship foundered early in the first century B.C., and the Sperlonga grotto was furnished with sculpture during the Imperial period, probably no earlier than the reign of Tiberius, it becomes obvious that the builders of the pool had access to the same prototype (or a workshop's sale catalog?) which had earlier produced the Mahdia satyr.[39]

The Sperlonga grotto and its sculptural finds have thus proved to be crucial to our understanding of Roman copies and Roman art in general. That copies of Hellenistic sculpture were included in the decorative program of the cave seems beyond doubt, but the most spectacular groups, the so-called Odyssey in marble, are too complex and monumental to have been made without consideration of the natural setting they were to occupy. The controversy over their exact nature—whether they are true copies, free copies with additions, or outright Roman creations—has not yet been settled. In my opinion, the Blinding of Polyphemos, the Skylla, and the Shipwreck should be no earlier than Tiberius's time and may fall within Titus's reign.[40] They would confirm that sculptors of the Roman Imperial period could create monumental compositions in Hellenistic style, in that epic baroque best suited to the mythological and heroic topic.

If this Roman creativity is accepted, it would undoubtedly force a revision of our thinking on Roman sculpture per se. We may therefore move to the consideration of the other two points: that the Romans were not always copying from a specific Greek prototype when producing sculpture in the round, and that they copied—and collected—selectively, according to criteria different from those we now attribute to them.

To be sure, much of our understanding of the Romans comes from their own writings and historical reliefs. As in the panels of the Arch of Titus in Rome, we see their conquering armies marching through cities laden with booty, carrying away the most precious objects belonging to the conquered enemy, leaving behind poverty and destruction in their quest for triumph. Through Cicero's orations against Verres we picture all their officials as predatory and ruthless in their greed, taking by force the most treasured possessions of their subjects, for monetary as well as for artistic value, collecting for their own sake rather than for the public good. Cicero officially is at great pains, it has been pointed out,[41] not to betray his own enjoyment of Greek art, to feign ignorance of major sculptors' names and attributions. He hastens to assure his hearers (rather, his readers, since only the first oration was actually delivered) that works of art had great meaning for their Greek owners, however much the fact would seem surprising to a true Roman. But privately Cicero writes to his friend Atticus to procure

sculptures for his library and his house; he urges him, and complains when the purchase is not to his liking, with the typical ambivalence of the cultured Roman in the first century B.C.[42]

Equally ambivalent is our general picture. On the one hand we list the masses of objects looted from Greece and Magna Graecia, we stress the Romans' desire to possess works by the famous masters, we draw up inventories of masterpieces known or believed to have been taken to Rome through its Republican expansionism or its Imperial abuses. On the other hand we see the Romans as tasteless barbarians lacking in refinement, who needed contact with Greek art to become sensitive to the more humanistic aspects of culture, who were incapable of producing works of sculpture and painting on their own and left the task to their "victims," while concentrating themselves on making roads and setting down laws. One can hear the echoes of the Latin sentences behind my very words.[43]

This is in fact part of our problem. The *Romans,* not their victims, have left us this scenario, have conjured up this picture of themselves and their culture. And although Horace's dictum about captive Greece conquering her savage captor has been recently argued to refer specifically to drama and not to art in general,[44] we continue to believe that without invading Magna Graecia and Greece the Romans would have never known "classical" sculpture and painting.

As the British statesman George Canning said 155 years ago, I can prove anything by statistics except the truth. The same archaeological evidence and the same literary sources have been reviewed by two scholars within a few years of each other, and two entirely different conclusions were reached. For Jerome Pollitt the Romans filled their city with masterpieces because of their artistic value, looted because of the great names behind the works, and eventually reacted by assimilating the impact of all that plundered art in their midst.[45] For Blanche Brown the emphasis can be reversed: taking for granted that influence moved from Hellenistic centers to Rome, she stresses instead "the influence that went from the dominant and conquering Romans to the Hellenistic centers" and the impact of Roman taste on Late Hellenistic art.[46] As always, truth lies somewhere in between the two extremes, but I shall move off center in an attempt to redress the traditional view.

The crucial period is during the formative years of the Late Republic, beginning with the fall of Syracuse in 212 B.C. (Livy, 25.40) and the second capture of Taras (from Hannibal) in 209, since little or no plunder had taken place in the first conquest of 274.[47] All authors, ancient and modern, agree that these events opened up the flow of Greek works into Rome and determined subsequent interest and corresponding depreda-

tion. Among the most flagrant examples of Roman greed as well as boorishness, the capture of Corinth in 146 B.C. is most often quoted and L. Mummius, its conqueror, held up as the prototypical Roman, cruel and uncultured.[48] Little is said of later years, although Sulla's sack of Athens and his exploits in the Aegean are supposed to have caused a great deal of looting and destruction. Of the emperors, Nero is singled out for his robberies from the Panhellenic sanctuaries of Delphi and Olympia. Later on in the Empire, artistic trends are supposedly set and Rome is accepted as the leading influence in all aspects of culture.

I shall try to present these same facts from a different viewpoint. In particular I shall argue (1) that our sources are limited, both in time and in focus, and can be read in different ways; (2) that war plunder looms large in modern literature, but was not a phenomenon limited to Graeco-Roman relationships and is not as important as other aspects of Roman assimilation of Greek culture[49]; (3) that the Romans plundered with selectivity, taking objects primarily for (a) monetary value, (b) psychological and symbolic reasons, (c) their relevant subject matter or exotic nature; (4) that the Romans set up as many statues as they took—or more; (5) that the Romans were not as uncultured—at least since the second century B.C.—as they said they were, and had had previous, and different, exposure to Greek art; (6) that the Romans' conception of the major sculptors may have been different from what we believe; that works by the classical sculptors were not specifically looted, nor copied as much as we assume (in particular, I shall maintain that no copying was allowed in the main Greek sanctuaries). Finally, I shall suggest (7) that the Romans "collected" Hellenistic sculpture as much as, or much more than, classical works. I should stress that my remarks are primarily addressed to sculpture, and only exceptionally shall I mention painting, although this form of art was particularly appreciated by the Romans and many pictorial masterpieces were taken to Rome for public or private display.

Notes

1. On the Athena Parthenos and its replicas see N. Leipen, *Athena Parthenos: A Reconstruction* (Royal Ontario Museum) (Toronto, 1971); Ridgway, *Fifth Century Styles,* pp. 161–66 with additional bibliography.

2. For an expression of the "standard theory" see, e.g., Wünsche, "Idealplastik," p. 63, or, more recently, Robertson, *Shorter History,* pp. 51–52.
 The concept of singularity in Greek art has so far been abetted also by our conviction that classical bronzes were cast by the direct process in the lost-wax technique, which requires the destruction of the mold to retrieve the finished product. It is now increasingly clear that the indirect method of lost-wax casting was known in the fifth century B.C., so that neither mold nor model need have been destroyed after use.

3. On the emotional reactions see, e.g., Strocka, "Variante," p. 144, about the possibility that Paionios's Nike might have had a double.

4. Artists have also copied from periods other than the antique without being accused of plagiarism. Pertinent comments applied to American art can be found in J. Lippman and R. Marshall, *Art about Art* (Exhibition Catalogue, New York, 1978) passim, and in its introduction by Leo Steinberg, pp. 8–31.

5. Lippold, *KuU,* pp. 5–6.

6. For my definition of the term *Roman* see infra. I do accept the fact that most Roman art, especially in the Republican period, was created by Greek artists, but I also consider as Roman all sculpture created for Greeks during the Roman period.

7. Bieber, *Copies,* passim. The other authors are all mentioned in the bibliography and will be often cited infra.

8. By this expression I mean that the cult image in a temple (a primary offering) could copy an original elsewhere, and that the small dedications made to a divinity (secondary offerings, in so far as subsequent to the existence of the cult image) could reproduce that very statue.

9. Lists of Greek "doubles" have been drawn up by F. Brommer, "Vorhellenistische Kopien und Wiederholungen von Statuen," in *Studies presented to David M. Robinson,* vol. 1 (St. Louis, 1951), pp. 674–82; most important is Strocka, "Variante," on which my own account depends most heavily. See also Vermeule, *Sculpture and Taste,* pp. 3–5.

10. To be sure, some scholars had already suggested that two different hands may have been involved in the making of the statues: see Ridgway, *Archaic Style,* bibliography for p. 70 on p. 81. The statistical profiles obtained by E. Guralnick, however, have the advantage of *proving* what previous analyses could only surmise: see *AJA* 86 (1982): 267–68. C. Vatin has now shown that "Kleobis and Biton" are the Dioskouroi and were made by Polymedes and Theodotos of Argos: *BCH* 106 (1982): 509–25.

11. N. Himmelmann, "Zur Entlohnung künstlerischer Tätigkeit in klassischen Bauinschriften," *JdI* 94 (1979): 127–42. In architecture, repetition had already been engendered by the practice of terracotta revetments and ornaments, which were mold-made and therefore automatically reproduced; cf. Strocka, "Variante," p. 158.

12. Athens, Ball-Players Base, N.M. 3476: R. Lullies and M. Hirmer, *Greek Sculpture* (New York, 1960), fig. 62. Kerameikos base, P 1002: F. Willemsen, *AthMitt* 78 (1963): Beil. 64.2–66. Strocka, "Variante," p. 166, argues that the inappropriate association of an athletic scene with animal subjects on the Kerameikos base, in conjunction with its earlier style, confirms that both it and the National Museum base derive from an independent, if contemporary, prototype.

13. See, e.g., K. Schauenburg, *Antike und Abendland* 20 (1974): 95, and nn. 57–58; also *AA* 1977, pp. 194–204. Contra, A. Steiner, *AJA* 86 (1982): 287. Cf. the more articulated viewpoint in J. P. Connor, *BABesch* 56 (1981): 37–42.

14. L. Beschi, "Il Monumento di Telemachos, fondatore dell'Asklepieion ateniese," *ASAtene* 45–46, n.s. 29–30 (1967–1968): 381–436. At the time of Beschi's writing, the fragment now in the British Museum was not yet known and could therefore not be taken into account for his reconstruction and chronology. E. Mitropoulou, who wrote after the British Museum acquisition, has argued that the "duplicate" was made at a later period (*A New Interpretation of the Telemachos Monument* [Athens, 1975]). A brief summary of iconography and chronological discussion appears in B. S. Ridgway, "Painterly and Pictorial in Greek Relief Sculpture," in *Ancient Greek Art and Iconography,* ed. W. G. Moon (Madison, Wis., 1983), pp. 193–208 and nn. 21–22.

15. For decrees set up in multiple copies see, e.g., Thucydides 5.47.11, who gives the text of IG I² 86 and at the end mentions provisions for copies to be set up at Athens, Argos, Mantineia, and Olympia (three copies in stone and one in bronze). Cf. also T. Linders, *Studies in the Treasure Records of Artemis Brauronia found in Athens* (Stockholm, 1972) pp. 72–73, for duplicates of Treasure records at Athens and Brauron. I am indebted to Prof. A. Boegehold for these references.

16. Paralos relief: L. Beschi, "Rilievi votivi attici ricomposti," *ASAtene* 47–48, n.s. 31–31 (1969–1970): 117–32; Ridgway (supra, n. 14), p. 199 and n. 30.

17. Strocka, "Variante," pp. 144–57. One more category discussed by Strocka is that of reliefs duplicating the same image (see plate 9) for emphasis on the divine powers of the icon. On this type of relief cf. also T. Hadzisteliou Price, "Double and Multiple Representations in Greek Art and Religious Thought," *JHS* 91 (1971): 48–69.

18. In this review of ancient copies I have concentrated on sculpture; we do know, however, that monumental paintings of considerable complexity were also copied. We are told, for instance, that Attalos II had the Pergamene artists Kalas and Gaudotos go to Delphi to copy some of the murals there (see, e.g., *EAA* s.vv. *Kalas* and *Gaudotos;* Lippold, *KuU,* p. 16). For a copy in Athens of Zeuxis's *Family of Centaurs* see infra, chap. 4 and note 37.

19. For the influence of the Tyrannicides on Temple E see W. Fuchs, *RömMitt* 63 (1956): 102–21. For the occurrence of the motif on architectural friezes see, e.g., Ridgway, *Fifth Century Styles,* pp. 88, 91 n. 35, 212, with additional references. On the Elgin Throne, now in Malibu, see J. Frel, *AthMitt* 91 (1976): 185–88 (dated ca. 300 B.C.); L. Beschi, *GettyMusJ* 5 (1977): 33–40.

20. For the influence of the Skopasian Maenad on the Mausoleum frieze see A. F. Stewart, *Skopas of Paros* (Park Ridge, N.J., 1977), p. 93; T. Lorenz, *BABesch* 43 (1968): 52–58.

21. For echoes of the Doryphoros on Attic works see also infra, pp. 65–66. For the Argos relief see, e.g., G. Neumann, *Probleme des griechische Weihreliefs* (Tübingen, 1979), fig. 25c, and his chapter 4 for several examples of statues reproduced on reliefs. The relief has been variously dated: Neumann, p. 44, does not specify a period but accepts considerable chronological distance between prototype and relief replica; Lippold, *Handbuch,* p. 163 n. 14, dates it still within the fifth century; Lorenz, *Polyklet,* p. 54, calls it Late Hellenistic or early Roman; Karouzou, *Guide,* p. 86, no. 3153, suggests the beginning of the fourth century; Strocka, "Variante," p. 163, prefers the late fourth century and gives additional opinions in n. 103.

For echoes of the Doryphoros on gravestones and reliefs see also Ridgway, *Fifth Century Styles,* pp. 142–43 and bibliography.

22. Relief from Nea Kallikrateia in the Chalkidike, and its similarity to the "Girl with Doves" in New York: A. Kostoglou-Despoinē, *Problemata tēs parianēs plastikēs tou 5ou ai. p. Chr.* (Saloniki, 1979), pp. 89–114, pls. 30–32.

The Ilissos relief and its imitation are illustrated by N. Himmelmann-Wildschütz, *Studien zum Ilissos-Relief* (Munich, 1956), pls. 18 and 17 respectively. For the attribution of other stelai to the Ilissos Master see J. Frel, *Les sculpteurs attiques anonymes, 430–300* (Prague, 1969), pp. 41–43.

23. On the phenomenon of *Gruppenbildung* see Trillmich, "Bemerkungen," esp. p. 266 for reference to the Persepolis Penelope; the type has been variously identified, including as a possible personification of Aidos: see most recently F. Eckstein in *LIMC* (Zurich, 1981), s.v. Aidos. For a summary of other positions see Ridgway, *Severe Style,* pp. 101–4 with bibliography, and *Fifth Century Styles,* pp. 232, for a possible connection with a nurse figure.

24. Thematic duplication of offerings for political antagonism is discussed by Hölscher, "Die Nike," with several examples; see esp. his chart on p. 79.

Some offerings may have been given in duplicate: Licia Vlad Borrelli tells me that the museum in Thana, South Arabia, houses many bronzes in double version, which range from the late sixth/ early fifth century B.C. to at least the time of Septimius Severus. The silk route passed through that area, and perhaps Persian influence is responsible for this phenomenon of duplication, but religious reasons may also have prompted it. For a much later example, although patterned after Greek prototypes of the fifth century, see the bronze horse in Washington, D.C.: G. M. A. Richter, *Catalogue of Greek and Roman Antiquities in the Dumbarton Oaks Collection* (Cambridge, Mass., 1956), pp. 26–28, no. 15, late fifth or sixth century A.C. Inscriptions on the horse mention that it was one of a pair.

25. Aphrodite from Daphni: A. Delivorrias, "Die Kultstatue der Aphrodite von Daphni," *AntP* 8 (1968): 19–31; Erotes frieze, from Athens, Nat. Mus. 1451 and 1452: S. Karouzou, *ArchEph* 1956, pp. 164–80; from Daphni, Athens Nat. Mus. 1591: Karouzou, p. 165, fig. 2. For a discussion see Ridgway, "Greek Antecedents of Garden Sculptures," in *Ancient Roman Gardens,* eds. W. Jashemski and E. McDougall (Dumbarton Oaks, Washington, D.C., 1981), pp. 22–25 and n. 38. See also Paus. 1.38.8 and 5.26.6, for other possible replicas of divine images.

26. On the Grimani statuettes and related monuments see Ridgway, *Fifth Century Styles,* pp. 194–98 with bibliography; cf. the comments by E. La Rocca, *ArchCl* 28 (1976): 225–34, esp. pp. 229 and 234. See also M. A. Minutoli, *DialAr* 9–10 (1976/77): 399–438, for Greek originals dedicated in a Sardinian temple (at Antas).

27. For the connection of the Delphic Apollo statuette with Chairestratos and the Kitharoidos in Athens see J. Frel, *GettyMusJ* 8 (1980): 206; J. Marcadé, *Etudes Delphiques* (*BCH* Suppl. 4, 1977): 395–98, figs. 7–9; for the trunk support see *GettyMusJ* 6–7 (1978–1979): 79, fig. 10. The Kitharoidos in Athens, which may be the Apollo Patroos by Euphranor, will be discussed infra. The important point to be made here is that it is a fourth-century type reproduced shortly afterward.

28. For a discussion of this Agora monument see infra, chapter 6, p. 70. A similar iconographic quotation may occur with Figure G on the east pediment of the Parthenon, possibly Hekate imitating the so-called Running Girl from Eleusis: cf. C. M. Edwards, *AJA* 86

(1982): 263, and a forthcoming article. In this case both the prototype and the imitation were part of architectural sculpture.

29. For this concept see Zanker, "Funktion," p. 302; cf. also M. Gernand, "Hellenistische Peplosfiguren nach klassischen Vorbildern," *AthMitt* 90 (1975): 1–47.

30. Besides Gernand, who deals not only with Pergamene statues, but also with finds from Delos, Thasos, and Samos, see also the Hellenistic adaptation of the head of the Athena Giustiniani type, Athens, Nat.Mus.3004, Karouzou, *Guide,* p. 164, pl. 55. For Athens in the Hellenistic period see Stewart, *Attika,* p. 54: "In general, the art of the period ca. 340–ca. 280 is ransacked for models." On the Hellenistic adaptation of the classical Aphrodite-of-Frejus type see Guerrini, "Motivo iconografico" and infra, chapter 7.

31. On the Delian destructions see, e.g., Marcadé, *Au Musée,* p. 45 and n. 4; *Guide de Delos,* p. 23; on the House of the Diadoumenos in Delos see also Stewart, *Attika,* p. 70; the statue will also be discussed infra (chap. 5, p. 50) with reference to the location of its prototype.

The date of the beginning of copying is given differently by different authors. Lippold, *KuU:* from ca. 50 B.C. to ca. 250 or 200 A.C. Lauter, *Chronologie:* turn into first century B.C. sees "strengthening of copying," as contrasted with earlier, freer style. Few copies from the third century A.C., still stock bodies, but no longer important to reproduce masterpieces as such. Preisshofen/Zanker, "Reflex": ca. second half of second century B.C., directly connected with eclecticism. Bieber, *Copies:* faithful imitation of works of art *which the ancients acknowledged as outstanding* (my emphasis), not begun until after first century B.C.; continues at least until 304 and 308 A.C. (statuettes of Athena and Asklepios dated by inscriptions); but no true end to copying, motifs continue even into Christian-Byzantine art. A head of Menander was copied in the fifth century A.C.

32. This is Richter's dating, *MMACat,* p. 32, no. 38. Lauter, *Chronologie,* p. 89, dates the New York Diadoumenos in the last decade of the first century A.C.

33. The sculpture from the wreck has been republished by P. C. Bol, *Die Skulpturen des Schiffsfunds von Antikythera (AthMitt BH 2,* Berlin, 1972). The miscellaneous material is discussed in "The Antikythera Shipwreck Reconsidered," *TAPS* 55.3 (1965): 3–48, by various authors; see esp. p. 4 for a summary on chronology. That the date of the wreck should be higher than ca. 80–60 B.C. has been argued, e.g., by Ph. Bruneau, *REG* 79 (1966): 517–18.

34. The quotation is from A. Hermann, review of Bol, *AJA* 77 (1973): 451–53; Homeric groups: Bol, pp. 78–83, nos. 26–29, 31.

35. Additions: *Deltion* 29.2.1 (1973–74), pls. 13–15. An even earlier, but freer (?), copy of the Knidia may exist in Berlin: the Kaufmann Head which Lauter, *Chronologie,* p. 120, dates to the second century B.C.

36. Herakles Farnese from wreck: Bol (supra, n. 33), pp. 48–49, no. 23, pres. height (without head but including plinth): 2.62 m. Another among the earliest replicas is a statuette version in bronze, from Hellenistic Pergamon: D. Pinkwart, "Drei späthellenistische Bronzen von Burgberg in Pergamon," in *Pergamenische Forschungen,* vol. 1, ed. E. Boehringer (Berlin, 1972) pp. 115–39; for a list of replicas of the Herakles Farnese see pp. 119–20, n. 6 (fifty-four, plus two variants and one sarcophagus representation; but note that the article was finished in 1965). The Pergamon statuette is dated to the late second/first century B.C., "pre-Augustan." On the Herakles Farnese type see also C. C. Vermeule, "The Weary Herakles of

Lysippos," *AJA* 79 (1975): 323–32, with classification into four groups according to faithfulness to the prototype. A more detailed classification is made by P. Moreno, "Il Farnese ritrovato—ed altri tipi di Eracle in riposo," *MélRome* 94 (1982): 379–526. For further comments on the type see infra, chapter 6, p. 73.

37. On the total cargo: W. Fuchs, *Der Schiffsfund von Mahdia* (Tübingen, 1963); the Niobe is no. 45 on p. 36. For the use of some of the bronzes as *oscilla* see D. K. Hill, "Some Sculpture from Roman Domestic Gardens," in *Ancient Roman Gardens* (supra, n. 25), pp. 83–94, esp. pp. 86–87. For the Niobe as a copy see Lauter, *Chronologie,* p. 120, although not all scholars accept this identification.

38. B. Andreae, "Schmuck eines Wasserbeckens in Sperlonga—Zum Typus des sitzenden Knäbenleins aus dem Schiffsfund von Mahdia," *RömMitt* 83 (1976): 287–309.

39. One more object from the Mahdia shipwreck is known through a second replica: the herm support on which the Agon by Boethos leans. See J. Frel, *GettyMusJ* 8 (1980): 96–98; the piece is said to be a poor copy but interesting for its method of attachment.

40. The official publication on the Sperlonga marbles remains *AntP* 14 (1974) by B. Conticello and B. Andreae; see review by P. H. von Blanckenhagen, *AJA* 80 (1976): 99–104. The literature on the subject continues to accumulate and the controversy over the dating of the pieces gives no sign of abating. One of the most recent contributions, H. Riemann, "Sperlongaprobleme," in *Forschungen und Funde* (Festschrift B. Neutsch, Innsbruck, 1980), pp. 371–83, would give a Tiberian date at least to the Skylla group and the Laokoon. My own views on chronology are not meant to deny possible Hellenistic inspiration, but even if a definite Hellenistic prototype was used for each complex group, I believe that it was considerably altered in its composition to suit the requirements of the difficult locale. I would moreover advocate that no true solution of continuity exists between Hellenistic and Roman sculpture, despite present chronological divisions and definitions. On this subject see the comments by Brown, "Questions," esp. p. 36 and n. 41.

For an undoubted example of a Roman creation in Hellenistic style see a bronze statuette of Vulcan from near Richborough, Kent: M. Henig and R. Wilkins, *Oxford Journal of Archaeology* 1(1982): 119–24. The piece is dated to the Hadrianic/Antonine period.

41. Pollitt, "Impact," pp. 162–63; R. Bianchi Bandinelli, *Rome, the Center of Power* (New York, 1970), pp. 43–44.

42. The pertinent references have been collected by Pollitt, "Impact," and *Art of Rome,* as well as by Becatti, *Arte e gusto.* See also Zanker, "Funktion," esp. pp. 284–88.

43. The most frequently quoted passage in this context is Vergil *Aeneid* 6, vv. 847–53; see, e.g., Pollitt, *Art of Rome,* p. xii.

44. Horace *Epistles,* II, lines 156–57; see the discussion by Brown, "Questions," pp. 29–30 and n. 12.

45. Pollitt, "Impact," p. 155, and passim. This position is also expressed in a posthumous publication by G. M. A. Richter, updated by J. D. Breckenridge, "The Relation of Early Imperial Rome to Greek Art," *ANRW* II.12.1 (Berlin, 1982): 3–23.

46. Brown, "Questions," esp. pp. 32–36; the quotation is from p. 32.

47. Thus most modern authors, who follow Livy, e.g., Pape, "Kriegsbeute," pp. 1, 6 and passim; Pollitt, "Impact," p. 155.

A different view of the capture of Taras, and a discussion of the bias in the ancient sources, can be found in P. Gros, "Les statues." Waurick, "Kunstraub," cites earlier beginnings.

48. Only M. Cary, in *A History of Rome down to the Reign of Constantine,* 1957 ed., p. 210, states that the Romans "made Cor-inth safe against social revolution by razing it to the ground and selling its inhabitants into slavery." More recent sources, to be discussed infra, have made a more moderate defense of Mummius, on the basis of archaeological evidence.

49. The latter part of point 2 will be discussed in chapters 7 and 8.

2 The Roman Evidence

We can now begin to discuss individually the points outlined in the previous chapter, in the same order. The time span involved will range from the Republican period to the fourth century after Christ, since copies were made as late as the reign of Constantine, if not later. The main focus, however, will be from the Late Republican–Augustan phase to the Antonine period. Obviously conditions and interests changed from phase to phase, and not all inferences apply equally to the entire range of evidence. I shall attempt to differentiate to the best of my knowledge.

The Sources

Most of our information for the events of the third and second centuries B.C. comes from historians who wrote considerably later, during the first. By that time, many of the monuments had already been destroyed, as stated by Livy himself (25.40.3). Historians like Livy, moreover, give little information on artists, since they used archival material, where items were usually listed by quantities and numbers and evaluated for their monetary rather than artistic value.[1] Other sources, like Polybios (202–120 B.C.), are slanted in their approach. Books on art theory written in antiquity are lost to us except as citations in other works, where they are adapted to serve the topic at hand.[2] Orators and poets had a specific "axe to grind," either as part of the point of view they were defending or to please the patron for whom they were writing.[3] Lucian, Plutarch, and Pliny are considerably later in time, yet they represent the most frequently cited sources for our information on ancient sculpture. It is important to remember that Pliny was writing as part of a general work on natural history, not on art, and that his main concern was the medium rather than the subject matter. He was, moreover, always intrigued by colossal size and complex compositions, which involved technical difficulties. He marveled, for instance (*NH* 36.37), at the fact that the Laokoon was made from a single block of marble (despite the fact that this has proven to be untrue), and his main reason for admiring the Punishment of Dirke (The Farnese Bull) was again technical: not only in one piece, but even the rope was made of marble (*NH* 36.34).[4]

That Pliny grouped artists in violation of chronological plausibility is a well-known fact, but he also

made no distinction between homonymous masters from different generations (e.g., Skopas major and minor, Polykleitos the Elder and the Younger) and in some cases was so distracted by phonetically similar names that he included the oeuvres of poetesses and other people among those of bona fide sculptors (*NH* 34.57–58, Myron/Myro).[5] Yet Pliny is our main source for attributing works to artists and for assessing what Greek masterpieces were in Rome during his lifetime.[6] Furthermore, Pliny himself acknowledged that some of the works of art he mentions no longer existed when he wrote, having perished in previous catastrophes. Finally, note that we have no serious art historical account for the Antonine period, when copying as we see it was at its height, and the demand for sculptural embellishment of the "marble cities" was greatest.

Quintilian (ca. 35–95 A.C.) is a frequently quoted authority; yet it has been suggested that the sculptors and painters he lists are chosen not on their merits, but to comply with specific numbers: ten painters and ten sculptors, with Euphranor cited between the two categories since he practiced both sculpture and painting. This number theory would be derived from a Hellenistic canon of ten, comparable to a presumed Pergamene canon of ten orators in vogue during the second century B.C.[7] A further danger is inherent in the modern practice of quoting only those ancient passages that refer to artistic matters, extrapolating them from their context. Such dicta acquire therefore an authority which would at least be challenged, were they read in their entirety. To return to Quintilian, even his famous passage on painting (*Inst. Orat.* 12.10.1–10) makes little sense, when he notes that Polygnotos and Aglaophon made almost primitive works, but were admired "for the sake of their antiquity" and that Zeuxis gave greater fullness to parts of the body and conceived it ampler and more solemn, following *Homer* (my italics), who liked a vigorous shape also for women.[8] One final point: Imperial sources on depredation tend to slander the past and gloss over the present. Pliny complains about Nero's greed, but has only praise for the policies of the Flavians; yet that looting and sacking took place under them is attested not only by the events but by the very depiction on Titus's triumphal panel. This important relief may serve as the basis for our next point.

War Plunder
The Romans' predatory policies toward Greece loom largest in the literature,[9] yet they were much less important than other aspects of Roman rule. The contemporaries of the Romans were not as dismayed as we are, since Greeks themselves had sacked cities and all ancient civilizations considered looting a right of war. The removal of statuary belonging to the enemy—albeit taken for magical purposes—could be dated as early as the legendary past: the Palladion from Troy, the idol of Artemis taken by Orestes from Tauris, the olive-wood figure stolen by the Aiginetans (Herod. 5.82–7). In historical times, the Persians removed Antenor's Tyrannicides from the Athenian Agora, the Carthaginians took a statue of Artemis from Segesta (later returned by the Romans), the Pergamene kings sacked Oreos in Euboia, and sculptural booty from Corinth has been tentatively recognized among statues from the Attalid citadel. In their turn, the Attalids were robbed of a statue of Asklepios by Phyromachos, taken by Prusias of Bithynia in 156 B.C.[10]

Pausanias himself (8.46.1, 4–5), in justifying Augustus for taking an ivory statue of Athena from Tegea, lists earlier examples as constituting precedent, and we need only refer to our own days to find comparable situations. Aside from the tragic excesses of the Spanish conquistadores, we can recall the Napoleonic campaigns which not only enriched France with Egyptian antiquities, but filled Paris with masterpieces from Italy and with ancient statues from Rome—in retaliation, as Napoleon said, for what the Romans had done to the Greeks.[11] That Italy suffered a similar fate during World War II is too well known to bear mention.[12]

The earliest and legendary thefts of statuary carry magical connotations; it is only in Hellenistic times that "collectionism" and antiquarianism assert themselves and prompt specific forms of artistic looting. But in so doing the Romans were following the examples of their Hellenistic colleagues. Through modern discussion, moreover, we receive the impression that only Greece suffered from such depredations. Yet the Romans began with Etruscan and Italic monuments during their expansion within the peninsula,[13] and brought home sculptural booty from Carthage, Egypt, Apollonia Pontica, and Syria.[14] The *Monumentum Catuli,* built by Q. Lutatius Catulus after his victory at Vercellae over the Cimbri (101 B.C.), was decorated with Cimbrian war spoils, although individual works of art are not mentioned in the sources. Finally, if the Arch of Titus can be considered accurate reflection of the event, the Jewish triumph included religious objects, like the Menorrah, which certainly qualify as works of sculpture and art, in precious metals.

Among works taken to Rome, some came from Pergamon and Bithynia, but these can hardly be considered booty, since Attalos III in 133 B.C., and then the Bithynian kings, willed their kingdoms to the Romans. And if Roman emperors returned from their travels with Greek statuary, this was not always "sequestered" but was occasionally bought, as we know for the statue of Hestia from Paros which Tiberius acquired during his trip to Rhodes in 6 B.C. and dedicated in the *Aedes Concordiae*.[15]

The last chapter on the removal of Greek works of art from Greece and from Rome itself was eventually written when the late Roman emperors transferred some of the last masterpieces to Constantinople, where they stood in the palace of Lausus, in the hippodrome and other places in the city, only to fall prey to later fires and destructions. To what an extent these were still original works or clever copies, we can no longer tell.[16]

Plundering Criteria

It has generally been assumed that the Romans took as booty whatever objects had the highest aesthetic value or carried the names of the most famous sculptors. Cicero himself, in the *Verrines,* gives the impression that the master's name added to the importance of the piece stolen. But is this assumption true? A valuable dissertation by Magrit Pape (Hamburg 1975) places art historical interest last among the reasons for the Romans' choice in collecting war booty, and some of her statistics convey a different picture.[17]

It stands to reason, in retrospect, that much of what was taken had to have monetary value. Sulla openly admitted to have financed his campaigns through his looting, and the same was true even earlier, for the Punic wars. Gold and silver play the major role in all mentions of war booty. Many of the objects were selected for their symbolic meaning or to impress the Roman populace—and more will be said about this point. But the list of what was carried in the triumphal procession commemorating the victory against Antiochos III (190 B.C.) after the capture of Magnesia-by-the-Sipylos is worth repeating in toto, for its implications. To be sure, as many as 134 statues of assorted deities were included, as if the very gods of the city had been taken prisoner—a truly Roman conception with psychological rather than aesthetic significance. The rest reads as follows: 224 military standards; 134 models of conquered towns; 1,231 sets of elephant tusks; 234 gold crowns; 137,420 pounds of melted-down silver[18]; 224,000 tetradrachms; 321,000 Asiatic coins (cistophori); 140,000 gold pieces (philippi); 423 pounds of engraved silver vases; 1,023 pounds of gold vases. It should be stressed that although such gold and silver vessels undoubtedly represented luxury items, they were listed by weight, and that the entry on melted-down silver may have represented the ultimate fate of similar objects.

L. Mummius, the conqueror of Corinth, was criticized by some ancient sources for his boorishness and lack of appreciation for Greek art. His soldiers are said to have eaten on boards from destroyed paintings, and he was ridiculed for admonishing the ship captains who were to take the Corinthian booty to Rome that should the cargo be lost at sea they were responsible for re-placing it with equivalent value (Velleius Paterculus 1.13.4). How could such priceless objects ever be replaced? Yet the clause was standard for all ancient maritime shipments, and Mummius was doing no more than insure the safety of his financial investments.[19]

Another important reason behind plundering was psychological. To return to the berated Mummius, Polybios reports that statues of personifications had been taken from the Achaians to stress their loss of freedom, in a move intended to erase the political symbols of the Greeks, but that Mummius himself returned some of them before leaving for Rome. Indeed only late sources, like Velleius and Dio Chrysostomos, write negatively about Mummius and his lack of artistic appreciation; Cicero, Frontinus, Livy, and Strabo praise him for his generosity, and Pausanias stresses that Mummius was the first Roman to make dedications in a Greek sanctuary (5.24.4).[20] Not only did he hang twenty-one gold shields on the Temple of Zeus at Olympia after the capture of Corinth, but he also set up bronze statues of Zeus in the Altis, and excavations there have found several inscriptions from his dedications; another fragmentary inscription shows that Mummius and the ten legates who administered Greece under him were honored with statues still respected and refurbished almost two centuries later. Epigraphic evidence reveals moreover that Mummius used much of his booty to set up public offerings, not only in Rome but also in other Italian cities and even in Spain.[21]

Like Mummius, other Roman generals took from the captured cities those statues that might have been most meaningful to their victims. In this practice they had a valid precedent in the Persians' removal of the Tyrannicides from Athens, and certainly some distant sequel in the V-1 bombings of England in World War II. T. Varro Lucullus removed from Apollonia Pontica (in 71 B.C.) a colossal Apollo by Kalamis (which he set up on the Capitoline), not only because of its impressive size but because it was the symbol of the city. L. Lucullus took the statue of Autolykos, made by Sthennis of Olynthos, from Sinope, because it represented the founding hero. Titus's panel, as we have seen, illustrates the removal of the Menorrah and other main Jewish religious symbols. Finally, when Augustus brought for his Egyptian triumph a gold statue of Kleopatra (later dedicated in the Temple of Venus Genetrix), he might have had in mind its impact upon the Romans in psychological as well as in monetary terms. The same applies to the Fallen Lion, which might have been taken by Agrippa from Lampsakos because it was said to be by Lysippos, but may equally well have appealed to the Romans as an allusion to a brave but defeated enemy.[22]

Psychology and symbolism were in fact equally operative on the Romans as on their victims. Most of the monuments taken as war plunder can be explained in

terms of their meaning for the conquerors as well as for the conquered. Pape has pointed out[23] that by Augustan times the most popular themes among the Greek spoils in Rome were:

portraits of Alexander (both in sculpture and painting): he was the prototypical heroic ruler and victorious general whom many Romans strove to emulate;

statues of Herakles, as the superhuman victor, and perhaps even as the possible ancestor of some Roman families[24];

statues of Zeus: he was the major god of the Romans, and as such particularly appropriate for subsequent dedication;

statues of Apollo and Venus, both deities with special meaning for the *Gens Julia* and for Augustus personally;

statues of Athena: as goddess of wisdom and victory, she was soon assimilated to the Roman Minerva and fused into the Roman iconography of Minerva-Victoria.

Many of these Greek statues were to be seen within the temples of the appropriate divinities, thus making it clear that correlation was sought between cult and offerings. Pape's lists, for example, reveal at a glance that all Greek spoils within the temples of Apollo Sosianus and Palatinus were related to that god,[25] while the *area capitolina* contained only monuments with subjects pertaining either to Zeus or to military exploits, or items surprising for their size and artistry.

Another interesting example of Roman attention to meaning is the case of the Ambrakian Muses. Why this group of statues taken by Fulvius Nobilior from Ambrakia (187 B.C.) should have been dedicated in the Temple of Hercules *in Circo Flaminio* had always represented somewhat of a puzzle. That the temple later came to be known as *Aedes Herculis Musarum* was certainly due to the presence of the Ambrakian statues rather than vice versa. The puzzle has now been convincingly solved by Maria Teresa Marabini Moevs with the help of Terra Sigillata fragments securely dated to the Augustan period through the signature of Cerdo of Perennius. On these sherds the Muses appear as recognizable, early Hellenistic statuary types, accompanied by *an actor* wearing a Herakles mask and the hero's club. The statues taken by Fulvius Nobilior must have therefore been part of a choragic monument, but their theatrical connection was disregarded by the Roman consul, who focused instead on the presumed Herakles for its implied significance. After the battle of Actium (near Ambrakia) Augustus consecrated the Muses as *symbulus actiacus* complementing his renovated cult of Apollo, and the event was commemorated in a special issue of Arretine ware reproducing the images of the Muses and the

Hercules/actor. Both meanings of victory (Hercules) and Apolline inspiration (Muses) could therefore find expression in the new dedication.[26]

A further instance of the Romans' use of Greek monuments for additional symbolism of their own is the case of the statue of a Nike from Taras which Octavian set up in the new Curia to signify his own *Victoria*. As Zanker has pointed out, these Greek works were given new contexts—and thus new meaning—from which they could no longer be dissociated, for propaganda purposes.[27]

We are under the general impression that the Romans took works of art as such; yet many objects listed in our sources fall under different categories. Aside from those sculptures taken for their spectacular size, there are statues with magical properties, luxury objects, curios, statues in exotic or unusual materials, and even objects with a subtle meaning of their own.[28] We learn, for instance, of the three statues of the *Nixi Dii* in the Temple of Jupiter Capitolinus: they were kneeling birth helpers, brought to Rome by M. Acilius Glabrio. In the same temple were Myrrhinian vases, and finger rings from the collection of King Mithradates, dedicated by Pompey. Livia herself dedicated in the Temple of Concord a sardonyx allegedly from the ring of Polykrates—a rather unbelievable assertion, considering the vicissitudes of that famous ring. In the same temple Augustus offered four elephants made of obsidian, and he seems to have taken from Tegea (which had sided with Antony) not only the ivory Athena Alea by Endoios that he placed as a pendant to an ivory Apollo at the entrance to his Forum, but also the tusks of the Kalydonian boar, which were to be seen later in the garden of Liber (Paus. 8.46.1 and 4–5; Pliny *NH* 7.183, Svet. *Aug.* 72). Archimedes' globe was in the Temple of Honos and Virtus, and a Greek sundial was set up on the Rostra. Two supports from Alexander's tent, presumably taken from Egypt, were dedicated by Augustus in front of the Temple of Mars Ultor[29]; Attalid carpets interwoven with gold were in the *Porticus Pompeii*, and a tripod table with a Greek inscription was donated by Titus and Vespasian in the Temple of Apollo Palatinus. We should finally mention the columns of Hymettian marble in the house of L. Crassus (104 B.C.) and those from the Athenian Olympieion set up by Sulla on the Capitoline.

Roman Monuments

Exotic materials were not only taken away as plunder, they were also used by the Romans in Rome and dedicated by them abroad. Apart from such extravagant creations as the portrait of Pompey made of pearls, which was used in his triumph of 61 B.C. (Pliny *NH*

37.14), a portrait of Augustus in amber was set up in the Temple of Zeus at Olympia (Paus. 5.12.7), and similar statues in obsidian seem to have been fairly frequent (Pliny *NH* 36.196). Imperial portraits in gold and silver were not only visible in Rome but were also sent to the provinces.[30]

Mummius's dedications on the Altis have already been mentioned; we should add at least another second-century-B.C. monument, a statue of Q. Marcius Philippus made by Andreas of Argos, attested through the finding of its base, but not listed by Pausanias, although he includes a wrestler's statue by the same sculptor.[31] That by the Antonine period statuary flooded the provinces is a well-known fact, attested by the many finds from North Africa, Asia Minor, and Greece itself.[32] But this is primarily sculpture in marble, with few bronze monuments surviving, although an unusually large group has now come to light in Asia Minor, and an equestrian Augustus has been recovered from the sea of Lemnos. The inscriptions, however, reveal a much more complex picture. An article by Pekáry has gathered much of this epigraphic evidence from Asia Minor; here I shall mention only a few examples taken from his work.[33]

Under Trajan, G. Vibius Salutaris gave the city of Ephesos 1 gold and 28 silver statues, including several of Artemis, 1 of Trajan, 1 of Plotina, statues of the Senate, the People, the Ephebeia of Ephesos, the individual tribes of the city.[34] In Knidos, during the Augustan period, an Artemidoros was commemorated with 3 marble, 3 gold, and 3 bronze busts, Even earlier, after the death of Attalos III (133 B.C.), the Pergamene politician Diodoros Pasparos, for services rendered, was honored with 9 statues, including 2 equestrian (one of which was "golden"), 1 colossal in bronze, which showed Pasparos being crowned by Demos, and 1 in marble set up in the Gymnasium. Athletes, charioteers, and especially actors were equally celebrated with monuments. The pantomime Ti. Iulius Apolaustus had approximately 23 statues erected in his honor: In Asia Minor alone, one each in Ephesos, Pergamon, Magnesia, Miletos, Sardis, Kyme; 2 each in Laodikeia and Thyateira; 3 in Hierokaisareia. Many women had statues of themselves set up, several gilded. And there are always the odd subjects. It is puzzling, for instance, to know that in a single occasion 125 statues of Nikai and Erotes were set up in the Ephesos theater; 5 Erotes were erected in Sardis, 18 in Tralleis, 25 in Thyateira.

We think of Nero as taking statues—but during his lifetime the Senate voted that one of their members, Volusius Saturninus, who had been consul in A.D. 3 and died in A.D. 56, be commemorated by three triumphal statues (one in bronze, two in marble), three consular statues, one statue as augur, one equestrian statue, and one showing him seated on the *sella curu-*

lis. Pekáry, who gives the location for all these monuments, adds that no golden ones were voted in this occasion because Nero had just finished receiving his own honors in that form.

Rome was filled with bronze statues long before Imperial times. We visualize the city decorated only with terra-cotta monuments, as mentioned by Livy and other Roman authors; yet these sources often intentionally play up the pretended poverty of the past to emphasize (even if to deplore) the contemporary splendor.[35] In reality, we know that statues of the kings and of famous men were set up in public places from early Republican times. Even Greek men occurred among the portraits: at the end of the First Samnite War, in the fourth century B.C., an oracle of Pythian Apollo ordered the Romans to set up statues of Greeks in their Forum. The Romans, surprisingly, selected Alkibiades and Pythagoras, and placed their images at the corners of the *Comitium* (Pliny *NH* 34.26; Plutarch *Numa* 8.20). By 179 B.C. so many portraits had accumulated that they had to be thinned out on the Capitoline, to allow unimpeded view of the Temple of Jupiter (Livy 40.51.3), and the same was done in the Forum in 158 B.C. (Pliny, *NH* 34.30–31).[36] In 58 B.C. the aedile M. Scaurus, on the three-storied *Scaenae Frons* of his temporary theater, placed ca. 300 bronze statues framed by 360 marble columns, in a display that attracted Pliny's disapproval but had considerable impact on future theatrical architecture (*NH* 36.6 and 113).[37]

The Brutus, the Arringatore, and, to my mind, the so-called Hellenistic Ruler in the Terme give us but a pale idea of the many bronze monuments in Rome.[38] The trend continued with renewed vigor in Imperial times. Despite fires, destructions, and other calamities, a list drawn up from the *Curiosum* (last quarter of the fourth century A.C.) and the various Roman *Regionarii* includes the following statues: 2 colossi (Augustus as Apollo, Nero as Helios), 22 colossal equestrian statues, 80 gilded statues of divinities, 77 chryselephantine statues, and 3,785 bronze statues of emperors and generals, not including sculpture decorating private and public buildings.[39] To be sure, some of these monuments could have been reused and reinscribed; nonetheless the total is impressive and justifies Cassiodorus's statement that the walls of Rome in his days contained a second population of statues.

Early Roman Exposure to Greek Art

The fall of Syracuse in 212 B.C. is generally taken as the first encounter of the Romans with Greek art; yet this can hardly be the case. According to the literary sources, two Greek artists, Damophilos and Gorgasos, had made the cult statue for the Temple of Ceres in the fifth century B.C. Trade contacts with Campania

and Magna Graecia can be attested by finds since the archaic period, by treaties afterward. Recent emphasis has been put on the agreement between Rome and Carthage in 348 B.C. by which it was stipulated that "in the Carthaginian province of Sicily and at Carthage a Roman may do and sell anything that is permitted to a citizen. A Carthaginian in Rome may do likewise."[40] The impact of Roman traditions on Hellenistic sculpture has also been postulated on the basis of iconographic motifs that find true meaning only according to Roman criminal law and Italic forms of punishment. If one such theory is correct, the famous Hanging Marsyas known through so many replicas would be a creation not of the Pergamene baroque but of a comparable style in Italy, which had asserted itself even before the creation of an artistic *koine* after the fall of Taras.[41]

An impressive list of monuments to be associated with Roman patronage, influence, or manufacture has been drawn by Blanche Brown.[42] In particular, we may cite here the well-known case of Antiochos IV who hired the Roman Cossutius to work on the Olympieion at Athens. A thorough study by Mario Torelli has suggested that he belonged to a family of Roman *equites* of Volscian origin, who had widespread economic interests in marble quarrying and shipment from the early second century B.C. onward. The family, which entered the Roman Senate at the beginning of the first century B.C., may have been proscribed around 40 B.C., since it disappears from the records. The trade for which the Cossutii were known, however, seems to have been carried on by a vast *familia* of *liberti*, whose representatives are attested in areas connected with marble quarries and harbors, such as Athens, Delos, Paros, Antioch, Eretria, Erythrai, and Ios, while members of the same *gens* were operative at the North African quarries of Simitthu (Chemtu, which produced the typical *giallo antico* stone).[43]

Roman commercial interests in Rhodes and Delos are too well known to bear repeating, but it is important to stress the prominence of the Agora of the Italians in the latter island, with its Graeco-Roman statuary and portraits, and built according to concepts more familiar from Italy than from Greece. The infiltration of Romans into the Greek world can best be understood by considering the number of Italic casualties in the Mithridatic Wars. Even if the figures given by the ancient historians are scaled down to balance inflation, the Romans killed in the uprisings (therefore not soldiers, but local inhabitants) can be counted in the tens of thousands in Asia Minor, on Delos, and other Aegean islands.[44]

Equally revealing is the number of bona fide commissions for monuments made in Greece but requested by the Roman market: not only honorary statues and portraits, but cult images of even colossal size. A typical example is the seated Herakles from Alba Fucens, now in the Chieti Museum, which has been dated to the second century B.C., or the large seated goddess (plate 25) in Boston, from the Abruzzi.[45] Neo-Attic sculptors like Timarchides were active in Rome around 180 B.C. and producing statues of Apollo and other gods; Timarchides' sons Polykles and Dionysios followed in the father's footsteps. Ostia has yielded at least two possible cult images of the second century B.C.: the torso of a bearded god, probably Asklepios, and the upper part of an Artemis figure which was completed with an Imperial addition. Praeneste may supply other examples.[46]

By the first century B.C. this production must have had the force of a landslide. Aside from shipments like that of Mahdia and perhaps of Antikythera, we may mention other cult statues for Roman temples[47]: that by Skopas Minor for the round temple on the Tiber, attested by an inscription; the akrolith from the Temple of *Fortuna Huiusce Diei* (Largo Argentina Temple B); the Dioscuri from the *Lacus Iuturnae*, which Coarelli attributes to the restoration after 117 B.C. Perhaps the most famous of all these images is that of the Venus Genetrix commissioned to Arkesilaos by Caesar who vowed it at Pharsalos. The statue, which was placed unfinished in the temple, may have displayed Hellenistic details, such as a low belt, added to a major fifth-century Greek type, thus functioning as a learned quotation.[48]

By the late Hellenistic period many Athenian sculptors may have worked purely for the Roman market. In this respect I need do no more than refer to the recent book by Andrew Stewart, *Attika,* and underline his contribution to the study of Delian portraiture as Athenian production for the Roman clientele.[49] On the other hand, we should not forget the Roman and naturalized sculptors active alongside their Greek colleagues, such as the Coponius credited by Varro (*apud* Pliny *NH* 36.41) with making fourteen statues of Nations to be placed around the Theater of Pompey (built in 55 B.C.), or the Athenian C. Avianus Evander, freedman of M. Aemilius, who directed an *officina* in Athens on behalf of his patrons, followed M. Antony to Egypt soon after 36 B.C., was taken to Rome in 30 B.C. as a war prisoner, and there applied himself to restoring old masterpieces. Of less certain date is the Novius Blesamus whose epitaph boasts that he filled the whole world with statues.[50]

If to this complex sculptural picture we add Roman impact on the production of jewelry and of gold and silver plate, the Late Republican Romans appear far from unsophisticated and uncultured but can rather be credited with providing the impetus for an artistic and commercial revival in a Greece spent by centuries of war and defeat.[51]

Works by Famous Classical Sculptors in Rome

One more common assumption, based, to be sure, on the writings of Cicero, Pliny, and Quintilian, is that the Romans greatly admired the major Greek sculptors of the fifth and fourth centuries B.C. whose works they actively sought in Greece and Magna Graecia and carried off to embellish their capital. An unofficial count by Pollitt for the Rome of the first century A.C. lists fourteen works by Praxiteles, eight by Skopas, four by Lysippos, three each by Euphranor, Myron, and Sthennis, two each by Pheidias, Polykleitos, and Strongylion, and single works by Timotheos, Chares, the Chian archaic sculptors Boupalos and Athenis, the sons of Praxiteles, and many others.[52] These numbers are impressive, yet they may be read otherwise.

The "Praxiteles" of some Plinian manuscripts is given by others as "Pasiteles."[53] Some works are of difficult attribution and Pliny hesitates between Praxiteles and Skopas; since the Niobids at least have been shown to be largely creations of the late Hellenistic neoclassicism, neither classical master is likely to have made them. The existence of a Skopas Minor active in Rome during the Late Republican period is attested by epigraphic evidence, yet no differentiation is made by Pliny between the two.[54] An Athenian Myron active at Olympia in the early fourth century B.C. is known through Pausanias, and it is legitimate to ask whether some of the naturalistic animals attributed to the severe master should instead be given to the later sculptor; even a Hellenistic Myron has been postulated on the basis of inscriptions and in connection with the well-known Drunken Woman.[55] Finally, Polykleitos—who was one of the most influential artistic personalities in the history of Roman taste, to judge by the large number of portraits placed on a Polykleitan body and by the many replicas of the Doryphoros—seems to have been represented in Rome only by two originals—a Herakles and a group of Astragalizontes which have not yet been convincingly identified in any extant replica and which, given their genre subject, may have been as late as the "Polykleitan" Kanephoroi from the house of Heius in Messana.[56] It is therefore surprising to note that at the time of Pausanias, approximately one hundred years after Pliny's account, several statues by Polykleitos the Elder could still be seen at Olympia, even taking into account the possibility that some of them were instead by the well-attested Polykleitos the Younger.

In our discussion of the great sanctuaries we shall mention Nero and his depredations; but we can here anticipate the comment that in his thefts at Olympia and Delphi the emperor does not seem to have been after the "big names." The great demand for, and the high price commanded by, the works of the Neo-Attic school suggest that these sculptures were appreciated on a par with earlier creations, perhaps even more

since the taste of the time was not entirely satisfied with any one period of Greek art—hence the eclecticism of the Late Hellenistic phase.[57] Even the Romans' conception of the great classical masters may have been different from our understanding of it, with moralistic overtones. Zanker has in fact argued that, when a strong classicizing trend set in around 150 B.C., works by Pheidias and Polykleitos were seen as the height of art—*not* for aesthetic, but for moral and spiritual principles; the *dignitas* Pheidias could impart to his images of the gods became therefore the ideal for Roman cult statues. In addition, Becatti has pointed out that the Athenian master was primarily praised for his skill in *caelatura*![58]

An anecdote related by Pliny (*NH* 34.62) is often used to exemplify Tiberius's interest in Greek art, since the emperor had the Lysippan Apoxyomenos (plate 115), placed by Agrippa in front of his Thermae, removed to his private bedroom. That the Roman populace reacted violently to this move and that the original statue had to be restored to public view are taken as indications that the citizens appreciated Greek originals and were not satisfied with copies. But is this the correct interpretation of the event? Dangerous as it may be to compare modern with ancient times, an episode which happened in Philadelphia, Pennsylvania, only a few years ago may be suggestive.

A work by Robert Indiana, the word *LOVE* in bronze, had been set up on public display not far from the Franklin Institute, although the piece had not been purchased by the city but was simply on loan from the sculptor. Passersby commented on the monument, criticized it, wondered how a word could be a work of art, made fun of the diagonal position of the letter *O*, and by and large had no idea of the master's name, despite the fact that dissemination of information today is much faster and wider ranging than in antiquity. After a certain lapse of time, Indiana recalled the loan and the sculpture was removed from the street and sent back to Indianapolis. At that time the people of Philadelphia became suddenly conscious of the masterpiece in their midst—since it was no longer there! Letters to the newspapers emphasized the loss of a monument which symbolized the very name of the city, and such clamor was made that Philadelphia eventually bought the "LOVE" and restored it to public display. Yet not many of those who clamored ever learned the name of the sculptor, nor were the Philadelphians particularly concerned with questions of art theory and aesthetics. The "mob" simply reacted to the loss of something to which they had become accustomed and which they considered their own. It is not unlikely that the Romans of Tiberius's time acted on the strength of similar feelings, without special consideration for Lysippos and his style.

Further support for my contention is perhaps pro-

vided by Cicero's letters to his friend Atticus, who served as his agent in Greece for the purchase of statuary. Note that in his requests for sculpture Cicero does not specify styles, periods, or masters, but only subjects; his term *gymnasiode* for the type of herms he wanted suggests that a whole line of production had already developed for this kind of villa decoration, as noted by Zanker.[59] Thus location determined subject matter and subject matter determined style: what was appropriate for a library or a special private garden was usually in classical—or classicizing—style, while for more active areas, for palestrae, grottoes, and Dionysiac gardens, Hellenistic prototypes were imitated or adapted. Portraits of famous men were also likely to be in Hellenistic (hence "realistic") style. This trend continued well past Cicero's time, late into the Imperial period, and is responsible, for instance, for the truly innumerable replicas of the Crouching Aphrodite—an appropriate figure for a pool or garden—despite the fact that its original maker is still uncertain. Were it even correct to assume that he was the Bithynian Doidalsas, nothing else by him can be mentioned, and he remains a totally shadowy figure in art—his success unacknowledged by the ancient literary sources—yet his Aphrodite (and its adaptations) achieved a popularity comparable only to that of the Knidia.[60]

To what extent were Greek monuments in Rome identified as the works of specific sculptors? Excavated evidence has shown that, for purposes of ease in shipping and matters of weight, statues were usually removed from Greece without their bases, which normally carried the sculptor's name. Although in some cases the inscriptions, and therefore the pertinent information, were repeated on new bases supplied when the monuments had reached their destination, frequently a new inscription was used, either because the dedicator wanted to emphasize his own name rather than the sculptor's, or because the latter had not been recorded at the moment of plunder.[61]

Under the best of conditions, when the sculptors' names occur on Italic soil, the Romans still manage to surprise us. Three travertine bases with inscriptions datable to the first century B.C. on epigraphic and contextual grounds were found at Ostia in 1969. They were used to support three bronze statues presumably taken from Greece without their pedestals. The new inscriptions (all carved by the same hand) identify the pieces as: Platon son of Archias, a qoet of comedy, made by Lysikles; Antisthenes philosopher, made by Phyromachos; and Charite priestess at Delphi ("themisteousa"), made by Phradmon of Argos. Fausto Zevi, who published the find, commented with surprise on the diversity of the subjects, their chronological range, and the limited reputation of at least one of the masters, Lysikles, whose name had hitherto been

unknown.[62] Yet his statue had been considered worth taking and dedicating to Hercules in Sullan times, probably by a victorious general who could have commanded a vast selection of monuments by famous masters, had he wanted them. By the time of Hadrian, although many Greek originals by major sculptors still existed in Greece, no emphasis seems to have been placed on owning the prototype rather than a copy, at least to judge from the statues uncovered in the Villa Hadriana at Tivoli, which were all made for their specific setting.[63]

Aside from the question of authorship, it is also possible that the Romans did not make fine distinctions beween original and copy. This has already been suggested in the case of Verres' appropriations from Sicily.[64] It seems plausible for the *small* Herakles Epitrapezios "by Lysippos," for which a surprising history is traced by Martial, through various owners, from Alexander the Great, through Hannibal(?), to Novius Vindex.[65] Lucian mentions the Diadoumenos next to Myron's Diskobolos, together with the Tyrannicides (see plate 10), in what is obviously the peristyle of a private house.[66] Given the unquestionable presence of the Tyrant-slayers in the Athenian Agora by Pausanias's time, what Lucian describes can only have been replicas, yet no indication is given of this fact. Similarly, Pliny (*NH* 36.34) writes about the "Punishment of Dirke" as a work in marble: at least one author has suggested that the original was a bronze group, as seen on Lydian coins, without the figure of Antiope.[67]

These examples could be multiplied and, considering the distance in time that separates Pliny from the classical masters, a certain amount of confusion and uncertainty is not surprising; yet some of it may stem not so much from the lack of proper information as from the intentional imitation of classical styles and from the resultant eclecticism of Late Hellenistic–early Imperial creations, which may have conjoined casts of parts from various earlier statues. This particular phenomenon will concern us later. Here let me mention one more possibility for confusion: the presence in Rome of clever forgeries.

Given the amount of present information, we may never be able to prove that such forgeries existed; perhaps only Pliny's comment (*NH* 34.5–7) on real Corinthian bronzes alludes to the fact that false ones must have been in circulation.[68] Yet one bronze figure, the so-called Piombino Apollo (plates 26–28), can at least be claimed to represent such an attempt at passing off a statue as much older than its actual date of manufacture. Stylistic considerations, the letter forms of the inscription on the statue's foot, the signatures of sculptors on the lead tablets found in the statue's interior, and even the metal alloy contribute to suggest that the Apollo was made by Menodotos of Tyre and ——phon of Rhodes in the first century B.C., but

presented (and probably sold) as a work of the archaic period, as in fact the bronze is still dated in most modern publications.[69]

It may be significant that the Piombino bronze portrays an adolescent Apollo—a subject and an age span obviously preferred by the Romans. They certainly bought selectively, as already discussed, and can be assumed to have copied just as selectively. Although, for instance, the Tyrannicides made by Antenor in the late archaic period had been restored to Athens after the capture of Persepolis, only the "replacement" figures made by Kritios and Nesiotes in 477 were ever copied—or else we have been unable to recognize Antenor's work among the very few extant copies, if any, of archaic originals. Yet the relative fame of the master and the anecdotal connotations of his Tyrannicides should have attracted the Romans, who always loved a good story.[70]

How many Greek originals did the Romans, in fact, copy? In later chapters I shall argue that no classical statue from Delphi and Olympia, or from other major Greek sanctuaries, was ever mechanically duplicated. Here suffice it to mention that not one of the Greek originals recovered from Rome itself can be shown to have been copied—not even the Albani relief (plate 29) which, if recent theories are correct, can be associated with Perikles' funerary oration made so famous among the Romans by Thucydides' passage. Yet Rome was definitely a copying center, as attested by excavational evidence, and by the very necessity of having to duplicate Imperial portraits.[71]

To push this line of inquiry further, note the case of the Greek originals mentioned by Pliny as being in Rome. They were presumably appreciated, since they were taken from Greece, dedicated in temples or public buildings or otherwise displayed, and finally considered worth mentioning in Pliny's account. Yet how many of these masterpieces have been unequivocally identified, either as the very ones noted by the writer or in later copies? Consulting the lists drawn up by Pollitt and Pape, I can find only the following.

None of the archaic pieces; of the fifth century, perhaps only the Herakles of Polykleitos, through Roman copies without attributes and therefore open to doubts. The Zeus from Samos, by Myron, may not have been accessible for copying since it was dedicated on the Capitoline (Strabo, 14.637b); it has been doubtfully identified in some Roman sculptures, but other scholars hold different theories. Among the fourth-century monuments, the Leto by Euphranor will be discussed in the last chapters, but it may be anticipated here that no connection can be definitely established with the Roman copies. Among the works of Lysippos, only the Apoxyomenos is known through Roman reproductions, but the Vatican statue remains our main evidence: one torso in reversed pose (mirror image) and

perhaps a replica from Side[72] are the only other possible echoes of this supposedly famous statue.

The Hellenistic monuments appear at first glance to have fared better, but may not stand closer scrutiny. Only one of them has been recognized with certainty as the very same seen by Pliny and still found in situ: the Laokoon (plate 30). Yet the discovery of the Sperlonga sculptures has cast some doubt on the Hellenistic date of the group; I personally believe, with Brein, that the monument seen by Pliny and now in the Vatican was specifically made for the house of Titus and should therefore be considered Roman, at least in that version.[73] No other replicas of it exist. Of the other sculptures cited in the *Historia Naturalis,* the Punishment of Dirke, as already mentioned, could have already been a copy, from a bronze or a painting, and in any case it cannot correspond to the Farnese Bull (plate 31), which came from the Baths of Caracalla and was made ad hoc for the vast room in which it was found.

The Attalid dedications taken from Pergamon by Nero for his Domus Aurea and given by Vespasian for display in the *Forum Pacis* have been correlated with the well-known marble replicas of the Gauls in the Terme and the Capitoline Museum. Whatever the correct date for the carving of these copies, they were found in the Gardens of Sallust, and therefore do not correspond to the *bronze* originals seen by Pliny (*NH* 34.84). If, moreover, the Capitoline Gaul (plates 32–33) is correctly considered a replica of the Trumpeter by Epigonos, Pliny, who cites the latter work as a masterpiece by the sculptor, gives no indication that the original was in Rome (*NH* 34.88), nor is Epigonos's name included among those whose sculptures were exhibited in the Temple of Peace—unless Pliny's text is emended.[74]

The Crouching Aphrodite (plate 34), mentioned by Pliny in the context of the *Porticus Octaviae* (*NH* 36.35), is indeed known from many copies, but there are several problems. First, we cannot be sure that Pliny's definition—a Venus washing herself, by "Daedalsas"—applies to the crouching type, which is not obviously engaged in ablutions. Secondly, the crouching type appears on Imperial coins of Bithynia, thus suggesting that the original might have been still there; the Roman piece would then have been a copy, probably from a bronze. Finally, "Daedalsas" has been transliterated as Doidalsas, a Bithynian name, but it has been argued that Pliny's manuscripts are here corrupt and the text should be read differently (e.g., *sede alia,* or *aede alia,* or *sede alta;* in any case—elsewhere!)[75]; we would therefore lose the sculptor's name, hence the connection with Bithynia, hence the correlation with the numismatic type. With so many uncertainties, the case cannot be convincingly argued.

One more monument, the Niobids, should by right

be listed among those of the classical period, since Pliny attributes the figures to either Praxiteles or Skopas. Some of these statues have however been recovered and they seem to have formed a mixed group, with definite Late Hellenistic additions, possibly around an early Hellenistic core. The latter was certainly not in Rome, since a probable replica of the Niobe was found in the Mahdia shipwreck. The sons and daughters are known through various replicas, but they were surely made, if not in Rome, at least during the period of Roman patronage and of artistic *koine,* and as such cannot rank among the Greek originals removed from Greek territory.[76] That they were copied brings us to our last point.

Roman Interest in Late Hellenistic Sculpture

By the first century B.C. many sculptors, Greek and otherwise, worked in Italy or in Rome itself for the Roman clientele. Many of these produced works in neoclassical style, others were openly eclectic. Recent discussions by Zanker and Coarelli have already stressed some of these trends and named the sculptors involved.[77] Even more detailed is the study by G. Becatti who analyzes the monuments displayed in the *Monumentum Asinii Pollionis* and considers them all expressions of the Neo-Attic movement; as shown by their subject matter, they were all carefully chosen to represent *charis,* elegance, and the *genus floridum* associated with Asia Minor.[78]

Besides the literary sources, we have the evidence of signed works: not so much those by Pasiteles, but certainly those by his pupils, Stephanos and Menelaos. The surviving works exemplify the eclectic criteria mentioned above, and will be discussed later. It is important to note here, however, that the well-known Stephanos Athlete (plate 35) was repeatedly copied, either alone or as part of more complex compositions (plate 36). It seems therefore indisputable that the Romans were equally attracted by works whose genesis could be considered contemporary, and which did not have the "aura" of a Greek prototype. Pollitt, in listing some of the exorbitant prices paid by Roman collectors for works by their classicizing contemporaries, wonders "what the price tag would have been for a Praxiteles."[79] One may rather ask whether a contemporary sculpture, catering to current taste, could not have fetched a higher sum than an "old-fashioned" piece, or at least if it could not have found a readier market. Demand was obviously at a peak, since sculpture of the Late Hellenistic–early Imperial period was put to uses never before attempted, especially in connection with public buildings, theaters, and private villas. It has been objected that, if many works so far considered copies of Greek originals were to be redated to later times and seen as classicizing rather than classical, the fifth and fourth centuries would be left almost empty, while the first century B.C. would be inflated with monuments and new creations. Yet this is as it should be, since the Greeks of the classical period were still producing sculpture for religious and for limited honorary purposes, while the Romans of the late Republic and the Empire had entirely different decorative programs in mind, and on a scale far surpassing anything attempted by the earlier Greeks.

It is well to remember that Pliny bestowed one of his highest compliments to an early Imperial work; in describing the decoration of Agrippa's Pantheon, carved by Diogenes the Athenian, he stated that "among the columns of this temple there are Caryatids which are praised as are few other works" (*NH* 36.38). One assumes the statement to be comprehensive.[80]

Notes

1. See, e.g., Pape, "Kriegsbeute," pp. 61–68.

2. On the specific slant of the books on art theory see Preisshofen/Zanker, "Reflex"; for comments on art theory in Pliny and Vitruvius and their moralistic overtones, see Gros, "Vie et mort."

3. For a discussion on the dangers of using the literary sources—or even the archaeological evidence—in isolation, see Ph. Bruneau, "Sources textuelles et vestiges matériels: Reflexions sur l'interpretation archeologique," in *Mélanges helleniques offerts à George Daux* (Paris, 1974), pp. 33–42. For general comments see also Pollitt, *Art of Rome,* introductory remarks, and Becatti, *Arte e gusto,* passim.

4. On Pliny and his interests see Becatti, "Letture pliniane," (note that the article was written in 1954). Pliny lists works from the point of view of difficulty in the carving and the length of time required in making such large groups. He deplores that many works in the Rome of his days do not enjoy the fame they deserve because there are so many of them and the citizens are so busy that they have no time and proper place for contemplation.

On Pliny's methods and use of earlier sources see Coulson, "Reliability." He tries to defend Pliny as an honest scholar rather than an indiscriminate excerpter, but see his p. 371 for a balanced view of the Roman's system of study and note taking, and for his nap-taking habits while working. On this point cf. also E. Sjöqvist, "Lysippos," in *Lectures in Memory of Louise Taft Semple,* 2d ser. (Cincinnati, 1966), pp. 1–7.

5. See Pollitt, *Art of Greece,* p. 62 and n. 25. Pliny places masters' *floruit* in the following sequence: Eighty-third Olympiad (447–444 B.C.)—Pheidias, Alkamenes, Kritios, Nesiotes; Eighty-seventh Olympiad (431–428)—Ageladas; Ninetieth Olympiad (419–416)—Polykleitos, Phradmon, Myron, Pythagoras, Skopas. That Myron and Pythagoras should have been contemporaries of both Pheidias and Skopas seems impossible.

6. This statement can be supported by statistics on the lists in Pollitt, "Impact," pp. 170–72. Of seventy-one sculptural entries, only five are given on the authority of sources other than Pliny: Pausanias (two), Dio Cassius (one), Propertius (one), Strabo (one); two more corroborate Pliny's information (Strabo; Strabo and Appian); the remaining sixty-four entries are derived from Pliny alone.

7. See, e.g., Becatti, *Arte e gusto*, pp. 184–85. As indication that ten was a classic number and that therefore this canon was influential as late as the second century A.C., it has been pointed out that Pausanias unnecessarily splits his account of Olympia and Elis into two books, to obtain a total of ten books for his *Periegesis*.

8. Becatti, *Arte e gusto*, p. 182. Pollitt, *Art of Greece*, p. 222, translates "who likes to use the most mighty form in every case, even in the case of a woman." But the Latin allows also the other meaning, which seems more likely within the context. In fact, that this is a literary citation is shown by the fact that Penelope is called "bigger and fatter"—not mightier, as usually translated—in Homer (e.g., *Od.* 21, v.6; cf. *Il.* 21, vv. 403, 424, Athena), presumably because at that time a plump figure was a sign of nobility. This point was stressed by N. Himmelmann during a lecture in Princeton on March 31, 1981. Art theories are also discussed in chapter 7, in connection with eclecticism.

9. See, e.g., G. M. A. Richter, *Ancient Italy* (Jerome Lectures, Ann Arbor, Mich., 1955), pp. 56–57, and *Three Critical Periods* (Oxford, 1951), pp. 38–39. R. Bianchi Bandinelli, *Rome, the Center of Power* (New York, 1970), p. 38; Pollitt, "Impact," pp. 156–58.

10. For the return of the Segestan statue, by the younger Scipio Africanus, see Cicero *Verr.* 2.4.72–74. The plunder of the Attalids, not only in Oreos but also at Aigina, is discussed by E. V. Hansen, *The Attalids of Pergamon*, rev. ed. (Ithaca, 1971), p. 47, n.2, and pp. 316–17, 353, and passim.

It is significant that the removal of divine images is mentioned in particular, even when much more extensive plundering took place: e.g., the Apollo Philesios by Kanachos, taken from Didyma by Darios in 494 and returned by Seleukos I (Paus. 1. 16.3). It is clear that the rest of the depredations are considered a right of war, as already mentioned, and are therefore not emphasized by the ancient authors.

11. These are the Napoleonic campaigns of 1796–98; see Pape, "Kriegsbeute," p. 3 and nn. 6–7.

12. Less well known is that the U. S. Army is responsible for taking 6,337 pieces of Nazi art from Germany, which are now being screened for possible return to their country of origin: see "The Pentagon's Nazi Art," *Newsweek*, February 22, 1982, p. 31.

13. On the sack of Veii (396 B.C.) and the removal of statues to Rome see Livy 5.22.3–8; for Praeneste, Livy 6.29.8–9. These and other sources are collected by Pollitt, *Art of Rome*, pp. 18–19, 24–25. More examples and important discussion in Waurick, "Kunstraub," p. 2 and map fig. 1 on pp. 4–5.

14. Carthage, statue of Hercules/Melqart (?) in front of which human sacrifices were made, set up by the Romans in the *Porticus ad Nationes* after the destruction of 146 B.C.: Appian, *Punic Wars*, 135.

On Egyptian booty see Pape, "Kriegsbeute," pp. 25–26. Some was set up in the Curia Julia and the Temple of Venus.

Booty from Apollonia Pontica, dedicated on the Capitoline: Pape, "Kriegsbeute," p. 150; see p. 152 for booty from Antioch in Syria, also set up on the *Capitolium*.

15. See Pape, "Kriegsbeute," p. 155, s.v. *Concordia, Aedes*, no. 9, and comment on p. 156; but cf. also her p. 168, no. 2 (s.v. *Horti Serviliani*). See also Becatti, "Letture pliniane," passim, who believes in a Hellenistic Skopas. That the Hestia is truly by the fourth century master is advocated, on architectural grounds, by G. Gruben, *AA*, 1982, pp. 674 and 677.

According to Suet. *Div.Aug.* 57.1, Augustus used money donated to him on his birthday to buy Greek, or imitation Greek, images which he dedicated in various wards of the city. Ref. Pollitt, "Impact," p. 166.

16. See, e.g., Zosimus 2.30–31, as quoted in Pollitt, *Art of Rome*, pp. 212–13, on the building of Constantinople. The Lauseion burnt in A.D. 475.

The transfer of statues from pagan sanctuaries to public baths and other public places is attested as early as 331–3, under the prefect Sextus Anicius Paulinus: see Strong, "Museums," p. 254.

17. Pape's concluding statement ("Kriegsbeute," p. 100) is worth quoting in full: "Allgemeine Kunstinteressen der Römer oder spezielle der Feldherren lassen sich in den Quellen kaum fassen. Das zeigt, dass die politischen Gründe für die Aufstellung weit wichtiger waren als die künstlerischen."

A similar strong statement, with a chronologically differentiated analysis, occurs in Waurick, "Kunstraub," esp. pp. 11–12 and 43.

18. This list is taken from Bianchi Bandinelli, (supra, n. 9), p. 38, who in turn takes it from Livy 37.59.3–5, and Pliny *NH* 34.34. Some problems occur with the translation of the item on "melted-down silver." The Italian text of the same work has "argento sfuso" but the Latin text reads "argenti pondo," thus giving no true indication whether precious objects and artifacts had been melted down. The main point, that the metal's worth was considered in weight, remains nonetheless unchanged.

19. This important point is made by Pape, "Kriegsbeute," p. 18; see her pp. 16–19 for a discussion of ancient sources on Mummius and a list of bases known to have carried Mummius's dedications. This picture has been considerably expanded and clarified by Waurick, "Kunstraub," esp. pp. 13–34, with lists of bases and discussion of the forms of dedications they carried, and distribution maps of Mummius's offerings, differentiating between sacred and profane purposes: figs. 2 on p. 35 and 3 on p. 38.

20. That this assertion is incorrect is shown most recently by Philipp and Koenigs, "Basen," see esp. p. 196 and n. 23. Anne Weis suggests to me that the late authors writing against Mummius may have used much earlier sources of Scipionic propaganda slanted against Mummius for political reasons. That Mummius was a generous and concerned admirer of the Greeks is suggested by Philipp, "Basen," pp. 202–3. But see also Waurick, "Kunstraub," esp. p. 37.

21. Philipp and Koenigs, "Basen," list all the bases connected with Mummius in Greece, and stress that although Mummius is considered the sole Roman responsible for Corinth's fate, in reality ten senators were sent from Rome to supervise his actions in that area. On the respect shown by Mummius toward previous dedications, see Waurick, "Kunstraub," pp. 34–35: Mummius rededicated previous offerings, but did not erase the original inscriptions, limiting his appropriation to the addition of his own formula. He also set up some original works made for the purpose. Both his dedications, and those erected in his honor, were placed on new bases around the mid-first century A.C.: Philipp and Koenigs, "Basen," pp. 197–200.

22. Besides the comments by Pape, "Kriegsbeute," pp. 65–68, see also Waurick, "Kunstraub," p. 43, who suggests the possibility that works of art in general were considered much more expressive of victory than other forms of spoils.

23. Pape, "Kriegsbeute," pp. 61–68.

24. When Q. Fabius Maximus removed from the Tarentine akropolis the seated Herakles by Lysippos (in 209 B.C.), he may have been inspired by the size of the colossus and by its meaning of victory. He may also, however, have considered the hero particularly appropriate for his *gens,* the Fabia, which claimed descent from Hercules, although this conceit, mentioned by Ovid (*Fasti* 2, 237), cannot be shown to go back as early as Q. Fabius Maximus's time. On this point see Pape, "Kriegsbeute," pp. 104–5, n. 36.

Herakles was especially important in Latium, where many legends were connected with him and several families could name him as their ancestor. For a mid-sixth century B.C. akroterion to the temple in S. Omobono, Rome, showing Hercules introduced to Olympus by Athena, see *Enea nel Lazio, Archeologia e mito* (Rome, 1981), p. 122, C3, color pl. on p. 121, and reconstructed drawing on p. 117.

25. Not all the sculptures from the Temple of Apollo Sosianus may have been spoils of war. Recent studies by E. La Rocca suggest that some of them, including the Muses by Philiskos, may have been part of a carefully planned program for the restructuring of the sanctuary after 179 B.C. See his comments in "Un frammento," pp. 29–31 and n. 68a.

26. The argument is much more complex and has been developed extensively by Prof. Moevs in her article, *BdA* 12 (1981): 1–58. For a summary of her paper on the same topic see *AJA* 86 (1982): 277. I am much indebted to Prof. Moevs for discussing her theories with me ahead of publication, and for lending me the use of one of her photographs.

27. Zanker "Funktion," p. 291; T. Hölscher, *Victoria Romana* (Mainz, 1967), pp. 6–10, discusses the meaning of the Taras Nike as reused in the Curia.

28. The Roman's attraction toward unusual subjects may have prompted some creations of their own: note Pliny *NH* 7.34, on the decoration of Pompey's theater, with "images representing miraculous events" and which included a statue of Alkippe "who gave birth to an elephant." On this peculiar statement see Becatti, "Roma di Tiberio," who considers the statues works by Greek masters set up by Tiberius. Coarelli, "Complesso pompeiano," believes the statues were dedicated by Augustus; his arrangement and interpretation have been reconsidered in a later study: see his *L'Area Sacra di Largo Argentina: Topografia e storia (*Musei Capitolini, 1981), pp. 11–51, esp. p. 27 and n. 2. See also M. Fuchs, "Eine Musengruppe aus dem Pompeiustheater," *RömMitt* 89 (1982): 69–80.

29. Much of this information can be found in Pape, "Kriegsbeute," under the discussion of each Roman dedicator or in the listing of Greek objects by location.

Some commentators on Pliny have suggested that the supports from Alexander's tent were statues and that Pliny may have misunderstood what were in fact the golden Nikai on Alexander's funerary cart as described by Diodoros; for the latest discussion of this point see Pemberton, "Corinthian bronzes," n. 52.

30. Pausanias, who usually bypasses Roman objects, cannot resist mentioning (2.17.6) a peacock "in gold and glittering stones" dedicated by Hadrian to Hera at the Argive Heraion, and a golden crown and a purple dress dedicated by Nero. This generosity existed also in Late Republican times; Waurick has argued that the silver shields given by Flamininus to Delphi and the golden ones donated by Mummius to Olympia cannot have been true spoils but were made ad hoc for the offering: "Kunstraub," pp. 40–42.

31. The equestrian statue of Q. Marcius Philippus is considered a dedication by the Achaian League (in 169 B.C.) rather than a Roman offering, in the latest discussion, by Philipp and Koenigs, "Basen," pp. 197–200 (taken together with dedications in honor of Mummius at Olympia). The Wrestlers by Andreas of Argos are mentioned by Pausanias, 6.16.7.

32. For an account of Roman sculptural finds in Greece and Asia Minor see C. C. Vermeule, *Roman Imperial Art in Greece and Asia Minor* (Cambridge, Mass., 1968).

33. Bronze group, from Sebasteion in Boubon: Inan and Jones, "Bronzetorso." See also C. C. Vermeule, "The Late Antonine and Severan Bronze Portraits from Southwest Asia Minor," in *Eikones* (Festschrift H. Jucker, *AntK BH* 12, 1980), pp. 185–90.

Equestrian statue of Augustus: M. E. Caskey, "News Letter from Greece," *AJA* 85 (1981): 460, pl. 68.12.

Pekáry, "Statuen," mentions also periodic erections of statues of the same individual—in one case, every four, in another (in North Africa) every seven years. In Aphrodisias sculptors' competitions took place every four years. Admittedly, some of Pekáry's evidence is fairly late in the Imperial period.

34. Some of these figures may have been statuettes: C. Fayer, "Il Culto del Demos dei Romani: un aspetto del culto tributato al potere romano nel mondo greco d'Oriente," *Studi Romani* 26 (1978): 461–77, esp. pp. 470–71; the cult starts in the third/second century B.C., together with that of Dea Roma, and is responsible for the erection of suitable monuments.

35. See the comment by Paribeni, "Sculture originali greche," p. 89; cf. also Pollitt, "Impact," pp. 158–61.

36. For comments on these points see Brown, "Questions," p. 31. Pollitt, *Art of Rome,* p. 6 and passim, collects many passages referring to other statues erected by the Romans, and cites Pliny's attribution of the beginning of bronze statuary in Rome to the reign of King Numa: *NH* 34.33; see also p. 28 n. 44, in which Pollitt points up Magna Graecian influence on the Romans' choice of Pythagoras and Alkibiades.

Portraits of these two famous Greeks have not been identified with any degree of assurance, despite the many statues of Alkibiades mentioned by the ancient sources; Richter, *Portraits* 1, pp. 105–6, figs. 449–50, illustrates a head type known in seven replicas, but on a highly tentative basis; cf. her pp. 79–80 for Pythagoras. Of great possible significance is the recent discovery at Aphrodisias of several busts within inscribed circular frames, two of which carry the names of Pythagoras and Alkibiades. The juxtaposition is unlikely to be accidental, but so far the heads belonging to the pertinent tondos have not been recovered: M. J. Mellink, "Archaeology in Asia Minor," *AJA* 86 (1982): 568.

37. See Zanker, "Funktion," pp. 292–93; Pollitt, "Impact," p. 159.

38. An attempt to redate the Brutus to the Augustan period has not met with general approval: W. H. Gross, "Zum sogenannten Brutus," in *Hellenismus in Mittelitalien*, pp. 564–75 and discussion on pp. 575–78. The preferred date is still ca. 330–300 B.C.

For a Roman identity to the "Hellenistic Ruler" in the Terme see, e.g., the attribution by J.-C. Balty, "La statue de bronze de T. Quintus Flamininus *ad Apollinis in Circo*," *MélRome* 90 (1978): 669–86, with summary of earlier opinions, esp. n. 2.

39. This list is taken from Becatti, *Arte e gusto,* p. 288. M. Marvin, *AJA* 87 (1983): 347–84, studies the marble sculptures in the Baths of Caracalla and estimates that ca. 150 statues filled the building by

counting the niches alone. This figure is likely to be conservative. On this topic see also infra.

On the display, care, administration, and restoration of art works in Rome see also Strong, "Museums."

40. The citation is from Polybios 3.24; see the discussion by C. G. Starr, *The Beginnings of Imperial Rome: Rome in the Mid-Republic* (Ann Arbor, 1980), p. 29. Starr stresses Roman urban expansion, unprecedented for the times.

On the subject of early Roman contacts with the Greeks see also supra, n. 24, akroterion for temple in S. Omobono, and the more extensive comments by A. Sommella Mura, *Bollettino dei Musei Comunali di Roma* 23: 1–4 (1977): 3–15.

41. See H. A. Weis, "The Motif of the *Adligatus* and Tree: A Study in the Sources of Pre-Roman Iconography," *AJA* 86 (1982): 21–38, esp. p. 31 and nn. 82–84. For the influence of Magna Graecia on Hellenistic culture see also M. Pfrommer, "Grossgriechischer und mittelitalischer Einfluss in der Rankornamentik frühhellenistischer Zeit," *JdI* 97 (1982): 119–90.

42. Brown, "Questions," p. 33–36.

43. M. Torelli, "Industria estrattiva, lavoro artigianale, interessi economici: qualche appunto," *MAAR* 36 (1980): 313–23; note the *stemma* of the Cossutii on p. 321.

44. Brown, "Questions," p. 33 and nn. 23–27.

45. On the Herakles, see *EAA Suppl.*, s.v. Alba Fucentia, with colored pl. opp. p. 24. The statue is there considered Rhodian. Coarelli, "Cultura figurativa," pp. 36–37 and n. 19, dates it ca. 80 B.C. The colossal seated goddess in Boston, from Samnite Amiternum, is not firmly dated in M. Comstock and C. C. Vermeule, *Sculpture in Stone: The Greek, Roman and Etruscan Collections of the Museum of Fine Arts* (Boston, 1976), pp. 59–60, no. 92. Dr. Simonetta Segenni, Fellow at the American Academy in Rome 1981–82, tells me that she has been able to trace documents proving the origin of the statue from the site, on the basis of early descriptions of it after the find. On the Roman meaning of cult statue see the comments by La Rocca, "Un frammento," p. 27, n. 54 with bibliography. See also the compilation by H. von Hesberg, "Archäologischer Denkmäler zu den römischen Göttergestalten," in *ANRW* II. 17.2 (Berlin, 1981): 1032–1199, esp. the introduction, pp. 1032–38, with further bibliography.

For statues dedicated by Asiatic kings, cities, and communities on the Capitoline and for a redating of these monuments to the second century B.C., see A. W. Lintott, "The Capitoline Dedications to Jupiter and the Roman People," *ZPE* 30 (1978): 137–44; R. Mellor, "The Dedications on the Capitoline Hill," *Chiron* 8 (1978): 319–30. The monument was reerected after the fire of 83 B.C.

46. On Timarchides and Polykles much has been written in recent years; see esp. La Rocca, "Un frammento," and several articles by Coarelli in *DialAr* 2 (1968): 302–68; 4–5 (1971): 241–65; "Cultura figurativa," and "Roma 150–50 a.C." See also, briefly, R. R. R. Smith, *JRS* 71 (1981): 24–38.

For the Ostia statues see Zevi, "Ostia Repubblicana," esp. figs. 21–25 (Asklepios) and *Addendum*. Other Greek originals from Ostia are listed in the article.

The chronology of the Praeneste statues is still debated, and hinges on the dates proposed for the architectural complex with which they are connected. For a Sullan date and an origin from Thasos, see Linfert, *Kunstzentren*, pp. 131–34, and figs. 333–53, but his opinion is influenced by Sulla's connections with that island, and his dating of the sanctuary. The building has however been redated to the mid-second century (down to 90 B.C. and with later rework-

ings) by H. Lauter, "Bemerkungen zur späthellenistischen Baukunst in Mittelitalien," *JdI* 94 (1979): 390–459, esp. p. 457. La Rocca, "Un frammento," p. 30, n. 68a, seems to accept a pre-Sullan date for some of the sculptures. A mid-second century B.C. date also appears on the present museum labels for all the sculptures, including the dramatic *Fortuna* in dark "Asiatic" marble. See also Coarelli, "Cultura figurativa," p. 36 and n. 17; F. Zevi, *Prospettiva* 16 (1979): 2–22, esp. pp. 20–21 on the Fortuna.

47. For all the monuments that follow see Coarelli, "Cultura figurativa," and "Roma 150–50 a.C.," with more specific bibliography; see esp. pp. 29–32 for a list of buildings and statues in Rome between 167 and 44 B.C., which includes earthquakes, fires, and thunderbolt strikes. Coarelli (pp. 28–29) attributes Pliny's ". . . revixit deinde ars . . ." to the new impulse given to sculptural production by Rome and resulting in the Neo-Attic movement seen as a precise ideological and political choice. The archaeological context of the Largo Argentina temples has been more recently discussed by Coarelli (supra, n. 28). For a first-century B.C. example of Neo-Attic work in Rome see also F. Coarelli and G. Sauron, "La Tête Pentini: Contribution à l'approche méthodologique du Néo-Atticism," *MélRome* 90 (1978): 705–51. Dr. La Rocca kindly discussed with me other possible cult images in the Capitoline Museums, which are as yet unpublished as such.

48. See Guerrini, "Motivo iconografico." Additional discussion in P. Gros, *Aurea Templa* (*BEFAR* 231, Rome, 1976).

49. Stewart, *Attika,* esp. chapter 2, "The Magnet of Classicism," and chapter 3, "Athens, Delos and Rome." See his appendix for lists of Athenian sculptors active from ca. 320 B.C. to ca. A.D. 14. A basically skeptical review of the book, by A. Linfert, in *Gnomon* 53 (1981): 498–500. On the problem of Roman versus Greek portraits see also Smith (supra, n. 46).

50. On the statues from Pompey's theater see supra, n. 28.

On Avianus Evander see J. D'Arms, "CIL X 1792: A Municipal Notable of the Augustan Age," *HSCP* 76 (1972): 207–16. On Novius Blesamus see *EAA* s.v. The undatable epitaph was found near an altar of the fourth century A.C. in the *Campus Martius*. In general, see the chapter by D. E. Strong and A. Claridge in *Roman Crafts*, ed. D. E. Strong (New York, 1976), pp. 195–202. If the C. VIBI RUFI inscribed on the plinth between the feet of a karyatid from the Forum Augustus can be taken as a master's signature, we can assume that these copies of the Erechtheion korai were made (at least some of them) by Roman carvers: E. E. Schmidt, "Die Kopien der Erechtheionkoren," *AntP* 13 (1973): 11 (AF 4) and n. 13, figs. 4–5.

51. A shift in taste by the mid-second century B.C. that prompted the use of flat colored stones in Late Hellenistic jewelry has been attributed to the Romans by B. Pfeiler-Lippitz, "Späthellenistische Goldschmiedearbeiten," *AntK* 15 (1972): 107–19, esp. p. 119; cited by Brown, "Questions," n. 37. For additional refs. see also D. E. Strong, *Greek and Roman Gold and Silver Plate* (Ithaca, N.Y., 1966), p. 107.

Gros, "Vie et mort," argues that Pliny, Livy, Florus, in repeating the anecdote about the "creation" of Corinthian bronze from the fiery destruction in 146 B.C., maintain that such event was beneficial to Greek art. Pliny (*NH* 34.9) even believes that Roman presence made Delos important, and promoted the manufacture of those kline supports in bronze that were considered more important than the making of divine statues.

For a Neo-Attic movement in literature, going from Rome to Greece, which originated as opposition to the inflated Asiatic style at the time of Cicero and Augustus, see G. W. Bowersock in *Entr-Hardt*, pp. 57–75 esp. 67, 73–74.

52. Pollitt, "Impact," p. 157.

53. *NH* 36.35. Pape, "Kriegsbeute", p. 187, n. 6.; Becatti, "Letture pliniane," passim. For confusion attributing the Thespiades to Praxiteles see also Pape, "Kriegsbeute," p. 160.

54. On Skopas Minor, beside Coarelli (supra, n. 47), see also *EAA* s.v. On the problem of the Kanephoroi in the *Monumenta Asinii Pollionis* and the *Horti Serviliani* see Becatti, "Letture pliniane"; cf. also Coarelli, *DialAr* 2 (1968): 364, n. 175 and *DialAr* 4–5 (1971): 256–57.

55. Pliny seems especially confused about Myron, to whom he attributes "a monument to a cicada and a locust," on the evidence of a poem in the *Palatine Anthology* mentioning a (female) Myro (*NH* 34.57–58; *AnthPal* VII.190; Pollitt, *Art of Greece*, p. 62 and n. 25). In general, Pliny's attributions reveal much uncertainty among his contemporaries: note his account of Lysippos (*NH* 34.61) who made a portrait of Hephaistion, the friend of Alexander the Great, "which some ascribe to Polykleitos, although he lived about a hundred years earlier" (Pollitt, *Art of Greece*, p. 144). Cf. Vitruvius, *De Ar.* 2.8.11 on the colossal akrolithic Ares at Halikarnassos, "by the hand of the noted artist Leochares. At least, some think that this statue is by Leochares; others think it is by Timotheos" (Pollitt, *Art of Greece*, p. 136). The attributions may be simply due to the fact that both artists worked for the Mausoleum, but the statue need therefore be by neither. On the Hellenistic Myron, dated mid-second century, see Stewart, *Attika*, p. 165, list for Period IV, and, more argumentative, P. Mingazzini, *ÖJh* 50 (1972–73): 13–22, especially for the statue of the runner Ladas. Yet Harrison, *Cincinnati Symposium*, argues that the severe period excelled in the realistic rendering of animals. Also a Hellenistic Lysippos is known through an inscribed base: Marcadé, *Signatures* 1, s.v. Lysippos II.

56. Polykleitan Kanephoroi: see Cicero *Verr.* 2.4.3 (= *Art of Greece*, p. 91); their authorship is queried by Becatti, *Arte e gusto*, p. 84; cf. also Wünsche, "Idealplastik," on lychnouchoi.
 That statues owned by Heius may have rather been copies is suggested by M. Torelli, *MAAR* 36 (1980): 320.

57. See, e.g., Preisshofen/Zanker, "Reflex"; also Wünsche, "Idealplastik," p. 65: "not one of the great Greek sculptors can fully satisfy Roman taste." Cf. Pliny *NH* 34.53 ff., Quint. 12.10.7–9. Important discussion also by F. Preisshofen, in *EntrHardt*, pp. 263–77, and the subsequent debate, pp. 278–82.

58. For Pheidian *dignitas* and moral connotations see Zanker, "Funktion," p. 302; also Preisshofen (supra, n. 57). On Pheidias praised for his skill in the toreutic art see Becatti, *Arte e gusto*, p. 206, and the sources in Pollitt, *Art of Greece*, pp. 122–23: Martial, *Epigrams* 4.39 (cf. 6.92 = Myron); Julian *Epistola* 67 (377, A, B).
 The special conception of Pheidias in Roman Imperial times, and the honors tributed to his descendants, are discussed most recently by R. Lindner, *JdI* 97 (1982): 303–400, esp. pp. 393–94, and cf. p. 321 and nn. 52 and 54. For the desire to have both biographies and portraits of famous men, see the comments by E. B. Harrison, *Hesperia* 35 (1966): 112.

59. Zanker, "Funktion," p. 299; for the ancient texts see Pollitt, *Art of Rome*, pp. 76–78. It is also worth noting that Cicero buys *Megarian*, not Athenian statues, as we would have expected.

60. A recent discussion of the replicas and adaptations of the Crouching Aphrodite is by D. Brinkerhoff, "Hypotheses on the History of the Crouching Aphrodite Type in Antiquity," *GettyMusJ* 6–7 (1978–79): 83–96, in which approximate figures are given: ca. twenty-eight statues in the round and many variants; cf. p. 90 and n.

32. I have personally seen several replicas in private houses and hotels in North Africa, and was told in one case that the marble had been found "in the sands" and had not been published (as of 1969). On the discussion over the attribution of the type to Doidalsas see infra, p. 23.
 M. Marvin, in her studies of bath sculptures, has noted that the Herakles Farnese is a frequent type found in Thermae; of the Athenas, the Ince type and related forms seem most popular, perhaps because the presence of the snake connected it, in Roman minds, with Hygieia. For statues found in baths see now the compilation by H. Manderscheid, *Die Skulpturenausstattung der kaiserzeitlichen römischen Thermenanlage* (Monumenta Artis Romanae 15, Berlin, 1981). See also G. Bejor, "La decorazione scultorea dei teatri romani nelle province africane," *Prospettiva* 17 (1979): 37–46. The dissertation by J. Raeder, "Statuenausstattung der Villa Hadriana" (Berlin, 1980) is, to my knowledge, still unpublished.
 H. von Hesberg, "Einige Statuen mit bukolischer Bedeutung in Rom," *RömMitt* 86 (1979): 297–317, suggests that certain motifs of *Idealplastik* were first expressed in sculpture in the round by the Romans, e.g., the child Dionysos riding a goat.

61. Cf. Pliny's description of the various inscriptions on the base of the *Hercules tunicatus* taken as booty by L. Lucullus: *NH* 34.93. See also Waurick, "Kunstraub," and U. Kron, *JdI* 92 (1977): 148–68.

62. Zevi, "Iscrizioni,"; see p. 112 for the statement; cf. also Zevi, "Ostia repubblicana," pp. 60–61, with the additional mention of a small base (probably for a statuette) inscribed with the name of [Athan]odoros son of Agesandros, Rhodios; its date is variously given as Imperial or Hellenistic.

63. On the statues from Villa Hadriana cf. Zanker, "Funktion," p. 300; Paribeni, "Sculture originali greche," p. 87. A head of Herakles in the Nat.Mus., Rome (*JdI* 65/66 [1950/51]: 216, fig. 7), has been mentioned as an original Greek work by R. Özgan, who advocates that other originals come from the Villa: *AA*, 1981, pp. 489–510, esp. n. 29. His point of view will be discussed infra.

64. For a similar attitude toward copies in the eighteenth and nineteenth centuries, see Haskell and Penny, *Taste*, chapter 11.
 Not only the Kanephoroi "by Polykleitos" (supra, n. 56), but also the Apollo dedicated by Publius Scipio in the Asklepieion at Akragas, which carried Myron's signature *in small silver letters* on the upper leg (Cicero *Verr.* 2.4.43.93, Pollitt, *Art of Greece*, p. 64), may have been a reproduction—or a forgery. This practice of inscribing a statue in silver inlays is unparalleled for the severe period and likely to be much later in terms of technique; cf. infra, n. 69, bibliography for the Piombino Apollo. Pemberton, "Corinthian bronzes," has also questioned as antique the dedication made by Scipio in the Sanctuary of the Great Mother near Engyion and stolen by Verres.

65. Martial 9.44; cf. Statius *Silvae* 4.6, ll. 32–47. The implication is that the piece was more important because of its famous earlier owners than because of its "famous" maker. That the Romans liked a good story and that guides were particularly fond of inventing, especially previous owners, are points made by Strong, "Museums," p. 260. On the embellishment of stories to increase their interest see T. P. Wiseman, *Clio's Cosmetics* (Leicester, 1979), esp. pp. 33–35, 40.

66. Lucian, *Philopseudes*, 18. See also infra, chapter 6. When Pliny states (*NH* 34.55) that the Diadoumenos was famous for having been sold for 100 talents, we should like to be told whether the price was paid to Polykleitos or in Pliny's own time, and whether it was for the original or for a copy.

67. Lippold, *KuU*, p. 49.

68. Pemberton, "Corinthian bronzes," comments moreover that Pliny refers to technique rather than style or iconography, and that the term *Corinthian* may have become a conventional label by Pliny's time. See also Martial *Epigrams*, 4.39: as pointed out by Pollitt (*Art of Greece*, p. 122), the wording suggests that silver plate and other works of the minor arts were claimed to be by Myron, Pheidias, and other famous Greek sculptors—obviously incorrectly. See also Gros, "Vie et mort," pp. 295–300.

69. Piombino Apollo, B. S. Ridgway, *AntP* 7 (1967): 43–75. For recent statements see, e.g., L. O. K. Congdon, *Caryatid Mirrors of Ancient Greece* (Mainz, 1981), pp. 61–62 and n. 215 (Archaic, Magna Graecian); and O. J. Brendel, *Etruscan Art* (Penguin Books, 1978), pp. 306–7 and nn. 5–6 on pp. 468–69 (Etruscan, ca. 460).

The late chronology of the Piombino Apollo may be now confirmed by the discovery in 1977 of a bronze "Lychnouchos" in the House of G. Julius Polybius in Via dell'Abbondanza, Pompeii: S. De Caro, *Cronache Pompeiane* 1978, pp. 230–31. I am most grateful to Dr. Fausto Zevi, who, noting the similarity between the new find and the Piombino Apollo, invited me to see the Pompeii bronze while still in the Istituto del Restauro, Rome (March, 1982).

For the innate desire of the forger to identify his own work, beside the examples cited in *AntP*, see *Times Magazine*, December 14, 1981, p. 88; the article relates how a young sculptor from Thailand named Yas, who forges ancient Cambodian art, "may bury his signature in the elaborate headdress of a Khmer head or seal a piece of paper with his name on it inside a statue" to be able to identify it as his work.

70. On the preference of the Romans for adolescent figures see infra, chapter 7.

Antenor's Tyrannicides: known to Pausanias, 1.8.5; the statues' return is mentioned by Pliny *NH* 34.70 and Arrian 3.16.7; 7.19.2, although the latter does not give Antenor's name. On the group in general see S. Brunnsåker, *The Tyrant-Slayers of Kritios and Nesiotes* (new ed., Stockholm, 1971), esp. pp. 39 and 110. See also Ridgway, *Archaic Style*, p. 316, and passim, and *Severe Style*, pp. 80–83, with bibliography.

71. Lists of Greek originals in Rome have been attempted by various authors, with ambiguous results. See, e.g., R. Lullies and J. Le Brun, *Griechische Bildwerke in Rom* (Munich, 1955) and Paribeni, "Sculture originali greche." Both lists can be criticized as including works arguably "Roman" rather than Greek, and possibly even forgeries, like the Boston Throne. Neither list, moreover, seems complete, especially after La Rocca's important discoveries of the Greek statues in the pediment of the Temple of Apollo Sosianus (supra, n. 25). At any rate, none of the works cited in these lists is known from copies, except for the so-called Penelope relief, for which a different explanation has been mentioned supra (p. 8). Lippold, *KuU*, p. 52, believed that Rome was not a major copyists' center; contra see Lauter, *Chronologie*, p. 122. For the discovery of a marble workshop in Rome, making copies of Greek works, see, e.g., Daltrop, *Il Gruppo mironiano*, pp. 14–15 and n. 32.

72. Herakles by Polykleitos: latest discussion in Zanker, *Klassizistische Statuen*, pp. 17–19, who admits that the connection between the statue in Rome mentioned by Pliny and the type identified through Roman copies is not certain. He adds: "Das vollständige Werk überliefert keine Replik." The type identified at present as the Herakles could indeed be a representation of the hero, whose hand on the hip might have given rise to a repetition of this gesture for Herakles statues through the centuries, including the special interpretation of it given by Lysippos in his Weary Herakles (on which see now Moreno [supra, chap. 1 n. 36]). The influences could however have moved in the opposite direction, from a famous late classical or Hellenistic statue to the classicizing creations of the Neo-Attic workshops; indeed the "Polykleitan" Herakles seems so close to the Doryphoros (despite being supposedly a late work of Polykleitos's career) that it is legitimate to wonder.

Zeus from Samos, by Myron: E. Berger, *RömMitt* 76 (1969): 66–92; *Munich Catalogue*, pp. 117–35, no. 11, with summary of identifications.

Lysippos's Apoxyomenos: for the statue in reversed pose (smaller than the replica in the Vatican) see H. Lauter, "Eine seitenverkehrte Kopie des Apoxyomenos," *BonnJbb* 167 (1967): 119–28; *Museo Nazionale Romano*, pp. 335–37, no. 199. For the replica from Side, Inan, *Side*, pp. 83–85, no. 28. Echoes of the Seated Herakles by Lysippos taken to Rome from Taras have been identified in statuettes: J. Floren, *Boreas* 4 (1981): 47–60.

73. F. Brein, "Zum Laocoon," *Classica et Provincialia* (Festschrift Erna Diez, Graz, 1978), pp. 33–38. On the findspot of the group, truly Titus's palace, see most recently G. P. Warden, "The Domus Aurea Reconsidered," *JSAH* 40 (1981): 271–78, esp. p. 277 and n. 40. See also supra, chapter 1, n. 40.

74. The Ludovisi and Capitoline Gauls are usually considered second-century A.C. copies (Künzl); for a Caesarean date see Coarelli, "Grande donario." That the original of the Capitoline Trumpeter may have been in marble is suggested now by R. Özgan, *AA* 1981, pp. 489–510. For Phyromachos having worked for Attalos II, not Attalos I, see A. Linfert, review of Stewart, *Gnomon* 53 (1981): 498–500. This whole complex problem is discussed again in chapters 4 and 8.

Gros, "Vie et mort," stresses Pliny's anti-Nero bias and his desire to flatter the Flavian emperors; he seems to doubt that works in bronze were transported from the *Domus Aurea* to the *Templum Pacis* and would accept as possible only the Ganymede by Leochares.

75. The main argument against a Bithynian Doidalsas is by A. Linfert, *AthMitt* 84 (1969): 158–64. Regrettably, this convincing theory has not found many supporters, although accepted by Robertson, even in his *Shorter History*, p. 202: contra see, e.g., E. Simon, *Gymnasium* 84 (1977): 355–59, esp. p. 356. The *lectio* "aede alia" has been suggested to me by G. F. Pinney.

76. For a recent summary of the problems connected with the Niobids see A. F. Stewart, *Skopas of Paros* (Park Ridge, N.J., 1977), pp. 118–20 and bibliography on p. 174, n. 30 (esp. H. Weber, *JdI* 75 [1960]: 112–33). I would agree that most of the Niobids must have been created toward the end of the second or the beginning of the first century B.C., if not entirely in early Roman Imperial times. I would even subscribe to E. Loewy's theory (*JdI* 42 [1927]: 80–136) that the figures in the round were created from two-dimensional patterns after fifth century works, possibly, as I believe, the Niobids on the arm-rests of the Throne of Zeus at Olympia, on which see infra, chap. 4.

77. Coarelli, "Cultura figurativa," and *DialAr* 2 (1968): 302–68. Zanker, "Funktion."

78. Becatti, "Letture pliniane," but see also supra, n.15. For a possible Hellenistic Boupalos see R. Heidenreich, *AA*, 1935, cols. 668–701.

79. Pollitt, "Impact," p. 162.

80. Cf. also Pliny 36.26, who states that the marble statues of Mars and Venus in the Temple of Mars were by Skopas, the Venus more beautiful than that by Praxiteles. If, as Coarelli has reasonably argued, these are works by Skopas Minor, Pliny's praise goes to a work of the Late Hellenistic period. Cf. Pape, "Kriegsbeute," p. 176 and n. 2.

3 Defining Copies and Their Problems

In the first chapter I attempted a brief survey of Greek "copies" defined as the intentional, though not entirely mechanical, reproduction of specific models. I should now clarify my conception of a fully mechanical copy.

That copying existed is beyond doubt. In fact, it has even been suggested that no sculpture, at any period, was made without the help of a previous model. It is certainly difficult to visualize that complex pedimental compositions, like those of the Parthenon, for instance, could be created spontaneously or simply from two-dimensional drawings, without the intermediate step of a scaled-down three-dimensional model. The weight involved was too great and the space too confining and limited to risk sculpturing complex groups that could then be found inappropriate for the position intended. But positive evidence is lacking. It was formerly believed that a group of statuettes from Eleusis represented models, at one-third the scale, of the corner figures for the Parthenon pediments. They would have been made as guidelines for the larger pieces and, their function completed, would have been dedicated within Demeter's sanctuary. We now know, however, that, far from preceding the Parthenon sculptures in date, the Eleusis figures imitate them and, with appropriate changes, filled the corners of a Roman (Antonine) gable, in the so-called Thesauros F near the Eleusinian Telesterion.[1]

Some evidence for mechanical reproduction can nonetheless be found in the pedimental sculptures of the Temple of Zeus at Olympia, where a few figures display uncarved areas or protrusions at key points on their heads, in those positions, in fact, where measurements with the pointing system would normally be taken. Although the use of a pointing machine should not probably be assumed as early as the severe period, it is nonetheless likely that some kind of rudimentary system existed by which certain basic dimensions could be transferred from a small model to a large block of stone, perhaps with the help of calipers and a plumb line. The specific areas on the Olympia statues would then be the points where such plumb line was fastened. A fifth-century female head (plate 37) in Providence, Rhode Island, that has plausibly been seen as pedimental, displays significant cavities at major facial points as well.[2]

What true pointing is like is shown by several unfin-

ished pieces, primarily portraits, that retain small mounds of stone pierced in the center by a minute hole for the compass point: the so-called *puntelli*.[3] Richter has given a careful account of the process, which is indeed followed even today by workshops that enlarge and reproduce in stone the original conception which the master sculptor has normally created in clay. Yet the Roman use may have been at once simpler and more sophisticated. A torso found at Aquileia—a center especially important for the marble trade and the distribution of sarcophagi in the third century A.C.—gives us an idea of how a male seminaked statue might have been built.

The torso is allegedly made of Greek marble, coming either from Asia Minor or from Greece itself. It is headless and without limbs, not as an accident of preservation but because it was to be fitted with separate parts. In particular, the rectangular cut on the left shoulder was meant for the fastening of a piece of drapery which would also—in additional sections—have been shown wrapped around the legs. The torso therefore represents the extent of the naked portions, or, more precisely, the parts to be carved from a single block. Three reference points on the front indicate the positions from which measurements were to be taken. The torso has been published as a workshop aid, to be used as reference whenever a commission came in: it could be fitted with different attributes and portrait heads, and thus be suitable for a number of representations. The style has been described as eclectic, almost pre-Pheidian in musculature but with Lysippan proportions—hence its dating within the first century B.C.[4]

What would have been used for the separate limbs? A finished product would undoubtedly have had stone arms and legs, but the models for these parts could have been made in plaster. Pliny mentions that Lysippos's brother Lysistratos was the first to make casts of parts of the human body and to use them in his statues (*NH* 35.153); this notice has either been discredited as improbable for the late fourth century B.C. (since the history of copying would suggest a later beginnning for the practice), or it has been taken as an attempt to explain the inception of realism in portraiture of the Hellenistic period.[5] That casts were used for jewelry and metal objects was not only accepted but clearly confirmed by the finding of such molds, for instance those from Begram in Afghanistan.[6] But the evidence for large statuary seemed to be confined to the literary sources, and that was none too clear, such as the allusion in Lucian (*Iupp. Trag.* 33) to the Hermes Agoraios "blackened by pitch because of the many molds that were being taken from it." Then a major find was made which, although still imperfectly published, could potentially throw a great deal of light on the cast-making process.

The discovery occurred over thirty years ago, but a complex of circumstances, including the untimely death of the original excavator, Mario Napoli, has prevented publication of the whole. A brief preliminary notice was given by Napoli himself in 1954, and Gisela Richter, who had recognized one of the casts as part of Aristogeiton's head (see plate 11), was allowed to publish that piece in 1970. Other announcements, of a more general nature, have been made by W.-H. Schuchhardt, and the publication of a complete catalog is now entrusted to Christa von Hees-Landwehr, who has discussed one of the major monuments represented among the casts in an article in *Antike Kunst*.[7]

What can be gathered from these accounts is that approximately 430 fragments of plaster casts were found in a cellarlike area, forming the substructure of a hall or terrace, in a vast thermal complex in Baiae. The casts were imbedded in a layer of fill or (alternatively) in a mass of debris that may have fallen from a higher level during the destruction of the total complex. Since the baths seem to have been damaged and rebuilt several times, down to the Middle Ages, the layer with the casts is not easily dated, although a time within the second century A.C. has been mentioned. The casts themselves seem to reproduce bronze statuary ranging from the severe period to ca. 100 B.C. Most of the pieces are too small or amorphous to allow identification, but approximately 40 are significant. Among the statues mentioned are: Aristogeiton (most of the face, part of the mantle); the so-called Corinth/Mocenigo Goddess (fragments from sleeves and arms, see plates 129–31); the Doryphoros (right hand and wrist, see plate 13); the Athena Velletri and the three best-known Amazon types (see plate 136) (attributed to Polykleitos, Pheidias, and Kresilas). According to von Hees, fragments attributable to a single statue range from 1 to 20, but so far no large, connected sections of the same monument have been identified.

The fragments are of two kinds. Some are veritable molds, hollow, presumably taken directly from the original bronzes. Other plaster fragments are solid and therefore represent a second stage in the process, when the hollow mold has already been utilized to produce a duplicate of the original in plaster. Bird bones and perhaps wood were used to reinforce the plaster, although the latter is only inferred through the presence of holes. The casts would have provided models of individual parts and limbs, or may have created a "gallery of casts" comparable to those so fashionable during the seventeenth and eighteenth centuries,[8] and which are coming back into vogue today. An impressive collection of casts exists in fact in Cambridge, England; in this country, Cornell University has refurbished its own extensive holdings, thanks to the efforts of Dr. Peter Kuniholm, and in Germany a detailed catalog (with bibliography) of the cast collection in

Bonn has just been published (1981). Indeed, at least one scholar has orally ventured the opinion that the Baiae casts may not be ancient, or at least not date from the Roman past.[9] Since official publication of the finds is still pending, speculation is premature; it is tempting, however, to speculate that—if ancient—only parts, and not total monuments, ever existed within the Baiae casts, to be used to create eclectic statues with the same piece-technique suggested by the Aquileia torso and well attested for bronze and terra-cotta statuettes. We shall return to this procedure in the final chapter.

Solid plaster casts could be used either to point off, in the making of a marble copy at the same or at reduced scale,[10] or to produce molds for the making of a bronze. In the former case, the individual carver could exercise his own skill and individuality, since the mechanical process leaves room for personal decision. The more numerous the measurements taken, the more precise the reproduction; but with only a few key points, the sculptor has ample scope for improvisation, although remaining within the proportions and the general outlines of the original. This is not so when casts are used to produce a bronze replica. The mold captures, in its interior face, the exact negative image of the original surface, which will then be reproduced, in positive, first by the wax used to coat the plaster, and then by the bronze poured in to replace the "lost" wax. This process is so faithful that such a replica of a bronze retains the markings of patches actually applied to casting flaws occurring on the original but *not* on the replica.

The evidence has been convincingly explained by Carol Mattusch in her discussion of the bronze torso in Florence. A counterargument, advanced on technical grounds (which would explain the cavity within the "ghost" of a patch as a feature of natural corrosion) claims a date within the severe period for the Florence torso, which would then be a Greek original.[11] I cannot contribute to the specific discussion, but I can point out that the method for the separate attachment of the head corresponds to Late Hellenistic–Roman practices rather than to Greek usage. In Greek bronzes, according to Bol's study of the Olympia remains,[12] part of the neck is cast in one piece with the torso and part with the head (cf. plates 38, 39); the two sections are then joined together along a horizontal line. But in the Late Hellenistic and Roman periods the join is made less visible by having it follow the contour of the jaw and the natural corner formed between chin and neck. The Florence torso is used as a specific example of this technique; I therefore side with Bol and Mattusch in considering it a Roman replica of an earlier original, obtained through the use of casts which could be pieced according to contemporary technical developments.

Such mechanical reproductions are the most faithful and should, in all details, give us an image of the lost original. It is therefore all the more surprising that the Doryphoros herm from the Villa dei Pisoni in Herculaneum should have been signed by its maker, Apollonios son of Archias, the Athenian, since the sculptor's contribution would have been limited to the technical process.[13] Reduction from a complete statue to a herm should not have been so difficult as to constitute a matter of pride; we can perhaps assume that the signature functioned as a trademark—almost a label notifying the viewer that Apollonios's workshop possessed a cast of the Doryphoros and could therefore produce copies at will. If Polykleitos's original was still in Greece, as we have no reason to doubt, ownership of such a cast would have been a valued opportunity, and access to it may have required the same permission that the King of France granted to have his collection of casts reproduced by other monarchs, when the Vatican holdings were no longer open to artists.

We have not yet had the fortune of finding both a bronze original and its bronze replicas. We do, however, have several monuments represented by replicas both in stone and in metal, and the contrast is often striking. Stock bodies, like that of the Lateran Sophokles (plate 40), have now been found in bronze, at Boubon in Asia Minor, serving for Imperial portraits—the Lateran type probably for Marcus Aurelius.[14] The ubiquitous Crouching Aphrodite (see plate 34) is known from both marble and bronze versions, raising the question whether the Eros often present in the stone replicas is an addition required by the more brittle medium but absent in the better-balanced bronze.[15]

Portraits raise some of the same issues mentioned for the Doryphoros herm. If a bronze is a direct cast from the original, it—and not the marble replicas—should give us the true reflection of the original. But in the case of the "pseudo-Seneca" (plates 41 and 42) do we believe in a Greek original that would resemble a genre study of old age? Richter has suggested that the portrait, one of the most frequently reproduced in Roman times, represents Hesiod: it would therefore be an imaginary likeness created well after the poet's lifetime and meant to emphasize the hardship of a life in the Boiotian fields. A different suggestion, by Helga von Heintze,[16] identifies the type as the Latin poet Ennius (239–169 B.C.), on the basis of a similar figure on a sarcophagus of the third century after Christ. The startling physiognomy would then be a product of Roman realism rather than of Greek imagination. I cannot take a position in such a debate; I can only stress how difficult we still find it to recognize the true nature and date of an original, to differentiate between a Greek and a Roman subject. Popularity alone, as gauged through the number of extant repli-

cas, cannot be used to advocate a specific date, since we now know that Roman creations were copied as much as Greek works—and perhaps more easily.

A similar controversy raged over the identification of the Menander type (plate 43), and may have been solved by the existence of a small bust with an identifying inscription confirming the standard interpretation.[17] We would then have a replica of a portrait made by the sons of Praxiteles, Kephisodotos and Timarchos, in the early third century B.C.: a seated statue located in the Theater in Athens, the inscribed base of which has been found. What is remarkable in this case is that the marble replicas vary so greatly from one another that the style of the latest makes the portrait almost unrecognizable. Some examples (and at least one can be dated to the fifth century after Christ) add hieratic expression and even the *contabulatio* of the Late Roman toga, thus completely altering the identity of the Greek original.

It is therefore legitimate to ask: when does a copy cease to be a copy? The answer may not be within the compass of our possibilities on present knowledge. That a replica can be far removed from its prototype even when the latter is an ideal work depicting a divinity and not an individual has been shown by the find, in the Danubian region, of a marble "Aphrodite of Frejus."[18] The figure, made in local stone and almost life-size, is made to lean on a pillar inscribed by the master: *Cla(udius) Satu/rnin(us) sculp/sit.* Although the classical type is still recognizable, and all the iconographical elements are present, the total composition has been flattened, all static values have been eliminated, and the forms are rendered as heavy and massive. The Greek chiton is retained, yet it looks almost like a Byzantine tunic, with no hint of transparency and a linear rendering of the greatly simplified folds. The date is suggested on the basis of parallels with Dacian reliefs of the late second–early third century A.C. The sculptor is otherwise unknown and the statue is considered a typical product of a backward area existing in artistic isolation. Yet the effort to repeat a specific model should be appreciated—hence the difficulty in answering the question previously posed.

Finally, like the Romans, we are occasionally unable to distinguish between original and copy, Greek and Roman work. The large Athena (plate 44) found in the Peiraieus as part of a cache of monumental bronzes has generally been considered an original of the fourth century B.C., taken to the harbor for shipment to Rome and then buried, probably at the time of the destruction caused by the sack of Sulla in 86 B.C. But a few tentative doubts have been expressed. Bol has pointed out that if this were indeed the Peiraieus Athena by Kephisodotos (as some advocate), it could not have been known to Pliny in the mid-first century A.C. (*NH* 34.74). In addition, at least one replica of the type exists, the so-called Mattei Athena in the Louvre, which should be dated to the Antonine period. If an original, the Peiraieus Athena was either buried *after* the making of the Antonine replica, or was originally created with a "double" which could serve as model for the later copyists. That the Athena from Peiraieus itself may be a Roman copy cannot be entirely excluded.[19]

How difficult it is to determine whether we are dealing with a classical original, a Roman copy, or an adaptation has been recently shown by the Riace Warriors, which have deservedly attracted such attention and admiration everywhere.[20] A fifth-century-B.C. date has been advocated by virtually all scholars who have seen the two statues, but some features of style are puzzling. That the two warriors were cast in the same workshop, at the same time, is suggested by their comparable height, stance, and subject matter, and by technical similarities, for instance in the rendering of the feet and of the navel. Yet they have seemed stylistically different, perhaps because by different masters, or because of the different age represented; but at least some archaeologists have seen the two pieces as separated by some decades (Paribeni, Arias). Certainly the short-haired warrior employs the Polykleitan chiasmos, despite his feet flat on the ground.[21] The other, with the same pose, has no such contrapposto and his stance appears pre-Polykleitan, with shoulders thrown back. His heavy lids, the irrational course of the curls which "turn the corner" over the temples without being held in place by the fillet, and the slightly open mouth revealing silver-lined teeth[22] out of a narrative context that may justify the realistic features are all traits that raise doubts as to an early date. That the technical quality and the general appearance of the figures are excellent is no argument, to my mind, against a later, classicizing chronology, but would, on the contrary, be totally in keeping with the Roman interest in recreating the classical past.

Notes

1. The figures have now received most thorough discussion per se, rather than as part of topographical or Parthenonian studies: R. Lindner, "Die Giebelgruppe von Eleusis mit dem Raub der Persephone," *JdI* 97 (1982): 303–400. Superimposed outline drawings show the variations introduced in the rendering of the Parthenon figures, and the "copying" is therefore assumed to have taken the form of drawings which only approximately reproduced the composition of the fifth-century pieces. The Eleusis pediment is dated to

the mid-second century A.C., a time of retrospective and nostalgic trends in art. See Lindner also for previous bibliography.

2. On the use of models during the severe period, see B. S. Ridgway, chapter 4, "Stone Carving," esp. pp. 108–10, in *The Muses at Work,* ed. C. Roebuck (Cambridge, Mass. and London, 1969). On the Providence head see Ridgway, *Classical Sculpture* (Catalogue of the Classical Collection, Museum of Art, Rhode Island School of Design, Providence, R.I., 1972) pp. 28–30, no. 8. For an example of a classical head copied in later antiquity see E. B. Harrison, *Hesperia* 29 (1960): 369–70, pl. 81a–b.: here the holes are equivalent to "pin pricks," and may suggest that not all marbles were copied through the intermediate step of plaster casts.

3. Although commonly used in the pertinent literature, the Italian word *puntello* means "strut" and is therefore misused in this context; point or measuring point (or mound) would be a more accurate name for the feature.
 For Richter's discussion of the pointing machine see her *Portraits* 1, pp. 24–27, figs. V–VII and no. 26 on p. 115; see also Richter, "An Unfinished Portrait of Sokrates," in *Studi in onore di Luisa Banti* (Rome, 1965), pp. 389–91. For a possible copy from an archaic relief see Harrison, *Agora 11,* pp. 77–79, no. 127. See also *Abgüsse,* pp. 14–15.
 P. Rockwell has recently (December, 1982) discussed Roman copying techniques as gleaned from unfinished marble statuary at Aphrodisias. He observed that two, rather than three, measuring points were used, thus suggesting that the sculptor was more interested in correctly reproducing the pose than the depth of his prototype. Rockwell could find no clear sign that a pointing machine was used. For a summary of his paper, see *AJA* 87 (1983): 254.

4. V. Santa Maria Scrinari, Museo Archeologico di Aquileia, *Catalogo delle Sculture Romane* (Rome, 1972), torso, no. 1.

5. On Lysistratos see the comments by Pollitt, *Art of Greece,* p. 151 and n. 80; to his reference to Carpenter add also *Greek Sculpture* (Chicago, 1960), pp. 232–36.

6. Even earlier than the Hellenistic Begram casts are the fifth- and fourth-century B.C. casts or molds for casts found in the Athenian Agora: E. Reeder Williams, "Ancient Clay Impressions from Greek metalwork," *Hesperia* 45 (1976): 41–66, with bibliography in nn. 1–4 and good technical comments.
 See also N. Winter, "News Letter from Greece," *AJA* 86 (1982): 548, for a recent discovery at Pella: shops of the time of Philip V, which seem to have sold molds rather than the finished products. The molds have relief scenes, some with Homeric and Dionysiac themes, and would imply that not all reliefs were copied through the intermediary of sketches, as often postulated, or the pointing process, as suggested by the Agora archaic relief (supra, n. 3). More information is however needed on the Pella find before speculation can continue.

7. My main text has been left substantially at the same level of information at which the lectures were delivered in 1981–82. In March–May, 1982, however, an exhibition of the Baiae casts was held in Freiburg, accompanied by a catalog by Ch. von Hees-Landwehr, to whom I am indebted for her great kindness in sending me a copy of *Abgüsse.* The information presented in the catalog varies from my account in the following points: (1) although the casts themselves are not specifically dated, the "Kellerraum" under the so-called Thermae of the Sosandra is placed in the first half of the first century A.C. on the basis of wall technique; (2) the range of the casts has been restricted to the fifth and fourth centuries B.C. (p. 10); (3) of the 430 fragments counted at the beginning of work, 80 were eliminated because no original surface remained, and many

were found to join, leaving a total of 292 pieces. Of these ca. 100 were so small or undiagnostic that they were unclassifiable. Of the remaining 190, 60 can be securely identified as coming from Greek bronze originals, 50 more can be attributed with some confidence to famous statues, and approximately 80 fragments, although well preserved and seemingly distinctive, have remained unidentified, perhaps because of gaps in our knowledge (p. 46). The Aristogeiton head identified by Richter, *AJA* 74 (1970): 296–97, is listed in *Abgüsse* (24–26, Katalog, p. 50, no. 7) as a replica of Antenor's group, here dated after 490 B.C. The Corinth/Mocenigo type, *Abgüsse,* pp. 27–30, has been discussed at length by von Hees in *AntK* 21 (1978): 108–10.
 That the chronological range of the bronzes represented by the casts goes no further than the late fourth century B.C. can be doubted on the basis of the illustrated sandals (*Abgüsse,* pp. 46–49), comparable to those of the Apollo Belvedere, which should belong to the Hellenistic period at the earliest. On this point see infra, chapter 8.

8. On the technique of cast taking see *Abgüsse,* pp. 16–18, with diagrams.
 On "Casts and Copies in Seventeenth century Courts" see Haskell and Penny, *Taste,* chapter 5.
 Anne Weis has brought to my attention Juvenal *Sat.* 2.4–5, who refers to the "unlearned whose houses are crammed with plaster casts of Chrysippos." It would seem, therefore, that casts were not always converted into bronze or marble replicas, but could be displayed directly.

9. G. Daltrop, as quoted by O. R. Deubner, "Der Gott mit dem Bogen," *JdI* 94 (1979): 240, n. 25.

10. That *marble-carving* workshops existed in Baiae is shown not only by the presence of replicas in marble from famous works (e.g., the Omphalos Apollo), but also by the large unfinished statue of the so-called Aspasia/Sosandra, of the early fifth century B.C.: cf. Ridgway, *Severe Style,* pp. 65–69, figs. 105–8.

11. C. C. Mattusch, *AJA* 82 (1978): 101–4. The counterargument, by E. Formigli, appears in *AJA* 85 (1981): 77–79; see also, by the same author, *Boreas* 4 (1981): 15–24.

12. Bol, *Olympia,* pp. 81–87; note the classical and early classical rendering of the neck as exemplified, for instance, in the scene of the Berlin Foundry Cup: C. Mattusch, *AJA* 84 (1980): 435–44, pl. 54, fig. 2. The practice continues at least until ca. 300: Ridgway, "The Lady from the Sea," *AJA* 71 (1967): 329–34. See plates 38 and 39.

13. For a discussion of the bronze herm from Herculaneum see, e.g., Zanker, *Klassizistische Statuen,* pp. 8–9, pl. 7.1 (dated second half of the first century B.C.).

14. Bronze Lateran-Sophokles body type, from Boubon: Inan and Jones, "Bronzetorso," pp. 281–82, no. 10, pl. 89. The statue is now in the Charles Lipson Collection, on loan to the Indianapolis Museum of Art.

15. For the various replicas of the Crouching Aphrodite see R. Lullies, *Die kauernde Aphrodite* (Munich, 1954); Brinkerhoff, supra, chap. 2 n. 60.

16. Pseudo-Seneca: Richter, *Portraits* 1, pp. 58–66, figs. 131–230, with a summary of the debate on identification (over twenty-six have been proposed). For von Heintze's suggestion see *RömMitt* 82 (1975): 143–63. For a recent argument in favor of Aesop see Frel, *Getty Portraits,* p. 37, fig. 86.

17. Replicas of the Menander head type are collected by Richter, *Portraits* 2, pp. 229–34; the inscribed bronze bust, in small scale, is in the J. Paul Getty Museum, which owns two more replicas of the type, in marble: *AJA* 77 (1973): 61 and pls. 11–12; Frel, *Getty Portraits*, 82–85, nos. 34–36. I question neither the authenticity of the Getty bronze nor that of its inscription, but since portraits with erroneous (ancient) legends are known, a certain element of doubt remains.

New replicas are constantly being excavated; see, e.g., *FA* 28–29 (1973–74, publ. 1979), pl. 20, fig. 45, from Lucus Feroniae. On this type see also infra, chapters 5 and 8.

18. L. Bianchi, "La Venere Genitrice di Claudio Saturnino," *ArchCl* 29 (1977): 128–33. The site is ancient Ulpia Trajana Sarmizegetusa.

19. Bronze Athena from the Peiraieus: this impressive statue has not yet been fully published; see Palagia, *Euphranor*, pp. 21–23, with issue of originality left open. For Bol's opinion see *Olympia*, pp. 45–46 and esp. n. 4 on p. 45. If the destruction which buried the Peiraieus bronzes had indeed been caused by Sulla, we would expect the statues to have been "rescued" as booty before the warehouse was demolished. If the Artemis from the cache were already a (pre-sack of Sulla) copy, Bol would consider the finds the earliest *bronze* copies so far known. For him even the Athena is an overrefined, sophisticated rendering of a fourth-century work, but not an original; he implies that the statue could be as late as the second century A.C. On the Antonine date of the Mattei Athena see K. Schefold, *AntK* 14 (1971): 37. A possible replica of the Athena type, in marble, is in Corinth: Ridgway, "Corinth," p. 442, n. 79. A new reconstruction of historical events explaining the Peiraieus "cache": Dontas, "Artemis," pp. 32–33.

20. Although virtually every important magazine and newspaper has carried accounts of the Warriors and their display, official publication is still pending. The most complete photographic documentation so far is by A. Busignani, *Gli eroi di Riace, daimon e techne* (Florence, 1981). My points are stated more extensively in an article contributed to a forthcoming issue of the *BdA* devoted to the Riace Warriors.

21. Accounts about various opinions voiced by archaeologists have largely appeared in newspapers. See however, W. Fuchs, "Zu den Grossbronzen von Riace," *Boreas* 4 (1981): 25–28; he connects them with the Marathon dedication at Delphi as works by Pheidias, although placed at some distance from each other within the group. Also in *Boreas* 4, pp. 15–24, E. Formigli discusses bronze casting techniques, with reference to the warriors. Frel, *Getty Portraits*, pp. 11 and 14, juxtaposes the Anakreon Borghese and the head of Warrior A, attributing both to Pheidias (figs. 36–37). For my own doubts on this chronology and earlier bibliography see Ridgway, *Fifth Century Styles*, pp. 237–38, figs. 151–53. Add that the manner in which the statues were originally fastened to a base would seem to correspond to that which Bol, *Olympia*, pp. 81–87, considers typical of the Roman period. Roman bases have a cavity corresponding to the outline of the entire foot, perhaps with just the tips of the toes omitted—hence in the statue the whole sole of the foot is "open" and filled with lead. This technique in Greece is not attested before our era, but its occurrence in Italy may be earlier, perhaps as early as the time of the Mars from Todi. This technique seems also to have been employed to fasten the Piombino Apollo to its base, at least to judge by its feet: *AntP* 7 (1967), figs. 10–11 (cf. supra, chap. 2, nn. 64 and 69, figs. 26–28).

22. Silver inlays, especially for teeth, as a sign of later (Late Hellenistic or Roman) date are discussed by M. Maass in connection with small bronzes, specifically the Maiden from Beroa in Munich: *Tainia*, (Festschrift R. Hampe, Mainz, 1980), pp. 333–42, esp. p. 339 and n. 41. The theory that the Delphi Charioteer had a silver blade inserted between the lips to suggest teeth is refuted by F. Chamoux, *FdD* 4.5, p. 52, n. 2, who interprets the lighter metal as the soldering for the copper lips.

4 The Evidence of the Panhellenic Sanctuaries

The Riace Warriors, with their shoulders-back stance, look to me posturing rather than simply standing, and recall Stephanos Athlete (see plate 35) which presents itself in the same "posed" manner.[1] Were it not, however, for a few signs of eclecticism, a fifth-century date would be plausible—so much so that Pheidias's name has repeatedly been connected with the two statues ever since they were revealed to the general public in their new, cleaned state after the long sojourn underwater. So convincing was this attribution that an attempt was made to measure the warriors' feet against the length of the base of the Marathon dedication in Delphi, the large monument erected by the Athenians in commemoration of their victory of 490 B.C., and which is known to have been made by Pheidias.

The dimensions of the Riace statues seem to be too large for the Delphic base,[2] so that at least this connection should be excluded. Other suggestions have linked the warriors with Olympia, since to our marveling eyes they look like the kind of monument that could only have been set up in one of the most important Greek sanctuaries. That these hypotheses could be made highlights however one more facet of our present knowledge: we have no secure evidence on the appearance of the dedications in the Panhellenic centers, unless the originals themselves have been preserved. Some works mentioned by Pausanias have been tentatively identified in Roman copies, but no certainty exists and no two scholars agree in the attribution game. The possibility is worth considering that no votive offering set up in a great sanctuary was ever mechanically duplicated in Roman times.

This suggestion had already been made by Lippold in his *Kopien und Umbildungen* (p. 69). It was then repeated by F. Eckstein, in his study of the severe dedications at Olympia, and by Bol in his publication of the bronzes from the same sanctuary. Finally, Uta Kron, in her investigation of representations of the Eponymous Attic Heroes (which indeed formed part of the Marathon dedication made by Pheidias), came to the same conclusion. Although other scholars have recently spoken against the theory,[3] it is striking that it should have been favored by those who had occasion to examine in some depth the evidence from the Panhellenic sanctuaries themselves. I therefore tend to side with the proponents of such theory.

Admittedly, this type of hypothesis is hardly capable of proof. It is also difficult to find an acceptable method to approach the issue. But a possible *modus operandi* is to check our finds against the monuments mentioned by Pausanias in the mid-second century after Christ, supplementing this information with whatever other evidence is available.

Delphi

This procedure has already been attempted by George Daux in his *Pausanias à Delphes* (Paris, 1937); and Jean Marcadé has compiled a collection of all artists' signatures excavated in the sanctuary. The two accounts coincide rarely (only in nine cases), but even the discrepancies are revealing.

Despite the relatively late date of Pausanias's visit, the periegetes saw (or at least named) over 206 statues within the sanctuary,[4] some of them in gold or gilded, several of iron, most of bronze, a few colossal. Among them were no less than 30 figures of Apollo, not counting those within groups or the temple image. This total appears even more impressive when we consider Pausanias's approach: not only did he not go everywhere within the sanctuary, but he also omitted to mention, by his own admission, all victors' statues, whether of athletes or of musicians, except for Phaylos of Kroton because he was not represented at Olympia (10.9.1). This statement may imply that most of the winners he had mentioned at the Peloponnesian sanctuary were also represented at Delphi; it may also confirm that Pausanias is not interested in artistic matters, but wants to record only famous deeds and men, or pious offerings.

Even more significant is the fact that no monument mentioned by him can be shown to be later than 260 B.C., as pointed out by Daux. Yet Roman monuments filled the sanctuary, some of them of considerable antiquity, like the pillar of Aemilius Paullus (after Pydna, 168 B.C.) and many others of Imperial date. Daux rightly objected to the suggestion that Pausanias never visited Delphi and simply utilized a source of the mid-third century B.C.: rather, Pausanias was an antiquarian who would logically omit the type of monument which in his day could be seen not only in Rome but in any major city of the empire—hence his elimination of anything "modern." But certainly the detailed account of Polygnotos's paintings in the Knidian Lesche could not have been written without direct observation, and it is unlikely that Pausanias would have omitted from his itinerary one of the most famous sanctuaries in Greece.

It is nonetheless remarkable that the Greek traveler tells us nothing about Krateros's dedication, the bronze Lion Hunt with Alexander the Great, made by Leochares and Lysippos. The attribution is based on Plutarch (*Life of Alexander,* 40) and Pliny (*NH* 34.61) and the subject is confirmed by the inscribed blocks themselves. Both the names of the personages represented and those of the sculptors should have attracted Pausanias. He therefore must have bypassed the monuments on the north side of the temple, ascending to the Knidian Lesche from the passage near the Kassotis spring, and then moving on to the theater from the upper level. That the Krateros monument was still there is suggested by Plutarch, who was almost a contemporary of Pausanias and had special priestly ties with Delphi. Once again, we must confront the fact that what would interest the modern archaeologist was not necessarily of equal importance to the ancient and that the fame of certain sculptors may have rated different reactions in the Roman viewer.

One additional point could be made. It has usually been assumed that the famous Alexander Sarcophagus from Sidon, now in Istanbul, gives us an echo of the Krateros Hunt.[5] Yet Alexander on the relief, although individualized and distinctive, looks like no other portrait that has come down to us in copies; more specifically, his round face is quite different from the elongated structure of the Azara Herm generally thought to copy an original by Lysippos, or of the Akropolis portrait (see plate 68) sometimes considered an original by Leochares. Our stylistic assumptions need close reviewing, whether regarding the sarcophagus or Lysippan/Leocharean style in portraiture.

Even with omissions, Pausanias cites many major masters in his total of approximately twenty-nine sculptors: on the day of his visit he could still admire works by Pheidias, Praxiteles,[6] Onatas, and Kalamis, not to mention others who to us remain mere names but who, judging from their commissions, must have had a strong reputation in antiquity—for instance, Ageladas and Antiphanes of Argos, Daidalos of Sikyon. Note that Pausanias names primarily classical artists apparently ranging from the early fifth to the late fourth century. At Delphi he mentions also one sixth-century master, Glaukos of Chios, but as the maker of an iron stand, more an artisan therefore than a sculptor, and noteworthy primarily for the unusual medium he employed. By contrast, he does not name the maker of the group vandalized by Nero: it consisted of a diver from Macedonian Skione, Skyllis, and his daughter Hydne, who endangered Xerxes' ships by cutting off their moorings during a storm. Nero took Hydne's statue, but not her father's, which was still visible in Pausanias's time (10.19.1); it would seem therefore that Nero was simply attracted by the unusual subject of a woman diver rather than by the artistry of the group or the fame of its maker.[7] Pausanias offhandedly comments (10.7.1) that Nero stole from Apollo five hundred different bronze images of gods and men, but this seems a rounded-off exaggera-

tion; he is moreover our only detailed source on Nero's thefts in Greece.[8] Certainly, by his own reckoning, some "masterpieces" were still there in his days.

According to the finds, however, over sixty sculptors can be named, some of them represented by more than one contribution.[9] We have evidence at Delphi for what may be one of the earliest statues by Lysippos: that of Pelopidas. Yet the Theban general has not been recognized in any of the extant Roman copies, despite the fact that other portraits of him must have been erected elsewhere. On the whole, however, the Delphic signatures yield only five or six names known also through the sources or attributed works: these include Kresilas and Phradmon and a Kephisodotos who could be either the father or the son of Praxiteles. Particularly surprising is the fact that no work by Polykleitos is attested at Delphi, either through the literary sources or by the inscribed bases; yet at least two students of the Argive master were active at the sanctuary. Myronian sculpture is equally absent, despite the fact that the artist flourished at a time of great activity within the sanctuary and that Pliny lists "Delphic pentathletes" among his works (*NH* 34.57).[10] Once again, we can only remark on the difference between the evidence and our own expectations.

Of the originals recovered through the excavations, none is also repeated in a Roman copy: not the karyatids/dancers of the akanthos column,[11] not the impressive philosopher of the Hellenistic period, who has not yet been identified,[12] not the members of the Thessalian dedication by Daochos, despite all arguments that the Agias (see plate 114) is itself a copy of a work by Lysippos.[13] That a sanctuary could accept a copy is shown much more clearly at Olympia; at Delphi a case in point may be the statue of Antinoos, of which other replicas exist, but, as for Imperial portraits, a prototype may have been distributed to several workshops more or less simultaneously. At least one theory, moreover, would consider the Delphic statue an *Urbild*, perhaps set up by Aristotimos, the Delphic moneyer who put Antinoos's portrait on the coins of his mint. Plaster casts of the head would then have been sent from Greece to the Roman world to be copied.[14]

Of the monuments mentioned by Pausanias only one has been found, at least partially, and recognized: the serpentine column that once held the Plataian tripod. A fragment from its shaft is now in the Hippodrome in Istanbul. Modern research is also beginning to recover some of the pedimental sculptures of the temple which Pausanias attributes to Praxias and Androsthenes.[15] Note that these two sculptors are known to us only through Pausanias's mention, and nothing else can be assigned to them; yet the Delphic commission must have been of some importance, even if the oracle in the fourth century was not as powerful as in the sixth. To be sure, this may be one more

instance of the fact that architectural sculpture, although competent and symbolic, need not have been of superlative artistry such as to require a major master's hand.

Isthmia

A second Panhellenic sanctuary, that of Poseidon at Isthmia, did not retain Pausanias's attention to the same extent (2.1.7–8). The athletic statues he sees are mentioned en masse, without reference to their makers. Contrary to usual practice, Pausanias describes instead the dedications by Herodes Atticus—Amphitrite and Poseidon on a quadriga flanked by Tritons—presumably because they were in gold and ivory and therefore resembled classical chryselephantine cult images. That such resemblance was intentional is suggested by the figured scene on the base, illustrating the Birth of Aphrodite amid marine personages.[16] Other statues mentioned by the traveler repeat themes connected with Poseidon and Palaimon, but although several representations of boys on dolphins have come down to us, including some from nearby Corinth, none can be assumed to be a direct copy of a work standing at Isthmia; they reproduce the theme rather than the form.

The excavations have recovered several fragments of marble sculpture, including the colossal upper torso of a seated goddess. The material is being studied for publication, but preliminary information suggests that the statue is Roman, and only generally resembling fifth/fourth-century style. More surprising are fragments of a frieze depicting the Slaying of the Niobids, a subject which occurred on the armrests of Zeus's throne at Olympia. That the Isthmia reliefs are patterned after the Pheidian examples seems unquestionable, although the arrangement of the individual Niobids may vary and some figures (e.g., Hermes) have been added.[17] Yet technique and size are different, so that no direct copying is involved. We may assume that this is an instance of intentional imitation and antiquarian quotation typical, in general, of Neo-Attic reliefs.

Nemea

Despite its former glory, the site of the Nemean games and of a famous temple of Zeus was in ruins by Pausanias's time (2.15.2–3). The traveler mentions that the temple roof had caved in and all the statues had been removed. He can only tell us the legend about the death of Opheltes (Archemoros) and make an allusion to the race in armor. That a famous group at the site may have commemorated the child's killing by the snake is perhaps suggested by a sarcophagus in Corinth, depicting both Archemoros and the Seven

against Thebes. Its date, however, is almost contemporary with Pausanias and its manufacture is probably Attic, so that no direct connection with Nemea, beyond the subject, can be made. The prototype, to be sure, is just as likely to have been pictorial, and no replica of either the group or the individual figures is known.[18]

Olympia

Here the situation is entirely different. Pausanias finds this sanctuary in full bloom, rich in statues and altars. His account fills almost two books, and his approach changes; instead of moving systematically along the main avenues of traffic, Pausanias lists dedications by categories: 42 statues of Zeus (not including statuettes), more than 70 altars, 192 athletes victorious at the games.[19] Some of his observations have been confirmed by the finds, others can no longer be verified, a few have been proven erroneous. Considering Pausanias's approach and his omission of Roman material, it is a fair estimate to assume that approximately 500 statues stood in the Altis around A.D. 174. In his study of the bronze remains, Bol has come to the conclusion that victors' monuments continued to be erected until the Herulian invasion in 267, to judge from the evidence of the bases and the imprints for naked feet on them. Extant inscriptions name Roman emperors down to the time of Caracalla, and the signature of an Andreas *marmararios* has been dated to the fifth century A.C.[20] Fragments from many gilded statues also survive, although Pausanias does not mention them; they stood thickest near the Temple of Zeus, according to the findspots.

Pausanias lists over eighty-three sculptors and alludes to others without naming them.[21] Some masters belong to the sixth century, although they are otherwise unknown to us (Dameas of Kroton; Dorykleidas, Hegylos, Medon, and Theokles, all Lakonians). The latest works mentioned, by our reckoning, seem to date to the mid-second century B.C. Although Herodes Atticus completed the splendid fountain of Regilla by A.D. 150, Pausanias omits it and its many impressive statues of members of Herodes' family and the Antonines. But he cites the statues of Demeter and Kore, in Pentelic marble, with which Herodes Atticus had replaced the ancient ones at the nearby sanctuary of Demeter Chamyne (6.21.2). Within the Temple of Zeus he mentions Augustus's statue in amber, and the ivory image of Nikomedes of Bithynia. Once again, subject matter and exotic materials seem of paramount importance, while contemporary marble figures can be disregarded.

Among the statues seen by Pausanias, five were by Lysippos, seven by Pythagoras of Rhegion, a few by Kalamis. Of the five or six said to be by Polykleitos,

some were probably made by Polykleitos the Younger, but some were undoubtedly by the more famous fifth-century master. The school of Polykleitos is also well represented, with several Sikyonian sculptors who seem to replace, in the fourth and third centuries, the many Lakonian masters prominent during the archaic and severe periods.[22] The only Myron mentioned by Pausanias seems to have been active ca. 384 and to be from Athens; but Lykios son of Myron must be the son of the severe sculptor, although the father is surprisingly absent from the roster. Paionios, who made the splendid Nike of the Messenians and Naupaktians and the akroteria of the Temple of Zeus, is known to us only through Pausanias's mention.[23] Again, it is important to note the difference between Roman treatises on art history (and their Greek sources) and the factual accounts of the periegetes. From his total of eighty-three names, fewer than ten sculptors can be connected with specific works, and most of these are attributions, not certainties; the others are no more than mentions in the sources, or signatures on empty bases, and the majority are entirely unknown.[24]

At Olympia, as in Delphi, Pausanias alludes to Nero's depredations, yet here too, as in Delphi, they seem to have been discriminating. Of a large Achaian dedication—nine Greek heroes standing on a semicircle and facing Nestor on a separate base, as the elderly king drew lots to determine who was to fight Hektor in duel—Nero took only one figure, that of Odysseus, and left the others behind, still visible in Pausanias's day (5.25.8); yet only Agamemnon's statue, according to his account, was identified by inscription, and the sculptor's signature (the severe master Onatas) was on Idomeneos's shield. It would appear that Odysseus was selected not because of its maker or its special artistry, but because the wily warrior might have appealed to Nero as a subject.

We are also told of Mikythos's offerings, made by Dionysios and Glaukos of Argos, at least twelve of which Pausanias could still admire.[25] He mentions that more were in the pronaos of the Temple of Zeus; others, dedicated by the same man, had been taken by Nero. Whether the looted offerings were by the same masters we do not know; if they were, the style of the two Argive sculptors remains otherwise unknown; if they were not, their makers were probably not famous enough to be recorded. That Nero left some of these dedications behind, taking only a few, seems hardly in keeping with the picture of wholesale looting to decorate the *Domus Aurea* which has been credited to that emperor's account; that he left behind works by Lysippos and Polykleitos seems even more surprising. And although Suetonius (a highly biased source) mentions that Nero had the statues and portraits of winnners in the Olympic games overthrown and dumped "so that

no memory or trace of any victor in the games other than himself should remain" (*Nero* 24), Pausanias does not repeat the gossip but tells us instead of the gold wreaths set up by that emperor within the temple of Olympian Zeus.

One more passage may be revealing: Pausanias (6.9.3) praises Cheimon's portraits as being among the finest works by Naukydes, "both the one at Olympia and the one that was taken to Rome from Argos and installed in the Temple of Peace." We may surmise that a dedication within the Altis was respected because of the sacredness of the sanctuary, while a statue set up within a town could be removed without fear of impiety.[26] That the Romans respected the Olympian Zeus is also shown by Mummius's dedication of two bronze statues of Zeus and twenty-one gold shields on the temple itself—the first Roman, Pausanias states, to dedicate in a Greek sanctuary. But an even earlier statue, of the general Q. Marcius son of Philippus, is attested by a base signed by the Argive sculptor Andreas in the early second century B.C. Some Roman looting undoubtedly took place, but with much more restraint than hitherto suggested by modern literature.[27]

If the Romans took with discrimination, how much did they copy? The answer may be: not at all. The great chryselephantine Zeus may have served as the prototype for other cult images, for instance at Cyrene and even at Athens, in the Hadrianic Olympieion, since Pausanias's account (1.18.6) mentions it was in gold and ivory. But it is unlikely that these replicas were more than approximate likenesses. The Nike supported by the hand of the Pheidian Zeus has been tentatively seen in some Roman statues in Berlin, known also from other replicas, but the latest study on the subject rightly considers them a classicizing type and categorically states that no Roman copy of a classical Nike is extant, with the very relative exception of the small Victory on the hand of the Varvakeion Athena.[28] Obviously, the inaccessibility of the cult image and the very media of which it was made prevented artists from close copying.

Elements from Zeus's throne may have fared better. At least two suggestions have been made, regarding the armrest supports in the form of sphinxes seizing Theban youths, and the Victories at the foot of each leg. Two sphinx-youth groups, in highly fragmentary conditions, were recovered by Austrian excavators at Ephesos from the Imperial Hall near the peristyle of the so-called Harbor Baths, which date from the time of Domitian into the second century.[29] The matching monuments stood on low bases and were made of black stone, presumably to imitate the ebony with which Pausanias says the Olympia throne (though primarily in gold and ivory) was variegated. Since the youths have been calculated to be approximately two-thirds life-size, a one-to-one correspondence with the

originals could be argued. Several elements however are puzzling. Why should two armrest supports from a throne be displayed in total isolation within a thermal hall? So completely divorced from their context, how recognizable would they have been to the Imperial viewer in Asia Minor? The iconography, moreover, is close to depictions on vase paintings and the dark stone may suggest bronze as well as ebony, especially since, in the original fifth-century monument, a black youth might have conveyed the notion of being an Ethiopian rather than a Theban. Since no other replica is known of what could have been a well-copied subject, the Olympia connection of the Ephesos groups should remain tentative, at least in terms of exact reproduction.

Three replicas are instead known of a type of kneeling figure which was at least once adapted into a fountain. On the basis of coins which depict kneeling Nikai at the feet of Zeus's throne, Stähler has suggested that the statues in Detroit, Naples, and Stockholm copy details of the Olympia seat. But a countersuggestion sees instead a severe upper body combined with a late-fifth-century rendering of the legs into a Roman eclectic creation at least as early as the Augustan period (the date given to the Detroit replica), perhaps inspired by late-fourth-century prototypes of mourners at a grave.[30]

The one definite identification is that of the Killing of the Niobids which decorated the armrests themselves. A depiction on a classical vase, showing figures outlined along the arms of the throne, has confirmed the location of the friezes known to us through several Neo-Attic replicas, and the example from Isthmia strengthens the connection. As in the case of Roman sarcophagi and Greek architectural friezes, copying of the composition probably took the form of sketches, which could then be adapted at will by the individual sculptor for the purpose at hand. Pattern books presumably transmitted the individual figures, and each master aligned them according to his own aesthetic criteria or logical principles.[31] At any rate, no one-to-one duplication in terms of dimensions seems to have occurred, and the fact remains that only a relatively small and decorative/narrative detail was copied from a highly complex monument.

Of all the other monuments known to have been at Olympia, the Nike of Paionios (plates 45 and 46) could represent that rare case in which both the original and the replicas are extant. Although the face is almost entirely missing, enough of the Nike's head is in fact preserved to have allowed correlation with two herms in Rome (plate 47), to which a third has now been added by the excavations of the Athenian Agora. Yet even this connection has now been undermined. Since the Nike stood on its high pedestal at the time of Pausanias's visit, the accessibility of the figure for

copying should have been minimal; yet the Agora herm is of Antonine date. That a duplicate Nike was set up at Delphi is no longer considered likely, and in any case that statue, on a similarly high pedestal, would have been equally inaccessible. The rather old-fashioned hairstyle, in contrast with the advanced drapery, had already been noted when the Olympia Nike was found. In addition, a discrepancy exists between original and replicas, in that the fillet which in the herms comes down along the neck is fully wound around the head in the original. It has now been argued that the herms reproduce not Paionios's Victory (dated ca. 425 B.C.) but Pheidias's, which stood on the hand of the Athena Parthenos (ca. 447–438 B.C.); the Mendean master would have been quoting the Athenian Nike when he created his own figure for the Altis. The issue of the Akropolis copying will be discussed later; suffice it here to state that even the one apparent case for the copying of an Olympia monument should now be dismissed.[32]

Other identifications remain entirely within the realm of hypotheses, since the originals have disappeared. The Hermes Kriophoros by Onatas has been recognized in bronze statuettes, but not in large-scale copies, despite some suggestions. Equally doubtful, if not outright improbable, are the very few identifications of other figures, such as the "Agamemnon" from the Achaian dedication.[33] The victory monument of Kyniskos, attributed by Pausanias to Polykleitos, has been connected with the so-called Westmacott Athlete, of which several replicas exist. The statue would have been one of Polykleitos's earliest, yet the advanced style of the copies would be more in keeping with a phase late in the master's career, or even with attribution to his school. The adolescent type itself—as in the case of the Idolino or the Naples Lychnouchoi—may seem more in keeping with Roman than with Greek taste. The base for Kyniskos's statue, on whose footprints (and reconstructed stance) the attribution rests, does not carry Polykleitos's signature, so that only Pausanias's mention warrants the connection; in addition Lorenz has pointed out that the attachment holes on the Olympia base could not fit the feet of the Westmacott Athlete and that the question of whether the original of that type was the Kyniskos cannot be answered.[34]

Some of the statue bases signed by a Polykleitos have been shown to belong to a younger sculptor of that name, even when Pausanias, who is otherwise aware of his activity at Olympia (6.6.2), does not make the distinction. In some cases, blocks appear to have been reemployed and reinscribed in later times.[35] Particularly intriguing is the case of the pedestal for Pythokles, which is generally attributed to Polykleitos the Younger: the upper surface preserves six large cuttings that cannot possibly belong to the same statue,

and three inscriptions of different dates, ranging from the late fifth to the first century B.C. The original statue seems to have faced toward the short end of the base; it was then removed and replaced with another facing toward one of the long sides. But the second set of footprints does not match the first, therefore the replacement cannot have been a close copy, yet Pausanias gives us no inkling that what he saw on the Altis was not Polykleitos's original. Finally, a statue base inscribed with Pythokles' name has been found in Rome, but the footprints on its surface seem to correspond to neither set at Olympia and to have belonged to a larger statue.[36]

Were the Romans responsible for making the substitution when they carried the original off to Italy? The theory is not impossible. The literary sources tell us that Zeuxis's painting, "The Family of Centaurs," was known through a copy in Athens, although the original had been taken by Sulla to Rome and may have sunk at sea.[37] Praxiteles' Eros at Thespiai was removed by Caligula, returned by Claudius, and retaken to Rome by Nero, but Pausanias could see at the site an Eros by Menodoros of Athens, copying Praxiteles' work (9.27.3). In both these cases, however, we do not know when the copies were made, nor at whose command; the Pythokles, being only an athletic "portrait" and obviously in no daring pose or of no special quality (to judge from Pausanias's silence), need not have prompted a replacement. At any rate, no speculation has yet explained the difference among the three sets of footprints.

Another sculptural find from the Altis has occasionally been thought to be a replacement copy for a looted original: the Hermes of Olympia (see plates 106 and 107).[38] The story of the Thespian Eros, attributed to the same master, could indicate a particular desire for retaining at least an echo of Praxiteles' works in Greece. Yet in this case the object being removed, *not* the statue standing within the temple, would have been copied, and certainly no other replicas of this same composition are known. Even this theory, however, is weakened if the Hermes can be shown to be an original—not by the famous sculptor but by a later artist. I shall discuss elsewhere what I consider to be its proper date and nature; suffice it here to state that other renderings of Hermes holding the baby Dionysos exist. Aside from the fragmentary group in the Athenian Agora, of which only the child sitting on a herm remains, a Hermes from Rhodes holds the baby in his lap,[39] and a type of standing Hermes with chlamys pinned on the right shoulder, partly covering the chest, has the child pressed against the body. This composition was apparently more popular than the one at Olympia, since it is known from several replicas, including a bronze statuette in the Louvre.[40] The original may well have been in metal, but the Roman

copyists seem to have had no difficulty in repeating the group in marble. It is therefore all the more remarkable that the more stable and easily supported group at Olympia should not have been copied. Finally, note that no other work by the fourth-century Praxiteles is attested within the Altis, either through Pausanias's account or the extant statue bases.

That a Roman copy of a Greek original could be accepted within the sanctuary is shown, for instance, by a body of the Dresden Zeus type, the original of which has recently been attributed to Agorakritos. It was therefore presumably acceptable to dedicate a work "quoting" or duplicating an original divine statue elsewhere. The most frequent type of duplication occurs however in the form of stock bodies for portraits: one of the Doryphoros (see plate 13), one of the so-called Hermes Richelieu type (see plate 21), two each of the two Herculanensis women—these last standing together within the Fountain of Regilla.[41] It seems obvious that Greek taste in Roman times was not disturbed by the presence of such replicas, even in close juxtaposition; indeed, Bol has argued that most female portraits within the Altis copied classical prototypes for their bodies.

Even Roman creations were copied. The Metroon, according to Pausanias, housed statues of Roman emperors, and seven have been found by the excavators. One of them, a Zeus-like rendering of Claudius, is signed by two Athenian sculptors, Hegias and Philathenaios, but repeats a statue from Lanuvium (plate 48), erected by the Senate and the people (according to the inscribed base) in 42/3, presumably after a bronze original in Rome.[42] One must assume that a suitable model was sent from Rome both to Lanuvium and to Olympia, to be copied. Yet the example in Greece may have been made considerably later than the one in Italy. Of the other imperial statues from the Metroon, those of the Julio-Claudians show them divinized, in "classical" style, while the Flavian portraits appear in contemporary costume; it has therefore recently been argued that the whole group of seven sculptures was set up, not at intervals, during the reign of the various families, but at once, in Flavian times. "Greek" style would therefore have served to emphasize the distinction between the living and the dead.[43]

This review of the four Panhellenic sanctuaries has failed to produce any evidence that the monuments within the sacred precincts were ever subjected to mechanical copying. Not only the sanctity of the places, but perhaps also the national (as opposed to regional) character of their priestly boards may have forbidden reproduction of the monuments for commercial purposes. It could be argued that none of the Panhellenic centers had a reputation for the making of sculpture and therefore neither facilities nor financial interest in such ventures. Yet undoubtedly marble was carved both at Delphi and at Olympia, not only for architectural but also for sculptural purposes, and Bol has suggested that the Olympia bronzes were cast in situ. The sculptors of Imperial times were from a variety of areas, including Athens and Aphrodisias,[44] but, like Pheidias before them, seem to have come to Olympia rather than to have shipped their work. Nothing, moreover, would have prevented carvers from elsewhere from traveling to the various centers to secure casts of the famous originals, to be then reproduced in their home workshops. The prohibition, although not recorded by the ancient sources, may have been purely of a religious nature; but equally strong is the probability that the Romans were not interested in athletic statuary per se, nor in individual dedications, and were equally unconcerned about famous masters. We should now consider the case of sanctuaries with more limited renown, some of them undoubtedly connected with the production of sculpture, to see if equally restrictive measures against copying were enforced.

Delphi: Sculptors mentioned by Pausanias, Book 10.8.4–10.32.1

Key: * = Sculptors named at Olympia
 † = Marcadé, *Signatures* I (1953) ca. 58 + 16 fragments of signatures
 ‡ = Sculptors named for more than one monument
 § = Sculptors known from other sources (or to whom attributions have been attempted)

Ageladas of Argos (early fifth century) *§
Alypos of Sikyon (late fifth century) *†
Amphion of Knossos (ca. 400?)
Amyklaios of Corinth (fifth century?)
Androsthenes of Athens (ca. 330)
Antiphanes of Argos (early fourth century) †‡
Aristogeiton (mid-fifth century) †
Athenodoros of Kleitor (late fifth century)
Chionis of Corinth (fifth century)
Daidalos of Sikyon (early fourth century) *†§
Dameas of Kleitor (late fifth century)
Diyllos of Corinth (fifth century)
(Glaukos of Chios—sixth century; iron stand) §
Hypatodoros (mid-fifth century) †
Kalamis (fifth century) *†‡
Kalynthos (early fifth century?)
Kanachos (late fifth century) *
Onatas of Aigina (early fifth century) *§
Patrokles (late fifth century) (*)§
Pausanias of Apollonia (mid-fourth century) †
Pheidias (fifth century) *§
Piso of Poros (late fifth century)
Praxias (second half fourth century)
Praxiteles (mid-fourth century) *§
Samolas from Arkadia (early fourth century) †
Theokosmos of Megara (late fifth century[?])
Theopropos of Aigina (early fifth century) †
Tisagoras (iron worker—not known to Pausanias)
Tisander (late fifth century)

Olympia: Sculptors mentioned by Pausanias, Books 5.7.1–5.27.12; 6.1.1–6.21.3

Key: * = Sculptors named at Delphi
 † = Attested by inscription at Olympia
 ‡ = Sculptors named for more than one monument
 § = Sculptors known from other sources (or to whom attributions have been attempted)

Ageladas of Argos (late sixth–early fifth century) *†‡§
Akestor
Alkamenes (ca. 430) §
Alypos of Sikyon (fourth century) *‡
Anaxagoras of Aigina (early fifth century)
Andreas of Argos (early second century) †
Apelle(a)s (fourth century) †
Aristokles of Kydonia
Aristokles son of Kleoitas (Sikyon; fourth century)
Ariston of Lakonia
Aristonos of Aigina
Askaros of Thebes (early fifth century?)
Asterion son of Aischylos
Boethos of Chalkedon (Hellenistic)
Chrysothemis of Argos
Daidalos of Sikyon (ca. 399) *†‡§
Daippos (ca. 300) ‡
Daitondas of Sikyon (ca. 320)
Dameas of Kroton (sixth century?)
Damokritos of Sikyon (first half fourth century)
Diomysikles of Miletos (Hellenistic)
Dionysios of Argos (severe?)
Dontas of Lakonia (archaic)
Dorykleidas of Lakonia (sixth century?)
Eutelidas of Argos
Eutychides of Sikyon (ca. 300) §
Glaukias of Aigina (early fifth century) †‡
Glaukos of Argos (severe?)
Hegylos of Lakonia (mid-sixth century; wood)
Hippias (fourth–third century?)
Kalamis (fifth century) *‡§
Kallikles of Megara (fifth century) ‡
Kalliteles (of Aigina?)
Kallon of Elis (late fifth century)
Kanachos of Sikyon (late sixth century) *
Kantharos of Sikyon (early third century) ‡
Kleoitas (fifth century; starting gates)
Kleon of Sikyon (fourth century) †‡
Kolotes of Herakleia (fifth century) §
Kratinos of Sparta
Leochares (fourth century–338) §
Lykios son of Myron (fifth century) §
Lysippos of Sikyon (fourth century) ‡§
Lysos of Macedonia (Hellenistic)
Medon of Lakonia (sixth century?)

Mikon of Athens (also painter, fifth century) †
Mikon of Syracuse (ca. 200)
Mousos
Myron of Athens (ca. 384?) ‡
Naukydes (early fourth century) †‡§
Nikodamos of Lepreos
Nikodamos of Mainalos (fifth–early fourth century) †‡
Olympos
Onaithos (and sons)
Onatas of Aigina (fifth century) *‡§
Paionios of Mende (ca. 425) †‡
Pantias of Chios (early fourth century) ‡
Patrokles of Kroton (*)
Pheidias of Athens (ca. 432) *(†)‡
Philesios of Eretria (early fifth century?) †
Philotimos of Aigina (mid-fourth century)
Phradmon of Argos (fourth century?) §
Polykleitos of Argos (fifth century) †‡
Polykleitos the Younger of Argos †‡
Polykles of Athens (ca. 156)
Polykles' sons
Praxiteles (fourth century?) *
Psylakos (and sons)
Ptolichos of Aigina (early fifth century) ‡
Pyrilampes of Messene (ca. 300) †‡
Pythagoras of Rhegion (severe) †‡
Serambos of Aigina
Silanion of Athens (ca. 328) ‡§
Simon of Aigina
Smilis of Aigina
Somis (late archaic?)
Sthennis of Olynthos (fourth century?) ‡
Stomios (late archaic?)
Telestas of Lakonia
Theokles of Lakonia (wood; mid-sixth century?) ‡
Theomnestos of Sardis (third century?)
Theron of Boiotia (ca. 200)

The Epidamnian Treasury was made by Pyrrhos and his sons
Lakrates and Hermon.

Notes

1. On the Riace Warriors, see preceding chapter, with bibliography in nn. 20–22. For Stephanos Athlete, also to be discussed infra, see Zanker, *Klassizistische Statuen*, pp. 49–54 and pl. 42.

2. The attempt to correlate the statues to the Delphic base has been made by S. Stucchi, as reported by L. Barbera, *L'Avventura dei Bronzi di Riace* (Messina, 1981), pp. 68–69. This same popular booklet mentions also the different dates suggested by P. E. Arias and E. Paribeni (chap. 3, p. 66), and summarizes in general most newspaper accounts up to its publication date.

3. F. Eckstein, *Anathemata: Studien zu den weihgeschenken strengen Stils im Heiligtum von Olympia (*Berlin, 1969), p.112, n. 31.

Bol, *Olympia*, p. vi; he states that he has excluded from his investigation Roman copies of Greek bronzes not only because of his belief that statues at Olympia "offenbar so gut wie nie kopiert wurde," but also because of the difficulty to prove connections with types known only through copies, without falling into circular arguments.

Kron, *Phylenheroen*, pp. 222–23; she has now repeated her conviction in "Eine Pandion-Statue in Rom—mit einer Exkursus zu Inschriften auf Plinthen," *JdI* 92 (1977): 139–68, esp. pp. 163–64 and n. 102, where additional supporters of her theory are listed.

Contra, see *Munich Catalogue*, p. 4 and n. 16; cf. also W. Fuchs, *Boreas* 4 (1981): 25–28, esp. n. 18, who believes that the discovery of the Riace Warriors will now allow recognition of copies of the Eponymous Heroes, either from the Delphic monument or from that in the Athenian Agora. But cf. A. Linfert's review of the *Munich Catalogue, BonnJbb* 181 (1981): 610–16, esp. pp. 611–12 (no. 1).

4. This approximate figure is based on my own reading of Pausanias's text, as well as on some information gleaned from Daux.

5. On the Alexander Sarcophagus in Istanbul see V. von Graeve, *Der Alexander-sarkophag und seine Werkstatt* (Berlin, 1970); on the connection between the sarcophagus and other monuments see, e.g., M. Robertson, *JHS* 85 (1965): 80–81. For the location of the Krateros Monument at Delphi see *FdD* 2. la (1927): 237–40, figs. 187–91.

For the Azara Herm, from Tivoli, see Richter, *Portraits* 3, figs. 1734–35. On the portrait from the Athenian Akropolis see infra, chapter 5.

6. Since Pausanias (10.14.4) mentions Praxiteles as the maker of a portrait of Phryne, he must mean the fourth-century master. Marcadé, *Signatures* 1, s.v., lists however only a signature of a mid-third century Praxiteles from Delphi. Praxiteles as portraitist will be discussed in connection with the Athenian Agora, in chapter 6.

7. "Illustrators" of ancient sources had once suggested that the diver Hydne was depicted in the so-called Esquiline Venus, a marble copy of the bronze stolen by Nero. The stylistic assessment of the Venus has now established it as a classicizing (severizing) work: see, e.g., Helbig[4], no. 1484 (K. Parlasca).

8. Pape, "Kriegsbeute," p. 203. The rest of the ancient sources are highly biased.

9. Marcadé, *Signatures* 1, discusses ca. fifty-eight inscribed sculptors' names and sixteen fragments of signatures.

10. For Lysippos's statue of Pelopidas see Marcadé, *Signatures* 1, s.v. Lysippos I; the monument is dated either 369 or 363 B.C.

That no statue by Polykleitos or Myron is mentioned by Pausanias could be explained by the periegetes' deliberate omission of victors' monuments. But the same picture is presented by the extant statue bases. The earthquake of 373 B.C., although responsible for some destruction, could have preserved as well as eliminated some of the evidence, witness the case of the Delphi charioteer. In addition, works by contemporaries of Polykleitos could still be seen by Pausanias. His relative disinterest in art historical matters is underscored by his indifferent mention of all sculptors' names, without differentiation between the more and the less "famous."

11. It is now accepted that the monument was not ruined by the earthquake of 373 B.C. and that it postdates it. For attribution of the Akanthos Column to Chairestratos see J. Frel, *GettyMusJ* 6/7 (1978–79): 75–82, with bibliography on p. 82, no. 3, and *addendum, GettyMusJ* 8 (1980): 206. Delphi has also yielded a statuette of Apollo Kitharoidos signed by the Rhamnousian sculptor, supra, p. 8 and n. 27, chap. 1.

12. Philosopher in Delphi: best illustration in Lullies and Hirmer, *Greek Sculpture*, fig. 245. For the most recent discussion see G. Waywell, *The Free-standing Sculptures of the Mausoleum at Halicarnassos in the British Museum* (London, 1978), p. 69. The statue is dated generally to the third century B.C.

13. The best illustrations of the various figures within the monument are in T. Dohrn, "Die Marmorstandbilder des Daochos-Weihgeschenks in Delphi," *AntP* 8 (1968): 33–52; for a recent discussion see P. Themelis, "Contribution a l'étude de l'ex-voto delphique de Daochos," *BCH* 103 (1979): 507–20. On the Agias as a typical Thessalian statue see H. Biesantz, *Die thessalischen Grabreliefs* (Mainz, 1965), esp. pp. 104–5.

14. Delphi Antinoos: Ch. Clairmont, *Die Bildnisse des Antinoos* (Rome, 1966), no. 1 and pp. 21–24. The occasion for the Delphic statue would have been Hadrian's third visit to Greece in 131/2. The Antinoos in Delphi is one of eight examples found in Greece.

15. On the Plataian Tripod and the remains in Istanbul see, e.g., Ridgway, *AJA* 81 (1977): 374–79, with bibliography. On the reconstruction of the Delphic pediments see F. Croissant, "Les frontons du temple du 4. siécle à Delphes. Premiers essais de restitution," *RA* 1980, pp. 172–79.

16. Pausanias writes about statues of Poseidon, Amphitrite, and Thalassa "in the pronaos," but mentions Herodes Atticus in connection with "statues in the interior." O. Broneer has suggested that this elaborate chryselephantine group must be the cult group by the time of Pausanias's visit, A.D. 160: *Isthmia* 1, *The Temple of Poseidon* (Princeton, 1971), pp. 88–90, 102; he had already advanced this idea in *Charisterion eis A. K. Orlandos* 3 (Athens, 1964): 78–79; see also Broneer's plate 20a for the marble female torso from the opisthodomos. In both publications Broneer discusses also the base and its possible ornament.

If the group donated by Herodes Atticus was indeed the cult image, its description and inclusion by Pausanias would be more understandable, since the periegetes elsewhere mentions similar replacement statues, also given by Herodes (see infra, p. 40). Pollitt, *Art of Rome,* p. 183, n. 184, states however that Pausanias's description at Nemea does not make clear what exactly was dedicated by Herodes.

Prof. Mary Sturgeon, to whom I am indebted for these references, is preparing the final publication of the sculptures excavated by O. Broneer at Isthmia.

17. On the Niobid frieze at Olympia, see infra, p. 41. Prof. Sturgeon kindly tells me that the Hermes might not go with the Killing

of the Niobid scenes, as originally thought, but with another theme which was once part of the same decoration. Her preliminary study suggests that such reliefs are too large for the decoration of the armrests of a throne (for the colossal female torso?) and may belong to different sides of a large base. For the recovered relief fragments see *Hesperia* 22 (1953): 191, pl. 58f; *Hesperia* 24 (1955): 129–31, pl. 50a–b; *AJA* 72 (1968): 269, pl. 91.17.

18. On the Archemoros sarcophagus now in Corinth see, most recently, E. Simon, *AA* 1979, pp. 38–43, figs. 7–9, dated before 160.

19. These figures are partly based on my own calculations from Pausanias's text, and partly on the figures given by E. N. Gardiner, *Olympia: Its History and Remains* (Oxford, 1925), p. 193, who utilizes the same source.

20. Bol, *Olympia,* p. 57. For the signature of Andreas see W. Dittenberger and K. Purgold, *Die Inschriften von Olympia,* vol. 5 in *Olympia,* ed. E. Curtius and F. Adler (Berlin, 1896), no. 657.

21. No work specifically on Pausanias at Olympia exists. The following comments are my own. Lists of sculptors active at the various sanctuaries can however be found in the *Encyclopedia of World Art,* under various entries and by periods of art.

22. On the School of Polykleitos see Arnold, *Polykletnachfolge;* also A. Linfert, "Von Polyklet zu Lysipp" (diss. Freiburg; Giessen, 1966).

23. On the Nike of Paionios see pp. 41–42. For recent discussion and bibliography, see, e.g., Ridgway, *Fifth Century Styles,* pp. 108–11.

24. Cf. the comments and statistics about statues of Zeus at Olympia in R. Wünsche, *JdI* 94 (1979): 107–11, esp. p. 109, and his conclusions about our attempt to attribute and identify the works of the masters mentioned in Pliny or other ancient sources.

25. Eckstein, *Anathemata* (supra, n. 3), discusses extensively the archaeological evidence for the monuments set up by the Achaians and by Mikythos, pp. 27–32 and 33–42. He suggests that the latter dedication held approximately twenty to twenty-two figures: cf. p. 115, n. 37 for possible identification in Roman copies, under-life-size. Eckstein's position seems to be against the possibility of copying at Olympia.

26. Prof. Margaret C. Root has pointed out to me that if victorious athletes always set up their own images in duplicate—one at the Panhellenic sanctuary where the victory was won and one in their own hometown—there is no way of knowing whether the statue that was copied was the one in the major center or the one at home. To be sure this is a question which we cannot answer at the present state of our knowledge. It seems, however, that the Romans had little interest in reproducing victors' statues per se.

27. Note in particular the case of Sulla, who needed money to finance his campaigns. He took gold and silver from Olympia, Delphi, and Epidauros (Asklepieion), which he then had minted into coinage, but he made at least partial restitution by giving the sanctuaries half the territory of Thebes, which had sided against Rome. See Pape, "Kriegsbeute," pp. 21–22.

28. For the statement see Gulaki, "Nikedarstellungen," p. 134; for the Berlin Nikai and related figures see her Group 5, pp. 218–36. Cf. also *Fifth Century Styles,* p. 185.

29. F. Eichler, "Thebanische Sphinx," *ÖJh* 30 (1936–37): 75–110, and reconstruction : Eichler, *ÖJh* 40 (1960): 5–22. See also Mander-

scheid (supra, chap. 2, n. 60), p. 88, nos. 169–70, dated early second century A.C. On the reconstruction of the Throne of Zeus in general see J. Fink, *Der Thron des Zeus in Olympia* (Munich, 1967).

30. K. Stähler, *Boreas* 1 (1978): 68–86, pls. 11–13; cf. Ridgway, *Severe Style,* p. 73, no. 9. For the classicizing date see Gulaki, "Nikedarstellungen," pp. 162–76, with discussion of the kneeling pose. The very idea of figures kneeling at the feet of a throne seems Oriental and almost implies an element of submission, although Nikai at the feet of Zeus may have symbolized the victorious power of the god. For a remote echo of this composition, see the kneeling personifications of the *Iliad* and the *Odyssey* on either side of an enthroned Homer in the relief by Archelaos of Priene: D. Pinkwart, *AntP* 4 (1965): 35–65, pls. 28–35.

31. For the Isthmia Niobid frieze see supra, n. 17. The latest discussion of the reliefs in connection with Olympia is by Ch. Vogelpohl, "Die Niobiden von Thron des Zeus in Olympia. Zur Arbeitsweise römischer Kopisten," *JdI* 95 (1980): 197–226; for the allusion to the vase see p. 198, n. 4. If the Niobids were ivory inlays into the ebony of the throne, it is unlikely that molding or pointing would have been allowed, especially since access to the statue was limited by "barriers." The classical vase has just been published by B. Shefton in *The Eye of Greece* (infra, n. 32), pp. 149–81.
 Possibly the same pattern books that were used for the Neo-Attic reliefs provided the inspiration for the Niobids in the round of the late Hellenistic period—cf. supra, chapter 2, n. 76.

32. On the Nike of Paionios, see supra, n. 23. Hölscher, "Die Nike," p. 76, n. 17. For the herm from the Athenian Agora see *Hesperia* 40 (1971): 273 and pl. 58.1. The theory that the Roman heads reproduce the Nike of the Athena Parthenos is by E. B. Harrison in *The Eye of Greece, Studies in the Art of Athens* (in honor of Martin Robertson) (Cambridge, 1982) 53–88; also *Cincinnati Symposium* (Leiden, 1984).

33. Both identifications have been most recently discussed by J. Dörig, *Onatas of Aegina* (Leiden, 1977). On the "Agamemnon" see also chapter 5, p. 55, in connection with the Anakreon on the Akropolis.

34. On Roman taste for adolescent figures see Zanker, *Klassizistische Statuen,* passim (e.g., p. 41 and n. 308); Trillmich, "Bemerkungen." On the Kyniskos and its base see T. Lorenz, *Polyklet* (Wiesbaden, 1972), p. 40 and n. 185. Fragments of the Westmacott Athlete type may have been found among the Baiae casts: *Abgüsse* pp. 41–42, and 52, nos. 94–96. Note, however, how smaller the casts are when inserted into a replica of the marble figure (*Abgüsse,* figs. 52–53). Given the rather "neutral" nature of the fragments (portions of buttocks and thighs from a naked male image) and the apparent discrepancy in proportion with the marble "copies," I should like to suspend judgment on this point, especially since I am uncertain about the chronological range of the bronzes represented among the Baiae casts: cf. supra, chapter 3, n. 7.
 For a hair fragment that could belong to a bronze original by Polykleitos see Bol, *Olympia,* pp. 35–37, no. 144, pl. 27, fig. 5.

35. Note that some inscriptions may have been renewed as early as the fourth century B.C., yet Roman looting cannot account for the change. Cf., e.g., the base for Xenokles, a monument attributed to Polykleitos the Younger, Lorenz, *Polyklet,* p. 45 and n. 200. The statue bases connected with Polykleitos and his school are discussed by Arnold, *Polykletnachfolge.*

36. The best discussion of Pythokles' base is Arnold, *Polykletnachfolge,* pp. 23–24 and fig. 38. Not all authors agree in assigning the Pythokles to the Younger Polykleitos: cf. Lorenz, *Polyklet,* pp. 45–

46, who states that the Olympia footprints could correspond to the Diadoumenos, but also to the Ares Borghese, and that since Polykleitos repeated his stances, it is impossible to make a definite identification. For the inscriptions see *Olympia* 5 (supra, n. 20), nos. 162–63; P. Arias, *Policleto* (s.l., 1964), no. 52. For the base in Rome: E. Petersen, "Funde," *RömMitt* 6 (1891): 304–6, no. 4; also *NSc* (= *MemLinc* 9) 1891, pp. 285–86. In order to reconcile the Roman with the Olympic evidence, Petersen assumes that also the base in Rome was used twice, and that the original base would have consisted of two blocks, the upper one with the "correct" footprints not having been found. Not only are the footprints preserved on the extant block suitable for a larger statue, but the left foot is shown as being forward, rather than the right as at Olympia.

Note that Pythokles won his victory in 452 B.C.; if his statue was erected ca. 400, it could have been after his death. It has often been noted that many athletic "portraits" were set up long after the victory was won; perhaps three successes were necessary before permission was granted to dedicate one's own portrait (at least in classical times). Perhaps, however, at least in the fifth century B.C., the athlete's death had to precede the erection of the victory monument, to prevent hubris. If this were indeed the case, it may explain the gap in time between event and monument, and stress the religious character of athletic dedications.

37. Lucian, *Zeuxis or Antiochos*, 3; Pollitt, *Art of Greece*, pp. 156–57. Lucian seems to imply that the painting was said to be in Rome; that it was lost at sea in a shipwreck is his personal opinion.

38. The Hermes of Olympia is too well known to need extensive references. For a summary statement of our present knowledge see the fair assessment by Robertson, *Shorter History*, p. 139. See infra, pp. 85–86 for further comments on the statue.

39. Agora group: Harrison, *Agora 11*, pp. 162–65, no. 210, pl. 56 (*after* the Hermes of Olympia, not a copy of Kephisodotos's group);

for a possible parallel from Sardis see N. H. Ramage, *HSCP* 78 (1974): 253–56, and G. M. A. Hanfmann and N. H. Ramage, *Sculpture from Sardis* (Cambridge, Mass., 1978), p. 107, no. 110, fig. 236. Rhodian Hermes: G. Gualandi, *ASAtene* 54, n.s. 38 (1976, publ. 1979), pp. 141–42, no. 110, fig. 147. Cf. also Marcadé, *Au Musée*, pl. 23 A142, for a Delian composition of a Papposilenos/Actor Dionysophoros with herm support.

40. For a discussion of this type, which he considers the bronze prototype for the Hermes of Olympia, see R. Carpenter, *AJA* 73 (1969): 465–68; marble versions of this type also exist in the Bardo Museum in Tunis and in the Bergama Museum in Turkey. For discussion of figures holding infants see E. Künzl, *Fruhhellenistische Gruppen* (Cologne, 1968), pp. 16–26; also comments in Trillmich, "Jünglingsstatue." For an unusual rendering: Hermes supporting the child on his propped-up right leg, see R. Bianchi Bandinelli, ed., *The Buried City: Excavations at Leptis Magna* (New York/Washington, 1966), fig. 155.

41. For all the sculptures from Olympia see, e.g., G. Treu, in Curtius and Adler, eds. *Olympia* 3.

42. For the marble statue from Lanuvium in the Vatican see Helbig[4] no. 45.

43. This theory is by S. Stone; see the summary of a paper on this subject delivered by him at the AIA Annual Meeting in San Francisco, December, 1981: *AJA* 86 (1982): 287.

For the possibility that the pedimental sculptures of the Temple of Zeus were copied in Roman times, see chapter 5.

44. A Kornelius Aphrodisieus worked at Herodes' Fountain: *Olympia* 5, no. 643. Hegias and Philathenaios, who made Claudius's statue, were Athenians.

5 Other Greek Sanctuaries

In order to assess the proper position of the four Pan-hellenic sanctuaries, we should now review what is known about the monuments in other Greek religious centers of repute.

Delos

This important sanctuary of Apollo was connected with a thriving commercial harbor and a prosperous town throughout the Hellenistic period. The site lost most of its prominence after its two major destructions, in 88 and 69 B.C., but life on the island seems to have continued without interruption, albeit on a reduced scale, until at least the fourth century A.C.[1] In addition, so many Roman traders frequented Delos during the second and first centuries B.C. that commissions for the duplication of important monuments could easily have come in. Although we lack Pausanias's account for the site, excavational evidence has been abundant, yet no clear proof exists that local statues were copied.

The total sculptural picture is indeed peculiar. The sanctuary was most prominent during the archaic period, when offerings of considerable size and importance were set up. Many marble dedications are preserved from the sixth century, and a few severe pieces also remain, but virtually no fifth- or fourth-century originals. Nothing significant seems to have taken place after the transfer of the Delian treasure from the island to Athens in 454, despite the impressive temple erected by the Athenians around 425, with its complex akroterial groups.[2] Sculptors' signatures listed by Marcadé number two or three for the sixth century although literary sources abound. But only one signature (on an altar) is from the end of the fifth, two date from the fourth (one of by [Praxi]teles?), and none of the major classical sculptors is mentioned as having worked on Delos.[3] By contrast, over fifty names belong to the Hellenistic period, and several sculptors produced more than one monument. Among the signatures we have a Lysippos son of Lysippos (ca. 100 B.C.), a Myron of the second century, a Eutychides who produced several statues at the turn into the first century B.C., and a Boethos of Chalkedon active in the second half of the second century. Stewart has tabulated the many Athenian masters active in Hellenistic Delos, and the presence of mainland statuary types,

mostly in statuette format or in adaptations, can perhaps be attributed to their influence; there is a variant of the Eirene (see plate 76) without the Ploutos, for instance, and one of the Athena Medici, as well as two unfinished figurines of the Herakles Farnese type (see plate 99), which attest to the manufacture of the sculpture on the island.[4] The only full-size copy of an ideal, fifth-century masterpiece is the famous Diadoumenos (see plate 18), which Marcadé assumes to be a local product but which could also have been imported from Athens.[5] Other replicas served as stock bodies for the many honorary statues erected by the Romans and others in the island, such as the Polykleitan figures of the pseudoathlete and the Gaius Ofellius made by the Athenian Dionysos and Timarchides around 100 B.C. Other statues, like Kleopatra (plate 49) and her husband Dioskourides (ca. 138/7 B.C.) may have been derived from Asia Minor prototypes, and similar provenience can be suggested for the adaptations of the Crouching Aphrodite, the Knidia, the Aphrodite tying her sandal (of which several exist), and the two "Philiskos" Muses. The so-called Slipper-slapper monument, set up by a Syrian merchant (Dionysios of Berytos) around 100 B.C., combines a Hellenistic type of Aphrodite with a Pan and an Eros not known from other sources.[6]

Of particular importance is the fact that several sculptors active for the Attalids of Pergamon are attested through their signatures in Delos. Nikeratos and Phyromachos worked on Galatian monuments set up in the island, yet no attempt has so far been made to identify possible copies of these works. More remarkable is the fact that the long-haired head of a Galatian extant from Delos, and the fighting Gaul (plate 50) probably by Agasias son of Menophilos, made for Marius after his victory over the Cimbri and Teutones in 101 B.C., bear no resemblance to the so-called Pergamene dedications and seem quite independent from that tradition, nor can they be found in other replicas.[7] Yet if the Romans were interested in the Attalids and their deeds, or were impressed by representations of the Gauls, those in Delos—made by the same artists—could have been copied as easily, if not more, than those in Asia Minor.

In summary, although most of the Delian treasures may have been looted in the first-century destructions,[8] nothing in present evidence allows us to believe that such monuments were copied, despite strong sculptural activity on the island itself, and the well-documented presence of a numerous Roman population.[9]

Samothrace, Thasos, Samos

A similar picture is conjured up by other sanctuaries well patronized by the Romans, such as that of the Great Gods at Samothrace. Of the statues which must have adorned the site in classical and Hellenistic times nothing is known, and even the Skopasian Pothos, which some scholars recognize in Roman copies, is supposed to be the one made for Megara rather than the one for Samothrace. I still have difficulties in reconciling the androgynous figure of the Roman replicas with an attribution to the fourth-century master.[10]

As for the other famous monument connected with the island, the Nike of Samothrace, the original has indeed been found in situ, but no replicas of it are known, not even the statue from Cyrene which was similarly posed on the prow of a ship within the Agora. This North African naval monument has been recently studied and redated to the mid-third century B.C. It would therefore be a precursor, rather than an adaptation, of the Samothracian composition. In either case, however, the differences between the two female figures are such that they cannot be related beyond the obvious use of the ship's prow, which recurs in other monuments.[11]

Although a thorough study cannot be made until a final publication has appeared, this same dearth of copies (and of copied monuments) seems to exist on Thasos and Samos.[12] Much more ambiguous is instead the evidence from Athens, to which we should now turn.

Athens, Akropolis

Because of the prominent place of Athens in cultural history, and because of the many copyists' workshops which undoubtedly existed in the city in the Late Hellenistic and Roman periods, it would be logical to assume that most monuments on the Akropolis were copied for the Roman clientele. The venture would have been economically profitable, and the local priesthood might have given permission for duplication in view of the financial benefits that would have accrued to the city and perhaps also the sanctuary. I believe, however, that this was not the case, that what was copied was merely sketched, rather than molded or measured off, and that the direct copying for which we have some evidence involved at the most architectural sculpture (not freestanding dedications) at times of damage and repairs to the structures. Although considerations of location (for ease in reproduction) may have influenced the choice of what could and should be copied, I suspect that these were secondary compared to religious restrictions by the Athenians and antiquarian interest in the subject matter on the part of the Roman commissioners.

Of the over sixty monuments mentioned by Pausanias in his account of the Akropolis, only one freestanding dedication has been found, and it too has been challenged: the Prokne and Itys set up by Alkamenes.[13] Beside the issue of whether or not the head

at present associated with the statue is pertinent, some scholars have advanced the doubt that the monument is a marble copy from a lost bronze original. I am confident that the tragic figure of the mother considering the murder of her child is indeed the work by Alkamenes, who probably carved his own dedication. But these problems are irrelevant to our specific viewpoint; it is important rather to determine whether the single piece—from Pergamon—to have been considered a replica of the Prokne can qualify as a bona fide copy. Because of the absence of the child, this statue could at best be labeled only an adaptation; in addition a recent study has pointed out the truly Hellenistic character of this peplophoros and of several others found at Pergamon and elsewhere. No copies of the Roman period are known. We can then turn to works whose prototypes are lost but which can be confidently identified in extant replicas.

That the Athena Parthenos by Pheidias was "copied" has already been mentioned, but nothing so far known is a true mechanical reproduction. Statues and statuettes at different scales convey the basic appearance of the figure, but simplify considerably and stress only those elements of importance to the purpose of each new monument. Even the Varvakeion statuette (see plate 1), which appears as a faithful reduction of the original, eliminates the elaborate reliefs of shield, sandals, and base, some decoration on the helmet, and the jewelry adorning the goddess, as well as the possible metal ornaments of the column capital under Athena's hand. Given the precious materials of which the statue was made, it is unlikely that close copying with molds or pointing was ever permitted, and size alone would have made the operation impractical.[14]

Individual details of the monument have a different history. Although the Birth of Pandora and the Centauromachy on the sandals have been tentatively identified in Neo-Attic reliefs, these are strongly abridged and isolated versions for which no certainty can exist. Complete assurance exists however for the many reproductions of the Amazonomachy (plate 51) on the exterior of the Parthenos's shield, among which the most impressive are the sarcophagus reliefs recently found at Aphrodisias.[15] The large scale of the figures implies a one-to-one correspondence, but the adaptation to the different fields—the flat and rectangular chest as contrasted with the round and convex surface of the original—demanded modifications in poses and placements of figures, and perhaps also the virtual elimination of the background elements which formed part of the total composition. Given the distance between Athens and Aphrodisias and the active sculptural schools of the Karian city, which did not need to import Neo-Attic carvings, the transmission of motifs may once again have occurred through pattern books and sketches, perhaps secured by those Aphrodisian

masters who are known to have worked on the Greek mainland.

It is also significant that most reproductions of the Shield Amazonomachy seem to date from the Antonine period, at a time when repairs were made to the Parthenon itself. The temporary closing of the temple to the cult may have increased the possibilities of artists seeking to copy or sketch parts of the Pheidian monument; it is nonetheless peculiar that no sculptural reproduction of the Gigantomachy in the interior of the shield has yet been identified. Either the style and rendering of this second composition were too pictorial to be readily reproduced in relief format, or visibility was limited and no major removal of the shield from its pedestal was involved. We should however note that the Battle against the Amazons returned to popularity during Roman times, so as to form the subject of several Battle Sarcophagi; while the Gigantomachy remained of much more limited interest as a form of decoration, and its theme seems restricted by its symbolism.[16]

If relief figures could be "copied" through sketches, to what extent was this method viable to reproduce sculpture in the round with any accuracy? The question is pertinent not so much to the issue of the Parthenos herself, whose scale was seldom, if ever, repeated in antiquity, but to that of the life-size Nike held on Athena's hand. Aside from the vague approximation standing on the hand of the Varvakeion statuette, no other replica has been convincingly identified, and —as for the Olympian Zeus—Gulaki has recently reclassified as classicizing the few candidates in our museums.[17] Her contention is based not only on stylistic analysis, but also on the consideration that classical Nikai were largely used as attributes, and that Victory did not receive a cult of her own until Roman times; no Greek cult image therefore existed to prompt Roman copying. This theory would be at least partially undermined by Harrison's suggestion that the three herms usually considered copies of Paionios's Nike reproduce instead the Pheidian statue connected with the Parthenos.[18]

That Paionios's Nike (see plates 45–47) could not be copied in Antonine times has already been accepted, and that Paionios "quoted" from the Athenian monument seems a definite possibility. In favor of Harrison's theory militate the "early" style of the herms and the relative rarity of female ideal types in such form. It is nonetheless surprising that no hint stronger than a narrow drapery neckline should be given, in the Roman replicas, that the original was a Nike—that original which, high on the hand of the Parthenos and at a relatively small scale, could not have been so clearly visible to the viewer as to prompt immediate identification in an abridged version and in a different medium. In addition, Harrison's drawing of

the forehead section taken from the Agora herm implies very close copying, yet the ivory face of the original may have prevented accurate measuring or the taking of casts. Finally, the lofty position of the Nike would almost demand that the total monument be dismantled for sculptors to have access to the figure without complex scaffolding; this last occurrence cannot however be excluded.

Be that as it may, the circumstances hypothesized for such copying seem to require direct control by the priesthood and the closing of the temple, such as would be possible only when repairs to the structures were carried out. It is on that occasion, of course, that the copying of the pedimental figures took place, not only for the reduced sculptures that occupied the corners of the Eleusis pediment, but also for the tritons (plate 52) and giants on the facade of the so-called Odeion of Agrippa in the Athenian Agora.[19] In the latter, only the torso was employed, taken from the Poseidon of the west Parthenon pediment and completed with appropriate appendices: snaky legs for the giants, seaweed girdle and fish tails for the tritons. That no other direct copies of the Parthenon decorations are known may imply either a lack of interest in architectural sculpture or a lack of opportunity. Indeed, the only echoes and adaptations of the Parthenon frieze known to us are of Greek date; the processional frieze of the Ara Pacis can only claim remote inspiration.

A second architectural monument duplicated in Roman times is the karyatid porch of the Erechtheion (plate 53). E. E. Schmidt's compilation of all extant copies could not include what are to date the closest to the Athenian originals: two examples from Corinth, one preserved only as fragments of a head, but the other an almost complete replica of the sixth kore on the porch. Their date is still uncertain; the excavators tend to place them in the Neronian or early Flavian period; but I would prefer an Antonine date in view of the repair work carried out on the Akropolis at that time.[20]

All other extant copies are not exact: those from the Forum Augusti are too fragmentary to be sure, those from Hadrian's villa seem somewhat larger than the originals, and in at least one case the copyist has betrayed his lack of accuracy in giving an anachronistic form of sandal to a fifth-century figure. In the Severan period differences are more pronounced and we can no longer speak of true copies. In all cases, the new context given to the karyatids stresses their function as learned quotations and implies a specific geographical allusion, so that they are not seen as Greek works in Roman versions but as Roman works with specific new meaning.

Other architectural sculptures from the Akropolis do not seem to have been copied, although some figures

from the Nike Balustrade (plate 54) were adapted to new compositions in Neo-Attic reliefs (plates 55 and 56)[21]. To be sure, the lofty position of the slabs, atop the bastion, would have made actual copying impossible without elaborate scaffolding, but not even the more accessible sections (e.g., above the lateral stairway) were duplicated exactly. Interest seems to have centered on individual figures—for instance the so-called Sandalbinder (see plate 54), which was in itself a citation from an earlier image on the Nike Temple frieze (east side, figure 2). Other Nikai were represented in reverse, or adapted to Roman taste, and once again only sketches need have been employed.

Neo-Attic reliefs are our single source of information also for the so-called Sokrates' Graces (plate 57), a representation of the three Charites that Pausanias mentions during his passage through the Propylaia, at the beginning of his visit to the Akropolis. The Neo-Attic versions are so full of stylistic peculiarities that we may reasonably assume transformations. The original monument was probably in the round, and a pictorial intermediary, such as a drawing, should therefore be postulated between the three-dimensional group and the Roman rendering.[22]

This meager group largely composed of variants and adaptations represents all works for which the original can be identified with certainty on the Akropolis. We come now to the sculptures cited by Pausanias which have been tentatively recognized in Roman copies.

Approximately twenty, from over sixty monuments, qualify, and for some the grounds for identification are so tenuous that no more than one attempt has been made to champion it. Among the latter, for instance, I would include the Theseus and the Minotaur, or the Theseus and the rock, advocated by Hafner on the basis of Campana plaques and with the aid of the so-called Conservatori Charioteer (plate 58) now generally considered a severizing work.[23] Similarly implausible is the identification of Lysimache in the head of an old woman (plate 59) in the British Museum. Not only does the London head possess all the stylistic traits of a classicizing piece, but Lysimache is said by Pausanias to have been portrayed in statuette format, while the head in England is about life-size. Given the fifth-century date and the rather obscure subject of the Lysimache dedication, it is unlikely that the Romans not only copied it but also enlarged it.[24]

Size, of both main statue and its attribute, may be a factor also for the identification of the runner Epicharinos, whose base has survived on the Akropolis. Although the signatures of both Kritios and Nesiotes are preserved, E. Minakaran-Hiesgen attributes just to the former sculptor the prototype of the helmeted warrior from the Canopus of Villa Hadriana at Tivoli; the Hermes from the same location, which forms such

a close counterpart to the warrior, she would consider a copy of a hitherto unknown work by the same master. In order to connect the Tivoli warrior with the Akropolis base, the German scholar must however assume that most of the pedestal was occupied by a large shield, which the copyist changed into a much smaller, Roman type. Even if this were the case, Epicharinos's pose, as reconstructed by Raubitscheck on the basis of the imprints on the pedestal, does not correspond to that of the presumed copy. Whether the front or the side of the block is taken to be the main face, the statue stood with one foot forward; yet the Tivoli warrior trails one leg. It seems therefore best to accept Zanker's theory, that both the Hermes and the warrior (Mars?) are classicizing creations inspired by early fifth-century style.[25]

A classicizing origin has recently been convincingly argued also for the beautiful Palagi head in Bologna, which formed the basis for Furtwängler's reconstruction of the Athena Lemnia. Not only is the Bologna head type "androgynous," comparable to that of the bronze Camillus in the Conservatori, and representative of the Romans' preference for adolescent and indefinite forms; its connection with the Athena torso in Dresden (plate 60) can be disproved. Although their drapery is not discordant with a fifth-century date, the two Dresden replicas, both coming from Rome, cannot be securely connected with the Pheidian creation. One more Akropolis monument can therefore no longer be visualized.[26] Equally classicizing may be the Kassel Apollo type, which some scholars consider the Apollo Parnopios "said to be by Pheidias." Since the correlation is tenuous and nothing but the vaguely "Pheidian" style identifies the Kassel type as the Destroyer of the Locusts, the case need not be discussed at great length. The Roman replicas of this Apollo are numerous, indicating that the prototype was popular in Roman circles, but this could apply even in the case of a Roman creation. The peculiar hairstyle and the motion stance of the figure point in this direction.[27]

One more Akropolis monument, this time surely Pheidian, could be mentioned at this point, but simply to register surprise at the lack of its replicas: the famous Athena Promachos. That size per se is no deterrent to copyists is shown by the case of the Parthenos; authorship and subject matter should have produced equal admiration for both monuments. Since the Promachos has so far not been identified in any but the smallest reproductions on lamps and coins, we can only surmise that it was the appeal of the rich materials (or the cult function ?) which made the Parthenos preferable to her bronze sister for the Roman copyists.[28]

Five more shadowy identifications can be discussed together in brief fashion. The bronze Dieitrephes pierced by arrows, which Pausanias saw within or near the Propylaia, has often been connected with the *Vol-*

neratus Deficiens attributed by Pliny to Kresilas, because a base has been found, in a secondary context, signed by that master and dedicated "aparchē" by Dieitrephes' son Hermolikos. Were the equation acceptable, it would eliminate from contention the so-called Protesilaos in New York (plate 61), certainly not wounded in more than one spot. Since, however, both the identification and the connection with the Akropolis base are still contested, they need not be overstressed.[29]

The Aphrodite dedicated by Kallias has been equated with the Sosandra by Kalamis and identified in the statue of a veiled woman (plate 62) of majestic appearance, of which both over- and under-life-size replicas exist. Nothing but the covered head in Lucian's description of the Sosandra supports the attribution, and a countertheory suggests that the veiled lady represents Europa, according to an inscribed statuette and a depiction on a vase. That similar types could be used for different personages is well known and makes me hesitate to accept even this second identification. Certainly the original monument portrayed a divinity, because we find it copied as a stock body for Roman portraits. Two versions in statuette format come from the twin Basilicas in Corinth, a city where Aphrodite was prominent, but the matronly appearance of the figure seems surprising for the Goddess of Love. Be that as it may, no assurance exists that the "Sosandra" type reproduces an Akropolis monument.[30]

The same comment applies to the Artemis of Gabii, (plate 63), in which some recognize the Brauronia by Praxiteles. The main strength of the argument lies in the fact that the youthful figure is busy pinning her mantle—a concern with clothing that would be appropriate for the goddess to whom garments of women who died in childbirth were dedicated. Since Praxitelean style—as we understand the expression—had considerable influence from the mid-fourth century onward, confirmation of the attribution is difficult and stronger arguments should be sought in its support.[31]

The Hermes Propylaios mentioned by Pausanias at the entrance to the Akropolis need not be the one by Alkamenes, since the epithet was appropriate for any herm guarding a gate; Pausanias's text actually suggests that the Hermes might also have been a work by Sokrates.[32] Finally the Perseus "after the deed with Medusa" does not necessarily correspond to the Perseus mentioned by Pliny as a work of Myron, and even the latter has not been convincingly identified among the Roman copies.[33] We can therefore turn to consideration of the four monuments which have most consistently been connected with plausible reproductions.

Athena and Marsyas
Pausanias describes on the Akropolis a group of "Athena striking the satyr Marsyas because of the

double pipes." Although the punitive gesture is not reproduced, fifth-century vases and Neo-Attic reliefs juxtapose an Athena to a satyr and are likely to depict a group standing somewhere in Athens. Because Pliny mentions that Myron made a satyr looking at the pipes and an Athena, it has usually been assumed that the works are cited not as independent creations but as part of a group, although they are but two in a long list.

This very assumption could be challenged. It is based on the presumed alphabetization of the works attributed to Myron, among which *Minervam* would occur out of sequence unless joined with *satyrum*. Yet alphabetization in antiquity was not used unless the list was long; in addition, Pliny's account of Myron's oeuvre is unusually confused.[34] Furthermore, the Frankfurt Athena type (plate 64) could stylistically be connected with Myron and his time, but appears different (in clothing, pose, and equipment) from the—admittedly varying—Athenas shown together with Marsyas on vases and reliefs. Finally, the satyr usually identified as the second member of the group has been considered chronologically and stylistically removed from the Frankfurt Athena, and these considerations, to my mind, carry considerable weight.[35]

Analysis of the extant replicas of the two sculptural types tends to support their separation. Of the Marsyas (plate 65), three statues have been found and an upper torso from the Roman Forum, in statuette size. Three heads are also extant of which one, in the Museo Barracco, has occasionally been doubted as ancient. Of the Athena we have one complete statue (the one in Frankfurt which gives the name to the type), seven torsos, and three heads, to which can now be added a fragmentary head in natural size and a colossal hand holding a cylinder, also from the Roman Forum. Since the Marsyas from the same findspot has reduced format, association with either the natural or the colossal Athena cannot be assumed.[36]

Of all extant replicas, only two could possibly have been grouped in antiquity: the Marsyas from the Esquiline in the Vatican (ex-Lateran), and the Athena torso in the Lancellotti collection which came from the same area. It should be noted, however, that the Marsyas was found (presumably in a sculptor's workshop) together with one resting and two dancing satyrs, and with two nymphs holding a shell and serving as fountains. The context thus suggests that the Marsyas was one more denizen of the natural and idyllic setting rather than a member of a narrative group; the satyr's pose could even be construed as dancing, rather than as shying away from a threatening presence, and indeed the piece had originally been restored with castanets in his hands. That a head of the Marsyas comes from the Circus of Maxentius would also seem to con-firm the independence of the satyr as a sculptural type.[37]

No replica of the Marsyas has so far been found in Greece; the bronze (large) statuette from Patras in the British Museum, though similar, is sufficiently different in pose and details to represent another type, perhaps even another context, and it has recently been suggested that it, and not the so-called Lateran Marsyas type, should be connected with the Akropolis monument mentioned by Pausanias. In this case, the Myronian attribution would have to be discarded and the Patras bronze could be seen as an approximation rather than as a mechanical copy of the original.[38] The marble replicas of the "Myronian" type all come from Rome or its vicinity (one is from Castelgandolfo), although no provenience is given for the copy in the Getty Museum. By contrast, one (highly fragmentary) replica of the Athena head comes from the Athenian Akropolis, one, in Dresden, is probably from Apulia, and, of the torsos, one in Toulouse is from Chiragan and another, in Reggio (an adaptation rather than a true copy, is still unpublished but could come from Magna Graecia. The Athena seems therefore to have enjoyed wider distribution, and presumably—with some alterations by the copyists—a life of its own, as image of a divinity and not necessarily within a mythological context. Once the association between the deity and the satyr is broken, no reason remains to connect the pieces with the Athenian Akropolis.[39]

Anakreon of Teos
Pausanias's description is one of the most vivid in his travelogue; the poet is "singing in his cups." There seems to have been an ancient tradition about an inebriated Anakreon: an epigram by Leonidas of Taras may describe a statue of the poet which depicts him "very drunk and bowed on a skillfully wrought plinth." Other details of that monument include a mantle trailing down to the ankles and one lost shoe; curling toes attempt to hold on to the other. The genre elements in this description may imply a late (Hellenistic) date for the monument. Another portrait of the poet stood on Teos, as mentioned by Theokritos (16), and coins of that city show both a seated and a standing figure, neither of which corresponds to the statuary type currently identified as Anakreon.[40]

The identification was made on the basis of an inscribed herm from Trastevere, which shows remnants of drapery over both shoulders. The same head type (although with different costume) occurs on a full-scale statue now in the Ny Carlsberg Glyptotek in Copenhagen, the only one known so far. It was found at Monte Calvo, in the Sabine Hills, where a villa was built around the middle of the second century by the father-in-law of the future emperor Commodus.[41] Of the seven additional heads preserved, none retains the

ancient bust; conversely, two inscribed herms (one from Tivoli and one, most important, from the Athenian Agora) are regrettably headless. Had the Greek herm come down to us undamaged, we would have gained important confirmation for our attribution.

At present, all replicas of the Copenhagen type are either known or likely to come from Rome or its vicinity; according to Lauter, they all date from the Hadrianic or early Antonine period, except for the head in the Louvre which may be as late as the third century.[42] Most of our conclusions therefore rest on the one complete statue in Copenhagen.

Were it not for Leonidas's epigram, we could assume that Pausanias mistook for drunkenness what was instead the lively pose of an inspired singer. The tilted head, the slightly open mouth, the restless stance of the Copenhagen figure accord well with both the subject and with a date in the severe period, shortly after Anakreon's death, although we are not told when the Akropolis statue was set up. On the other hand, the monument could have been erected much later, thus allowing for a clearer depiction of intoxication than that presented by the Ny Carlsberg type. Posthumous, imaginary portraits erected even several centuries after the death of the subjects are a common occurrence in Greece. Since Pausanias seldom describes what he sees in interpretive terms, we could assume that he was intrigued by an explicit rendering of a human weakness.

That the other copies of the type are in herm form does not per se speak against equating the Copenhagen type and the Akropolis monument. Anakreon's portrait was obviously included among those of other learned men and philosophers of the past, as part of herm galleries in libraries and peristyles. Nor should we puzzle over the fact that Athenian red-figure vases approximately contemporary with the poet show him in what has been termed feminine garb. This is more likely to have been Oriental costume, in keeping with Anakreon's provenience and luxurious taste, and as such might have been inappropriate for a public statuary monument. What makes me question the possible Greek date of the prototype is the fact that the Copenhagen body wears the chlamys in the same unusual fashion as the Oinomaos of the Olympia east pediment, and may thus be an adaptation from that famous monument.

The garment lies over both shoulders, but is not thrown symmetrically around the neck like a shawl; in the back it twists, so as to emerge from under the right arm, rather than above it. This rendering occurs on a male figure in the Capitoline Museum—the so-called Poseidon Borghese, which has recently been identified as the Agamemnon of the Achaian dedication at Olympia made by Onatas. I would rather assume that both works—the Anakreon and the headless statue in Rome—were patterned after the pedimental figure, perhaps at the time when replacement sculptures were set up on the west gable, or at periods of repair to the architecture which required scaffolding to be erected around the building.[43]

This theory may seem farfetched and is basically unnecessary to our main argument on copies. For the latter it suffices to stress the lack of information on the dating and authorship of the Akropolis monument, the apparent discrepancy between the Copenhagen type and the statue seen by Pausanias, and finally the distribution pattern of the portrait replicas, which may imply a Hadrianic origin for the prototype, or at least a source on Italic soil.

The Perikles
Although Pausanias speaks of a full statue on the Akropolis, in this case only herms are preserved and very few at that. The head in Berlin comes from Lesbos, but the two best-known were found at Tivoli, in the same villa, so-called of Cassius.[44] This common findspot seems remarkable in view of the different expression of the two heads: the inscribed one in the Vatican (plate 66) cold and classicizing, the one in the British Museum (plate 67) slightly romantic. One more head, in the Barracco Museum, comes from the Castellani collection and is probably from Rome. So is the fragmentary head in Princeton, which is however not distinctive enough to rank as a true portrait, of Perikles or otherwise. Thus a total of four, at the most five, examples seems meager indeed, especially when compared with the over fifty known portraits of Demosthenes (see plates 77 and 78) of the same characteristic type, and in consideration of the common provenience of the two most divergent renderings.

The problem has been made more complex by Pliny's mention that Kresilas was known for his Olympian depiction of Perikles. It has therefore been assumed that this master's work should be the one copied in Roman times and, moreover, that Kresilas's statue must have been the one which stood on the Akropolis, although Pausanias does not say so. Yet Plutarch tells us that most sculptors depicted Perikles wearing a helmet, and that many portraits of the statesman who was elected strategos fifteen times existed throughout the city. The situation presents therefore the following possibilities.

a) The Roman copies reproduce the "famous" work by Kresilas (only known through Pliny's mention), but we have no way of knowing where it stood—we cannot assume that it was an Akropolis setting which gave it fame.

b) The Roman copies reproduce the Akropolis portrait, regardless of its maker; given the negative evidence of all the other dedications from "closed"

sanctuaries, and the great number of helmeted statues of Perikles existing in Athens, this assumption seems at least unprovable.

c) The Roman copies reproduce an ideal conception of Perikles (comparable to the Roman fabrication of a herm of Aspasia), in the style of the fifth century, perhaps originating in Hadrianic times.[45]

Certainly the narrow range of geographical distribution may speak in favor of an Italian prototype. Yet the existence of a replica in Lesbos remains surprising, whether the original was in Athens or in Rome.

In the face of this complex situation, and given the lack of other elements on which to base our stylistic analysis, I would conclude that the evidence is inadequate either to assert or to deny that the extant herms copy the Akropolis statue, but that the direction of our inquiry would support a negative more than a positive conclusion. Although a deep meaning has been read in its specific location on the Akropolis (away from his father's portrait), a possibility exists that Perikles' image was erected by his sons, in which case it would constitute a private dedication rather than an official honor and therefore be less likely of being copied.[46] Given its presence within the main sanctuary of the city, the statue was probably posthumous; a date after 429 may however place it beyond the chronological range of Kresilas, who must have been active as early as the severe period. The Kydonian master might have instead created Perikles' portrait at the time when the statesman was at the peak of his popularity, during or just before the erection of the Parthenon. Such a statue may well have stood in a public area and thus have been accessible for copying. The extant herms are not incompatible with Attic style around 440 B.C., but the limited number of replicas and their distribution remain puzzling.

The Attalid Dedications[47]
According to Pausanias, they stood on or near the south Akropolis wall and depicted giants, Amazons, Persians and Gauls, with clear allusion to all the major victores of the mythical and historical past. The issue is well known and we need consider it only from the specific point of view of the copies, regardless of whether the dedicant was the first or the second Attalos. The specific (under-life-) size and the poses—which imply a viewpoint from above—have insured the identification of four sculptures, now in the Naples museum, as replicas of the Akropolis monument. Yet, as Lippold has already noted, they are made in blue-gray Proconnesian marble, which implies an Asiatic origin. It has therefore been assumed that a set duplicating the one in Athens was set up somewhere in Pergamon, and that it was the latter which was copied, rather than the Athenian originals.[48] No true evidence exists for this dupli-

cate set, and it could be argued that a "foreign" marble was used by the Roman Imperial copyist to convey the connection of the Athenian statues with Asia Minor. Since, however, Proconnesian marble was not used in Greece, at least to judge from the complete absence of Proconnesian sarcophagi there,[49] nor was the stone as distinctive as, say, Phrygian pavonazzetto, we would still be left with the need to postulate an Asia Minor copyist reproducing a monument from casts taken elsewhere. The single-replica status of the Naples figures increases our difficulties.

Other statues of Gauls and giants exist in European museums, which could qualify as copies of the Athenian monument. The problem should be restudied in the light of present knowledge; in this context it is perhaps sufficient to admit to an element of doubt.

*Other Akropolis Works Not Mentioned by
Pausanias*
Thus far we have followed the steps of the periegetes, trying to recapture the monuments seen by him during his visit to the Athenian sanctuary. We should now consider the actual finds preserved in the Akropolis museum and their possible replicas elsewhere.[50]

This more concrete picture is immediately clouded by the fact that the Propylaia, and the Akropolis itself, were used as repositories for a variety of sculptures collected from the city and placed on the citadel for safekeeping at the time of the Turkish war. Thus should we explain, for instance, the presence of an unfinished torso of the so-called Jason type (see plate 120), which must have come from one of the various workshops in the Kerameikos; that its original stood in Athens is a definite possibility, but we can be relatively sure that it was not on the Akropolis itself.[51]

Easily dismissed is also the seated-Hermes/fountain which Bieber considered a Greek original with replicas now in Florence and Leningrad. No doubt remains today that this fountain piece is not only out of place on the Akropolis but undoubtedly of Roman date. Equally puzzling as to its ultimate origin is a spectacular pedimental statue of a seated lady, datable to the late fifth century B.C., which has been recently recomposed from several fragments; yet none of the Akropolis gables could have housed it. Other such monuments, including a severe gravestone, could be cited.[52]

More complex is the case of the portrait of Alexander as a young man (plate 68), which is generally considered an original, perhaps by Leochares. Yet the most recent study of the head type, in connection with another replica of it in Schloss Erbach, has suggested that the Akropolis marble is itself a copy, perhaps one of the earliest known, datable to ca. 100 B.C. The replica in the Schloss Erbach comes from Villa Hadriana at Tivoli and should belong to the Hadrianic period; a third copy, now in Berlin, was found in Madytos, in

the Thracian Chersonnesos, and seems of Antonine date.[53]

That as many as three replicas exist of this Alexander portrait can be considered unusual, since all other examples occur in single version (unless we accept, with some reservation, as an Alexander the so-called Eubuleos type for which many copies are known).[54] Alexander's influence on art was so strong that several independent personages may have been given the ruler's features. A dramatic example of this fact has been obtained through the recent recognition that the baroque "portrait" in Istanbul, from Pergamon, is instead the head of one of the giants from the Great Frieze. As for the Akropolis Alexander, some traits are unusual: not only is the distinctive *anastole* missing, perhaps because of the youthful age of the subject, but a corkscrew curl over the left ear has been pointed out as restricted to this type and surprising for the fourth century B.C. In addition, the head lacks the distinctive tilt of other Alexander portraits, not because, as Fittschen believes, it comes from a herm, but because it may reproduce the chryselephantine original from Olympia.[55]

Were this the case, we would have evidence that statues set up at Olympia could be copied, since the only portrait of Alexander in gold and ivory recorded by the ancient sources is the one in the Philippeion within the Altis. As I have argued for the great cult images, however, we may doubt that close access to such precious works was permissible, and in particular that casts or measurements could be taken from them. We may perhaps assume that a free version was attempted in marble, as a preliminary model or, more likely, as a reminiscence of the rare monument. It is nonetheless possible that the prototype for the three marble replicas stood in Macedonia—hence the provenience from the Thracian Chersonnesos of one of them. Finally, I fail to see why a chryselephantine statue should be more rigid and immobile than a stone version. Even inclusion within a family group or in the guise of a quasi-religious image would not impose a straightforward glance. The only basis for connecting the type with the Olympia portrait would therefore be eliminated.

We come finally to the one Akropolis dedication for which Roman copies undoubtedly exist: the Xenokles base (plate 69).[56] Two fragments are preserved of a monument decorated with a relief frieze of Pyrrhic dancers: naked warriors with shield and helmet in various pirouetting poses, with feet off the ground. Remains of an inscription—Xenok[les]—have allowed connection with the gymnasiarch of 346/5 B.C. who was also agonothetes in 307/6. The subject of the relief is quite appropriate as symbolic of either function. That the monument originally stood on the Akropolis is not certain, but possible.

Four Neo-Attic replicas are known of the same relief: two on volute amphoras, one on a fragmentary krater, and one, the closest, on a long base now in the Vatican (plate 70) which preserves a series of confronted warriors. Since however the man at each end dances without partner, it has been assumed that the Roman piece is only a section from a longer frieze dated to the Sullan period. The Akropolis original has been placed around 330 B.C.

As in the case of the Paralos monument or of the elaborate relief from the Athenian Asklepieion, we could assume that even Xenokles' dedication was set up in more than one version: one on the Akropolis and another in an accessible public place, perhaps near the spot where the games and dances were performed. A simpler explanation is however possible. As we have seen, there is reason to believe that Neo-Attic ateliers worked primarily from sketches: this is true for the replicas of the Parthenos's shield, the Nike Balustrade, the Niobids from the Throne of Zeus. The clarity with which the warriors stand out from the background, and the strong outline incised around the figures on the Vatican base, definitely suggest that a linear sketch served as intermediary between the two forms. The decorative rhythm of the Pyrrhic dance must have appealed to the Neo-Attic masters who saw its potential for adaptation—witness its use on marble vases—and to the Roman clients who had warlike inclinations. Differences between the classical and classicizing version have been noted and bespeak the relative freedom of the adaptors.

To summarize this lengthy review, we may state the following. The Athenian Akropolis, like Olympia and Delphi, could receive as dedications copies of originals that stood elsewhere (i.e., the Alexander head) but did not permit the mechanical and exact reproduction of dedications set up within its precinct. Monuments of two-dimensional nature were obviously sketched by Neo-Attic artists, who adapted them to a variety of forms and compositions, at times with new meanings. Major cult images like the Parthenos were reproduced in different format and in free versions, probably because of the specific appeal of the work and its symbolic value, rather than for its artistry or authorship. Finally, architectural sculptures, which did not qualify as true dedications, could be mechanically reproduced and were indeed copied—but I suspect that even within this more limited and, so to speak, lay sphere copying was allowed only at times of repairs to the architectural structure. Of the many freestanding monuments cited by Pausanias on the Akropolis, not one can be *safely* recognized in a Roman copy, since for each identification exists at least some element of doubt or an alternate explanation. Admittedly, this constitutes only negative evidence, an argument *e silentio*, as it were.

Yet positive evidence can be found that sculptures in other areas of Athens were copied, as we shall see in the next chapter. The silence from the Akropolis becomes therefore all the more significant.

Before abandoning the subject of the major sanctuaries, we should consider, where known, the Roman attitute toward dedications and sacred objects. The Greeks, to be sure, considered sacred all gifts to the divinity. It has been recently suggested that the archaic sculptures damaged by the Persians were buried out of a sense of tidiness rather than respect[57]; yet religious considerations should also have played a role. At Paestum, the very terra-cotta revetments from the temples, replaced when damaged, could not be thrown away but were tactfully put in *bothroi*.[58] Not every offering was allowed to stand forever, but whenever the "display" was changed, votives removed from sight were carefully stored away in temple treasures.

As for the Romans, the evidence suggests that they believed in the sanctity of statues and their connection with specific locations from which they could not be removed. We know, in fact, that the *imagines majorum* remained with the house even when the family left and the owner changed (Pliny *NH* 35.7). There was also a definite ritual of *evocatio,* to determine the proper formula for addressing gods, especially foreign, when their cult—and especially their statues—were brought to Rome. We learn from Livy (26.34.12) that images and bronze statues taken from Capua after the siege of 211 B.C. were turned over to the college of priests to determine which was sacred and which profane.[59]

A peculiar anecdote is told by Strabo (8.6.23) and Cassius Dio (22.76.2) in connection with the notorious L. Mummius. Of the statues he brought back to Italy after 146 B.C. he lent some to L. Lucullus, who wanted to embellish a temple he had built on the occasion of its dedicatory ceremonies. When, however, Mummius asked for the return of his loan, it was refused, on the grounds that the statues had been consecrated to the deity and thus could not leave its temple.[60] The same Mummius refrained from taking the Eros by Praxiteles at Thespiai "because it was consecrated" (Cicero; Paus. 9.27.1). According to Pape,[61] the Romans considered no place, and therefore no statue, sacred outside their own territory (Pliny *Epist.* 10.50). Yet Greece and Asia Minor could already be counted as Roman possessions by the end of the second century B.C., and the entire ancient world was Roman in Imperial times. When a divine statue was taken from a foreign temple, we find almost invariably that a corresponding cult existed on Italic soil, so that the god was transferred, as it were, rather than taken captive. I submit that the same feeling of religiosity prevailed in the matter of copying, and that not lack of interest alone, but a sense of respect for private offerings prevailed in determining rules of conduct within ancient sanctuaries.[62] We shall now see that sacred places of a more public nature did not fall under such restrictions.

Appendix
**Akropolis Monuments
in the Order of Mention by Pausanias,
Book 1.22.4–1.28.3**

Key: * Monuments for which at least one tentative identifi-
cation has been made
† Monuments of sure identification

1. Horsemen (Xenophon's sons?)
2. Hermes Propylaios by Sokrates (?) *
3. Charites by Sokrates *
4. Lioness (Leaina)
5. Aphrodite by Kalamis *
6. Dieitrephes *
7. Hygieia
8. Athena Hygieia
9. Boy with sprinkler by Lykios
10. Perseus and Medusa by Myron *
11. Artemis Brauronia by Praxiteles *
12. Bronze Trojan Horse
13. Epicharinos by Kritios *
14. Oinobios
15. Hermolykos the pankratiast
16. Phormion
17. Athena striking Marsyas *
18. Theseus and Minotaur *
19. Phrixos and the ram
20. Herakles and Serpents *
21. Athena rising from Zeus's head
22. Bull of the Areopagos
23. Athena Ergane
24. Hermes
25. Helmeted man by Kleoitas
26. Ge praying to Zeus
27. Konon's son, Timotheos
28. Konon
29. Prokne and Itys dedicated by Alkamenes *†
30. Athena and Poseidon in contest
31. Zeus by Leochares
32. Zeus Polieus
33. Athena Parthenos †
34. Hadrian

35. Iphikrates
36. Apollo Parnopios by Pheidias (?) *
37. Perikles *
38. Xanthippos *
39. Anakreon of Teos *
40. Ino daughter of Inachos
41. Kallisto daughter of Lykaon by Deinomenes
42. Attalos's dedications *
 giants
 Amazons
 Persians
 Gauls
43. Olympiodoros
44. Artemis Leukophryene
45. Seated Athena by Endoios *
46. Wooden Athena (Polias)
47. Bronze palm tree (lamp) by Kallimachos
48. Wooden Hermes
49. Lysamache (18 inches high) *
50. Bronze statues of Erechtheus and Eumolpos
51. Theainetos the soothsayer
52. Tolmides
53. Ancient images of Athena blackened by fire
54. Boar hunt
55. Kyknos fighting Herakles
56. Theseus and the rock *
57. Theseus and the bull
58. Kylon
59. Athena (Promachos) by Pheidias *
60. Chalkidian chariot
61. Athena Lemnia*

Hekate Epipyrgidia by Alkamenes (2.30.2) *

Notes

1. For this statement see *Guide de Délos* (Ecole Française d'Athenes, Paris, 1966), p. 23. Only the Hellenistic sculpture from Delos has been discussed by Marcadé, *Au Musée.* See also his *Signatures* 2. Studies in general stop at the first century B.C., including the recent book by A. Papageorgiou-Venetas, *Délos. Recherches urbaines sur une ville antique* (Munich/Berlin, 1981); see pp. 116–26 for tabulations and estimates of economic activities and socioprofessional groups on Delos, where contacts with the Mediterranean world are stressed over the "secondary ones" with mainland Greece.

2. For the theory that the Boreas of the east akroterion imitates the Poseidon on the Parthenon west pediment—an early example of a Greek quotation—see V. Bruno in *In Memoriam Otto J. Brendel* (Mainz, 1976), pp. 55–67.

3. For this statement see Marcadé, *Au Musée,* p. 45.

4. These comments are based on Marcadé, *Signatures* 2 and *Au Musée,* where the Athena Medici is shown on pl. 54 and the Herakles Farnese type on pl. 62; cf. his p. 457 for comments on the unfinished state. On the variant of the Eirene and Ploutos see chapter 6. Besides Stewart's lists of Athenian sculptors in *Attika,* see also S. V. Tracy ("Athens in 100 B.C.," *HSCP* 83 [1979]: 213–35), who stresses the political ties and commercial interests on Delos of many prominent figures in Athenian politics around 100 B.C. (I thank Prof. V. Bruno for this reference).

5. That the *original* of the Diadoumenos might have stood in Delos, because of inscriptional evidence, is considered and rightly rejected by Marcadé, *Au Musée,* p. 45, n. 4.

6. A fragment of a hand holding a sandal, from Samos, has been mentioned as a possible adaptation at smaller scale of this unusual composition, and dated to the second century A.C.: *AthMitt* 92 (1977): 189–90, pl. 89.

All the previously mentioned sculptures from Delos are well known and can be found in Marcadé, *Au Musée,* and in Stewart, *Attika.*

7. For these two sculptures see Marcadé, *Au Musée,* pls. 79 and 80 respectively.

8. To the looting of Delos G. Dontas has recently connected the existence of the Peiraieus bronzes on the Greek mainland: *AntK* 25 (1982): 15–34, esp. pp. 32–33. The statues, as part of the sacred possessions of the Delians, would have been sent to Athens by Mithridates' general Archelaos under the supervision of Aristion, who had two thousand men under him to help him guard such sacred objects (App. *Mithr.W.* 28). Note, in this connection, that the Athenians had already attempted to take away Delian treasures, through the philosopher Apellikon of Teos, but had been stopped by the strong reaction *of the Roman general* Orobius; the Romans, more than the Greeks, were in this case the protectors of sacred objects: Poseidonios, *apud* Athenaeus 5, 53 (ref. Dontas, p. 33).

9. Prof. V. Bruno, who is preparing a publication on the Hellenistic frescoes from Delos, tells me that, although the compositions vary, one of the subjects derives from a comedy by Plautus, and the technique employed on the island is the same as that found on Campanian walls. He assumes, however, that the masters who painted the latter had been in turn taught by Greeks—not necessarily by Delians but probably by Athenians, since the same methods of wall fresco painting are found at Knidos, Athens, and Delos during the second century B.C.

10. On the Pothos, most recently, Stewart, *Skopas of Paros,* pp. 108–10 and lists of copies and variants on pp. 144–46 (twenty-four statues and four statuettes, without including variants and reproductions in different media). See also P. W. Lehmann, *Skopas in Samothrace* (Northampton, Mass., 1973), pp. 8–9 and fig. 31, for a different attribution and reconstruction of the Pothos in group with Aphrodite.

11. For the North African monument see A. L. Ermeti, *L'Agorà di Cirene* 3.1—*Il Monumento Navale* (Monumenti di Archeologia Libica 16, Rome, 1981), esp. p. 128. This monument, which had been previously dated to the first century B.C., is however given an earlier date purely on stylistic grounds, since it is considered a Hellenistic original. On naval monuments in general see K. Lehmann, "The Ship-Fountain from the *Victory of Samothrace* to the *Galera*," in P. W. and K. Lehmann, *Samothracian Reflections. Aspects of the Revival of the Antique* (Princeton, 1973), pp. 179–259.

12. Publication of the sculptures from Thasos is still pending, but see *Guide de Thasos* (Ecole Française d'Athenes, Paris, 1968) and, partly, *Thasiaka* (*BCH* Suppl. 5, 1979), especially pp. 155–67 (article by F. Salviat) for a peplophoros from the choragic monument in Thasos which finds echoes in a Samian figure: R. Horn, *Samos* 12. *Hellenistische Bildwerke auf Samos* (Bonn, 1972), pp. 1–4, 77–79, no. 1, pls. 1–4, 10. Both statues also in M. Gernand, *AthMitt* 90 (1975): 3–14. Since the same figure appears on the Bema of Phaedrus in the Theater of Dionysos in Athens, we do not know whether the island sculptures reflect an Athenian prototype, rather than copying each other. On the Bema in Athens see M. C. Sturgeon, *AJA* 81 (1977): 31–53. On Thasian sculpture see also Linfert, *Kunstzentren,* esp. pp. 123–36; see also pp. 112–16 for comments on Delos and pp. 83–97 on Rhodes. The island of Rhodes presents very much the same picture as Delos and Thasos in terms of lacking copies of popular monuments such as one finds in the Roman cities of Asia Minor and North Africa. No true copies can be found even for the Hellenistic period: see G. Gualandi, *ASAtene* 54 n.s. 38 (1976 publ. 1979), pp. 7–259 and esp. pp. 8, 13, and 243.

13. Pausanias's description of the Athenian Akropolis is broken by a lacune; we may therefore be unaware of additional monuments which could have existed on the citadel at the time of his visit. The figures here given are based on my calculations derived from Pausanias's text; groups of more than one figure have been counted as one unit in the approximate total cited. See also the appendix to this chapter for a list of unidentified Akropolis monuments.

On the Prokne and Itys see H. Knell, *AntP* 17 (1978): 9–19; also *Fifth Century Styles,* pp. 175–76 with bibliography. Were the group in the Akropolis museum a copy from a bronze original, it would still fail to undermine my basic theory, since, as we have seen at Olympia and elsewhere, sanctuaries could accept replicas of originals elsewhere. For the Pergamene "version" of the Prokne see M. Gernand, *AthMitt* 90 (1975): 23–24 and *Fifth Century Styles,* pp. 186–87, no. 6.

14. On the Athena Parthenos, besides the book by N. Leipen (supra, chap. 1, n. 1), see Ridgway, *Fifth Century Styles,* pp. 161–67, with bibliography, also on details of the decoration. For the Varvakeion figure, see the detailed description by W.-H. Schuchhardt, *AntP* 2 (1963): 31–53, pls. 20–37; he dates it to the Hadrianic period and probably to the same workshop that made the reliefs found in the harbor of Peiraieus, from the shield of the Parthenos, on which see infra. These have been more recently dated to the Antonine period. In any case, some significance may attach to the contemporaneity of these reproductions inspired by the Athena in the Parthenon. The Varvakeion figure is approximately in a relationship of 1:12 to the original.

15. These are thoroughly discussed by E. B. Harrison, *AJA* 85 (1981): 281–317, pls. 46–51; see p. 290 for her suggestion that the copyists of the Amazonomachy "worked from plaster casts rather than simply from drawings." and n. 18 for her comments on the concentration of copies from the Parthenon in the early Antonine period, which she also connects with repairs that could have facilitated the making of casts. For the pedimental sculptures see however supra, chapter 3, n. 1 and infra.

16. Pausanias, 10.34.4, tells us that the statue of Athena at Elateia (Phokis) made by the sons of Polykles—hence in the Late Hellenistic period—had a shield copying the work on the Parthenos' shield in Athens. Nothing from this monument has come down to us, and the date itself would suggest no close copying. The lack of reproductions of the Gigantomachy may be due to the different techniques used for the outside and the inside of the shield, as usually suggested: the Amazonomachy was probably in relief, whether carved or appliqué, while the Gigantomachy may have been simply engraved or painted. This differentiation has been attempted in the reconstruction at the Royal Ontario Museum in Toronto: Leipen, pp. 94–95, figs. 86–87.

17. See supra, chapter 4, n. 28.

18. On the Nike of Paionios and Harrison's theory see supra, chapter 4, pp. 41–42 and n. 32.

19. On the Eleusis statuettes, from Building F, see supra, chapter 3, p. 31 and n. 1. The recent study, by Lindner, concludes that the "copying" was not so close and that no direct measurements were involved. If sketches sufficed for such reproductions, the same assumption could be made for all other comparable renderings. Indeed, complex Roman sarcophagi in high relief are generally considered the product of pattern books, rather than of plaster models. Lindner, n. 66, would consider the Agora Tritons and Giants equally made from sketches, not from casts. The theory that these architectural figures of the Antonine period copy the Parthenon pediment was advanced by H. A. Thompson, *Hesperia* 19 (1950): 31–141, especially pp. 103–24. Reactions to the proposals are summarized in Bruno (supra, n. 2), pp. 60–62 and nn. 8–10. See also *Agora 14*, p. 113, for a discussion of the phase of the Odeion of Agrippa which incorporated the figures. On possible copies of the Parthenon architectural sculptures see the trilogy by F. Brommer, *Die Skulpturen der Parthenon-Giebel* (Mainz, 1963); *Die Metopen des Parthenon* (Mainz, 1967); *Der Parthenonfries* (Mainz, 1977).

20. Erechtheion karyatids: E. E. Schmidt, *AntP* 13 (1973), lists all replicas with detailed photographic commentary, except for the Corinth karyatids, which were found too late to be included. On the latter see C. K. Williams, *Hesperia* 44 (1975): 22–23; nos. 26, 27, pls. 7–8; Ridgway, *Hesperia* 50 (1981): 438–39 and n. 71. That the karyatids were considered a work of architecture has been suggested by F. Brommer, *AA* 1979, pp. 161–62, because of a small rectangular boss left by the carvers within the folds of one of the statues. See Ridgway, *Fifth Century Styles*, 105–6 and n. 1.

21 On the Nike Balustrade the major publication remains R. Carpenter, *The Sculpture of the Nike Temple Parapet* (Cambridge, Mass., 1929); for latest additions see M. Brouskari, *The Acropolis Museum: A Descriptive Catalogue* (Athens, 1974), pp. 156–63. For Neo-Attic reliefs see Fuchs, *Vorbilder*, pp. 6–20, and Bieber, *Copies*, pp. 30–32, pl. 9.

22. Charites by Sokrates: the problem is summarized in Ridgway, *Severe Style*, pp. 114–21. Strictly speaking, we have no absolute proof that the Charites of the Neo-Attic reliefs stood on the Akropolis, although that is the general assumption.

23. Theseus groups on the Akropolis: G. Hafner, *Geschichte der griechischen Kunst* (Zürich, 1961), pp. 148–51, figs. 133–34 (reconstructed drawings). For the Conservatori Charioteer see *Severe Style*, pp. 134–35 and figs. 172–73. See also *Museo Nazionale Romano*, pp. 219–20, no. 137 (Minotaur).
The Herakles with the Serpents has been equated with a Hellenistic Herakliskos strangling snakes: G. Lippold, *RömMitt* 51 (1936): 96–103. A discussion of the type prompted by a possible terra-cotta replica, however, attributes the original to Pergamon: E. R. Williams, *Hesperia* 51 (1982): 357–64.

24. Lysimache: *Fifth Century Styles*, pp. 231–32 and n. 7, p. 234, fig. 146. The attribution of the British Museum head to Demetrios of Alopeke, master of the Lysimache, is still repeated by Frel, albeit with a query: *Getty Portraits*, p. 19 and fig. 48. Admittedly, Pausanias's text is troublesome at this point.

25. E. Minakaran-Hiesgen, "Zum 'Krieger' in Tivoli," in *Tainia* (Festschrift R. Hampe, Mainz, 1980), pp. 181–95. For the inscribed base on the Akropolis see A. Raubitschek, *Dedications from the Athenian Acropolis, A Catalogue of the Inscriptions of the Sixth and Fifth Centuries B.C.* (Cambridge, Mass., 1949), no. 120. For Zanker's opinion see Helbig [4] no. 3198, pp. 161–62; see also *Fifth Century Styles*, pp. 238–39 with further bibliography.
Undoubtedly many sculptures found in Hadrian's Villa "copied" a definite Greek prototype (for instance, the Erechtheion karyatids, the Mattei Amazon type), but many adaptations and new creations also existed. The point can be made more clearly by considering the numerous statues in Egyptian stones or even in marble, following Egyptian formulas, now in the Egyptian galleries of the Vatican Museums. Although these works can be described as being in general Late Egyptian style, they do not copy specific prototypes, and the classical intrusions into their schemata can easily be detected. See the perceptive comments, and the catalogue of finds from Hadrian's Villa (p. 51), in A. Roullet, *The Egyptian and Egyptianizing Monuments of Imperial Rome*, EPRO, vol. 20 (Leiden, 1972), pp. 18-22. This lack of exact copying (perhaps even only in terms of stock bodies to be completed with a portrait head) is all the more surprising in that Egyptian carvers were probably active in Rome and were responsible for some of these monuments, not only for Hadrian, but even in earlier and later periods.

26. K. Hartswick: paper delivered at the College Art Association Meeting in New York, February 25, 1982 (summary), and "The Athena Lemnia Reconsidered," *AJA* 87 (1983): 335–46. Whether or not the Palagi head can universally be accepted as classicizing (and I am convinced it can: see *Fifth Century Styles*, pp. 170-71), the tenuous grounds on which the Dresden Athena type was identified as the Lemnia, as made clear by Hartswick, should suffice to revise present opinions. It is also remarkable, for a statue of such reputed fame, that so few replicas of the body should exist: besides the two in Dresden, only three variants are known (one of them a karyatid), and all are associated with Rome.

27. Kassel Apollo: all replicas of the type are collected in E. E. Schmidt, *AntP* 5 (1966) for a total of two complete statues, five torsos, thirteen heads, and three statuettes. Of these, only one head and one torso were found, not far from each other, in Athens, near the Olympieion, and seem to be of Hadrianic date, a time which Schmidt identifies as having had a special interest in this type. For a discussion and a classicizing date see Ridgway, *Fifth Century Styles*, pp. 184–85, no. 3.
Vermeule, *Sculpture and Taste*, pp. 65–66, has recently mentioned where the name piece now in Kassel was found: at Lago di Paola (once di Soressa) between Nettuno and Terracina, within a little temple and in a marble niche with fine decoration. A cult purpose may be implied by such setting.

28. Comments and some bibliography in Ridgway, *Fifth Century Styles,* p. 169 and n. 14: that the Athena in New York mentioned in that note is an original seems unlikely, but it has been suggested by R. Tölle-Kastenbein, *Frühklassische Peplosfiguren. Originale* (Mainz, 1980), no. 36c and pls. 143b–45, pp. 201–3. The Akropolis Promachos was as famous as the Parthenos, and served as a landmark of Athens in antiquity.

That the Athena Parthenos was a cult statue is still being debated: cf. *Programm, Internationaler Parthenon-Kongress Basel* 4–8 April 1982, papers by F. Preisshofen and G. Zinserling which question the Parthenon as a true temple (pp. 26 and 30).

29. Given the fifth-century date of the Akropolis monument, it would seem doubtful that Dieitrephes' son would set up a statue of his father about to expire; if contemporary gravestones are any indication, the deceased was not shown in any kind of emotional or dramatic situation, and even Dexileos appears as triumphant over the enemy, rather than dying.

The Protesilaos in New York has been the subject of a controversy between J. Frel and E. Langlotz, the former advocating that the figure is the *Volneratus Deficiens* by Kresilas (*BMMA* 39 [1970]: 170–77; *AA* 1973, pp. 120–21), the latter insisting that the replica of the type in the British Museum represents Poseidon (*AA* 1971, pp. 427–42; *AA* 1977, pp. 84–86).

30. Sosandra by Kalamis and association with veiled (so-called Aspasia) type: for a summary discussion see Ridgway, *Severe Style,* pp.65–69, figs. 105–8. For the Corinth statuettes see *Hesperia* 50 (1981): 442 and n. 81 with further bibliography. For the Cretan replicas see now L. Guerrini, "Copie romane del tipo 'Aspasia/Sosandra' da Creta," in *Antichità cretesi. Studi in onore di D. Levi* (Catania, 1974, publ. 1980): 227–34. It is noteworthy that, at the time of his writing, Lauter, *Chronologie,* p. 116, could state that all extant replicas had been made within a thirty-to-fifty year span. Yet that the type was important in Greece is shown not only by the replicas in Corinth and Crete, but also by a head recently found in the Agora at Saloniki, with inserted eyes: *BCH* 95 (1971): 944, fig. 327 on p. 951. This distribution may suggest that the original stood in Athens, but nothing indicates exactly where. The current interpretation is that the figure represented Europa or even Demeter/Europa.

For another statue of Aphrodite of a well-known type, an Akropolis location has been advocated on the basis of a fragment from the Athenian citadel which is considered part of the original. The type—the so-called Olympias or even Agrippina, because of its use as stock body for Roman matronly portrait—seems patterned after the reclining Aphrodite on the east frieze of the Parthenon, and meant for all-around viewing. A. Delivorrias has suggested that this type was the Aphrodite by Kalamis dedicated by Kallias: *Ath-Mitt* 93 (1978): 1–23. I believe however that the Akropolis statue may have been made in Roman times and patterned *after* the Parthenon frieze, to serve as a portrait of Livia, perhaps, in honor of Augustus's wife and Tiberius's mother: see *Fifth Century Styles,* pp. 234–37. My chronology is mainly based on the elongated form of the composition, which forces the figure into a stretched-out pose, as if on a chaise longue. Prof. Harrison kindly informs me that a fragment of the same type, but of Roman workmanship, comes from the Athenian Agora.

31. The attribution to Praxiteles and the identification as the second cult image of the Braufonion on the Akropolis are already doubted by Lippold, *Handbuch,* pp. 239–40, pl. 83.4; stronger doubts are expressed by I. Kontēs in "Artemis Brauronia," *Deltion* 22 (1967): 156–206, esp. pp.193–99, in the light of recent excavations at Brauron. Since the iconography of the many votive reliefs found at Brauron never once reflects the type of the Artemis of Gabii, the connection seems improbable. The same conclusions are reached by T.

Linders (supra, chap. 1, n. 15) p. 15, n. 70. For a recent mention see R. Lindner, *JdI* 97 (1982): 359, n. 152, who refers to the forthcoming volume of *LIMC* s.v. "Diana." Since an entry for Artemis is also included in the *LIMC,* the discussion of the Gabii type under the Roman goddess may be significant. Of the type, beside the statue in the Louvre from Gabii (between Rome and Praeneste; no Temple of Artemis/Diana is so far attested at the site), we know the torso in Naples, the statue in the Palazzo Doria (*EA* 769 and 2285 respectively) and a fragment from the Lecce theater (*AA* 1938, col. 725).

32. The most recent discussion on the Hermes Propylaios and the Alkamenes type are by A. Hermary, *BCH* 103 (1979): 137–49. The comments by E. B. Harrison (*Agora 11,* 86–98, 122–24) seem still pertinent.

Another statue, also attributed to Alkamenes, is mentioned by Pausanias (2.30.2) in his discussion of Aigina, but described as being on the Athenian Akropolis: the three-bodied Hekate Epipyrgidia. Many Hekataia have come down to us, although largely of Hellenistic and Roman date, but although the basic composition is the same, individual renderings and attributes vary, so that a one-to-one copying of Alkamenes' work on the Akropolis should be excluded, even if echoes of his work are undoubtedly to be recognized in many of these replicas. For a discussion of the type see, e.g., Harrison, *Agora 11,* pp. 86–98. For the largest example of a triple Hekate known to me so far see the fragmentary marble in Corinth, *Hesperia* 50 (1981): 431, n. 37. See also infra, chapter 6, pp. 70–71 and n. 37.

33. For the latest discussion and summaries of attributions see M. C. Sturgeon, *Hesperia* 44 (1975): 280–90, no. 1, pls. 70–71 (a head from Corinth, attributed to Myron or his circle), and J. Frel, *GettyMusJ* 1 (1974): 55–57, where the "Perseus" head type, represented by a replica in the Getty Museum, is considered a Hermes and assigned to Kalamis.

34. On this confusion see supra, chapter 2, n. 55.

On ancient alphabetization see L. W. Daly, *Contributions to a History of Alphabetization in Antiquity and the Middle Ages* (*Latomus* 90, 1967), and cf. its review by S. Kuhn, *Speculum* 47 (1972): 302. I owe these references to Prof. Ch. Witke, of the University of Michigan at Ann Arbor, to whom I am most grateful. To be sure, Pliny seems to alphabetize in *NH* 34.91, but he is there dealing with names of masters, rather than with monuments which could be cited under different titles.

35. On the general issue see H. A. Weis, "The 'Marsyas' of Myron: Old Problems and New Evidence," *AJA* 83 (1979): 214–19, with all previous bibliography, and good illustrations of the Patras bronze satyr in the British Museum.

36. These figures are taken from Daltrop, *Il gruppo mironiano,* where new interpretations are proposed. The equation with the Akropolis group is however taken for assured.

37. Prof. John Humphrey, of the University of Michigan at Ann Arbor, has been researching the topic of sculptures on the *spina* and other areas of the Roman *circus.* I am grateful to him for sharing some of his thoughts with me.

38. On the Patras satyr see Weis (supra, n. 35).

39. Good illustrations of the Athena, besides Daltrop, *Il gruppo mironiano,* also in B. and K. Schauenburg, *AntP* 13 (1973): 47–65, pls. 8–14 and numerous detailed figures. The replicas of the Athena are there distinguished into more or less accurate replicas and variants; p. 62, n. 74 advances the theory that the Athena was varied in order to give it independent value, without the satyr. It is remark-

able, however, that as the same footnote points out, *none* of the Athena replicas, whether closer to or farther from the prototype, has been found together with a replica of the Marsyas. The head in Athens is illustrated in *ÖJh* 37 (1948): Beibl. 6, fig. 2: it is so fragmentary that attribution to the type seems hazardous.

As for the reconstruction of the composition, even the cylinder held by the hand from the Roman Forum need not be one of the double pipes, as suggested by Daltrop; a similar object in the hand of one of the replicas had originally been seen as a spear and this interpretation, challenged in the light of the Marsyas story, may still be right, given the shield added, for instance, to the Florence "variant." Note the more developed, less severe, style of the torso in Reggio (at reduced scale) and the contoured soles of the Lancellotti Athena, which would be anachronistic in an early-fifth-century work—but these renderings could be imputed to the copyist.

Reconstructions of the "group" in casts have usually been criticized as showing too small an Athena next to a towering satyr. The divinity should always be larger than other beings, and even the addition of a tall-crested helmet does not compensate for the discrepancy engendered by the relative size of the extant replicas—one more argument against combining the two.

40. Anakreon: Richter, *Portraits* 1, pp. 75–78, figs. 271–97. Frel, *Getty Portraits*, p. 14, fig. 36, makes the interesting point that the Copenhagen statue is infibulated "in accordance with the belief that chastity improved not only the voice of singers but also the performance of athletes." Frel stresses the similarity between the Anakreon and the long-haired Riace Warrior, in which he finds confirmation for a Pheidian attribution of both. That the Anakreon was by Pheidias has been argued on the basis of the statue's similarity to a Neo-Attic type connected with the reliefs after the shield of the Athena Parthenos; and from the fact that Pausanias cited Anakreon's image immediately after speaking of the portrait of Xanthippos, Perikles' father, it has been assumed that the Xanthippos might also have been made by Pheidias. Given the manner in which Pausanias proceeds, two statues mentioned one after the other might have been separated by considerable distance, and nothing in Pausanias's wording implies that the two portraits formed a group. Since Frel then states that "The Xanthippos grouped with the Anakreon (fig. 38) on the Acropolis is identified by comparison with Anakreon: the only strategos of the same style," the attribution game deplored by Frel himself (pp. 33–37) seems to be in full swing. For the Xanthippos see his no. 1 and pp. 38–39, as well as fig. 84 on p. 34. Richter, *Portraits* 2, p. 101, figs. 426–28, has different candidates but is doubtful about their identification as Xanthippos.

Besides Pheidias, Kolotes, Kresilas, and Pythagoras have also been mentioned as possible sculptors of Anakreon's statue, which must have been erected posthumously and on imagination, since the Tean poet died in 487 B.C.

41. On Monte Calvo see Vermeule, *Sculpture and Taste*, p. 65.

42. Lauter, *Chronologie*, p. 114.

43. In *Severe Style,* p. 71, no. 4, I had already mentioned the similarity between the Oinomaos and the Anakreon, but had accepted the latter as a ca. 440 prototype. Further investigation into the problem of Roman copies, and the similarity with the so-called Poseidon Borghese, have led me now to different conclusions. On the Poseidon Borghese and its identification as the Agamemnon of the Achaian dedication at Olympia see J. Dörig, *Onatas of Aegina* (Leiden, 1977), pp. 27–28, with good illustrations. Note that the "Poseidon" had been identified as Xanthippos (by F. Poulsen, ref. Dörig) because of its similarity to the Anakreon, but Dörig states that "except for the mantle arrangement the works really have nothing in common."

That the pedimental sculptures of the Temple of Zeus at Olympia

could have been copied at the time of repairs to the structure is suggested, not only by the "replacement figures" on the west gable, but also by comparison with other sculptures of the Roman period. See M. L. Säflund, "Ein Zeuskopf im Museo Chiaramonti," *Opus-Rom* 9.5 (1973): 43–52, esp. p. 5l. Several periods of repair to the Zeus Temple are documented through the different styles of the lion-head waterspouts.

44. Richter, *Portraits* 1, pp. 102–4, figs. 432–45. She states that the British Museum herm came from the Villa di Cassio with other herms, but on p. 81 a different date is given, and the villa is called "of Brutus." The true account of the find can be read in C. Pietrangeli, *Scavi e scoperte di antichità sotto il pontificato di Pio VI*, 2d ed. (Collectanea Urbana 1, Rome, 1958), pp. 139–46 (on the Villa di Cassio), esp. p. 142. Other herms from the same villa occurred in duplicate versions. The portraits of the Seven Wise Men, also found there, are obviously imaginary portraits made to satisfy the antiquarian taste of the Roman clientele (Richter, p. 17).

45. On the Vatican Aspasia see Richter, *Portraits* 1, pp. 154–55, figs. 875–76; Ridgway, *Fifth Century Styles*, pp. 240–41. See also the comments by E. B. Harrison, on the portrait of Pheidias, which must have been prompted by the Romans' desire to own a likeness of the renowned master: *Hesperia* 35 (1966): 112. An inscribed although headless herm of Pheidias was found in the same villa with the Perikles portraits. That the anecdotes speaking of a portrait of Pheidias on the Parthenos's shield are later fabrications is maintained by F. Preisshofen, *JdI* 89 (1974): 50–69. See however Frel, *Getty Portraits*, pp. 16–17, for a literal interpretation of the anecdotes and identification of Pheidias portraits in gems, small bronzes, and a marble head in Copenhagen (his fig. 43).

46. For the meaning of Perikles' statue and its positioning on the Akropolis see T. Hölscher, *WürzJbb* n.s. 1 (1975): 187–218; for the dedication being made by Perikles' sons see A. Raubitschek, *ArchCl* 25–26 (1973–74): 620–21.

47. For a quick review of the issue see Robertson, *Shorter History*, pp.192–94; or M. Bieber, *The Sculpture of the Hellenistic Age* (New York, 1961), pp. 107–10; recent monographs have concentrated on the Pergamon dedications, rather than on those in Athens.

48. Lippold, *KuU*, p. 112; this idea is repeated by Stewart, *Attika*, p. 32, n. 93 (with discussion of the Attalid dedications in general, pp. 19–23) and especially in *AJA* 84 (1980): 253 (Stewart's review of Wenning, *Die Galateranatheme Attalos I*). The assumption is that, had the dedications been copied in Athens, Pentelic, or maybe Parian, marble would have been used.

The discussion has been made more complex by recent attempts to connect with the Akropolis dedications the works taken from Pergamon by Nero and mentioned by Pliny as being in Rome in his day, when Vespasian had them transferred to the *Forum Pacis* (see however supra, chap. 2, n. 74, ref. to Gros). This hypothesis ultimately rests on a comparison between the Dead Giant in Naples and the portrait of Antisthenes as known through Roman replicas, which a signed base in Ostia allows us now to assign to Phyromachos (on Antisthenes' portrait see also infra, chap. 8, p. 98). This sculptor's name would therefore establish that Attalos I was the dedicant of the Akropolis sculptures, as well as suggesting that it was the "smaller votary" that Nero took to Rome. In such case, however, he could have only taken the duplicate set and not the originals, in bronze, which were on the Akropolis in Pausanias's time. The Phyromachos connection has been advocated not only by Stewart, but also by B. Andreae, in *Eikones, Studien zum griechischen und römischen Bildnis* (Festschrift H. Jucker, *AntK BH* 12, 1980), pp. 40–48, esp. Addendum on p. 48 with the examination of a theory by Coarelli. This latter will be discussed in chapter 8; suffice it here to state that Co-

arelli advocates Nero took originals, and not copies, to Rome, thus potentially negating Andreae's theory. The comparison between the Naples Giant and the Antisthenes is, to my mind, so uncertain that there is no point in speculating further on this matter within the specific viewpoint of my topic. Let us simply acknowledge here that the "victims" in Naples are in Asiatic marble and are therefore unlikely to have been made in Athens.

49. On the distribution of sarcophagi see Ward-Perkins, "Marble Trade," and infra, chapter 7, p. 89.

50. For the so-called Corinth/Mocenigo type, of which a fragment has been found on the Akropolis, see infra, chapter 7, pp. 90–91.

51. Unfinished "Jason" on the Akropolis: see, e.g., Ridgway, *AJA* 68 (1964): 116 and pl. 38. For discussion of the type and bibliography, see infra, chapter 7, p. 88 and n. 50.

52. Hermes Fountain: Ridgway, *Fifth Century Styles*, p. 242, no. 1; the classical date given by Bieber, *Copies*, pp. 27–28, had already been questioned by Lippold, *KuU*, p. 122, because of the fountain arrangement.
 Pedimental statue of a woman: A. Delivorrias, *Attische Giebelskulpturen und Akrotere des fünften Jahrhunderts v. Chr.* (Tübingen, 1974), pp. 8–15; Ridgway, *Fifth Century Styles*, pp. 66–67, no. 5.
 Severe gravestone: Akr. 1350, M. Brouskari, *The Acropolis Museum. A Descriptive Catalogue* (Athens, 1974), p. 83.

53. K. Fittschen, *Katalog der antiken Skulpturen in Schloss Erbach* (Berlin, 1977), pp. 21–25, no. 7, pl. 8; for the Berlin head see his Beil.3, for the head in Athens, Beil.2. For the portraits of Alexander, Richter's account is very summary; see however, M. Bieber, *Alexander the Great in Greek and Roman Art* (Chicago, 1964).

54. The equation Eubuleos = Alexander has been suggested by E. B. Harrison, *Hesperia* 29 (1960): 382–89, pl. 85c-d, on the basis of an unfinished bust of that type from the Agora. It has been rejected by, e.g., A. Krug, *Gnomon* 46 (1974): 694, and G. Schwarz, *GettyMusJ* 2 (1975): 71–84, who suggests instead that the youthful head represents Triptolemos. She also assigns the prototype to Bryaxis, on the basis of a resemblance to the Sarapis type. She does not however deny that the Eubuleos may show influence from Alexander's portraiture (p. 84). How dangerous the identification of Alexander in various renderings may be was shown, most recently, by the realization that the Pergamon Alexander now in Istanbul is instead the head of a giant from the Great Pergamon Altar: W. Radt, *AA* 1981, pp. 583–96.
 Only the "Alexander with the Spear" seems to be known in more than one replica, but so far they are all of statuette size.

55. That herms may repeat the tilt present in the prototype is shown, e.g., by the herm of the Anakreon Borghese (supra, n. 40). The chryselephantine theory is by Harrison (supra, n. 54), p. 384, n. 63, p. 387, n. 73.

56. Fuchs, *Vorbilder*, pp. 41–44; see also his entry in Helbig⁴ no. 58 (the base in the Vatican). For the Akropolis fragment see O.

Walter, *Beschreibung des Reliefs im kleinen Akropolismuseum*, nos. 402 and 402a.

57. J. Boardman, *Greek Sculpture: the Archaic Period* (Thames and Hudson, 1978), p. 64. Note, however, that Pausanias mentions some statues that had been gutted by the Persian fire, yet stood in his day. Endoios's Athena, now to be dissociated from the seated Akr. 625, was also visible in the second century A.C.

58. See, e.g., M. Napoli, *Paestum* (Novara, De Agostini, 1970), p. 40.

59. See also Livy 23.11.1–2, for the account of Fabius Pictor's mission to Delphi, where he had the task to draw up a complete list of gods and goddesses and to enquire about the proper forms of address for each. Cf. Gros, "Les statues," for such points. See also Waurick, "Kunstraub," p. 3 and n. 18, for the statues of the gods taken from Veii under the ritual of *evocatio*. On *evocatio* in general see U. Basanoff, *Evocatio* (Paris, 1947); I owe this reference to Dr. Lydia H. Lenagan. For an important example as late as 75 B.C. see J. Reynolds et al., *JRS* 71 (1981): 133.

60. Dio 48.42 tells a comparable episode. Domitius Calvinus seems to have borrowed some statues from Octavian for temporary display in the Regia, but then refused to return them on the grounds that it would be sacrilegious to remove them from their new locale.
 Even in later times, when the cult of the emperor was thoroughly established and unopposed, Marcus Aurelius forbade the citizens of Ephesos to melt down some unrecognizable images of early emperors to cast new portraits of himself and Lucius Verus, because "it was not right to do so": T. Pekáry, *Boreas* 5 (1982): 124–32, and esp. 125–26 for the Aurelian example. The whole article gives much important information on imperial portrait statues and their status. For the text of the imperial letter see D. Magie, *Roman Rule in Asia Minor* (Princeton, 1950) vol. 1, pp. 663–64; vol. 2, p. 1534 n. 10; Ephesos 11, no. 23 (frg. 9 = *O.G.I.* 508).

61. Pape, "Kriegsbeute," pp. 36–37, on "Sakralrecht."

62. To be sure, there is ample evidence from Late Republican times onward, and perhaps even from the classical and Hellenistic periods, that statues could be rededicated or reused for different purposes. See H. Blanck, *Wiederverwendung alter Statuen als Ehrendenkmäler bei Griechen und Römern* (Rome, 1969). For the rededication of statues taken by Roman generals see also the comments by Philipp and Koenigs, "Basen," esp. pp. 202–3, and Waurick, "Kunstraub," esp. pp. 31–40. In such cases no compunction was felt because the offering itself was not taken away from the divinity, but simply given another sponsor or a different meaning. In other words, the sacredness of the offering lay not in its donor but in its recipient. Thus an Attalid monument could be renamed after Agrippa since the gift itself remained untouched within the Akropolis: T. L. Shear, Jr., *Hesperia* 50 (1981): 361, n. 25, with further references; see also p. 363 and n. 34 for another reused monument. Augustus is also known to have relocated cult images from devastated shrines, partly from piety and partly to attract inhabitants to his newly founded Nikopolis: Paus. 7.18.5–6.

6 The Evidence from the City of Athens and Other Sites

If statues in the main sanctuaries were not copied, where did the sculptures stand that the Romans undoubtedly reproduced? Where were, for instance, the famous Diskobolos by Myron (plate 71) and the Diadoumenos by Polykleitos (see plates 18 and 19)? Pausanias does not mention them in his visit, yet neither does Pliny list them as being in Rome, and the assumption must be that they were left in Greece. A work by Lucian has given us a vivid description of the Diskobolos, the primary source for the current attribution which is undoubtedly correct. What is less well known is that the same dialogue (the *Philopseudes*) mentions the Diadoumenos next to the discus-thrower—a juxtaposition still plausible within a gymnasium or a palestra but of which we are not generally aware, since the allusion to each statue is normally quoted in isolation, within the context of the oeuvre of Myron or of Polykleitos respectively. Yet such inference of location is proven wrong when Lucian's description is read in its entirety. The dialogue takes place within the peristyle of a private house, where Diskobolos and Diadoumenos stand next to a veristic portrait of a general, Pellichos, and—more significantly—to the Tyrannicides. It is therefore obvious that copies, not the originals, are being described, since undoubtedly in the second century A.C., at the time of Lucian's writing, the bronze Harmodios and Aristogeiton were seen by Pausanias in the Athenian Agora.[1]

The existence of replicas within a specific city provides no assurance that the original also stood there. This is clearly exemplified already in Greek times, when echoes of the Polykleitan Doryphoros (see plates 13–15) occur on the Parthenon west frieze and on Attic stelai like that of Chairedemos and Lykeas. These allusions to the famous work by the Peloponnesian master had prompted the theory that Polykleitos had spent some time in Athens, but we should more readily think in terms of stylistic influence than of active participation. Had Polykleitos worked on the Parthenon sculptures, some ancient source would not have failed to mention it, given the popularity of that sculptor in Roman times.[2]

Yet precisely the Doryphoros may provide a clue as to the location of "copyable" works. Despite all attempts at identification with specific mythological figures (including, most recently, the entry on Achilles in

LIMC I), the short hair and the lack of attributes indicate that the Spear-bearer should be considered human. The superhuman size of most replicas, however, militates against the possibility of an athletic portrait for an individual victor in some unspecified competition. Polykleitos is known to have created his statues according to an ideal canon of proportions (most likely based on Pythagorean principles) on which he also wrote a book. If the Doryphoros is correctly identified, as I believe, with the visual embodiment of the canon, it is also plausible that it was not made on commission but that it stood in front of Polykleitos's workshop, in Argos, as an *exemplum* of his art.[3] That this theory is not farfetched will be shown below, in connection with Lysippos.

If no religious purpose was attached to the original Doryphoros, it is not surprising that the statue could be copied. In full size, it is attested among our earliest known replicas of Greek works—perhaps the earliest from Italy—in the first-century-B.C. marble from the Palestra at Pompeii, where its isolation emphasized its importance. The body had already been used for a portrait statue, probably of a Hellenistic ruler, in the same century and the same area, as well as for some Roman individuals in Delos. At Pergamon, a bronze statuette of the second half of the first century B.C. eclectically combined features of the Doryphoros in a rendering of Mars Ultor. No full replica of the Doryphoros, to my knowledge, has been found in Athens, but nearby Corinth has produced a romantic version of the head (see plate 14) made in Imperial times, and a copy of the body was used for a portrait at Olympia. More than twenty examples of the Doryphoros proper exist, one of them even in green basalt to reproduce the shine of bronze, while the stock bodies are too numerous to count. This was certainly one of the most copied statues of antiquity.[4]

If this surmise about the location of the original Doryphoros is correct, it follows that statues set up within cities could be copied. Confirmation for this fact emerges from a consideration of excavational evidence from the Athenian Agora taken in conjunction with Pausanias's account, which should now be reviewed.[5]

The Athenian Agora: Originals Seen by Pausanias and Still Extant

As is his custom, Pausanias concentrates on monuments of the Greek period; and a few among them may have survived. The most notable is the cult image for the temple of Apollo Patroos on the west side of the square, which was made by Euphranor. A headless but still colossal marble figure (plate 72) has been unanimously recognized as a Greek original of the second half of the fourth century B.C. and is therefore

likely to be the work seen by Pausanias, since it was found not too far from the temple itself. The god is represented in the long costume of the citharode—a well-known iconographic type which is also repeated in Roman works, although none of them can be considered an exact copy. Closer to Euphranor's statue, probably to recall it specifically, are some statuettes: one (at one-tenth of the scale) from the Agora itself (plate 73), and another, from Delphi, signed by Chairestratos of Rhamnous who seems to have specialized in quoting earlier monuments.[6] Since these are only free copies, we must assume that no cast taking was allowed within the temple. I would also stress (other opinions to the contrary) how closely Euphranor's Patroos resembles the Apollo on the Sorrento Base (plate 74), of Julio-Claudian date, which is plausibly thought to depict the Apollo by Skopas taken from Rhamnous to the Palatine temple in Rome.[7] This similarity confirms the popularity of the iconographic type and alerts us to the dangers of judging sculptors' styles from free and later reproductions.

Pausanias mentions also two statues of Aphrodite within the Temple of Ares, which was moved to the Agora in Augustan times. Although their connection with those seen by Pausanias cannot be proven, two statues have been found which could be thought to depict that goddess. The earlier, an over-life-size marble of the late fifth century recovered in a most fragmentary state, is not known through any exact replica so far, though its style and costume recall the Hera Borghese type.[8] The other, a colossal Hellenistic figure, heavily draped and with left hand on the hip, is much better known from a vast number of examples, most of which, in all sizes, come from the island of Rhodes. There the type has been identified as Artemis/Hekate, but a case has also been made for Aphrodite, which may be more plausible for the Athenian figure. Two statuettes of Roman date, remarkably thin and flat in execution, come from nearby Corinth (plate 75), and one of them retains, on her shoulders, the legs of a small Eros, at present visible only in the back view since his upper body is missing. None of the Rhodian examples is as large as the Agora figure, which may imply that the type originated in Athens. But as many as over twenty items from Rhodes alone must have some meaning, especially in consideration of the fact that the island, for all its active schools of sculpture, does not seem to have produced copies of classical works, neither in Hellenistic nor in Roman times. Given the high quality of sculpture from the Roman period in Athens, it is even difficult to be sure that the colossal Agora "Aphrodite" is a Hellenistic original rather than an Imperial copy.[9]

Pausanias sees some statues of Athena while crossing the square; an original marble torso of the advanced fifth century can therefore be included here as

possibly the one by the Parian Lokros mentioned as being in the Temple of Ares (1.8.4), although no assurance exists that we are dealing with the same monument. The torso, with its diagonal aegis and belted overfold, belongs to a definite iconographic type but no exact copy can be cited. Finally, in a remarkable departure from the norm, Pausanias speaks of a portrait of Hadrian (1.3.2), and he probably meant the cuirassed, and now headless, figure which the American excavators have reerected at the approximate spot cited by the traveler.[10]

Monuments Seen by Pausanias, Extant Only in Roman Copies

The list of original works recovered from among those mentioned by Pausanias is therefore rather meager, and only one or two are definite identifications. We fare better, however, when we consider monuments cited by the periegetes and plausibly identified in Roman copies. Of these the most convincing and important are the often mentioned Tyrannicides (see plates 10 and 11) by Kritios and Nesiotes.

These bronze statues stood not too far from the Temple of Ares and the Panathenaic Way. H. A. Thompson has even suggested that they were erected in proximity of the Leokoreion, where the actual assassination took place.[11] Next to them stood the original monument by Antenor, taken to Susa by the Persians but returned to the Athenians after Alexander's victorious campaigns in the East. Only the severe group was copied by the Romans, as already mentioned. Of greater interest for our topic is also the fact that depictions on black- and red-figure vases (therefore by painters active when only the replacement statues could be seen in Athens) show two distinctive figures which can be identified without fail in extant marble replicas. Not many such copies were made in Imperial times (perhaps because of the subject matter which glorified death to the tyrant), but that some were is beyond doubt. Correspondence among the extant replicas implies the use of a common original, and the presence of a fragmentary Aristogeiton head among the Baiae casts ensures that molds could be directly made on the bronzes.[12]

The Tyrannicides were used as eloquent silhouettes for the episema on the shield of Athena on a Panathenaic amphora. These prize vases often incorporated important Athenian monuments in their decoration, and a second sculpture cited by Pausanias can thus be added to our list, on the evidence of the amphorae. This time the statues are shown not as episema but atop the two tall columns which came to flank the goddess in the classical period. They were the symbols—as it seems—of the archon Kallimedes, active in 360/59 B.C., whose name appears within the traditional

inscriptions. Several of these amphorae, whole or in fragments, have been found at Eretria and Eleusis, and there is no mistaking the small white figures in their lofty position: they depict the Eirene and Ploutos.[13]

A matronly peplophoros with long hair loose on her shoulders, tenderly balancing a child on her left hip, as well as holding (probably) a cornucopia and a scepter, had long been identified as the work by Kephisodotos, probably Praxiteles' father, seen by Pausanias on the west side of the Agora. The monument is best exemplified in a replica from Rome in Munich (plate 76), but copies of the torso exist also in Naples (from Cumae) and New York (also from Rome), and in other museums, among which the more significant are the fragmentary replica in Cherchel, the miniature version in Heraklion, from Gortyn, and a copy of the Ploutos in the Peiraieus Museum. Variants of the type are also known, including a possible "Leto" in Delos of Hellenistic date, and an Imperial one in Rome, Palazzo Corsini. The diffusion of the type in areas under Athenian influence (Delos, Crete, Cyrene, Cherchel) would confirm the location of the original monument.[14]

Another sculpture of secure identification is Demosthenes' portrait (plates 77 and 78), erected by his nephew in 280 B.C. and made in bronze by the sculptor Polyeuktos. It was seen by Pausanias not too far from the Tyrannicides, and an anecdote recounted by Plutarch in his *Life* of the orator gives some idea of the composition, a man standing with hands clasped. The best preserved copy is the statue in Copenhagen, but others exist, including a large number of busts, since the portrait must have been popular among Roman intellectuals. The distribution of the over fifty replicas ranges widely but at least three (and perhaps the full statue in the Vatican) come from Athens, and one is from Cyrene. Other statues of the orator are mentioned by the ancient sources or are attested by inscribed bases, including one erected in Pergamon by the sophist Polemon of Smyrna during the Hadrianic period; but since the standard head type is found at least twice with the body type described by Plutarch's anecdote, it follows that the many extant copies repeat the Athenian monument, from which all subsequent versions might have been derived.[15]

The four or five copies of Perikles' portrait seem few indeed when compared with the mass of Demosthenes' replicas. Kresilas, if the statue copied is truly by him, should have been more famous than an early Hellenistic artist by whom nothing else is known; it was therefore not the fame of the respective sculptors but the importance of the subject to the Romans which determined demand and consequent production. It could also be argued that the relative numbers are dependent on accessibility, yet this can not have been the case. Once one copy had been obtained, all

subsequent replicas could have been derived from it. We should rather believe that Perikles did not carry the moral and rhetorical connotations of a Demosthenes for a Roman clientele.

The sculptures we shall consider next have also been connected with some specific monuments cited by Pausanias, but the degree of certainty is much less. I shall discuss them in order of diminishing likelihood.

The Temple of Ares, moved from the deme of Acharnai to the center of the Athenian Agora during the Augustan period, housed an image of the god seen by Pausanias who states it was made by Alkamenes (1.8.5). It has been generally assumed that this was the cult image for the fifth-century temple: the date of the building, the fact that it was by the same architect of the Hephaisteion,[16] for which Alkamenes had also provided the cult statues, and the general chronological range of the sculptor, militate in favor of this hypothesis although no ancient document exists to support it.

Since the subject is rare in Greek art, Alkamenes' Ares has been identified in the so-called Borghese type, of which some twenty replicas exist.[17] The god, in "Attic" stance open diagonally to the proper right, is shown youthful and beardless; some versions give him a shield on the left arm, others make him hold a spear; helmet and longish hair are distinctive features of the head. This iconography of the god of war may have been introduced by Pheidias and his circle; it certainly existed by the time of the Parthenon frieze, which depicts Ares equally beardless and without body armor, albeit seated, as required by the context. The Borghese type averts his eyes from the viewer, but this trait alone is not enough basis on which to reject an original cult function. In its favor speaks instead the fact that several Roman emperors, including Hadrian and perhaps Commodus (plate 79), chose the body as a stock type for their own portraits, either alone or in combination with an Aphrodite figure which reinforced the allusion.[18]

The popularity of the Ares Borghese within Roman circles is somewhat surprising in consideration of the fact that the typical Mars was depicted in full armor and heavily bearded: a mature figure, as befitting the father of Romulus and Remus and hence of the Roman people. We must assume that the youthful type had a special meaning which we can no longer fathom (since it was not necessarily used only by younger emperors, nor just by philhellenes). The original was perhaps copied at the time when the Attic temple was transferred from its original position to the center of the marketplace, since no Hellenistic replica is yet known of the type, and it may not be a coincidence that inscribed statue bases from Athens hail Gaius Caesar and Tiberius's son Drusus Caesar as "New Ares."[19] Alkamenes was probably an Athenian and

was certainly a student of Pheidias: his Ares, with its distinctive stance, could easily be the best exponent of Attic virile sculpture around 420 B.C. Yet one peculiarity should be mentioned in this context: the Ares' striking similarity (barring head and respective attributes) to the so-called Diskobolos by Naukydes (plate 80).[20]

To be sure, the attribution of the athletic figure to Polykleitos's student is based purely on Pliny's mention that the Argive sculptor made a diskobolos; it could even be disputed on the basis that the marble replicas thus identified show a youth carrying, not throwing, the discus—a Diskophoros rather than a Diskobolos. The head type of the athlete is small and roundish, in keeping with an early-fourth-century date and quite different from the elongated visage of the Ares. Nonetheless the poses are remarkably similar, although Naukydes should be a representative of the Peloponnesian school and Alkamenes of the Attic one. It seems therefore worth mentioning, in this connection, what may be a revealing coincidence in another context.

In July, 1964, during the laying of a water main in the general region of the Olympic Stadium (built by Herodes Atticus) in Athens, a chance find produced seventeen bronze statuettes of various sizes, which have since been known as the Ambelokipi bronzes from the name of their findspot. The bronzes have been dated to the second/third century after Christ, and were discovered in the proximity of a cache of sixty-six lamps of the fourth century or later. The official publication has yet to appear, but preliminary notices suggest that the bronzes copied famous originals of the classical period, although some subjects (Harpokrates, Serapis, a barbarian depicted as a juggler) seem in keeping with a later date. The statuettes have been cleaned and are now on display in the Athens National Museum.[21]

Among the classical types we can recognize Myron's Diskobolos, a Poseidon of the Lateran type, a fairly large Apollo Lykeios type and a Hermes holding a ram under one arm. But the most interesting for our purposes is a statuette (0.31 m high) of the Doryphoros holding a spear and wearing a crestless helmet. The addition of this headgear turns an athletic figure into a warrior or an Ares, despite the unmistakable pose. It is legitimate to ask whether some similar transformations may not have occurred in the case of "Naukydes' " Diskobolos and Alkamenes' Ares. The helmeted imperial portraits on the body type would suggest that the Ares identification was the prevalent one, after the cult image, so that the athletic contamination would be a secondary manifestation. In light of this possibility, however, it would be best to dissociate the diskophoros from Naukydes' name and to consider it, at most, a variant of Alkamenes' Ares originating

in Attic, if not just in Roman, circles. We shall have occasion to discuss again this phenomenon of eclecticism that combined different heads with different bodies to create new statue types.[22]

Alkamenes is also credited with having created the cult images for the Temple of Hephaistos, once again on the grounds that statues of the smith god were rare and that the Attic sculptor was known to have made one. Only one herm and one torso seem possible replicas of this presumed masterpiece, and I find such evidence all too tenuous for a definite attribution. The same applies to the Athena, which has been variously recognized in the so-called Cherchel or in the Velletri type. I do believe that the Velletri Athena copies a definite Greek prototype of ca. 420 B.C., since too much correspondence exists among replicas, from colossal to diminutive, to be fortuitous. I am not sure, however, whether the original stood in the Hephaisteion or in some other temple or location.[23] Ironically enough, the accounts for the construction of the two cult images in the Hephaisteion have survived, so that we know the exact date of their erection (421/0 to 416/5 B.C.), and can even calculate the amount of lead involved in the manufacture of the peculiar *anthemon* which accompanied the two divine figures. But the sculptor is not named and the visualization of the actual statues, to my mind, remains nebulous. Only the central group of the figured base, with the Birth of Erichthonios, has been preserved for us in Neo-Attic reliefs, yet here too sketches were probably used to reproduce the crucial scene.[24] Since the Temple of Hephaistos does not seem to have undergone major repairs until the thorough remodeling of the interior in Christian times, and since the cult images were among the latest features to be completed in the long-ranging history of the building from its inception (ca. 449 B.C.), we may perhaps surmise that no opportunity arose for the two cult statues to be copied. Extant herms of Hephaistos may as easily reproduce the Roman Vulcan, and some bearded heads with a pilos could even represent Odysseus, who is occasionally depicted with the short *exomis* typical of artisans, equally appropriate to Hephaistos. As for the Athena, as long as a clear connection with the Hephaisteion cannot be established, it seems best to refrain from pinpointing the sculptural types of such a popular goddess.

Pausanias states that two statues of Apollo, beside the cult image, stood in front (within the pronaos?) of the temple of Apollo Patroos: one made by Leochares, and one, by Kalamis, called the Alexikakos because it had freed the Athenians from the plague. The latter has occasionally been connected with the Omphalos Apollo type, of which approximately twenty-six replicas exist, including one almost complete from the theater of Athens (plate 81).[25] But this work belongs undoubtedly to the severe period, while the plague coincided with the beginning of the Peloponnesian War, around 430/29 B.C. To retain the identification we should either disregard Pausanias's notion or think in terms of another evil which the god might have averted. The question should therefore remain open. As for the Apollo of Leochares, no true grounds exist for attributing to that master the Belvedere type (see plates 96 and 97), which we shall discuss later in a different connection and which, at any rate, seems to be represented by only one replica.[26]

A frequently copied piece was the bronze Hermes Agoraios, seen by Pausanias near a gate and the Painted Stoa; indeed Lucian (*Iupp. Trag.* 33) mentions that it was smeared with pitch all over from the frequent casts taken of it. It is however impossible to determine which of the numerous Hermes types should be the Agoraios, since the epithet was shared by images of the god in marketplaces elsewhere, for instance at Sikyon (Paus. 2.9.6). A late source implies a pre-Persian date for the erection of the Athenian Hermes and, despite the *opinio communis,* Lucian's and Pausanias's words could even refer to a herm rather than to a full-sized figure.[27]

Finally, in front of the Metroon, Pausanias saw the monument of the Eponymous Heroes. Since they were also represented in the Marathon dedication by the Athenians at Delphi, one could assume that the same types were repeated in both places; this however cannot be proved and at any rate we have no idea what the Delphic figures (by Pheidias) looked like. The recent study by Uta Kron has concluded that indeed the latter were not copied in antiquity, because of their location. Some young and some mature men on the East Frieze of the Parthenon, standing next to the seated deities, have been identified as the same Eponymous Heroes, and an occasional Roman statue has been given a hero's name on the basis of its similarity to one or another of the Parthenon figures. But the connection between the latter and the Agora statues has yet to be proven, not everybody agrees that the Parthenon frieze depicts the Attic heroes, and finally the presumed Roman copies could derive from other sources. All in all, not enough evidence exists for identification and the Agora monument, behind its railing and on its lofty pedestal, may well have been inaccessible for copying. Alternately, the subject matter probably held no appeal for the Romans.[28]

Greek Originals Surviving, but Not Seen by Pausanias

Various sculptures of the Greek period have been found by the American excavations of the Athenian Agora, but we cannot correlate them with Pausanias's account, either because he did not see them, or be-

cause he disregarded them. Yet some of them may be quite important for our study.

We shall have to bypass all record and votive reliefs, even when they represent well-known types, because they belong to the history of Greek, rather than of Roman, reproductions. We can also dismiss the many herms, or the fragments of archaic sculpture which obviously rolled down from the Akropolis in later times or were transferred from the Kerameikos. A headless Athena and a male torso which had once been attributed to the Hephaisteion pediments have now been reclassified as freestanding because of their different marble, finish, and perhaps date, but they are too generic to permit identification in copies, although the draped deity seems quite familiar.[29]

A case apart is a fragmentary peplophoros which, when intact, would have been approximately 4 m high. It could have been one of the cult images for the Southeast Temple, and a comparison has been made with the Demeter in the Capitoline usually attributed to Alkamenes, that may reproduce the same type. It is still uncertain, however, whether the Athenian statue is Greek or Roman in date, and I suspect that the Capitoline Demeter may be a Roman creation in classical style. In addition, Harrison has noted that "several adaptations but no exact replicas" exist among the statues usually grouped with the Demeter in Rome.[30]

Definitely fourth-century in date, however, is the beautiful torso of the colossal Themis found before the Royal Stoa. The identification is confirmed by its resemblance to the smaller figure of the same goddess signed by Chairestratos and found at Rhamnous, where Themis had a special cult. It has therefore become apparent that the Rhamnous figure was a deliberate Hellenistic quotation of an earlier Athenian monument. No true copy of the type is known, although a related figure, with a triangular "apron" and a cornucopia, was used as a Tyche type in other cities and is known from approximately twelve Roman replicas. That a cornucopia may have formed part of the Athenian statue is suggested by the presence of holes for the attachment of a metal attribute.[31]

A last group of original sculptures would seem, at first consideration, to be unprofitable, yet this is not the case. I refer to the many marble akroterial figures found within the limits of the Agora. Aside from the flamboyant marble Nike which is generally attributed to the Stoa of Zeus, and from the "Nereid" in transparent chiton, other fragmentary figures in the National Museum in Athens have been tentatively connected with the Temple of Ares. Of these, the central peplophoros with wind-blown drapery remains unknown through other replicas, but some Nereids on dolphins exist also in Roman copies from Crete (plate 82), which repeat the theme with slight modifications. The matter is at present under study and only brief prelimi-

nary mentions have been published. Given the difficulty of copying an akroterion standing in its lofty position, we would have to assume once again that the reproduction was made possible by the transference of the building from its original site. That Crete had repeated contacts with Athens is shown by the pattern of distribution of many other replicas, as already mentioned, and will be further discussed later on.[32]

Roman Copies of Greek Originals Standing Elsewhere

As at Olympia and Delphi, so within the Athenian Agora sculptures of Roman date were found which undoubtedly copied works erected in other areas.[33] Some of them came from the Kerameikos workshops in various states of finish, like the bust of the so-called Eubuleos which retains the distinctive measuring points of the copying process. Others, like the herm of "Paionios Nike" and the tritons (see plate 52) and giants from the Odeion of Agrippa, have already been discussed in connection with the Athenian Akropolis. We may add a slight variant of the Aphrodite Naples/Frejus (plate 83), completed with a water jug and appropriately found near the nymphaeum in front of the mint and next to the Southeast Temple. The original was obviously a famous monument in antiquity, since it was used as a stock body for Roman portraits and in a variety of other arrangements, including an adaptation of Hellenistic date and a probable citation in the Venus Genetrix made by Arkesilaos for Julius Caesar.[34]

This type reappears quite frequently among the many statuettes from the Agora, which are largely still unpublished. Indeed Aphrodite seems to be the favorite subject for much of this miniature sculpture, some of which is unfinished and gives further witness to the closeness of the Kerameikos workshops. Conversely, however, no inference as to the proximity of the original monument to the Agora can be made from such finds. Other works reproduced at smaller scale are in fact the Aphrodite of Knidos (see plate 22), and a type with mantle covering only one of the goddess's legs.[35] Similar in its reduced size but remarkable for its quality and unusual medium is an Apollo Lykeios in ivory, after a type that has been attributed to Praxiteles, but which has proven difficult to define, given the many variations among the replicas.[36] All these smaller figures, however, cannot rank as direct copies and have purely antiquarian interest for our topic. It is also debatable whether the various Hekataia recovered from the Agora should be included in the present group: some of them are small, but a few are of considerable size. We cannot be sure, however, that they reproduce the Hekate Epipyrgidia or—what may be one and the same monument—the three-bodied

Hekate said by Pausanias to have been first depicted by Alkamenes. Hekataia must have formed such a common feature of Athenian life that their presence in the marble workshops cannot surprise; the great variation among preserved examples (plates 84 and 85) indicates that the spirit, rather than the letter, of the image was followed.[37]

Roman Copies of Greek Originals Attributed to the Agora but Neither Found There Nor Mentioned by Pausanias

We should finally consider those monuments that are thought to have stood within the Agora, either through excavational evidence or on other grounds, and which are known to us through Roman copies. One such work is Karneades' portrait. An inscribed base has been found in front of the Stoa of Attalos, with the dedication to the philosopher by two of his pupils. Ariarathes of Cappadocia and Attalos of Pergamon sign without indicating their "foreign" origin, and equation with the famous Hellenistic rulers has at times been doubted. Such doubt seems nonetheless unnecessary, because Attalos II is known to have studied in Athens, and the erection of a large and costly monument would befit a future king with Athenian connections. The likeness of Karneades has survived in some (inscribed) Roman copies, which probably reproduce the seated Agora statue, but the philosopher was famous in his day, both in Athens and in Rome, which he visited as an official delegate, and we cannot be sure that only one statue of him existed.[38]

One more set of sculptures should be mentioned, although their original presence in the Agora is uncertain and, in this case, truly doubtful. Excavation of the square precinct around the Altar of the Twelve Gods had revealed that a parapet ran between posts over a low plinth. Only one entrance into the temenos is still attested, since the opposite side of the enclosure was destroyed by the building of the modern Peiraieus Railroad, but the published reconstruction postulated a symmetrical arrangement comparable to the two openings of the Ara Pacis. It was further assumed that the panels of the parapet on either side of each entrance were decorated with reliefs, and that available dimensions corresponded enough to identify such panels in the so-called Three-Figure Reliefs grouped together by most scholars. The attribution was strengthened by the belief that the Altar of the Twelve Gods, of appropriate late-fifth-century date in its parapet-ringed phase, was one and the same as the Altar of Pity, for which the subject of the reliefs would have been particularly meaningful.[39]

This last assumption has now been challenged by the dissociation of the two altars; that of Pity probably stood near the Roman market, as distinct from the Altar of the Twelve Gods. It was pointed out in addition that *Eleos* should be translated not Pity but Mercy, thus making the connection between the reliefs and the cult quite tenuous. Finally, not only is the existence of a second doorway uncertain, but the carving of the extant reliefs (copied at the same scale, since their suitable dimensions were a strong point for the attribution) implies a viewpoint different from the one demanded by the low position on the parapet plinth. A recent suggestion advocates that the originals of the Three-Figure Reliefs formed part of a funerary monument, probably for a tragic poet, and that they once stood almost at eye level. But no agreement has yet been reached, either on the nature of the reliefs or on their deeper meaning.

Of the four compositions, the best known is that with Hermes, Orpheus, and Eurydike (plate 86), the least that with Herakles, Peirithoos, and Theseus. Herakles in the Garden of the Hesperides has now been reinterpreted as Herakles at the Crossroads (plate 87), a definite possibility in fifth-century Athens.[40] The Peliads relief was for a long time known through a single replica, in the ex-Lateran Collection (plate 88), of such outstanding workmanship that it had been considered either an original or a Late Hellenistic copy. A fragment from a second replica has been however recognized at Corinth—the only one of the entire series to have been found in Greece proper.[41] Since, as we shall see, Corinth has yielded other examples of Neo-Attic reliefs connected with Athenian monuments, we can assume that also the Peliad panel was imported directly from Athens but we are no closer to visualizing the exact location of the original. To my knowledge, classical funerary monuments with nonmythological content were not copied, although a few Roman tombs reused, or echoed themes of, classical gravestones.

This brief discussion of the Three-Figure Reliefs terminates our review of sculptures from the Athenian Agora. Many more items were found by the American excavations, including a large number of Roman portraits of outstanding quality, but their affiliations are irrelevant to our topic. Other omissions can be justified on grounds of pending publication, but even new finds are not likely to alter considerably the picture we can form at present. In summary, although only three Agora monuments can be securely identified as having been copied in Roman times—the Tyrannicides (see plate 10), the Eirene and Ploutos (see plate 76), and the Demosthenes (see plate 77)—they are sufficient to prove that sculptures within the Agora were accessible to copyists. The question therefore arises as to the nature of the area.

That the Agora was not simply a marketplace is well known, although commerce was certainly one of its functions. Agonistic events and theatrical as well as

political manifestations took place within it, and a certain religious connotation was lent not only by its many temples and altars but also by the *horos*-stones, which imply a sacred area.[42] Yet an agora was not a closed sanctuary, like the Akropolis, and although individual offerings could be set up at altars and temples, it is unlikely that monuments erected in open spaces had the character of private dedications, even when, as for the Demosthenes, they were promoted by a relative. They were, rather, public statements meant to honor important citizens or to flatter powerful rulers—and for which official permission was probably needed. We could thus explain the accessibility of the Tyrannicides and the Demosthenes, which can both pass as state monuments. The case is more difficult for the Eirene and Ploutos, which must have possessed religious significance, since a cult of Peace was instituted in Athens in 375/4.[43] Perhaps in this case the allegorical value of the two personifications and their public location took precedence over cultic meaning. Since the original group stood in the open air, it may have ranked with the Tyrannicides, to whom hero honors had been granted. Finally, it should also be remembered that the status of the Agora, as contrasted with that of the Akropolis, had changed in Roman times.

Before leaving the Athenian Agora we should mention some sculptors' signatures found in the excavations. The fourth-century Praxiteles made the statue of Kleiokrateia, whose husband Spondias was immortalized by another sculptor; only a few letters survive from the latter's signature. Theoxenos of Thebes made the statues of Physteus of Acharnai and his wife Peisikrateia, dedicated by their son Demopeithides during the second half of the fourth century B.C. From Roman times we have a Jason of Athens who signed the statue of the Odyssey, still extant but entirely Roman in its conception.[44] That Praxiteles made one portrait statue, perhaps more, may be significant for our evaluation of the fourth-century master. Another such monument, perhaps of an athlete, also by Praxiteles, stood in Thespiai, as attested by the signed base. Finally, Pausanias tells us that a gilded portrait of Phryne by the master was at Delphi. That it was the statue of a mortal has been doubted because of the gilding, which may suggest an Aphrodite to which the courtesan's name was later given for anecdotal reasons. But Athenaeus (13.591B) mentions the same story, and a recent theory advocates that Praxiteles *specialized* in the making of portrait statues, particularly of initiates in the Eleusinian mysteries—a theory largely argued on the evidence of the Agora bases and their relative location near the Eleusinion.[45]

That Praxiteles came from a family of sculptors is easily surmised through the recurrence of certain names among surviving masters' signatures. They attest to a fifth-century Praxiteles, whose son Kephisodotos was probably the father of the fourth-century artist. In turn, Praxiteles' sons were named Kephisodotos and Timarchos, and these names too continue down through the centuries. Praxiteles' sons are known to have made the portrait of Menander (see plate 43), thus continuing what may have been a family specialization. Were we to conceive of *the* Praxiteles as primarily a portraitist for the religious middle class of Athens, we would derive a different picture of the master from what is held at present.

The other side of that picture may be quite dissimilar. Judging by the liturgies entrusted to Praxiteles' son, Kephisodotos the Younger, Lauter has suggested that not only he but the entire family must have been quite wealthy. Since, moreover, the younger Kephisodotos may have exercised his profession rather late in his life, he must have supported himself on accumulated capital prior to that time. We shall return to Praxiteles later on.[46]

Evidence from Other Athenian Monuments

The fragmentary Peliad relief mentioned above (see plate 88) is not the only Neo-Attic work from Roman Corinth: aside from possible replicas of the Parthenos and of the scene from the Parthenon east pediment (or the Parthenos's base), the site has yielded also an almost complete slab with one of the Frenzied Maenads usually attributed to Kallimachos.[47]

This monument, one of the most frequently reproduced in ancient times, is of difficult localization. We are not even sure how many Maenads danced originally around the possibly circular pedestal, since Roman ateliers are well known for their ability to duplicate subjects in mirror image, or to produce comparable figures to increase numbers to a desired total. The distribution of the Maenad reliefs is so wide that no meaningful pattern can perhaps be derived from it; nonetheless the existence of one such Maenad panel in Corinth (and of several in the Peiraieus) could confirm an ultimate origin from Athens. The subject of the frenzied creatures dismembering animals may well connect them with a choregic monument, perhaps after Euripides' *Bakchai;* that they decorated the base of Alkamenes' chryselephantine Dionysos mentioned by the sources seems today less probable in view of the fourth-century date assigned to the temple of that god near the theater, and in consideration of the fact that other statue bases in fifth-century Athens seem to have displayed scenes of divine births—a subject that would have been appropriate also for the god of wine, whose birth was indeed miraculous.

Be that as it may, certainly the Athenian theater housed many important monuments, several of which seem to have been copied in antiquity. We need only

mention the imaginary portraits of fifth-century playwrights erected by Lykourgos in the second half of the fourth century, of which many replicas exist in appropriate style—especially the Sophokles of the so-called Lateran type (see plate 40), for which a body scheme is also preserved, rather than just a herm.[48] The Menander, for which only one head type remains (see plate 43), is likely to have been the statue by the sons of Praxiteles, whose signed base has been found in the theater. The portrait was one of the most popular in antiquity, and continued to be made as late as the fifth century after Christ. Over sixty-three examples of the head are recognizable, despite all possible variations. Here too it is significant that Corinth has produced a veristic rendering of the poet which finds its closest parallel in a portrait from Athens itself.[49] If the original monument stood nearby, would copyists have dared to alter the features of their replicas to such an extent? Should we rather assume that the original was already realistic in its rendering of an ascetic and emaciated man, and that the copies which depict him with smoother traits have been deliberately made more classical, therefore classicizing? The question cannot be answered in this context, but is of considerable interest.

Another work suitably connected by subject and finds with the Athenian theater and, once again, with Corinth, is the Dionysos of the "Sardanapalos" type, although the location of the original cannot be ascertained. The Late Hellenistic replica found in the theater is the closest to the Imperial one from Corinth; the distribution list of the replicas includes some colossal statues in Rome and a statuette from Knossos, thus confirming that link between Athens and Crete already noted.[50]

Finally, from the Athenian theater comes also a torso (plate 89) of the Aphrodite of Arles type. The name derives from the fact that the most famous example was found in Arles (plate 90), in the Augustan theater of the French city, and there is a possibility that this semidraped Aphrodite is itself classicizing, not a classical creation, perhaps specifically meant for theatrical surroundings. In such case, the torso in Athens may be the Late Hellenistic prototype from which the Arles statue would be derived. Other examples come from Rome.[51]

On this cumulative evidence, it seems reasonable to assume that monuments housed within the Theater of Dionysos in Athens could be, and were, copied. Like the agora, the theater possessed some religious connotations, but its civic and public aspects may have predominated, at least by Late Hellenistic and Roman times.

Of the many other monuments erected in Athens and reflected in the Roman copies little can be said. Certainly Epikouros's portrait is likely to have existed also in the city where he taught, but the literary sources mention primarily statues in his native Samos, and one inscribed base of the second half of the second century B.C. has been found on Cyprus. The echo of one major portrait has come down to us in the many Roman replicas, including a possible image of the seated body and thus of the total composition, but we have no way of knowing where the original was.[52] A portrait of Sokrates, by Lysippos, was in the Pompeion, but the type has been identified only on stylistic grounds.[53] The already mentioned Apollo Lykeios is attested through Athenian coins from 50 B.C., and may have stood in the philosophy school–gymnasion of the Lykeios—hence his name—although no consistency exists among the various replicas.[54] Finally, one more monument, the famous Herakles Farnese (see plate 99), has been claimed for Athens (even for the Agora) on numismatic evidence, but earlier coins of Sikyon—late-fourth-century silver tetradrachms of Alexander the Great—show the typical silhouette of the resting Herakles as diminutive mint mark.[55] That small marble and bronze versions of the type have been found in the Agora excavation is not per se indication that the original adorned the Athenian market place, since this is one of the most—as well as the earliest—copied monuments of antiquity. Two unfinished marble statuettes of the Farnese Herakles have been found on Delos, usually so poor in copies of famous monuments, and another, in bronze, comes from Hellenistic Pergamon. The Antikythera wreck, as will be recalled, included a massive marble replica of the muscular kind, another served as portrait of the emperor Commodus, still another was made for a vast hall in the Baths of Caracalla, and almost one hundred replicas in various sizes are now known. By the third to fourth century after Christ, imperial coins of Asia Minor showed the type, presumably on the basis of copies within Asiatic cities.

Where was the original of the Farnese Herakles? The Sikyonian coins combine with a mention in Pausanias to suggest that it stood not far from the Sikyonian agora (although not *in* it, as normally believed) and was made by Lysippos.[56] That the work was so often copied was probably not due simply to its location and to the fame of its maker, but also to the subject matter which greatly appealed to the Romans.

Monuments Set Up in Other Cities and Sanctuaries

At this point we might review—rather haphazardly—whatever few monuments, albeit known only through Roman copies, can be definitely localized on the Greek mainland and elsewhere on Greek territory. A peculiar instance, although revealing in its implications, is that of another statue by Lysippos, the Kairos

or Opportune Moment. The subject, with its outlandish features of a bald head in the back, a long forelock in front, a tiptoe stance on winged feet, a scale balanced over a razor edge, has easily been recognized through description in ancient sources and at least three replicas in relief format. Perhaps the Kairos was so precariously balanced that no marble figure in the round could adequately copy it and Roman workshops had to translate it into a two-dimensional image. Yet an epigram by Poseidippos, writing just a generation after the sculptor's death, explains that the Kairos had been placed in his maker's *prothyron* to serve as a *didaskalia,* a didactic statement to his fellow men. This specific account, so close in date to the erection of the bronze, should serve to eliminate the theory, based only on vague allusions, that the Kairos stood in the Temple of Zeus at Olympia. It has been convincingly argued, instead, that it was kept in front of Lysippos's house in Sikyon not only as a moralistic message but also as an advertisement of the sculptor's art. We would therefore have here a definite case in support of our theory on Polykleitos's Doryphoros.[57]

Lysippos is also known to have made a bronze Eros for Thespiai—a city which venerated that god above all others (Paus. 9.27.1-4)—as his contemporary Praxiteles had made one of stone, later taken to Rome and replaced with a copy. The Lysippan Eros was still at Thespiai when Pausanias visited the site; but it has been identified (purely on stylistic grounds) in a childish figure with a bow (plate 91) often reproduced by Roman copyists. The subject was certainly most popular with the imperial clientele because it lent itself so well to the decoration of gardens and villas, without retaining the religious connotations undoubtedly associated with the Greek cult. If, however, these works indeed duplicate Lysippos's bronze, we should admit that the Thespian sanctuary, at least, allowed direct copying.[58] The Praxitelean Eros, which Cicero and Pliny mention as a veritable tourist's attraction, has not been convincingly identified in any imperial work, and we know that after being taken by Nero, it perished by fire (Paus 9.27.3), but neither do we seem to have copies made after the substitute figure by the Athenian Menodoros in Thespiai.[59] The conclusions to be derived from this state of affairs are ambiguous and the problem should be tackled in depth, perhaps through a study of the distribution of copies after the "Lysippan Eros" type.

Other works, however, present the same difficulty for our general theory of religious restrictions, and must be here mentioned for a proper evaluation of the evidence. Major among them is the case of the Nemesis by Agorakritos, which was the cult statue for the temple in Rhamnous. Through his brilliant recomposition of the many original fragments in Parian marble, Despinis was able to recognize the type as preserved in eleven copies (plate 92), at reduced (human) size. By the felicitous juxtaposition of original and replicas we are able to judge the accuracy in rendering possible in Roman times. The body type was used—at least once—for a portrait head, but also with an idealized head type which however does not preserve the elaborate crown described by the sources for the original. None of the replicas, moreover, seems to retain the goddess's attributes. That the cult image was copied, and probably by mechanical means, is nonetheless certain.[60]

We could assume that the material—marble instead of a more precious medium—made for easier access, yet the contrary should be true, since molding must have been made difficult by the painted details. If, moreover, our surmise about religious taboos is correct, a better explanation for the copying is needed. To be sure, some religious respect for the statue must have prevailed, since it was not taken away to Rome (like its neighbor the Apollo Rhamnousios by Skopas, for instance), and yet the Romans traveled to Rhamnous to see it.[61]

The chronology and distribution of the eleven replicas of the Nemesis furnish a possible clue. The earliest and most accurate copy, now in Copenhagen, dates from the first half of the first century after Christ and comes from Italy. As we know from the architectural remains, the Temple of Nemesis at Rhamnous was extensively restored under Claudius and rededicated to Livia. It is perhaps at that time that the cult image was made accessible and even utilized for a portrait of the divinized empress. This is not to say that Agorakritos's image had its head replaced with Livia's portrait, as for instance was done with Apelles' painting of Alexander whose head was replaced with that of Augustus by Claudius. But it is likely that a first reduced version of the Nemesis with Livia's head was made for export to Rome.[62] Once a cast of Agorakritos's work was made available, the type continued to be reproduced, even within Greece itself. Of the replicas, which range from Claudian to late Antonine times, one comes from Athens, one from Patrai, one from Messene, one from Crete (now in Istanbul) and one even from Albania. The continued presence of the original at Rhamnous implies that the accuracy of the reproductions could be verified and, conversely, that the quotation could be understood albeit out of its natural context and deprived of divine attributes.

The Nemesis temple is the fourth in a sequence of buildings attributed to a single architect. Although this theory has now been challenged, it is intriguing that the cult images of three out of the four have been recognized—or at least tentatively identified—in Roman copies, but no such attempt has been made for the fourth temple, that of Poseidon at Sounion. Pausanias may not have visited the site in person, since he

seems to confuse the Temple of Athena with the one on the promontory; it would be strange, however, if the religious building had no cult image. That no Poseidon type has been readily connected with the Sounion temple may be due to our imperfect knowledge; it may also imply that no copying was possible, that not all cult images were worth copying, or even that no interest was attached to the specific god.[63]

This last hypothesis runs counter to the possible equation of the so-called Lateran Poseidon with the statue that stood at the entrance to the Lacheion, one of the two harbors of ancient Corinth. Usually attributed to Lysippos, and once even connected with the master's signature on a base in Corinth itself, this image of Poseidon with right foot propped on a rock (or on a ship's prow), is known through several bronze statuettes, including one from Pella (plate 93) and a much later one among the Ambelokipi finds. Several marble replicas also exist, as well as numismatic representations which have prompted the attribution to the Corinthian harbor. The public location would have allowed direct copying without special permission.[64]

Yet other instances are known of statues within shrines for which copying undoubtedly took place. The prime example is that of the Aphrodite Knidia by Praxiteles (see plate 22). The type has been definitely identified through representations on coins, although many variants of it also exist. It was among the earliest copied works, not only in Hellenistic adaptations, statuettes, and free renditions, such as the famous Kaufmann head, but also in "true" replicas, one of which, for instance, has been identified among the Antikythera marbles. Yet direct molding should have been made impossible by the skillful and important painting of the surface.[65] A passage in Pseudo-Lucian (*Amores* 13–14) hints at difficulties in approaching the original, and at the presence of double doors to the temple, in order to allow some visitors a view of the figure's back. From this very source, therefore, one derives the mental picture of a traditional, rectangular cella which could exceptionally be entered through a rear door. Yet a statement in Pliny (*NH* 36.20) contradicts this impression, and excavations in Knidos have revealed the foundations of a round monopteros most likely to be the Aphrodiseion—a plan confirmed by the find of a replica of the Knidia within a round colonnade at Hadrian's Villa. On this admittedly tenuous basis, we could suppose that the original round structure was later closed and transformed into a tholos to restrict an all-round viewing of the famous image. The transition from one form of structure to the other could have offered the opportunity to duplicate Praxiteles' Aphrodite. Logically, however, the progression should be reversed, from more to less limited viewing, as fame of the image spread, and especially to judge from the stylistic traits of the statue as seen in

the Roman copies. Front and back views are definitely more satisfying than the two profiles; indeed, the composition appears narrow and almost out of balance from that specific viewpoint, as contrasted with the restful stance of the front and the sinuous curve visible from the back.[66]

Another image which may have cultic connotations is the Tyche of Antioch by Eutychides (plate 94), recognizable in several statues and statuettes. In this case it is perhaps improper to speak of replicas, since too much variation exists among them; yet the prototype is unmistakable. The rock on which the deity sits is undoubtedly the graphic rendition of the high location of the city itself, on Mount Sipylos; the youthful god in powerful swimming motion at the foot of the rock is certainly the river Orontes, circling the Sipylos. Regardless of whether the original statue stood (probably inside a water basin) within or without a temple structure, copyists must have seized on the main features of the monument, which were then adapted for many other allegories of cities from antiquity to our own days.[67] Other monuments attributed to cities in Asia Minor and Egypt have been tentatively recognized in Roman marbles, but each case could be debated. Yet the Aphrodite Knidia and the Antiochian Tyche are two indisputable proofs that sculptures outside of Greece proper were copied.

One final monument should here be mentioned, although its proper nature has not yet been established: the Great Eleusinian Relief. It was found reused as paving slabs within a church in Eleusis, but its unusual size has prompted the theory that it served almost the function of traditional statuary in the round, for a building, the Telesterion, which did not correspond to the standard temple. Yet literary sources mention colossal reliefs of the classical period as private or semipublic dedication, and Eleusis itself has yielded other examples at comparable scale albeit of later date (e.g., the Lakrateides relief).[68] The mythological subject would be equally appropriate for a cultic as for a votive relief, and it has been suggested that the youth between the two goddesses may not be Triptolemos but should rather represent a Hearth Initiate, or even the establishment of the office as part of the Eleusinian mysteries. Given the large size of the slab and the close correspondence of the copies, including a highly fragmentary one in Corinth, we must assume exact duplication; that some of the replicas are in terra-cotta implies a decorative use of what originally had religious meaning. Accessibility can only be surmised, and the case must remain as an example of copying that defies my basic premise, even if sketches cannot be excluded.

A summary of the evidence presented so far would suggest that public places, including some with religious connotations, were accessible to copyists, not

only in Athens with her schools of carving, but also in other cities, which should however have had some local marble workshops, given the extensive program of embellishment and the strict connection between sculpture and architecture during Roman times. In addition, some cult images in temples were definitely duplicated, but in most cases a temporary closing of the structures could be postulated, thus permitting access to the statue of the divinity while religious rites were suspended. The types of statues selected were obviously of those gods that were worshipped by the Romans themselves: the agrarian divinities, Nemesis as a form of Aphrodite, Aphrodite/Venus, and Tyche as the personification of a city. One more god, Asklepios, had widespread cult among the Romans, and in fact his image reflects a standard iconography. I find it difficult, however, to pinpoint the location of the original or the name of its maker, although several suggestions have been made. The Asklepios Giustini type was certainly most popular, but the seated image at the main cult site, in the Temple at Epidauros, perhaps because in gold and ivory, has not so far been recognized in any copy.[69]

Subject matter—even more than material or location—seems therefore of primary importance in determining whether a statue was or was not copied. But can we automatically assume that each Roman marble of suitable subject and in Greek style duplicated a Greek original somewhere? How should we define copying? An answer to these questions will be attempted in the final chapter.

Notes

1. On this anecdote see also supra, p. 22. That Lucian is speaking of copies is also stressed by Vermeule, *Sculpture and Taste*, pp. 7–8. Note, moreover, that the ancient dialogue satirizes the boastful liar, and therefore no credence should be attached to the description of locale, despite the fact that Lucian spent considerable time in Athens: the villa of the dialogue could be visualized almost anywhere in Greece.

2. On Polykleitan influence see supra, chapter 1 and n. 21, for the different dates assigned to the relief from Argos.

3. That the Doryphoros is no specific individual but the exemplification of the canon is a point also made by L. Beschi in *EAA* s.v. Policleto, p. 268, who favors a location of the statue in the sculptor's workshop in Argos. The point of supernatural size is made by M. Robertson (*Shorter History*, p. 115) for the Diskobolos by Myron, to support his belief that the statue was not for a victorious athlete.

For a discussion of the Doryphoros's canon see R. Tobin, *AJA* 79 (1975): 307–21; see also Ridgway, *Fifth Century Styles*, p. 203, fig. 128, for a diagram of the balancing forces in the composition.

4. Doryphoros from Palestra and Pompeii: Robertson, *Shorter History*, p. 113, fig. 155.

Statuette of Doryphoros type with portrait of Hellenistic ruler, from Pompeii: Zanker, *Klassizistische Statuen*, p. 9, no. 6, pl. 5.2 (late second/early first century B.C.). The same piece is cited by E. J. Dwyer as a representation of Mars, on the basis of comparison with wall paintings: "Sculpture and its Display in Private Houses of Pompeii" in *Pompeii and the Vesuvian Landscape* (Symposium of the AIA and the Smithsonian Institution, Washington, D.C., 1979), p. 62 and nn. 54–56.

Pergamon statuette; D. Pinkwart, *Pergamenische Forschungen* 1 (Berlin, 1972), pp. 131–39; only the pose is Polykleitan; the body has been covered with a cuirass and the bearded head is helmeted.

Doryphoros from Corinth: *AJA* 30 (1926): 462, fig. 15; both legs from the knee down and the left foot to above the ankle were found together with the head.

Among the Baiae casts, some fragments were identified as belonging to the right arm of the Doryphoros: *Abgüsse* 53, no. 134. There are at least two full-scale marble replicas of the Doryphoros at present on the antiquarian market or in private collections, but they are unpublished.

5. The sculptures of the Agora are primarily known through excavation reports and occasional articles in *Hesperia*. The two volumes in the *Agora* series so far devoted to sculpture, 1 and 11, cover the Roman portraits and archaic and archaistic sculptures respectively. My survey is therefore far from being complete.

6. The main publication of the Agora statue is H. A. Thompson, "The Apollo Patroos of Euphranor," *ArchEph* 1953–1954 (publ. 1961) 3, pp. 30–44. He states that no exact copy of the Apollo is known, but gives a list of free adaptations: pp. 33–36. For a more recent list and discussion see O. Palagia, *Euphranor* (Leiden, 1980), pp. 13–20. Both authors acknowledge that the only large replica, though not as large as the original and considerably different from it, is the Apollo in the Vatican, Sala a Croce Greca. The others, reliefs or statuettes, are mere echoes. For the small-scale reproduction signed by Chairestratos, in Delphi, see chapter 1, n. 27.

7. On the Rhamnousian Apollo as depicted on the Sorrento base see Palagia, *Euphranor*, p. 17, where the figure is considered more flamboyant than the Patroos and iconographically not attested earlier than the first century B.C.

The Apollo Patroos of the Agora has been recently compared to the bronze Artemis from the Peiraieus to prove Euphranor's authorship of the latter: G. Dontas, *AntK* 25 (1982): 15–34. Palagia had already attributed to Euphranor the Peiraieus Athena: pp. 21–23.

8. Agora Aphrodite S 1882: E. B. Harrison, *Hesperia* 29 (1960): 373–76; see also Ridgway, *Fifth Century Styles*, pp. 111–12, for additional bibliography. For a possible fragment from the Hera Borghese type among the Baiae casts see *Abgüsse*, pp. 36–37, fig. 45.

9. T. L. Shear, Jr., *Hesperia* 4 (1935): 384–87, figs. 11–14; *AJA* 37 (1933): 542–44, fig. 4. *The Athenian Agora* (Athens, 1976), pp. 183–85 (S 378) mentions the possible association with the Aphrodites cited by Pausanias, as well as a statuette version of the same type also in the Agora. This latter, like the Corinthian figurine, is accompanied by an Eros. There are, however, noticeable differences in type between the Rhodian and the other examples, suggesting derivation from at least two different prototypes.

The Rhodian material has been recently published by G. Gualandi, *ASAtene* 54, n.s. 38 (1976, publ. 1979), pp. 130–37, nos. 88–103; the deity is there considered Artemis/Hekate. For a discussion

of the Rhodian examples see also G. Merker, *The Hellenistic Sculptures of Rhodes* (SIMA 40, Göteborg, 1973), pp. 27–28, nos. 19–35.

Corinth replicas: Ridgway, *Hesperia* 50 (1981): 446, and n. 95 with further bibliography, pl. 96d.

Large scale replica with base inscribed to "Aphrodite Hypolympiada" from a sanctuary of Isis in Dion: *AA*, 1982, pp. 733–35, fig. 7.

10. Athena S 654: *AJA* 40 (1936): 196, 198, fig. 14; *Agora 14*, p. 164 and n. 246; *Agora Guide* (supra, n. 9), p. 201, fig. 104; W. B. Dinsmoor, Jr., suggests a possible connection between the Athena and the Southwest Temple: *Hesperia* 51 (1982): 437, nn. 51–52.

Hadrian: *Agora 14*, p. 101, pl. 53b.

11. Thompson, *Hesperia* 50 (1981): 348 and n. 26; *Agora 14*, pp. 121–23 and, on the Tyrannicides, pp. 155–58. For further references see chapter 2, n. 70.

12. That the Baiae cast may reproduce the Aristogeiton by Antenor, rather than the later statue by Kritios and Nesiotes, has been suggested by Ch. von Hees-Landwehr in *Abgüsse*, 24–26 Cat. p. 50 no. 7; cf. chapter 3, n. 7. The date of the original is however irrelevant to our point, that casts could be taken from bronze statues set up in the Agora during Hellenistic and Roman times. For the list of replicas and a discussion of chronology of the copies see Ridgway, *Severe Style*, p. 81, n. 1.

13. The latest discussion of the Eirene and Ploutos is Vierneisel-Schlörb, *Munich Catalogue* no. 25, pp. 255–66. To her references on the Panathenaic Amphorae under the archonship of Kallimedes add *Praktika* 1979 (publ. 1981), pls. 35–39, esp. 36, where the statue atop the column seems slightly different from the version seen on, e.g., the detail of another amphora, *AAA* 2 (1969): 414–15, figs. 4–5.

14. Delos variant: Marcadé, *Au Musée*, p. 181, n. 3, pl. 34, A 4127; M. Gernand, *AthMitt* 90 (1975): 14–17, pl. 15.2.

Variant in Rome: G. De Luca, *I monumenti antichi di Palazzo Corsini in Roma* (Rome, 1976), p. 19, no. 4, pls. 7–9; the connection with the Eirene and Ploutos is made by Gulaki, "Nikedarstellungen," p. 351, n. 771.

These two variants are not cited in the *Munich Catalogue*. On the links among the various sites and the meaning of the distribution of replicas see also infra, chapter 7.

15. Demosthenes: Richter, *Portraits* 2, pp. 215–23, figs. 1397–1513, lists a total of forty-eight heads, including one found in 1965 and mentioned in *Portraits Suppl.*, p. 7, figs. 1412a–c. Six more replicas are mentioned by E. Diez, *ÖJh* 50 (1972–1973): 1–7 and *GettyMusJ* 1 (1974): 37–42. One of the Getty portraits is an eighteenth-century version: Frel, *Getty Portraits*, pp. 104–5, no. 54; see also no. 40 for a Roman replica.

The base for a sizable statue of Demosthenes found in Pergamon is cited by Pekáry, "Statuen," p. 738 and n. 32.

16. I use the name Hephaisteion to indicate the temple that stood on the hill of Kolonos Agoraios, overlooking the Athenian Agora. The identification has been doubted by E. B. Harrison, who wants to see in it the Temple of Artemis Eukleia: *AJA* 81 (1977): 137–39, 422–26. Her candidate for the Hephaisteion seems, however, to be truly a Hellenistic structure with no forerunner: R. L. Pounder, *AJA* 84 (1980): 227.

For the transfer of the Temple of Ares see *Agora 14*, pp. 162–65; if H. A. Thompson is correct in stressing the coincidence of an Ares and an Athena appearing together on a fourth-century decree from Acharnai, the cult image of the temple would have been a cuirassed type trailing the left leg, totally unlike the pose of the Ares Borghese. This theory, however, has met with skepticism. That the temple was moved to be rededicated to Gaius Caesar, is suggested by T. L. Shear, Jr., *Hesperia* 50 (1981): 362 and nn. 26–28.

17. On the possibility that the cult image might have been different see Thompson, supra, n. 16. For the few opponents to the identification of the Ares Borghese as the cult image of the temple see also Vierneisel-Schlörb, *Munich Catalogue*, p. 183, n. 14. Hers is the most recent discussion of the Ares Borghese type: no. 16, pp. 178–85.

18. On the issue of the weapons see Vierneisel-Schlörb, *Munich Catalogue*, pp. 178–79; see also her n. 3 on pp. 182–83 for discussion of the type used for imperial portraits in conjunction with an Aphrodite figure. For the group from Ostia, the so-called Commodus and Agrippina, see Bieber, *Copies*, p. 44, figs. 107–9.

19. On the rededication and the statue bases see Shear, supra, n. 16.

On the bearded Roman Mars, especially as the cult image for the Augustan Temple of Mars Ultor, see, e.g., P. Gros. *Aurea Templa. Recherches sur l'architecture religieuse de Rome à l'époque d'Auguste* (Rome, 1976), pp. 166–69. Gros discusses also a type of beardless Mars (*Iuvenis*) but considers it inappropriate for a cult image, and known only in statuette format.

20. Naukydes' Diskobolos: see, e.g., Lippold, *Handbuch*, pl. 68.2. Arnold, *Polykletnachfolge*, pp. 110–31, thoroughly discusses the type and gives the outline of the footprints in fig. 35 (Vatican copy). Cf. those of the Ares Borghese given in *ÖJh* 9 (1906): 133, fig. 56. To be sure, the angle formed by the feet is more pronounced in Naukydes' Diskobolos, but the stance is closer to the Ares Borghese than to any of the other bases and footprints illustrated by Arnold in her review of statue bases. She herself admits (p. 110) that the attribution of the Diskobolos type to Naukydes is "as safe as that of any other based on later copies and literary sources."

21. Ambelokipi bronzes: *Deltion* 20 B1 (1965): 103–7, pls. 58–71, and fig. 36 on p. 104 for sketch of finds in place; *Deltion* 29 B1 (1973–74): 9, pl. 16b, for statuette of young Dionysos, cleaned and installed; *JHS AR*, 1964–65, p. 5, for a brief notice of the find. The Juggler has been published by S. Karousou, *ArchEph*, 1975, pp. 1–18, pls. 1–5. For the Sarapis bust see *BABesch* 52–53 (1977/78): 202–3, fig. 5. For some of these references I am indebted to Dr. J. P. Binder and to Artemis Hionides.

22. For the Doryphoros statuette see *Deltion* 20 (supra, n. 21), pl 62a. That the Doryphoros type could be changed into a Hellenistic ruler or a Mars has already been mentioned: supra, n. 4. The similarity between the Ares Borghese and the Diskobolos has been repeatedly noted, either to be accepted with surprise or to be entirely rejected. See Lippold, *Handbuch*, who juxtaposes the two statues on his pl. 68 (figs. 1 and 2 respectively) and comments on the formal connection of the Diskobolos with the Ares (p. 199), although the Ares' pose is considered Polykleitan: p. 186, n. 9. Linfert, *Von Polyklet zu Lysipp* (Giessen, 1966), p. 14, curtly dismisses the similarity as no hindrance to the attributions. Lorenz, *Polyklet*, pp. 49–52, discusses the Ares Borghese as a product of Polykleitan influence. Vierneisel-Schlörb, *Munich Catalogue*, pp. 180–81, explores the connection in terms of the Doryphoros, rather than Naukydes' Diskobolos. According to Lippold, *Handbuch*, p. 199, n. 10, the latter statue appears on coins of Amastris (Pontus), Bithynium and Philippopolis (Thrace). It is, of course, equally possible that an original athletic statue was later converted into a Mars/Ares. C. A. Picón has pointed out to me that most replicas of the Diskobolos render the right foot with toes "dug into the ground," an athletic pose.

On the phenomenon of eclecticism see also infra, chapter 7, and cf. Zanker, *Klassizistische Statuen*, section III, esp. pp. 76–80.

23. The most extensive discussion of the cult images by Alkamenes for the Hephaisteion is by E. B. Harrison, *AJA* 81 (1977): 137–78, 265–87, 411–26; see p. 137 for the best summary of the situation, with ancient references. Harrison also discusses the inscriptional evidence for the *anthemon,* the decoration of the base, and gives a list of replicas of the Velletri Athena. Several fragments among the Baiae casts have been identified as reproducing the same statue type: *Abgüsse* 38–39. 52, nos. 75–90. See also Vierneisel-Schlörb, *Munich Catalogue,* pp. 136–43, no. 12.

24. Harrison, *AJA* 81 (1977): 266, assumes that the Neo-Attic relief in the Vatican has been copied at the original scale, which would imply some exact measuring for the reproduction. Since, however, the Louvre relief with the same scene, also inspired by the Hephaisteion base, is smaller, it seems dangerous to reconstruct the size of the original monument on the basis of these later echoes that were enlarged or reduced at will, according to the decorative purposes of their time.

25. Omphalos Apollo type: latest discussion in Vierneisel-Schlörb, *Munich Catalogue,* pp. 7–15, no. 2; see esp. p. 9 for a definite rejection of the Kalamis attribution. For a list of replicas, in connection with a find from Baiae, see W. Johannowski, *ASAtene* 45–46 n.s. 29–30 (1967–1968), pp 373–79. Where the original of the Omphalos Apollo type stood remains an open question: even Athens is only a plausible but not certain location. The Roman copy of the type found in the Theater of Dionysos carries no special connotation, since its presence there must be attributed to the Romans, not to the Greeks: Schwingenstein, *Figurenausstattung,* p. 52.

26. Belvedere Apollo: see infra, chapter 8, pp. 201–2.

27. Hermes Agoraios: *Agora 14,* p. 95; *Agora 3,* pp. 102–3, nos. 296–300. The terms *eugrammos* and *euperigraptos* used to describe the Hermes could refer to details and contours of face and hair, not necessarily of body, especially given the archaic date of the piece; to me they suggest accuracy in the engraving of hair strands or curls and total neatness, rather than appreciation for a body which was likely to be in a style the Romans did not greatly appreciate. Thompson, *Agora 14,* suggests that what Lucian and Pausanias saw was a replacement for the original statue damaged or taken away at the time of the Persian Wars.

28. Monument of the Eponymous Heroes: *Agora 14,* pp. 38–39, esp. nn. 81 and 86; T. L. Shear, Jr. *Hesperia* 39 (1970): 145–222.
 The most thorough discussion of the statues is by Kron, *Phylenheroen;* by her see also "Eine Pandion-Statue in Rom," *JdI* 92 (1977): 139–68, and a paper delivered at the International Parthenon-Kongress, Basel, *Programm* 24 (on the Heroes in the Parthenon frieze). Authors who have suggested identification of the heroes in Roman copies (Hölscher, Berger) are cited in Kron's two published works. W. Fuchs, *Boreas* 4 (1981): 25–28 and esp. n. 18, suggests that the discovery of the Riace Warriors will help us recognize copies of both the Marathon dedication and the Eponymous Heroes in Athens. Kron does not believe in copying at the Panhellenic sanctuaries, but remains open to the possibility for the Agora statues. Since these had civic meaning, and the statues in Delphi emphasized military prowess, the similarity between the two monuments need not have been strong.

29. On these two statues, and their possible connection with the Hephaisteion pediments, see H. A. Thompson, *AJA* 66 (1962): 339–47; for a later rejection of his theory see Thompson, *Agora Guide,* pp. 194–96 (S 1313, male torso; S 1232, Athena).

30. Harrison, *Hesperia* 29 (1960): 371–73; the statue was found in the cella of the Southeast Temple, erected by the Romans reusing columns from the Temple of Athena at Sounion: for the latest discussion of these "itinerant temples" see T. L. Shear, Jr., *Hesperia* 50 (1981):364, where it may be implied that also the Southeast Temple was dedicated to a form of imperial cult. In that case, the colossal image would have been made for the purpose and given a portrait head, or may have had its original one changed, if it indeed belongs to the fifth century B.C. For a more recent discussion see now W. B. Dinsmoor, Jr., *Hesperia* 51 (1982): 410–52, esp. 435–37 for the colossal peplophoros.

31. I have left my text as delivered, but I have since become aware of O. Palagia, "A Colossal Statue of a Personification from the Agora of Athens," *Hesperia* 51 (1982): 99–113, which publishes the sculpture in great detail. The author considers it a possible representation of Demokratia dated ca. 335–330 B.C., and discusses several variants and one copy (in Leptis Magna) of the type, of Severan date (pl. 33c). The relationship of the Agora statue to the Themis by Chairestratos is explored on pp. 105–6, and the latter is defined as an eclectic piece. The variant with the triangular apron and the cornucopia (Tyche, Bona Fortuna) was mentioned by T. L. Shear, Jr., in the original publication after the Agora find: *Hesperia* 40 (1971): 270–71, pl. 55; it is further discussed by Palagia, who does not exclude the possibility that the "Demokratia" may represent Agathe Tyche (p. 110), although she would not restore it with the Horn of Plenty.
 There is no point to mention in my survey an equestrian statue in gilt bronze, probably of Demetrios Poliorketes, since only fragments of the leg and a sword have been recovered, and no possible Roman replica of it exists, because the monument was destroyed around 201 B.C.: Shear, *Hesperia* 42 (1973): 165–66, pl. 36; Palagia, p. 112; C. Houser, in *Macedonia and Greece in Late Classical and Early Hellenistic Times,* Studies in the History of Art, vol. 10 (Washington, D.C., 1982), pp. 229–38.

32. On the Agora akroteria see Ridgway, *Fifth Century Styles,* pp. 60, 62–63, and n. 28 for the Nereids riding dolphins, with bibliography.

33. Besides the references given in chapter 3, nn. 2–3 (Harrison), note that much of the evidence for carving workshops in the Athenian Agora or its proximity is still to be published, but I understand from Professor Thompson that evidence is increasing with every excavation season. Cf. also *Agora 14,* pl. 95a.

34. Agora "Aphrodite" with water pitcher: *Agora 14,* p. 203 and pl 102c. the monopteros with which the statue is there associated has now been reconstructed by W. B. Dinsmoor, Jr., *Hesperia* 43 (1974): 412–27, who leaves the question of function open but suggests possible connections with Aphrodite. He does not, however, mention the pitcher-carrier. The monopteros is dated to the Antonine period.

35. The Aphrodite statuettes from the Agora are being studied by Dr. M. E. Carre Soles, to whom I am indebted for these preliminary comments. I understand from Prof. Harrison that also a statuette of the veiled (Aspasia/Sosandra) type has been found in the Athenian Agora.

36. Ivory Apollo Lykeios, made in the second or third century A.C.: *Hesperia* 6 (1937): 349–51; *Agora Guide,* p. 271 and fig. 144. On the Lykeios as a type see Ridgway, *AJA* 78 (1974): 9–11; *Museo Nazionale Romano,* pp. 62–65, nos. 52–53.

37. On Hekataia and their possible setting see *Agora 14,* p. 169 and pl. 85; the main publication is by E. B. Harrison, *Agora 11,* pp. 86–107. Most of the finds from the Agora are Late Hellenistic or Roman. A three-figured Hekataion of some kind may have existed on the Athenian Akropolis as early as the time of the Old Propylon

destroyed by the Persians in 480 B.C.: W. B. Dinsmoor, Jr. *The Propylaia to the Athenian Akropolis*, vol. 1, *The Predecessors* (Princeton, 1980) 31–34; see also A. Linfert, *AthMitt* 93 (1978): 25–34, esp. 26–29.

38. The inscribed base (IG II² 3781) is illustrated in *Agora 14*, pl. 55c, see p. 107. For the Basel replica of the portrait and a recent discussion see Stewart, *Attika*, pp. 22, 53, pl. 17b. See also Richter, *Portraits* 2, pp. 248–51, figs. 1681–96.

39. The issue is summarized in Ridgway, *Fifth Century Styles*, pp. 206–10, with bibliography, but see also infra, nn. 40 and 41, for additions.

40. This theory is by H. Meyer, *Medeia und die Peliaden* (Rome, 1980), appendix pp. 133–39. See also U. Hausmann, "Reliefmedaillon Herakles und Hesperide," *OlBer* 10 (Berlin, 1981): 209–27, esp. p. 224 for reference to the Three-Figure Reliefs. The medallion from Olympia dates to the late third/early second century B.C. The article is also valuable for comments on the manufacture of clay objects from metalwork and other technical problems.

41. Corinth fragment: Ridgway, *Hesperia* 50 (1981): 437–38, n. 66.

42. Horos stones: *Agora 14*, pp. 117–19, but see also p. 118, nn. 1 and 5 for markers of public areas. For comments on the sacred functions of the Agora see *Agora 3*, p. 218, and, more recently, F. Kolb, *Agora und Theater, Volks- und Festversammlung* (Berlin, 1981), esp. pp. 20–58, on the Athenian Agora and the religious connotation of its early theater.

43. See the ancient sources collected in *Agora 3*, pp. 365–67 and esp. p. 66, no. 157, Cornelius Nepos, *Timotheos* 2.2, for the establishment of an altar.

44. On the statues and their bases signed by the sculptors see *Agora 14*, pp. 153–54; for the Odyssey statue see p. 115 and pl. 63.

45. For the theory see a summary of a paper by V. J. Harward, *AJA* 86 (1982): 268–69. On the portrait of Phryne at Delphi see also supra, chapter 4. If Phryne was so generous toward her native city of Thespiai, it may not be impossible that her compatriots honored her with a statue at Delphi.

46. For a fifth-century Praxiteles, see E. G. Rizzo, *Prassitele* (Milan/Rome, 1932), p. 3, the maker of a cult image for Plataia in 426. See also Marcadé, *Signatures* 2, s.v. Praxiteles. On the master's family see H. Lauter, "Zur wirtschaftlichen Position der Praxiteles-Familie," *AA* 1980, pp. 525–31.

47. Neo-Attic reliefs in Corinth: *Hesperia* 50 (1981): 437–38 and bibliography in notes. For the Maenads in general see Ridgway, *Fifth Century Styles*, pp. 210–13, with bibliography.

48. For statues in the Athenian theater, and on Greek theaters in general, see Schwingenstein, *Figurenausstattung*, esp. pp. 64–68, for Lykourgos's program. On the Sophokles of the Lateran type see also supra, chapter 3, n. 14, for a bronze replica from Boubon possibly used for Marcus Aurelius. We should therefore assume that the type was also admissible for philosophers, rather than just for playwrights, since the Roman emperor would not have wanted to appear in the guise of a Sophokles. On a new replica of the Euripides see Frel, *Getty Portraits*, pp. 62–63, no. 15. All three playwrights are illustrated and discussed in Richter, *Portraits* 1.

49. Menander: cf. supra, chapter 3, n. 17. Corinth Menander: *Hesperia* 50 (1981): 446 and n. 93; the replica in Athens: Richter, *Por-*

traits 2, p. 233, no. 42, figs. 1624–26. Doubts may still remain as to the identification of the Corinth head.

50. Dionysos Sardanapalos: E. Pochmarski, *ÖJh* 50 (1972/73): 41–67, with a list of replicas and mention of both the Corinth and the Athens examples.

51. Aphrodite of Arles: for a Late Hellenistic date and discussion of the replica from Athens see Ridgway, *AJA* 80 (1976): 147–54.
 For the Roman replica of the Omphalos Apollo type also found in the theater of Dionysos see supra, n. 25; for an illustration see Ridgway, *Severe Style*, fig. 97.

52. *Pace* Frel, *Getty Portraits*, p. 87, who states that the seated image of the philosopher was erected in his Garden after 271/70. This is a plausible assumption, but it is not substantiated by archaeological or literary evidence. One of the two Getty head replicas is of particular interest since it comes from a statuette (no. 38): Frel quotes Pliny's statement that "everybody has an image of Epicurus in his bedroom, and many carry it with them on their travels." On the reconstruction of the composition, see B. Frischer, *CSCA* 12 (1980): 121–54, and, more extensive, his discussion of the Epicurean use of portraits for "missionary" reasons: *The Sculpted Word— Epicureanism and Philosophical Recruitment in Ancient Greece* (Berkeley-Los Angeles-London, 1982), esp. pp. 87–96; pp. 122–26 (on the manipulation of secondary images and their consequent resemblance to one another); pp. 180–97 (on the specific date and location of Epikouros's portrait). Throughout Frischer's book, many comments on the function and impact of ancient statues are pertinent to our topic.

53. On Lysippos's Sokrates, beside Frischer, *CSCA*, (supra, n. 52) and Richter, *Portraits*, see E. Sjöqvist, "Lysippus," *Lectures in memory of Louise Taft Semple* 2, (Cincinnati, 1966), pp. 18–25.

54. The epithet of the god may, however, be independent from the Athenian gymnasium, since Pausanias (2.19.6) mentions a sanctuary of Apollo Lykeios at Argos.

55. Herakles Farnese: supra, chapter 1, p. 16, nn. 35–36. For the theory that the original statue stood in Athens see M. Bieber, *The Sculpture of the Hellenistic Age* (New York, 1961), p. 37; F. W. Imhoof-Blumer, P. Gardner, *Ancient Coins Illustrating Lost Masterpieces of Greek Art. A Numismatic Commentary on Pausanias* (Enlarged ed. by Al. N. Oikonomides, Chicago, 1964), appendix pp. 171–72.

56. For an illustrated account of the attribution see, e.g., Sjöqvist, "Lysippus" (supra, n. 53), pp. 28–31. Pausanias 2.9.6 places the Herakles by Lysippos "near the sanctuary of Apollo Lykeios and near Hermes Agoraios."

57. On the Kairos and its location see A. Stewart, *AJA* 82 (1978): 163–71. Other scholars, because of the reference to a pronaos in the ancient sources, believe that the Kairos stood at Olympia, in the Temple of Zeus, but Poseidippos, *Anth.Pal.* 16, 275, is clear in his statement. Stewart points out that Poseidippos is also a contemporary of Lysippos; in fact this Macedonian author wrote around 270 B.C. It is worth noting that all other ancient sources on the sculptor are at least three centuries later, the earliest being Velleius Paterculus, of the early first century B.C., on the Granikos group. For the Kairos see also Kallistratos *Eikones* 6, and Himerios *Eclogae* 14.1.

58. Another possibility, favored by some scholars, is that the Eros of the marble replicas stood at Myndos in Karia, whence it was taken to Constantinople and destroyed in the fire of the Lauseion in 475: F. P. Johnson, *Lysippos* (Durham, N.C., 1927), pp. 104–15, on

the authority of a passage in Kedrenos. For a recent discussion of a variant of the Eros type see *Museo Nazionale Romano*, pp. 86–87, no. 68, with bibliography (J. Papadopoulos). See also H. Döhl, *Der Eros des Lysipp—Frühhellenistische Eroten* (Göttingen, 1968). On the motif of stringing the bow, attributed to the Lysippan Eros, see T. Seki, *AA, 1981*, pp. 44–64.

59. Another (not the Thespian) Eros by Praxiteles has been recently identified in a winged torso with quiver close to the Praxitelean Satyr pouring wine. The identification could be considered a Roman variation on the theme, but the bronze Eros forming the handle base for a hydria of the fourth century B.C. suggests that the variant existed as early as the classical period. M. Pfrommer, "Ein Eros des Praxiteles," *AA* 1980, pp. 532–44, argues that Praxiteles intentionally made the Satyr and the Eros similar, and bases his identification on a description by Kallistratos.

60. G. Despinis, *Symbolē stē meletē tou Ergou tou Agorakritou* (Athens, 1971); for a review of the book see, e.g., J. M. Cook in *JHS* 93 (1973): 264–65.

61. For this statement see, e.g., Becatti, *Arte e gusto*, p. 70: Varro went to see it during his Athenian stay (Pliny *NH* 36.17), cf. p. 291.

The problem of taking casts from a painted marble statue was cited by Rizzo, *Prassitele* (supra, n. 46), p. 45 as a definite hindrance to the process; G. M. A. Richter, *Ancient Italy* (Ann Arbor, 1955), p. 39, states however that a modern artist told her the molding could easily be made with the help of a separator. Since the replicas are not at the colossal scale of the original, the pointing process is a more logical method to have been used, to facilitate corresponding reductions in size.

62. On the extensive repairs to the Rhamnous Temple see most recently the comments by T. L. Shear, Jr., *Hesperia* 50 (1981): 368 and n. 55 with bibliography. A recent discussion of the Nemesis base in the Temple, by B. Petrakos, has pointed out that barriers or ropes probably surrounded the pedestal, to prevent visitors from approaching too close to the cult image, to judge from markings on the floor paving: *BCH* 105 (1981): 227–53, esp. p. 251.

On the painting by Apelles and the replacement of the head see Pliny *NH* 35.94; Pape, "Kriegsbeute," p. 163. More controversial is the case of an equestrian statue of Alexander by Lysippos, whose head was replaced with a portrait of Caesar: Statius *Silv.* 1.1.84–88; cf. Pape, p. 132, n. 82. Blanck, *Wiederverwendung*, pp. 14–20, gives several additional examples.

63. The four temples are: the Hephaisteion, the Temple of Ares, the temple of Poseidon at Sounion, and the Temple of Nemesis at Rhamnous. That the last two temples named may be by a pupil of the main architect has been suggested by H. Knell, *AA* 1973, pp. 94–114.

Wooden idols of great antiquity and "primitive" forms were objects of great veneration, but not of direct copying or of aesthetic appreciation. The case of the Ephesian Artemis will be discussed in chapter 8.

64. On the Lateran Poseidon type see E. Walde, *AthMitt* 93 (1978): 99–107, with previous literature. For the Ambelokipi bronzes see supra, n. 21. For the Pella Poseidon see, e.g., the Catalogue of the Alexander Exhibition in Saloniki, *Alexander the Great, History and Legend in Art* (Thessaloniki, 1980), p. 60 (Pella Arch. Mus. Inv. no. M 383).

65. On this issue see supra, n. 6l. Modern scholars disagree as to the greater or lesser accuracy of the replicas of the Knidia that have come down to us.

66. The problem of the Knidia's setting has been explored by A. H. Borbein, *JdI* 88 (1973): 188–94, who concludes that it stems from Pliny's conflation and paraphrasing of his sources; the passage in Pseudo-Lucian should give us the true setting: a naiskos with two doors and limited room. That such structures with more than one opening existed in antiquity is shown not only through the plans of the temples at Bassai and Tegea, but also by Iamb. *VP* 185, where the story is told of Euphranor who asked his friend Lysias to wait while he went inside a temple to pray. But then Euphranor forgot his friend and went out by another door, leaving the faithful Lysias to a very long and vain watch. Yet the matter is complicated by the discovery in Knidos of a round structure which the excavator has identified as the location of Aphrodite Euploia: *AJA* 76 (1972): 402–3 and, for the latest report, *AJA* 77 (1973): 419–24, with a plan of the site on p. 414, fig. 1. Borbein dismisses the possibility that Praxiteles' statue stood in the monopteros because of its size (p. 190 and nn. 622–23) and because of its relatively late date (n. 619); but I. C. Love tells me that the terrace on which the monopteros stood can definitely be dated to ca. 350 on the basis of the finds, and should have been built to house the round structure. A series of alterations to the building could be reconciled with a later transformation from monopteros to tholos.

In support of the theory come also the other examples of round buildings in honor of Aphrodite, not only the one at Hadrian's Villa, but also the small temple in the Gardens of Sallust: F. Coarelli, *Roma* (Guide Archeologiche Laterza) (Rome, 1980), p. 250. A. Linfert, *BonnJbb* 181 (1981): 615, dismisses the Tivoli example as another instance of Hadrian's "Disneyland" approach fusing a famous image and a famous (but independent) landmark among the buildings of Knidos. He believes that the image by Praxiteles stood on the naiskos of rectangular plan also uncovered by the recent excavations, and that it did not have cultic significance. While final publication of the Knidos excavation is still pending, the question should remain open.

67. The main investigation on the Antioch Tyche remains T. Dohrn, *Die Tyche von Antiochia* (Berlin, 1960); see also E. Simon, *Gymnasium* 84 (1977): 351–54.

68. Great Eleusinian Relief: complete discussion with list of replicas in L. Schneider, *AntP* 12 (1973): 103–24; see also Ridgway, *Fifth Century Styles*, pp. 138–41, and, for the Corinth fragment, *Hesperia* 50 (1981): 437 and n. 65.

For the Lakrateides relief see, e.g., G. E. Mylonas, *Eleusis and the Eleusinian Mysteries* (Princeton, 1961), fig. 71.

69. On the Asklepios Giustini see, e.g., Ridgway, *Fifth Century Styles* p. 183, no. 1, *Munich Catalogue*, pp. 216–24, no. 20.

On the issue of the meaning of cult statue (as contrasted with divine image dedicated in a temple) for the Romans, see P. Gros, *Aurea Templa* (Rome, 1976), pp. 155–69 and esp. nn. 44–49.

"Unquestionably, I think, Shakespeare's *sententia* is an 'imitation' of this passage in the *Tusculan Disputations*. Nor was it derived through Dolman's translation. It is either from the original, or from some unknown rendering of the original which is quite a close translation." This quotation is taken from T. W. Baldwin, *William Shakespere's Small Latine and Lesse Greeke* (vol. 2 [Urbana, 1944] pp. 602–3), and refers to a passage in *Hamlet*; yet, with the proper changes or omissions, it could be applied to any sculptural discussion of Roman copies. I have intentionally selected an example from the world of literature, and an author whose genius is beyond doubt, to emphasize the point that imitation is not per se a symptom of lack of creativity, nor is it limited to specific periods and forms of art. Yet it is only in the realm of Roman sculpture that we insist on seeing slavish duplication of Greek prototypes, while all later periods and manifestations are credited with having recast the received inspiration into different molds and meanings.

In the visual arts, a comparable point can be made by looking at Bertel Thorvaldsen's *Jason* (plate 95).[1] The statue was made in 1802, after the sculptor's visit to Rome in 1797. At that time, he was impressed by the Doryphoros (see plate 13), not by the Belvedere Apollo which he could not see because the piece was in France; yet the Doryphoros is static and balanced, the Jason has that incipient motion so typical of the Apollo (plates 96 and 97). Thorvaldsen, therefore, transformed into his own conceit the prototype he "copied," accepting certain forms, rejecting others, adding attributes to his figure in order to transform an anonymous athlete into a mythological hero connected with a specific deed. In the rendering of the golden fleece he betrayed a technical virtuosity, an interest in texture quite alien to fifth-century Greek art (although possible in Roman works). He gave the head a more refined, if colder, face and, in general, succeeded in turning a classical model (albeit perceived through a Roman copy) into a neoclassical creation, as much a "Thorvaldsen" as the original Doryphoros was a "Polykleitos."[2]

Thorvaldsen's case may be considered unusual, since the Danish master was directly involved in the restoration of Greek works; yet his own creations consistently partake of the classical ideal, and he came to be considered "the modern Pheidias" by his contem-

poraries. His sculptures take us one step farther down the road which had led from the Greek to the Roman creations. In a paraphrase of F. Otten,[3] we could state the sequence as follows. Greek classical sculpture was an expression of theoretical forms and abstract proportions considered ideal. Roman sculptors imbued comparable forms with specific content, so that form took second place to the idea or, rather, to the communication of that idea, thus splitting the Greek unity between the two. Finally, the neoclassical movement rejected implicitly the deeper content of ancient sculpture, since pagan religion and myth were superseded, but adopted its subject matter and exterior forms selectively and eclectically, to convey an ideal of beauty based purely on the imitation of the past and what it stood for in the romantic conception of the eighteenth and nineteenth centuries. Canova, Houdon, Danneker, and Sergel could all be cited as examples of this movement.

Even more important for our topic is the consideration of some contemporary work. At Cornell University, as part of an exhibition of faculty work, is a colossal statue by Jason Seley (plate 98) which openly copies the Herakles Farnese (plate 99). The figure is at the same scale as the Farnese giant, and was inspired by a cast of that monument in Cornell's cast collection. What makes the new figure extraordinary, however, is the fact that —like many of Seley's creations—it is made from Volkswagen bumpers soldered together in such a way that the joins appear as scars and wounds on the colossal torso. A new implication—of superhuman strength, of defense, of mechanical force—has been added by the very medium, so that our admiration of the work invests not only the difficulty of bending the intractable car parts into the classical forms, but also the subtlety involved in thus recasting the familiar composition. Strictly speaking, the metal statue is a new replica of the Herakles Farnese, but should it be judged a copy of Lysippos's work or is it a "Jason Seley"?[4]

It is clear that the moment has come to attempt some definitions. Yet our very terminology is already tinted with negative connotations,[5] or is insufficient to cover the many possibilities involved in the transmission of artistic conceptions. Lippold in 1923 envisaged many categories: copy, replica, repetition, type, original, change of stylization, transformation, change of creation, development, contamination, use, and reuse.[6] To these terms others could be added—pasticcio, stylistic mixture, eclectic rendering—all of them carrying a pejorative meaning.[7] In more recent years Strocka attempted to reduce this intractable mass of subdivisions into more precise and fewer categories. He restricted the word *copy* to the exact reproduction of a work from the past, reproduced because of its content or form, distant in time and meant to replace the original through strict duplication. Thus defined, *copy* can only apply to some Roman production. He then selected other terms to define different cases. *Series* indicates the contemporary production of two or more examples of the same prototype (*Entwurf*), similar not only in composition but also in scale. *Reproduction (Wiederholung)* is applicable when the scale changes or variations appear in small details, such as, e.g., different hairstyles used for the same figure. Finally the term *variant* would apply to examples of the same basic type, in comparable format and made during the same time span, but with considerable changes in individual details. The difference between variant and reproduction, according to Strocka's conception, is therefore one of degree rather than of substance.[8] Thus defined, these categories involve only works of the Greek period and well underline the endless variety of iconographic transmission possible within the ancient world, especially in the religious sphere, where repetition of a certain image ensured recognition and had the value of a deliberate quotation, albeit within the range of changes introduced by different workshops and periods. But what about the so-called Roman copies?

A further definition, by Otto Brendel, may help us realize that no true solution of continuity exists between the two periods—the Greek and the "Roman"—and that the phenomenon of reproduction recognized by Strocka's categories in the former continues unabated in the latter. According to Brendel, "copying implies recourse to a particular exemplar, usually from the past; variations indicate the continuing presence of an active iconographic meaning."[9] It is this specific meaning which was highlighted by the Romans, but not only for Greek works. The very same process was applied to their own creations, and it is only this recollection of the Greek past, as a survival of the iconographic meaning, which often fools us into believing we are dealing with true copies of Greek originals.

The "Roman" gradations in their imitation of the past have been pinpointed by Wünsche with a language taken from the sphere of ancient literature.[10] Accordingly, we should speak of *interpretatio* when we have a literal translation (as through an interpreter) of an earlier work—a definition which comes close to Strocka's *copy*. *Imitatio* would instead involve a free rendering of a single Greek prototype, while *aemulatio* would produce a creation after several prototypes, thus resulting in a new, if assimilative, original. This final work, in turn, could become the subject of the same process: it could be copied exactly, it could be imitated more freely, and it could contribute in part to the creation of a new whole. Allusions and similarities would thus multiply, with "Roman" masters contributing as much or more to the total artistic picture.

To the negative mind, this process of *aemulatio* could seem to result in the old *pastiche* and the change in terminology appear only as a way of making medicine palatable by putting it in a new bottle. Yet *aemulatio* is not a simple matter of eclecticism, nor is it limited to pure juxtaposition of parts which, in theory, could once again be taken apart and reattributed to their respective originals. To steal again my arguments from the world of literature, "emulation implies competition and invites judgment."[11] Thus *aemulatio* introduces the expression of a new ideal obtained, as it were, through the manipulation of the accepted stylistic and iconographic tradition.

This pursuit of an ideal suitable for Roman needs but different from the Greek has been recognized by Trillmich even within Wünsche's more restrictive category of *imitatio*. Accordingly, the term is by him enlarged to mean not dependence from a single original, as inspiration, but from an idea, or rather an *ideal*—so that it would be inaccurate, for instance, to speak of a type in the case of a recognizable figure repeated with minor variations, but we should think instead of an ideal form, accepted and perpetuated because it responds to a specific Roman taste and conception.[12] Trillmich illustrates his point by considering five "replicas" of a youthful figure with long chlamys tied around the neck over the right shoulder and hanging behind (plate 100). The basic physical type corresponds only in general to late Polykleitan youths, but occurs in a Neo-Attic relief and is thus likely to have been created in the first century B.C. A tabulation of common features and discrepancies among the five works in the round yields no rule by which extant differences can be explained; it is therefore concluded that the statues are not individual replicas of a single prototype, but ever new variations on a beloved "model," an ideal type which should not be assigned to any Greek master. Trillmich then sounds a final warning: "By limiting questions of criticism of the copies (*Kopienkritik*) to the search for replicas and the reconstruction of types we are bound either to misunderstand a large part of Roman ideal sculpture or to bypass it."[13]

The adolescent male figure preferred by Roman taste is also the focus of Wünsche's attempt to discover the Roman element in the plastic arts. Beginning with an examination of the bronze Youth from Magdalensberg (plates 101 and 102), he considers the so-called Lychnouchoi as a specific genre, some of them closer to severe, others to Polykleitan formulas. Their size, averaging ca. 1.45 m, represents a common feature; another is their stance, which had prompted earlier scholars to suggest that they should be seen from a three-quarter viewpoint. To the contrary, a few pieces are set on a rectangular, not on a round, base, which conclusively shows, by its orientation, that the

frontal was meant as the main view. Whatever the pose conveys of instability and the momentary should be considered a desideratum rather than a fault. And if the total figure looks uncertainly balanced and unharmonious *by Greek standards,* this very effect might have been sought by its Roman creator.[14]

Several statues of such adolescents are known, both in bronze and in marble, and a few exist in more than one replica. Even omitting the openly archaistic types (not only the Piombino Apollo [see plates 26 and 27], but also a recently found bronze from the House of C. Julius Polybius in Pompeii, so remarkably similar to the former as to defy coincidence),[15] there are at least two lychnouchoi (plate 103) from Pompeii, the Volubilis bronze ephebe, the already cited Magdalensberg Youth, the Idolino (plates 104 and 105) (of which a possible copy in basalt is also known), a bronze (from Antequera) and marble youth in Madrid, and the Sabouroff bronze. As Wünsche remarks, only this last work may come from Greece, since it was reputedly fished off the waters in front of Eleusis; all the others were found in openly Roman territory, and therefore were probably made on Italic soil. Since the art trade moved in both directions, not only from Greece to Italy but also vice versa, the Sabouroff statue may have been shipwrecked while in transit from Rome/Naples toward the Greek market.

Chronologically, the type seems long-lived, from at least the Late Republican period (Magdalensberg Youth) to the Late Hadrianic (marble youth in Madrid). Confirmation for the initital date is given by the approximate chronology of the Pasitelean school: Pasiteles himself was a contemporary of Pompey, around 50 B.C.; Stephanos, whose athlete (see plates 35 and 36) is strongly severizing, belongs to the end of the Republic and the time of the second triumvirate; finally Menelaos, whose work is openly assimilative, falls around the birth of Christ. A Pasitelean youth may have been found in Athens in 1910, but recent guides to the National Archaeological Museum still define it as a first-century A.C. copy from a bronze of ca. 450 B.C.[16] It is nonetheless likely that taste changed according to fashions, and that Greece itself, in the Roman period, might have accepted artistic standards that had originated, if not from Roman artists, at least on Roman soil.[17] Neo-Atticism, besides producing many decorative adaptations of classical works within Greece proper, found fertile grounds in Late Republican Italy with its many temples in need of cult images so that this particular "retrospective" and conservative style may have flourished more in Rome than in Athens itself. Adolescent figures may be easier to recognize as part of this Roman creativity, but I shall later attempt to distinguish variations and changes within other types.

In the light of our approach, it is clear that every

modification on a presumed Greek model was introduced for a specific purpose and on the basis of definite criteria. Thus, not only was the quality of a "copy" not dependent on its degree of faithfulness to the prototype, but close adherence to the original (for us a prerequisite of any copy) was rather to blame than to praise unless clearly perceived as a form of quotation. As pointed out by Wünsche, according to Cicero and Terence, he who does a proper translation has created something new. But he who "imitates" employs a higher form of art, since he paraphrases rather than translates, he modernizes an earlier creation and improves it according to the taste of its times.[18] In other words, we might say that a sculptor, by subtly changing the forms of its inspiration, turned something Greek into something Roman, thus making it "better."

It is ironic that this position should be so strongly advocated as part of the Jerome Lecture series. Exactly thirty years ago another Jerome lecturer, Gisela Richter, could assert: "we have given too much leeway to the Roman copyist. . . . many apparent changes are not his doing, but can be attributed to the direct copying of a related [Greek] original."[19] Yet new discoveries, new approaches, and especially the awakening realization that many of our positions were based on a romantic conception of art and artists, have brought us to a diametrically opposite stand within the compass of three decades. That many Greek originals could share stylistic and iconographic features is undoubtedly true, but that each Roman ideal work is a faithful rendition of a Greek prototype is—equally undoubtedly—wrong.

If *imitatio* is improvement, *aemulatio* goes a step further in the creation of a new whole. To stress that the results are eclectic is to interpret negatively what should be the most positive aspect of the process. As an art theory, it finds expression in ancient sources which have been most thoroughly analyzed and explained by P. Zanker and F. Preisshofen.[20] According to the early-first-century B.C. author of the *Rhetorica ad Herennium,* specific parts of a single statue should be made after different examples by the classical masters: caput Myronium, brachia Praxitelae, pectus Polycletium—not in the sense of literal juxtaposition, but in the sense of recognizing and then emulating each master's excellence in a specific genre or rendering. Thus in Roman times Myron was famous for his animal sculptures, Polykleitos for human figures, Pheidias for his deities.

Some modern scholars have compared this passage in the *Rhetorica ad Herennium* with Cicero's account of Zeuxis's method in finding a model for his Helen of Troy.[21] The painter had selected five of the most beautiful girls in Kroton, and had then conceived his perfect woman as a synthesis of all of them. Yet, as Zanker and Preisshofen point out, this classical approach is in virtual antithesis to the Hellenistic, in that it creates an *ideal* from many different beauties and thus unifies the resultant work, while the author of the *Rhetorica* advocates that a new unit be formed by adding separate parts from works which were units in their own right. Much more comparable is instead Lucian's process in creating the ideal portrait of Pantheia whose individual parts were described after the most felicitous rendering of each feature by different masters.

Another echo of this aesthetic current can be detected in the disapproving comments by Pliny (*NH* 35.4), who objects to the contemporary practice of changing parts of statues, to the point that a female head could be placed on a male body and vice versa. Actual finds show us Polykleitan torsos completed with severe heads and hairstyles and given fourth-century proportions overall. Besides a preference for adolescent types, this artistic current also emphasized a certain grace and a romantic appearance which lent some works an almost androgynous effect. Other sculptors, in sturdier fashion, mixed Lysippan and Polykleitan forms, translated Hellenistic iconography into classical styles, combined renderings typical of bronze work with others typical of marble carving, and in brief so managed to cloud the stylistic picture that our judgment, based on the vertical development of art, can no longer isolate the individual components of these new wholes.[22]

As long as we consider all such works as pastiches, refusing to accept their eclecticism as expression of a different aesthetic approach, we fail to grasp the message of "Roman" art. As already pointed out, no single Greek master was capable of satisfying entirely the new Roman taste, yet each could contribute to it.[23] A sculpture combining diverse renderings and styles may seem discordant to us, but it was obviously meaningful to the Romans. Nor should we attribute such tendencies solely to the "jaded" taste of the Late Hellenistic period, since various manifestations of the same approach can be noted well down into the Antonine period. The most obvious example are the so-called stock bodies—an unfortunate term which implies mass prefabrication and should be translated into a more positive expression. If we called them "formulaic" or "ideal" bodies, we could better understand why they were completed with portrait heads in contemporary styles without startling the viewer, who perceived the "message" conveyed by the Republican man as a Polykleitan athlete, the Flavian lady as Aphrodite, the emperor Hadrian as Ares, Marcus Aurelius as a Greek philosopher, Commodus as the Weary Herakles.[24]

The more openly eclectic creations, portraying mythological beings or deities, present a more complex,

less obvious picture, although enjoying an equally long-lasting popularity. The process may have started much earlier than the Late Hellenistic period, and could even have originated on Greek soil, as a by-product of manufacturing techniques. As early as the late sixth century B.C. large bronzes were made through the additions of individual parts, cast separately for ease in removing the bronze from the enveloping mold. The famous cup by the Foundry Painter illustrates models for feet, or spare parts for statues, hanging on the wall, thus proving the existence of the practice. Obviously, at that time, each part was made with a view to the whole, perhaps sectioned only in the mold taken from a complete model. Yet in the minor arts the tendency soon developed for interchanging elements at comparable scale. The process is well known for early Hellenistic terra-cottas, which utilized separate molds for heads and bodies that could thus be combined into diverse compositions. From terra-cottas to small bronzes the step is short, and has been conclusively argued by D. K. Hill on the basis of extant examples.[25] For large statuary the "invention" by Lysistratos of taking casts from human bodies may have led to just such fractioning and recombining. In light of the Baiae casts, we may even ask whether the rhetorical exhortation ad Herennium may have found its literal application in the sculptural workshops which owned "heads by Myron, arms by Praxiteles, torsos by Polykleitos." Ancient praises for the Magna Graecian Pasiteles who was interested in reviving and imitating classical works may imply that he used such casts from earlier prototypes to create his classicizing sculptures, and the finds from Baiae could help pinpoint the place of his activity.

Should it be objected that such piecemeal pratices reveal a deplorable lack of imagination and creativity, let us remember that, to the Romans at least, art seemed to revive just when Neo-Attic classicism began.[26] Nor should we forget that comparable approaches have been used in more recent times, by great masters. Typically enough, the members of the French Academy around 1700 utilized casts of ancient masterpieces, quoted, or extrapolated from them in their own works, while sculptors themselves "were encouraged to think out their sculptures by parts".[27] Even closer to our era, Auguste Rodin made use of casts and photographs to obtain desired effects. As Albert Elsen has shown, the French master kept casts of hands which he would hang in different positions and photograph from various angles, before deciding how to use the part in a specific composition, or in several.[28] In all such cases, clearly conceived artistic criteria came into play, and any apparent form of eclecticism was the result of careful and deliberate choice.

To go back to the ancient past, it can be shown that the trend existed not only in Italy or in Magna Graecia, but even in Greece proper. I have already pointed out the peculiar similarity between the Ares Borghese and the so-called Naukydes' Diskobolos (plates 79–80), but the explanation of the fact remains a matter of conjecture. More definite, and more firmly defined chronologically, is the case of the famous Hermes of Olympia (plates 106 and 107). Its elongated, elegant body has become the epitome of Praxitelean style in our handbooks, and recognition of its similarity to the Antinoos Belvedere, the Hermes Farnese (plates 108 and 109) and the Hermes of Andros (plates 110 and 111) has only served to extend the Praxitelean attribution to these other works.[29] Yet in July 1967, in the ancient city of Elis, within the peristyle of a first-century B.C. house, a torso was excavated, so similar to the Olympia Hermes that no doubt can remain about its being a formulaic body. In pose and proportions, the Elis find is quite close to the Hermes, but its right arm is lowered, its left shoulder raised and a chlamys is worn on the left shoulder.[30] It becomes therefore clear that the Olympia Hermes is a further instance of this body type adapted to represent a Hermes Dionysophoros, just as the other examples may represent that god in other aspects. But the body alone would not be sufficient evidence to consider the Olympia statue an eclectic creation, were it not for other revealing details.

An unpublished analysis by K. Hartswick has shown that the profile of the Olympia Hermes corresponds exactly, in its basic outline, to that of the so-called Munich Oil-pourer (plates 112 and 113)[31]; only the placement of the inner features changes, but no difference can be detected when the contours of both heads are traced and the line drawings are superimposed. To this interesting observation we can add one more remark. Seen from the front, the two heads are not identical, yet both reveal a roundish face (unexpected from the elongated profile) and pronounced frontal lobations forming almost a V-pattern above the nose and best noticeable under special lighting conditions. As Fink has argued for another head type, a basic cranial form may have been adapted for a variety of renderings.[32] What is so striking, to my mind, is that the Munich Oil-pourer has a definitely Polykleitan-Lysippan body, so close to the Agias (plate 114) and the Apoxyomenos (plate 115) that attribution to the Sikyonian master has now been argued, while the Hermes of Olympia is "typically Praxitelean" and should give us the only original by that sculptor. One more detail, however, can explain the latter statue and its nature.

As part of a total study of Greek footwear, K. Dohan has been able to trace the development of sandals, from archaic to Late Hellenistic times. Since she has taken into account only Greek originals, in order to avoid possible contaminations by later copyists, her

taxonomy should present as objective a criterion as that provided by Greek moldings in Lucy Shoe's chronological arrangement. Yet, according to the evidence of the indented sole (with deep notch between big and first toe), the relationship of toes to sole (with the former overhanging the latter), and the elaborate uppers, the extant sandal of the Hermes of Olympia cannot be dated earlier than the second century B.C.[33] The statue is then revealed as a composite piece based on a formulaic body, an idealized head type and a type of footwear contemporary with the creation of this specific composition, probably commissioned ad hoc as a Dionysophoros. Should we still believe that the sculpture was made by a Praxiteles, we could conceivably think in terms of a younger descendant of the famous master, who utilized the compositional idea of his forebear's Eirene and Ploutos (see plate 76) while adopting the anatomical forms preferred by his own age.[34]

Other examples of additive composition may be more dramatic but have long been recognized and are now accepted. The so-called Esquiline Venus (plates 116 and 117) has been shown to result from the Aphrodite of Cyrene type (plate 118) in combination with a boyish upper torso grafted onto the more feminine body at waist level. The Cyrene Aphrodite has been dated to the Antonine period, while the Esquiline Venus may belong to the Julio-Claudian, thus confirming the independent life of the single prototypes and the continuing popularity of the eclectic approach.[35]

Eclecticism can be expressed not only within single figures but also through juxtaposition of two statues in a stylistically heterogeneous group. The typical example is the Pasitelean group of Orestes and Elektra (see plate 36) in Naples, where the severizing Stephanos Athlete has been connected with a classical Aphrodite Naples/Frejus (see plate 83) type.[36] Yet note the variations within each figure. The Youth has an unbalanced stance, a head proportionately too small for the truly severe body, a romantic expression. The Elektra has been given a male coiffure—and stylistically severe at that—a severe face and a classical costume modernized by the addition of a low belt over which the garment forms mannered small kolpoi. This iconographic motif of the belted chiton has been analyzed by L. Guerrini in over forty figures, which she divides into two groups. One group comprises statues with slight torsion and a hint of motion in their poses, and begins in the early Hellenistic period; the second group is much closer to the Naples/Frejus Aphrodite and may go back to the Venus Genetrix by Arkesilaos, who created it as the cult image for the Forum of Caesar. The Pasitelean Elektra belongs to this second group and must therefore be a close imitation or adaptation of Arkesilaos's work.[37]

Because of its Pasitelean associations and its (pre-

sumed) Late Hellenistic chronology, the eclecticism of the Orestes and Elekra group in Naples has been readily accepted as a manifestation of the mixed taste of the period. Yet a relatively recent discovery comes to confirm that such combinations existed in much later times and within different artistic spheres. Excavations at Perge in Pamphylia have uncovered a group composed of one ideal and one portrait female figure, slightly different in height but within natural range. Of the two women, one follows the prototype of the Naples/Frejus Aphrodite with added Hellenistic belt; she rests one hand on the shoulder of the second woman who is heavily draped after a prototype of the second century B.C. The Aphrodite-like figure has long locks loose over the shoulders and idealized face: she therefore should not be a mortal. The second woman shows more individualized features, comparable to a portrait of Plankia Magna also from Perge, and therefore helps to date the entire group to the Hadrianic period.[38] What is more remarkable is that a mirror-image rendering of this group may have existed, since Perge has yielded a torso belonging to the same Hellenistic type as the woman of the first group, and with a similar hand on the shoulder from a now missing figure. Since, however, the left and not the right shoulder is being touched, the second group may have matched the first in mirror reversal. Together these two monuments exemplify some of the workshop practices analyzed by Trillmich: the balancing of one true interpretatio with an imitatio, and the duplication of the groups to form symmetric and decorative arrangements.[39]

Locations of Workshops and Locations of Originals

The Naples/Frejus Aphrodite with the low belt is a type found not only at Perge but in many other Asia Minor cities (Ephesos, Kremna, Miletos), as well as in North Africa, during the second century A.C. If Guerrini's surmise about Arkesilaos's Venus Genetrix is correct, the prototype from which such "copies" originated was in Rome, within a temple. We may be dealing, however, with imitations, rather than with bona fide interpretations, according to our meaning of the terms; moreoever, once the cast of the type had entered the workshops, replicas could be produced at will and distributed along the routes of the sculptural trade.

Such routes are of particular importance for Asia Minor, North Africa, and Greece during the first two or three centuries of the Empire, since these are areas that have yielded the greatest number of marble works. Could it be possible, by plotting patterns of distribution, to locate the workshops responsible for the copying of certain sculptural types? And could this information aid in determining the setting and nature

of the prototypes for such copies? I could not attempt a proper study in the brief compass of my research, but some comments may be made on the basis of a few types. We shall return to Ephesos below, but let us now trace the pattern of an unusual monument, the so-called Leto.

This composition of a running peplophoros holding a child in each arm, against her chest, was primarily known through two statuettes, both of them in Rome. Pliny (*NH* 34.77) mentions a bronze Leto with the newly born Apollo and Artemis, made by Euphranor and standing in the *Aedes Concordiae*. It had therefore been assumed that the Roman statuettes echoed the larger group in the city, to be dated around the middle of the fourth century. The most recent monograph on Euphranor has left the matter open, although considering the attribution attractive, and has assigned the prototype behind the Roman statuettes to ca. 370, tentatively suggesting influence from Kephisodotos. An attribution to Skopas has also been mentioned as possible.[40] This situation has now been complicated by the discovery of three more examples of the type, but of large, almost heroic size: one from the theater at Miletos, one from Seleukia, and another from Kremna in Pisidia. This last, from Building Q, belongs to the Late Antonine period and was dedicated by Lucius Aelius Julianus with his son Rutilius and his daughter Lucilla. Obviously the subject, including two children of different sex, was considered particularly appropriate for the father of a son and a daughter. In her publication of the find, J. Inan stresses the severe traits in the rendering of the peplophoros and opts for an original date of ca. 460–450 B.C. Linfert, in a recent review, returns to Euphranor and a possible prototype in Ephesos.[41]

To be sure, the motif of the running woman clad in a peplos, with motion conveyed by the pattern of her folds as much as by her pose, goes back to the Running Maiden from Eleusis (ca. 480 B.C.), in itself a possible inspiration for Figure G on the Parthenon east pediment. A severe Leto would form a link between the two, while a fourth-century Leto could be plausibly explained as a successor to both. A recent analysis within the context of flying or running figures, however, has pointed out the many classicizing traits of the composition as known through the two Roman statuettes and two of the large replicas from Asia Minor.[42] I would agree with this assessment, adding one more detail to Gulaki's list. Both statues and statuettes share a type of sandal with an indented sole which, given the consistency among the replicas, could hardly be a copyist's addition. Yet this form of sandal can now be confidently assigned to the Hellenistic period, on the strength of Dohan's study.[43] That a classicizing creation should be copied comes as no surprise, but the location of the original remains uncertain.

Should we assume, given the size of the Asia Minor monuments, that the original was there rather than in Italy? This supposition may be confirmed by the fact that coins of Kremna from the time of Caracalla show the same unmistakable woman with the two infants. Yet so do coins of Ephesos, Miletos, Phrygia, and Lydia.[44] Does this numismatic evidence reflect the distribution of copies or should it be interpreted otherwise? It would seem however that Rome's claim as the seat of the prototype has now been considerably weakened by the new finds.

That the cities of Asia Minor were connected through the distribution of copies is shown by the abundant sculptural discoveries from Pamphylian Side, so well identified and studied by J. Inan.[45] In her publication, however, in the interest of her students, the Turkish scholar chose to discuss each piece chronologically, not according to the time of its manufacture but to that of the presumed prototype. Her book on Side has therefore resulted in a virtual handbook on the evolution of classical sculpture, but has also fractioned the unity of the sculptural programs as they existed in Side during Imperial times—in other words, the statues have been considered singly, from the Greek point of view, rather than together in the conveyance of their Roman message.

The latter has now been tentatively reconstructed by A. Linfert in his important review of Inan's book. In particular, he has isolated the various statues coming from the Imperial Hall of Building M, probably a library, and has worked out their display in the two levels of niches.[46] He has therefore noted subtle correspondences, both in the vertical and in the horizontal matching of figures and subjects, perhaps even of artists. Thus the Ludovisi Diskobolos (perhaps after an original by Pythagoras) stands four niches away (that is, with three niches between the two) from Myron's Diskobolos on the second story; at the first level, the Diadoumenos and the Doryphoros (?),[47] both by Polykleitos, are separated by a single figure (the Ares Borghese),[48] while a vertical relationship between the Apoxyomenos (below) and the Sandalbinder (above) is staggered through another male statue in repose, the so-called Cyrene/Perinthos Youth. A more direct vertical correspondence exists between statues of Demeter and Kore; Asklepios and Hygieia stand on neighboring niches at the lower level, although the latter is flanked on the other side by a replica of the same type, now utilized as Nemesis.

Because the statues from Building M share technical peculiarities, such as the strut functioning as a neck support, invisible from a frontal view, they were probably made all at the same time, for their specific setting. They therefore give us a useful cross section of what was available in marble workshops of Asia Minor around the middle of the second century A.C. Another

important consideration is the fact that many of the same types represented on Building M occur also in various other cities of Anatolia and North Africa, notably Leptis Magna (at least seven), Perge (five), Aspendos, Ephesos, and Kremna.[49] Linfert concludes that the few unfinished or recut pieces discovered at Side are not sufficient to prove the presence of local ateliers, especially given the lack of nearby marble quarries. The style, common to Anatolia in Imperial times, the nape struts which suggest the need for precautions in transport, and the pattern of distribution of comparable replicas, lead Linfert to propose that the manufacturing center was in Synnada or in Aphrodisias. He also comments that in the number and types of Greek works copied, Asia Minor seems closer to Rome and Italy than to Greece. Yet one of the niches of Building M housed a good replica of the "Lysippan" Sandalbinder, and another of excellent quality has been found at Pamphylian Perge (plate 119), but the presence in Athens of an unfinished copy of the same statue (plate 120) suggests that at least casts of it were available in Athenian workshops.[50]

Another possible link between Greece and Anatolia is represented by two victory akroteria from the Side Nymphaeum which, according to both Gulaki and Linfert, imitate an akroterial figure from the Temple of Athena Alea at Tegea.[51] The two scholars differ in assessing the degree of dependence of the Side statues from the fourth-century B.C. akroterion, but the primary question remains the manner in which an architectural figure set up at considerable height in the middle of Arkadia could provide a model, albeit not to be followed exactly, for the Anatolian sculptors. We have already noted that Nereids riding Dolphins, which had functioned as akroteria of a fifth-century temple in Athens, perhaps that of Ares, had been adapted and copied in Roman times (see plate 82), but the history of that itinerant building lent itself to such a possibility. The Tegea situation is more problematic and we can only assume that the Greek akroterion itself was a quotation or an imitation of a freestanding statue which, through the centuries, could find additional echoes in the creations of Anatolian workshops.[52]

That the Romans were not averse to utilizing as architectural sculptures figures which had originally been created for different functions is perhaps shown by the akroteria of the Temple of Marcus Aurelius at Philippi.[53] There a central Minerva repeated, with slight modifications, the Parthenos type, but her shield resting on the ground, supported by her left hand, acquired a more poignant meaning since the goddess was flanked by two Victories as lateral akroteria. The total message, as read across the facade, was therefore that Athena/Minerva, the goddess of Athens and civilization, could rest her shield because she was victori-

ous, as attested by the presence of her companions. This adaptation of familiar types into new compositions is typically Roman Imperial: each statue conveys not only its individual message but also a more elaborate meaning through appropriate juxtaposition and context.

It is true perhaps, as Zanker deplores, that by the Antonine period nothing new could be said in public monuments and that the language, though universally understood, was merely monotonous and repetitious. The value of the *exemplum* inherent in the setting up of a single copy (as for instance that of the Doryphoros in Pompeii) may be lost in the great choral compositions of the Empire. Nonetheless the "reduced message" of the individual figure is enhanced by the total program, even if this latter has to be read as a text. A consequence of this approach *may* be the lessened need for accurate copies, since each work was no longer a focus of attention but only a part of a greater whole. But I believe that adaptations and "emulations" had occurred from the very beginning of what we might call Roman art, in the very century that chose to set up the Doryphoros in solitary splendor; it is our imperfect understanding, combined with the wide dispersion of finds through the many modern collections, that is responsible for our present conception.[54]

If the Athena/Minerva of the Philippi temple imitated the Athenian Parthenos, the Victories as lateral akroteria had a more complex pedigree. Gulaki has recognized their connection with a Victoria in Naples, which in turn provided inspiration for several other representations—at Miletos, Tralleis, Syrian Laodikeia, and Pisidian Antioch—but in a variety of combinations. Gulaki's tabulation clearly exemplifies the vagaries of the type and her comments stress how this form of *aemulatio* formed a *topos* of the Roman workshops.[55] The distribution pattern of the various adaptations once again suggests an active sculptural production in the Anatolian area.

Where was the main "copyists' center" of Imperial Asia Minor? Although Synnada, Ephesos, and Nikomedeia have also been named, Aphrodisias makes the strongest candidate as the supplier—at least for South Anatolia, Greece, Italy, and North Africa—since so much important statuary has been found, and continues to be discovered, in the Karian city. In addition, the famous peopled scrolls of the Severan Forum at Leptis Magna have long been attributed to Aphrodisian carvers, thus supporting the links with North Africa already noted in connection with the production of statuary in the round. Recently, however, the late Ward-Perkins has challenged this attribution, noting that similar floral compositions can be found as early as 161–162 A.C., in the repertoire of Bithynian carvers at Nikomedeia.[56] Such carvers were very active

in Tripolitania, Pamphylia, and the coastal cities of the western Black Sea (the province of Lower Moesia). The exploitation of the marble quarries, both those of Proconnesos and of Dokimeion, for architectural purposes, had resulted in the establishment, probably at Nikomedeia, of an efficient organization controlling shipment and trade. The Bithynian school of carvers had been flourishing since Hadrianic times. With the introduction of Proconnesian marble, a radical stylistic change could take place, which assimilated the varieties of local expressions current during the first century A.C. into a more unified "Asiatic" style that drew from prototypes current in second-century Anatolia.

Despite his comments on sculpture in general, Ward-Perkins is primarily concerned with sarcophagi and their various monopolies and trade routes. Yet these may be usefully cited for our purposes, since the same network was probably used for the distribution of "copies," perhaps with some modifications.

Attic sarcophagi had a virtual monopoly in mainland Greece. In Asia Minor they shared the market with several imported types: from Dokimeion in Phrygia, from Proconnesos, and with some produced at Ephesos, Aphrodisias, and Karian Mylasa. In Syria they shared the market with Proconnesian caskets. They are totally absent from Alexandria, but again they have a virtual monopoly in Cyrenaica. In the West, their main markets are Rome and the North Adriatic, through the importing center of Aquileia.

Proconnesian sarcophagi show an entirely complementary distribution pattern. There are none in mainland Greece, and highly sporadic finds come from Cyrenaica. They have however a virtual monopoly in Alexandria and the Black Sea, the areas bypassed by the Attic trade. As already mentioned, they share the Syrian and Asia Minor markets, and occur sparingly in Rome before the Late Antique period, although they are plentiful in the North Adriatic, but through a different importing center, Ravenna, where a branch workshop was also located.

Ward-Perkins's comments apply specifically to sarcophagi and thus to a period somewhat later in general than the range under our consideration. It should be noted, for our purposes, that areas with a strong religious tradition of their own, as for instance the Holy Land, did not greatly favor the import of classical works. There is the occasional Zeus-like colossal figure, which may have served for an emperor, a portrait of Hermarchos, some statues or statuettes of Asklepios and Aphrodite, a Hermes, a Muse, some draped women, but the major types are absent and total production is limited.[57]

Proportionately, even Sardis has yielded few copies of Greek masterpieces. The Great Herculanensis type is represented, however, and there are several statuettes of Asklepios here too, perhaps because of the importance of his cult to the Romans.[58] In outlying provincial areas like Gaul and Britain, the more distinctly Roman types are more frequent than the Greeks, and underlying them is a strong local flavor, which leads to local adaptations and transformations away from the classical norm, in a deliberate fusion, at times, with indigenous gods. The few pieces in marble with strong classical traits—for instance, statues for Mithraea—are definite imports in Graeco-Roman style, which do not copy identifiable Greek works.[59]

It would seem therefore that the world of "copies" is circumscribed around the shores of the Mediterranean, with special emphasis in Italy, North Africa, and Anatolia (that is, those areas with a long tradition in classical civilization), and a special kind of activity in Greece,[60] which we shall now discuss but which deserves closer scrutiny than we can give it here. The presence of abundant supplies of marbles, the efficient organization of trade, and the prosperous conditions make Asia Minor the most important of these regions, and Aphrodisias—with its undoubted sculptural workshops and its flourishing schools through the centuries—a major center for statuary in the round, whatever claims may be made for Nikomedeia and its importance for architectural and funerary sculpture.

The "school of Aphrodisias" as previously known through the finds from Rome and elsewhere will have to be revised in the light of new evidence, which has shaken many of the earlier positions. Although final discussion will be possible only after complete publication of the recent discoveries, preliminary reports and fuller accounts on portraits have already given an idea of the wealth of sculpture in the city, well down into the Late Antique. Equally important are the historical reliefs, from the Zoilos frieze to the more recently excavated panels of the "Sebasteion."[61] As for statuary in the round, Aphrodisian artists seem to be largely original thinkers who adapt known works and themes in their own way. Of "copies" proper we can so far mention only some ideal portraits of poets and philosophers, and some epic groups: the Menelaos and Patroklos and the Achilles and Penthesileia.

Where the originals of these groups stood is still a matter of conjecture.[62] We can however be sure of contacts between Aphrodisias and Greece proper on several counts: besides the already mentioned signatures of carvers in Olympia and the spectacular sarcophagus fragments in Aphrodisias itself, taking figures from the Amazonomachy on the shield of the Athena Parthenos, some sculptures found on Greek soil have stylistic traits that can be associated with the Aphrodisian school.

Three, perhaps four, impressive pieces are in Corinth: an Apollo citharode (plate 121), a naked male torso (plate 122), a second torso with drapery (plate 123), and perhaps a second Apollo. These four sculp-

tures share the unusual type of marble and polish, the typical rendering of the digitations as a fractioned series of protrusions typical of some satyrs and pugilists from Aphrodisias, a distinctive marking of a vein along the abdomen, which can also be paralleled on statues in the Karian city. Although all these finds from Corinth have Hellenistic and classicizing style, no direct parallel can be established with other works. The peculiar carving of the back suggests that they were meant for frontal viewing; the non-Greek marble implies direct import, or carvers traveling with their material.[63]

Corinth, among the Greek cities, invites closer study because of its historical circumstances. It was supposedly razed to the ground by Mummius in 146 B.C., yet new excavational evidence suggests some continuity of life at a greatly reduced level. In 44 B.C. a new city, as Roman colony, was founded at the site, although the location chosen for the forum does not correspond to that of the Greek agora. The first colonists came from Italy, thus bringing with them artistic ties with Rome. But soon proximity to Athens must have opened new sources of statuary, while eventually Corinth's prosperity and the increasing demand for urban embellishment promoted the establishment of local workshops.

Since so much of Corinth had been looted or destroyed, some need must have existed for giving the city a sculptural past. To such a need may be ascribed some archaistic works; the tall pedestals with divine figures on three sides, some fragmentary korai and a Hermes Kriophoros (plate 124) which is probably a monument of some importance since another replica of it is known.[64] Other statues were copied directly from Athens and nearby sanctuaries: two karyatids from the Erechtheion, the Great Eleusinian Relief, relief adaptations of the Athena Parthenos and of either the scene on its base or that of the Parthenon east pediment, the "Kallimachean" Maenads. In the round, we have already mentioned the Dionysos "Sardanapalos," the highly realistic Menander, and two statuettes of the Aspasia/Sosandra type, as well as two of the colossal Agora "Aphrodite" which may be a Rhodian Hekate (see plate 75). Other copies are less easy to recognize or may involve originals set up elsewhere within Greece: an Aphrodite of the Naples/Frejus type was recut into a Late Antique male figure, the Knidia is represented in statuette format, the Leaning Satyr (see plate 137), often attributed to Praxiteles, is known in virtually life-size, and there are two versions of the Rospigliosi Artemis, as well as some Apollos in classical/classicizing style. A strong classical trend asserts itself in the admirably carved figures from the pediment of Temple E, in the Antonine period, but they emulate, rather than imitate, Greek prototypes.[65]

A special problem is represented by some of the best-preserved statues from Corinth; their state of preservation could be due to chance, but it seems remarkable that the works recognizably patterned after Greek prototypes should be so highly fragmentary as contrasted to these specific figures. These include some formulaic bodies: the Large and the Small Herculanensis (see plate 138), and a variant also known from Olympia, with which artistic ties were forged through Herodes Atticus's patronage, extended to both cities.[66] Other iconographic ties have now been established with Cyrene through a female figure which at Corinth is identified as Tyche/Nemesis (plate 125) through the addition of a wheel, while at the North African sanctuary a dedicatory inscription by Helbia Timareta labels it as Kore (plate 126).[67] Three more figures remain to be analyzed; a peplophoros turned into an Artemis by the addition of a strap and quiver, that is a rethinking of the severe formula in more advanced style; the so-called Corinth/Conservatori Kore (plates 127 and 128); and the Corinth/Mocenigo type (plates 129–131), perhaps also a Demeter or a Kore.

Controversy has been rife over the last two images, which have alternately been called severe/classical and classicizing. The latest analysis in depth of the Conservatori type has pronounced it classicizing; conversely, the most recent discussion of the Mocenigo type has opted for a truly classical origin, on the strength of some fragments from it recognized among the Baiae casts. At Corinth, all three figures should come from the same workshop, since they display similar carving techniques and share the high polish of the fleshy parts in contrast to the matte finish of the drapery. In addition, all three have the same style of sandal with side cylinders that, according to K. Dohan's study, do not occur on Greek footwear until the end of the fourth century B.C., if not later. Yet this detail alone is not probant, since it could be attributed to workshop practices, shoes being left perhaps to minor masters or to attendants. In the case of the Corinth/Mocenigo type a weightier argument might however be the specific costume worn by the figure.[68]

The heavy garment over the thin chiton has usually been interpreted as a belted peplos unpinned over one shoulder; yet the unusual form of the draping—reaching only to midshins and thus exposing a great deal of the chiton, while the overfold is remarkably long, and forms virtually no kolpos over the belt—suggests that it is a mantle worn in archaistic fashion. To be sure, the same large square of woolen cloth was probably used in antiquity to serve both as peplos and as himation; yet, if any value can be attributed to fashions in terms of style, the Corinth/Mocenigo figure should be considered archaistic rather than classical. It is perhaps significant that the type could almost be severizing, because of its notable quadrifaciality, or rather, squareness of section, and the smooth treatment of the overgarment; but the rich cascade of folds on either

side of the opening, over the right hip, clearly suggests a date at least contemporary with the Athena Parthenos for the prototype. The answer to these stylistic discrepancies may lie in the eclectic nature of the original, probably made some time during the Augustan period, presumably even in Athens, from which a fragmentary replica comes.

This theory is supported by the statuette version of the type, more openly archaizing, found in Delos, and by the large-scale reproductions—even more archaistic—functioning as karyatids, from Tralleis and Cherchel.[69] It would therefore seem logical to conclude that an Augustan creation mixing styles from various Greek periods could be subjected to *imitatio*, which emphasized each component style in turn, once making the figure more classical, once more severe, once more definitely archaistic. The issue should remain open, in hope that additional evidence may be forthcoming to settle it; but it would be important to know whether "Roman" pieces found more favor in Corinth than outright copies—hence their scale and state of preservation.

The Cherchel karyatid has been dated to Hadrianic times, while the Corinth figure should be somewhat later, within the Antonine period. Conversely, the Tralleis karyatid, closer to the North African statue, should be earlier. Transmission of models may have occurred directly from Asia Minor, given the distinct similarity of the two karyatids, but links between Cherchel and Athens should be postulated on other grounds.[70] It is regrettable that the many sculptural finds from the Algerian city are not better known, since the history of Iol/Caesarea could be equally revealing in terms of copyists' practices. Under Juba II the links may have been with Rome, since the young king had been brought up in the Italian capital. Yet some attempts were made to create in Caesarea an African Athens, and such efforts continued well after Juba's reign, since many statues (including a replica of the Omphalos Apollo [see plate 81]) come from the Baths, of later date. Around the turn from the first into the second century some local marble was found, thus promoting the establishment of local workshops, which produced types common to the rest of North Africa but not popular elsewhere. Among the replicas we note several groups of satyrs and hermaphrodites, of general Hellenistic cast; a Doryphoros; statues of Artemis of the Rospigliosi type; a colossal Herakles recently attributed to Onatas on insufficient grounds and likely to be classicizing; and—to my mind equally classicizing—the two famous Demeter statues, named after the city, of which only one additional replica/variant is known, from Italy.[71]

Another North African site, Cyrene, has yielded several sculptures that can be considered bona fide replicas, but many need reevaluation. A test case has been provided by the current excavations of the sanctuary of Demeter and Kore just outside the city walls. Preliminary study of the female figures shows increasing evidence for local workshops, despite the lack of good local stone.[72] Some figures from the Roman period are recognizable copies of late-fourth-century and Hellenistic types, but most are adaptations or products of *aemulatio*, combining classical with Hellenistic motifs. Links with Greece and the Ionic area of Asia Minor (e.g., Ephesos) seem stronger than those with the Pamphylian and Pisidian cities, not simply in terms of iconography but also of techniques.

These outlines of finds from various cities are inevitably sketchy and superficial, but they may serve to point the way for future research. With the help of the computer, it should be possible to tabulate all statuary types found within a city, with an approximate indication of chronology, and then to establish cross references to determine the distribution pattern of a specific figure. Thus routes could be traced and workshops of origin located, while a more refined study may even be able to pinpoint the local variations vis-à-vis the imported models.

Notes

1. All comments on Thorvaldsen and his work are primarily taken from *Bertel Thorvaldsen: Eine Ausstellung des Wallraf-Richartz-Museums in der Kunsthalle Köln, Februar 5–April 3, 1977,* and especially the contribution by F. Otten, "Thorvaldsen und die Antike," pp. 17–23. Also of some importance for my topic is *Bertel Thorvaldsen: Untersuchung zu seinem Werk und zur Kunst seiner Zeit* (Cologne, 1977).

2. We should, however, question to what extent this process of transformation had already taken effect in the translation from the Greek bronze to the Roman marble.

3. Otten: supra, n. 1.

4. When my lectures were delivered, both at Ann Arbor and in Rome, I had not seen Seley's Herakles myself and I owed knowledge of it to the kindness of Prof. P. Kuniholm of Cornell University. I have since had the opportunity of admiring the colossal original at an exhibition in Allentown, Pa. (May, 1982) and can testify to its power, as well as to a certain air of bravado totally absent from the Graeco-Roman prototype. The modern statue can definitely be considered a creation in its own right.

5. It is worth recalling that our modern word *copy* comes from Latin *copia,* which has an entirely different connotation: of richness and abundance, therefore totally positive, in contrast with our own present conception.

6. Lippold, *KuU,* pp. 2–4; the translation is by Bieber, *Copies,* p. 3.

7. Cf. Leo Steinberg's introduction to J. Lipman and R. Marshall, *Art about Art* (New York, 1978), p. 25; he quotes Sir Joshua Reynolds discussing "Imitation" in the sixth of his *Discourses* and using such terms as *borrowing, gathering, depredation, appropriation, assimilation, submitting to infection or contagion.* Needless to say, these are all relatively modern concepts which had no currency in antiquity.

8. Strocka, "Variante," esp. pp. 157–61.

9. O. Brendel, *Prolegomena to the Study of Roman Art,* 2d expanded edition, with preface by J. J. Pollitt (New Haven, 1979), p. 182.

10. Wünsche, "Idealplastik," and modifications in Gulaki, "Nikedarstellungen," pp. 147–50.

11. J. Van Sickle, "Reading Virgil's Eclogue Book" in *ANRW* II.31.1 (1980): 590, n. 40. The entire article (pp. 576–603) deals with the question of originality, allusion, and emulation. I am much indebted to Prof. Van Sickle for this and many other references to comparable problems in ancient literature. Several of his works deal with the same issues, for instance "Style and Imitation in the New Gallus," *Quaderni Urbinati di Cultura Classica* 38, n.s. 9 (1981): 115–24. Particularly relevant for our viewpoint is the appendix (pp. 122–23), "The Question of Quality," inspired by the discovery of a new papyrus with Gallus's work in 1978. Although the newly found verses invite comparison with major Augustan poets and ten of them echo just one poem, they are not considered as evidence of plagiarism but rather of knowledge and emulation. The issue is therefore to determine "what Callimachus became in Gallus, then Gallus in Virgil, Propertius, and Ovid."

12. The concept of ideal form is explored in Trillmich, "Jünglingsstatue," but see also Trillmich, "Bemerkungen." By the same author, on the issue of copies and variations, see also "Eine Kopfreplik des Typus Monteverde in Mérida," *MadMitt* 22 (1981): 268–89. For some approaches typical to Roman *Idealplastik* cf. H. von Hesberg (supra, chap. 2, n. 60).

13. Trillmich, "Jünglingsstatue," p. 360. See also H. G. Niemeyer, "Klassizistischer Torso aus Italica," *MadMitt* 22 (1981): 290–98.

14. Wünsche, "Idealplastik." His main concepts remain unchanged, and his comparisons valid, despite the fact that more recent study has suggested that the Magdalensberg Youth is not a nameless adolescent, but a representation of Mercury with petasos and kerykeion—not as later adaptation, but in the original conception. The suggestion is based on the inscribed round object which appears next to the statue in engravings: originally taken to be a shield, added to change the youth into a Mars, it is now seen as a petasos: E. Walde-Psenner, "Zum Jüngling vom Magdalensberg," *JdI* 97 (1982): 281–301; see esp. the reconstructed drawing on p. 299, fig. 11. The statue is here dated to the first half of the first century B.C., rather than to the second, as suggested by Wünsche.

That the Romans preferred statues differently balanced from the Greeks is suggested also by Gulaki, "Nikedarstellungen," who often identifies as "classicizing" works where the legs appear in three-quarter view while hips and torso are frontal: see, e.g., p. 182 and figs. 138, 140. Not only are the two halves of the body conceived for different viewpoints: the pose also presents ambiguity, compounded as it is of movement and immobility, as if the statue had stopped in midstep.

15. For this archaistic statue, still virtually unpublished, see supra, chapter 2, n. 69. All the other statues cited can be found in Wünsche, "Idealplastik," with bibliographical references. They are also illustrated and discussed in Zanker, *Klassizistische Statuen.* For the different interpretation of the marble youth in Madrid as a man of culture (whose long locks suggest an African identification) see R. Winkes in *ANRW* I.4 (1973): 915–16 and fig. 24.

16. Athens, National Museum 3020: Karouzou, *Guide,* p. 44. Trillmich, "Jünglingsstatue," p. 223, n. 46, states that if the statue is truly a copy of the "Pasitelean Pylades," this would be the only replica of the type found in the East.

17. This situation would apply particularly to the new foundations, such as Corinth in 44 B.C., which was peopled by freedmen and veterans, mostly coming from Italy; see *Hesperia* 50 (1981): 429–30 and n. 29 with references.

Note also that, in terms of Roman influence and expansion, the last two centuries before Christ should no longer be considered Hellenistic: cf. supra, chapter 2 and n. 44, and, for the depiction of a play by Plautus in Delos, chapter 5, n. 9.

18. Wünsche, 'Idealplastik," pp. 64–65, with ancient references, esp. nn. 96–99.

19. G. M. A. Richter, *Ancient Italy* (Ann Arbor, 1955), pp. 44–45. The lectures were delivered in 1952.

20. Preisshofen/Zanker, "Reflex."

21. Cicero: *De Inventione* 2.1.1 (cf. Pollitt, *Art of Greece,* p. 156). For a modern comparison of the *Rhetorica ad Herennium* and the Cicero passage see, e.g., Becatti, *Arte e gusto,* pp. 99–100.

22. Besides the examples cited by Preisshofen/Zanker, "Reflex," and Zanker, *Klassizistische Statuen,* see also the typical example of male/female confusion of the Anzio Apollo: *Museo Nazionale Romano,* pp. 192–94, no. 122. Cf. also chapter 9 in Ridgway, *Severe Style.*

23. Cf. Diod.Sic. 26.1 (Pollitt, *Art of Greece,* p. 224); also Quintilian, 12.10.7–9 and Pliny *NH* 34.53ff.

24. For the Roman interpretation of such practices see, e.g., Statius *Silvae* 5.1.228–38 and cf. Becatti, *Arte e gusto,* pp. 200–2. Significantly enough, no Athena type, to my knowledge, was ever given a portrait head, thus suggesting true discrimination in the iconographic selection and no real consideration of authorship. Artemis types were occasionally, if seldom, selected for young girls: cf., e.g., *Museo Nazionale Romano,* pp. 23–24, no. 24, from Ostia, dated to the late Julio-Claudian or the early Flavian period.

25. On the Foundry Cup see supra, chapter 3, n. 12 and, in general, pp. 32–33. For the practice in small bronzes and terra-cottas see D. K. Hill, *Hesperia* 27 (1958): 311–17, and *Hesperia* 51 (1982): 277–83.

26. Cf. Coarelli, "Roma 150–50 a.C.," pp. 28–29.

27. This sentence is quoted from B. Rosasco, "The Sculptures of the Château of Marly during the reign of Louis XIV" (Ph.D. diss., Institute of Fine Arts, NYU, 1980), p. 119; see her entire discussion, pp. 117–22, with extensive citations from contemporary sources and examples from Late Baroque Rome. Note in particular her comment (p. 117): "Certain ancient groups have furnished the sculptors with very specific gestures which were copied so directly that they remain clearly recognizable." A list of individual examples

follows. I am much indebted to Dr. Rosasco for discussing this related phenomenon with me.

28. A. Elsen, "In Rodin's Studio: the Sculptor and the Photographer," lecture presented at Swarthmore College, Swarthmore, Pennsylvania, on September 13, 1981.

29. Hermes of Olympia: cf. supra, chapter 4 and n. 38.
 Antinoos Belvedere: Helbig[4] no. 246 (von Steuben; dated to the Hadrianic period but not considered a true portrait of Antinoos).
 Hermes Farnese: Lippold, *Handbuch*, pp. 275, pl. 96.4.
 Hermes of Andros: S. Karousou, *AthMitt* 84 (1969): 143–57, has an important discussion on the findspot of the statue, which seems to have stood in a naiskos over a grave, together with a female figure of the Large Herculanensis type. Karousou dates both the Hermes and the Herculanensis to the first century B.C., although other dates had been previously suggested, and reviews the various attributions of the Hermes type (p. 154).

30. E. Andreou, *Deltion* 31.1 (1976, publ. 1980), pp. 260–64, French summary on p. 365, pls. 58–60; it is there suggested that the Elis torso was dedicated to Hermes Enagonion in one of the gymnasia or palestrae of the city, but this suggestion seems at variance with the findspot within a private house. The distinction of the general type into three groups (one earlier and one later) may be questioned, but the association of the Elis Hermes to the Hermes of Olympia and its related statues is very convincing.

31. Munich Oil-Pourer: for a recent discussion see. A. F. Stewart, *AJA* 82 (1978): 301–13, and figs. 15 and 17. The type of the Oil-Pourer is there attributed to Lysippos on the basis of comparison with the Vatican Apoxyomenos; cf. *Munich Catalogue*, pp. 304–14, no. 29, with good profile view of head.

32. J. Fink, "Ein Kopf für Viele," *RömMitt* 71 (1964): 152–57, and "Der grosse Jäger," *RömMitt* 76 (1969): 243–44. See also S. Lattimore, *AJA* 83 (1979): 71–78; F. Causey, *GettyMusJ* 4 (1977): 77–87; E. G. Raftopoulou, in *Stele* (Memorial volume for N. Kontoleon) (Athens, 1980), pp. 388–93.
 A similar discrepancy between elongated profile and roundish front view occurs also in a bronze head on display on the lower floor of the Basel Antikenabteilung. The head (BS 235) is labeled as a work made "around the birth of Christ, in free imitation of sculpture of the first half of the fourth century B.C."

33. K. E. Dohan, "HYPODEMATA. The Study of Greek Footwear and its Chronological Value" (Ph.D. diss., Bryn Mawr College, 1982), pp. 138–40.

34. The same type of "Praxitelean" revival probably gave origin to the Arles Aphrodite: see supra, chapter 6, p. 73 and n. 51. My doubts as to a Praxitelean attribution extend to the preserved versions of the Apollo Sauroktonos, although more study is needed on this particular monument. In brief, however, it could be anticipated that its style is considerably different from that of the Knidian Aphrodite, the only work clearly attributable to Praxiteles on good grounds, albeit through Roman copies. A Lysippan revival in the Late Hellenistic period is accepted by most scholars and may represent a comparable phenomenon within the eclectic-classicizing movement: cf. Raftopoulou, supra, n. 32.

35. Esquiline Venus: the suggestion is by R. Carpenter, *MAAR* 18 (1941): 30–35, with superimposed photographs. More recently, see Helbig[4] no. 1484, pp. 304–5 with bibliography; Ridgway, *Severe Style*, p. 133.
 Cyrene Aphrodite: *Museo Nazionale Romano*, pp. 170–76, no. 115 (O. Vasori).

At a symposium organized by the University of Cincinnati on April 2, 1982, Prof. E. B. Harrison expressed the opinion that the Esquiline statue is not an Aphrodite but a Grace, severizing in its style to convey purity: her paper will be published in the near future. Whatever the interpretation and the message embodied in the statue, its artistic components are not in question.

36. On the Orestes and Elektra see Ridgway, *Severe Style*, pp. 135–38 with bibliography. Other Pasitelean groups are illustrated and discussed in Zanker, *Klassizistische Statuen*.

37. Guerrini, "Motivo iconografico," discusses also a third group, more loosely formed by all figures which share the same motif of the low belt but are so different that they cannot be classified with either previous group and cannot even be linked with one another. According to Guerrini, most replicas of the Genetrix belong to the second century A.C.
 The question naturally arises on the availability of a cult image in Rome for copying purposes. Since, however, the statue was created in Italy, at a time when reproduction was favored and indeed expected, Arkesilaos may have preserved models or dimensions of his sculpture, for future duplication; we need not assume that the very statue dedicated by Caesar was approached for measuring. Arkesilaos's creation itself utilized a fifth-century B.C. prototype which must have been available to him in models or sketches.
 Doubts have been raised as to the type of the Venus Genetrix made by Arkesilaos, and a more heavily draped type has been proposed: see, e.g., S. Weinstock, *Divus Julius* (Oxford, 1971), pp. 85–86 and references in notes. Any other type, however, does not seem to have reached the popularity of the Naples/Frejus type.

38. Group from Perge: J. Inan, "Neue Porträtstatuen aus Perge," *Mélanges Mansel* (Ankara, 1974), pp. 643–61, esp. pp. 654–55, pls. 206–7; for Plankia Magna's statue see pp. 648–49, pls. 195–97. The latter is shown with the body type of the Large Herculanensis, but is crowned with the headdress of Priestess of the Imperial cult, and inscribed bases give her title. Her face is close to a portrait of Sabina previously found at Perge and therefore enables the chain of reasoning that establishes the date for the "eclectic" group.
 For another example of Antonine eclecticism see also a head from Casalcipriano, near Campobasso in Italy: R. Rower, *DialAr* 9–10 (1976–77): 497–503. The head is particularly interesting for its resemblance to Pasitelean works and for its combination of male and female features, especially in the hairstyle.

39. Trillmich, "Bemerkungen," pp. 266–67 and 276–78.

40. O. Palagia, *Euphranor* (Leiden, 1980), pp. 36–39, lists all the ancient sources mentioning a Leto with children (one, in Delphi, by unknown sculptor), representations on vases (only three), and on coins of Asia Minor (p. 38). Palagia discounts the early appearance of the statuette in the Conservatori Museum as an intentional recasting in severe forms of a classical prototype, and believes that "the profile appearance of Leto's legs, although awkward, is still within the classical tradition for the running figure" (p. 39). See her figs. 58–60 for the two statuettes in Rome. On the one in the Conservatori Museum see also Helbig[4] no. 1501 (v. Steuben) where the date of the prototype is given as preclassical
 The statue made by Skopas for Ephesos represented Leto holding a scepter, while the infants Apollo and Artemis were held by the nymph Ortygia. It cannot therefore be the same monument as that represented by these marble replicas. The Torlonia statuette was found in the Circus of Maxentius, the one in the Conservatori is probably from the Via Appia. When I saw the latter in March 1982 I could see no actual trace of the infants on her shoulders, although the broken areas correspond to the position where they appear in the other replicas.

In March, 1983, I noted one more statuette of the same type, with the two children, in the J. Paul Getty Museum, Malibu, but to my knowledge, the piece is still unpublished, and I have no information on its provenience.

41. The replica in Miletos is know to me only through the mention by A. Linfert, review of *Munich Catalogue, BonnJbb* 181 (1981): 614 (under no. 26, footnote 11 of *Catalogue*). For the Kremna statue see J. J. Inan in *TürkArkDerg* 19.2 (1970): 66–68, no. 5, pl. 20.2; and for the statue from Seleukia see Gulaki, "Nikedarstellungen," fig. 49.

42. Gulaki, "Nikedarstellungen," pp. 100–2 and further bibliography in nn. 386–87.

43. Dohan (supra, n. 33), p. 244. In her appendix I (pp. 258–63), Dohan examines representations of footwear on Roman copies, and concludes that the inaccuracies of some replicas requires that copies "be treated as a totally separate corpus of material." When however such thorough consistency exists among replicas of different date, provenience, and especially size, the assumption that they reflect a specific prototype, at least in chronological terms, should not be discarded.

44. Some of the coins are listed by Palagia (supra, n. 40), p. 38, but the most interesting for our purpose is one from Kremna: Bieber, *Copies,* fig. 466.

45. Inan, *Side.* For Linfert's review of the book see *BonnJbb* 179 (1979): 780–85. All the statues mentioned below are specified in Linfert's review and in Inan's book.

46. Linfert's review, p. 784.

47. Inan, *Side,* no. 345: only a plinth with two legs remains; the Doryphoros identification is Linfert's.

48. The location of the Ares in this niche is not assured. Note that the Side replica has the same cuirass strut as the statue from Leptis Magna: R. Bartoccini, *Le Terme di Lepcis* (Bergamo, 1929), p. 119, fig. 118—same workshop?

49. Linfert's review, p. 785. Other comparisons could be established by considering other sculptures; suffice it here to mention a type of classicizing Dioskouros, which recurs at Perge (*AA* 1956 [publ. 1958] cols. 106–8, figs. 56, 58), Leptis Magna, Cyrene, probably Corinth, and significantly, Aquileia: cf. V. Santa Maria Scrinari, *Museo Archeologico di Aquileia, Catalogo delle sculture romane* (Rome, 1972), nos. 19–20, with reference to parallels. For Corinth see *Hesperia* 50 (1981): 441 and n. 76.

50. Sandalbinder (also so-called Jason): see supra, chapter 5 p. 56 and n. 51. For a recent discussion of the type see *Munich Catalogue,* pp. 457–68, no. 42, and Linfert's review, *BonnJbb* 181 (1981): 615–16 with additions to the list of replicas. The Perge statue, which I am able to illustrate thanks to the kindness of Prof. Inan, has solved several problems and shown the incorrectness of other hypotheses; Prof. Inan tells me that C. Caprino's list of replicas (*BdA* 59 [1974]: 106–14) should be carefully scrutinized and may include a forgery. The Perge Sandalbinder is discussed by J. Inan in *Belleten* 43.170 (1979): 397–413. That the original of the type represented a Hermes seems now proved on the basis of the Perge replica which retains traces of the kerykeion; I am still uncertain about a Lysippan attribution. In discussing a head of the Ares Ludovisi/Jason type, E. G. Raftopoulou suggests that in Late Hellenistic Athens "Lysippan" works were created (see supra, nn. 32 and 34).

51. Side Nikai: Inan, *Side,* nos. 64–65; Gulaki, "Nikedarstellungen," pp. 74–78 (Tegea Akroterion), esp. p. 75 for the comparison with the Side Nikai. Close comparisons can also be established with a Nike in Cyrene, see Gulaki's figs. 28–34 for the entire group. A connection with the North African city has already been noted for other sculptures from Side. For Linfert's comments on the Tegea/ Side parallel see his review of Inan, *BonnJbb* 179 (1979): 780–85, under no. 64.

52. It is perhaps significant that the Tegea akroterion has no wings, while both the Side and the Cyrene imitations have been openly transformed into Victories.

53. Philippi akroteria: E. Lapalus, *BCH* 59 (1935): 175–85, pls. 7–9. That the Romans could use unusual "types" as akroteria is also shown by the statue of Augustus's grandson, Lucius Caesar, dedicated by the Demos of Athens as the central akroterion of the propylon to the Market of Caesar and Augustus, which T. L. Shear, Jr., argues was a veritable Forum: *Hesperia* 50 (1981): 359–60 and n. 19.

54. Zanker, "Funktion," p. 305; cf. also pp. 294–99. Note the criticism leveled by H. P. Laubscher against Vermeule's *Sculpture and Taste* in his review of the book, *ArtB* 63 (1981): 506–8: "not much more than an enumeration, albeit an informative one, which lacks an underlying structure based upon consideration of essential problems" (p. 506). Our present arrangement of statues in museums and collections constitutes exactly a form of—visual—enumeration.

That more originality might have existed in sculptural works for private use as late as the fifth century A.C. is suggested by the unusual Ganymede and the Eagle from Carthage: E. K. Gazda, in J. H. Humphrey, ed., *Excavations at Carthage 1977,* vol. 6 (University of Michigan) (Ann Arbor, 1981), pp. 125–78.

55. Gulaki, "Nikedarstellungen," pp. 177–81, with the tabulation on p. 181, figs. 123–37; cf. also her comments on the Minerva/Victoria, p. 192.

56. J. Ward-Perkins, "The Marble Trade and its Organization: evidence from Nicomedia," *MAAR* 36 (1980): 325–38; a more tentative statement is presented by him in "Nicomedia and the Marble Trade," *BSR* 58 n.s. 35 (1980): 23–69, but the article includes distribution maps for the sarcophagi, and more detailed epigraphical and archeological evidence. Some of his conclusions had already been reached, before the discovery of the quarries, by G. Ferrari, *Il commercio dei sarcofagi asiatici* (Rome, 1966). See also H. Dodge, *Yayla* 4 (1981): 8–11 and fig. 1 showing main quarry sites in Roman Asia Minor.

57. C. C. Vermeule and K. Anderson, "Greek and Roman Sculpture in the Holy Land," *BurlMag* 123 (1981): 7–19; see esp. p. 19: "So far, no replicas of famous Greek statues have been found in the Holy Land." See also Vermeule, *Jewish Relations with the Art of Ancient Greece and Rome* (Boston, 1981), and *AJA* 79 (1975): 327, n. 13, for the comment that "Side and Salamis (in Cyprus) were on the same Greek Imperial trade routes toward the Syrian coast."

For a replica of a Hellenistic Muse in Jerusalem see G. S. Merker, *IEJ* 23 (1973): 178–80.

Some of the Victories illustrated by Vermeule/Anderson, figs. 31–33, compare fairly well with Gulaki's Naples/Philippi type, with conflations including the Minerva/Victoria.

58. See G. M. A. Hanfmann and N. H. Ramage, *Sculpture from Sardis* (Cambridge, Mass., 1978), and review by B. Freyer-Schauenburg, *Gnomon* 52 (1980): 502–5, esp. p. 504 and n. 14.

59. Cf., e.g., C. Lindgren, *Classical Art Forms and Celtic Mutations* (Park Ridge, N.J., 1980), esp. p. 135 and her pl. 67, pp. 95–96, the Minerva head from the Walbrook Mithraeum, London.

60. This statement does *not* apply to the Greek islands, especially Rhodes and Delos, on which see chapter 5.

61. For a brief summary see M. Floriani Squarciapino, *Studi Romani* 26 (1978): 384–89; periodic accounts by Prof. Kenan Erim in his yearly newsletter, and M. J. Mellink's "News Letter from Asia Minor," in *AJA;* those for 1981 and 1982 give accounts of the newly uncovered Sebasteion, and a reconstruction drawing appears in *National Geographic* 160.4 (October, 1981), p. 549; see there pp. 526–51, and also K. Erim, *RA* (1982): 163–69, for some illustrations of sculptural finds. The Zoilos Frieze is excellently illustrated on pls. 21–29 of A. Alföldi, *Aion in Mérida und Aphrodisias* (Mainz, 1979), cf. pp. 38–40 for an epigraphic appendix by J. Reynolds, and pp. 35–37 for a description of the frieze by K. Erim. Many of the Aphrodisias portraits are published by K. Erim in J. Inan and E. Alföldi-Rosenbaum, *Römische und frühbyzantinische Porträtplastik aus der Türkei* (Mainz, 1979).

For general surveys of Aphrodisias see also K. Erim, in *EAA* Suppl. (1970) s.v. *Afrodisiade;* C. Roueché, "Rome, Asia and Aphrodisias in the Third Century," *JRS* 71 (1981): 102–20, for links among areas in the late Empire; J. Mladenova, "L'école d'Aphrodisias en Thrace," *Rivista di Archeologia* 3 (1979): 91–94. A. Barattolo, "Afrodisia e Roma: nuove testimonianze per la storia della decorazione architettonica," *RömMitt* 89 (1982): 133–51, points out connections with the Temple of Venus and Roma, and the Pergamon Trajaneum.

For a redating of the "Tiberius porticus" to the Antonine period see Linfert, *BonnJbb* 181 (1981): 613 under no. 17. The frieze from the Aphrodisias portico is important for its many heads reproducing well-known types of the classical and Hellenistic period.

62. On the Achilles and Penthesileia see now *LIMC* 1 (1981) s.v. *Achilles,* and cross-reference s.v. *Amazones.* For the Menelaos and Patroklos group the most important summary remains that by B. Andreae in *AntP* 14 (1974): 87–89. Note that a variant of this group has been found at Aquileia. A colossal version seems to have existed at Loukou, Herodes Atticus's estate. Whether the Sperlonga example is Menelaos/Patroklos or Odysseus/Achilles is still uncertain.

63. Corinth sculptures: *Hesperia* 50 (1981): 444–45 and n. 85, pl. 96a–c. See the entire article, pp. 422–48 for a survey of sculpture from Corinth, which includes all the examples cited infra.

64. Hermes Kriophoros: *Hesperia,* p. 431 and n. 36, pl. 92c. The replica that was once in Wilton House is now in the Warburg Institute entrance hall, London.

Pedestals with archaistic figures: C. K. Williams, *Hesperia Suppl.* 20 (1982): 175–81.

65. On the sculptures from the pediment of Temple E see now, most recently, E. Voutiras, *AJA* 86 (1982): 233, pl. 32.7–8; the figures are considered "copies" of a fifth-century pedimental composition in Athens, not much later than the Parthenon.

66. On these types see infra, chapter 8.

67. Helbia Timareta's dedication at Cyrene: D. White, *AJA* 85 (1981): 23 and n. 37; for the Corinth version see *Hesperia,* p. 440 and n. 75. See there also for discussion of ties between Corinth and Cyrene or with North Africa in general.

68. Corinth/Mocenigo type: *Hesperia,* pp. 439–40, n. 72 and pl. 95.b. For discussion of the Baiae casts, beside the article by Ch. von Hees in *AntK* 21 (1978): 108–10, see now her *Abgüsse,* pp. 27–30.

69. Delos archaistic version: Marcadé, *Au Musée,* pl. 54, and cf. list of plates on p. 510, A 1731.

Tralleis and Cherchel karyatids: H. P. Laubscher, *IstMitt* 16 (1966): 115–29, esp. pp. 128–29 for prototype from Athens; the dating suggested here for the karyatids is Laubscher's.

70. The sculpture from Cherchel is still in need of thorough publication and discussion. For a general account of the city see *EAA* s.v. Cherchel; also *PECS* s.v. Iol. For comments on sculpture from the theater see G. Bejor, *Prospettiva* 17 (1979): 37–46. Articles on the sculptures by E. Boucher-Colozier have appeared in *MélRome* 66 (1954): 101–45; *Libyca* 1 (1953): 13–35; 2 (1954): 73–87; 3 (1955): 77–85. See also M. Leglay, *La Sculpture Antique du Musée Stéphane Gsell* (Algiers, 1957). From Cherchel comes the only cuirass statue comparable to the Prima Porta Augustus: K. Fittschen, *JdI* 91 (1976): 175–210.

71. For the Herakles see J. Dörig, *Onatas of Aegina* (Leiden, 1977), pp. 10–15, figs. 9–11, 19, 22.

For the two Demeter statues see Ridgway, *Fifth Century Styles,* p. 186, no. 5.

72. S. Kane, "Draped Female Sculpture form the Sanctuary of Demeter and Persephone at Cyrene" (Ph.D. diss., Bryn Mawr College, 1978) and a forthcoming publication in book form. My comments are taken from Kane's conclusions.

8 Letting the "Copies" Speak for Themselves

In these concluding pages I shall consider two specific aspects of the world of copies: the duplication of works in Rome, and the reliability of numismatic depictions as aids in determining the location of the sculptures. I shall then modify the approach so far followed: looking only at the site of Ephesos as an individual unit, I shall focus primarily on the monuments themselves, both those with the greatest distribution and popularity and those known in single exemplar, in the attempt to isolate trends and likings in the ancient world.

The first aspect involves a question already asked by Lippold: were sculptures *in Rome* copied for distribution to outside markets?[1] The German scholar had answered in the negative, believing that the Italian capital was not a copyists' center, but this position can easily be disproved. Not only were the Romans directly involved in the distribution of Imperial portraits; several statues in Italian marble—replicas of specific prototypes—were surely made locally, and remains of workshops, specifically one on the Esquiline, have been found. The enormous demand created by the many constructions within the capital city, and the undoubted existence of sarcophagus carvers in Rome itself, suggest that local ateliers complemented the extensive imports evidenced by finds and wrecked cargoes.

Such production, however, could have taken solely the form of adaptations from models, of a rethinking of certain prototypes without exact duplication. We should therefore ask a more defined question: do we know of such copies, and can we point to original works in Rome that are represented by replicas elsewhere? To the first part of the query an answer is best provided by a Roman rather than by a Greek work, since we need incontrovertible evidence. In the Museo Gregoriano Profano (ex-Lateran) within the Vatican there is a colossal statue of a Dacian in fringed costume (plate 132). Remains of measuring mounds and abundant tool marks clearly indicate that the statue was left unfinished, and indeed it was found within a workshop context. It is clear, however, that the marble faithfully copies the Trajanic Dacians at present on the Arch of Constantine, as well as some comparable figures (plate 133) still to be seen today within Trajan's Forum.[2] Interestingly enough, the drapery of the replica follows that of the originals almost fold by

fold, but the actual rendering of the channels is different, with greater use of the drill and technical mannerisms which suggest a later (Severan?) style. Be that as it may, this unfinished piece is proof that exact copying was carried out in Rome, even when the model was an ideal *Roman* rather than a Greek type.

As for the second part of the question, we have already answered it partially in discussing the works cited by the ancient sources as being in Rome; there, however, our quest was limited by the literary mentions.[3] We can now address the issue from the point of view of actual finds. I shall confine my investigation to one case which, although providing only indirect evidence, should be reasonably probant.

Although no literary reference remains to a statue of Antisthenes, it had been considered likely that one had been erected in the Kynosarges gymnasion where, as a follower of Sokrates, he had taught before his death around 365 B.C.[4] An inscribed herm from Tivoli had suggested a specific head type, and a terra-cotta statuette from Pompeii had illustrated a sitting pose. Then in 1969 a base was found in Ostia, which not only gave Antisthenes as the subject of the piece it once supported, but also mentioned Phyromachos as its author. The base, as already mentioned,[5] was one of three, obviously of Roman date and inscribed by the same hand, presumably repeating information from the original Greek pedestals left behind when the monuments they supported were taken to Italy. The statues themselves were not recovered, and their history might have included other trips after the one from Greece, since the Roman bases in turn were reused within an Augustan structure.

The connection of Phyromachos's name with a portrait of Antisthenes has attracted some attention.[6] It has been assumed that the type known through Roman replicas must coincide with Phyromachos's statue, since they all repeat the same features. Hence Phyromachos's style has been derived from Antisthenes' portrait, especially since the sculptor's chronology, although still debated, implies an imaginary likeness created no less than 150 years after the subject's death.

Be that as it may, the known findspots of extant Antisthenes portraits—when Richter wrote her *Portraits of the Greeks* in 1965—all clustered around Rome, or at least Italy, thus seeming to confirm a Roman location for the Greek original. But in 1966 the Germans made known one more replica of the head, found with other portraits of philosophers and one of Euripides, in Pergamon.[7] Since this single replica of the type to have been found in Asia Minor is judged to be of late Hadrianic or early Antonine date, we should assume that it copied the statue in Italy, or at least a model was made available by Italian workshops.

The second aspect to be considered here involves the reliability of numismatic reproductions to determine the location of the original. In discussing the Leto and her Anatolian replicas we have already noted not only that a classicizing creation could be reproduced on Roman coins, thus showing that it has as much importance in Roman eyes as the older and presumably more famous Greek originals, but also that the same image could be adopted by more than one mint, thus diminishing the value of the information for localizing the monument. Comparable conclusions could be drawn from the numismatic distribution of the Crouching Aphrodite (see plate 34),[8] the Invitation to the Dance (Kizykos), the Farnese Bull (see plate 31), even the Weary Herakles (see plate 99), but for all these monuments, the location of the original could be debated. No doubt however exists for one of the most famous monuments of antiquity, yet its numismatic reproduction is so frequent and widespread as to become useless for our purposes: the Artemis of Ephesos (plates 134 and 135).

Recent studies by R. Fleischer on this important cult image and related Anatolian types have convincingly shown that the many-breasted type, far from being a Hellenistic invention or replacement, can only go back to an early "xoanon" in wood, probably to be dated as early as the seventh century B.C.[9] To the basic wooden image, ornaments and the so-called ependytes were added in gold foil, and the goddess's wardrobe may have been extensively and frequently changed, thus partly explaining the great variation in details among the replicas. Yet Fleischer concludes that coins reproduced the true appearance of the image—its official form, as it were—while sculptural copies could aim at conveying the power of the deity through various symbolic attributes not present in the cult image. He stresses that this numismatic faithfulness applied also to Imperial coins, which from Hadrianic times onward reproduced even early archaic statues.[10]

Given this accuracy of reproduction, one would be led to believe that such coins were issued at Ephesos itself, but this is only partly the case. If I have not misread Fleischer's distribution maps, approximately fifty-seven mints in Anatolia alone used the Ephesian Artemis for their coinage, as well as two mints in Palestine (66 B.C.) and one each on Andros and on Crete, for a total production spanning almost four hundred years, from ca. 159–133 B.C. until the reign of Valerian. Were we to attempt to locate the specific city where this powerful Artemis was worshipped on numismatic evidence alone, without the help of literary sources, we would be entirely misled by such abundance.[11]

Should we therefore conclude that numismatic studies on sculptural reproductions are valueless? To the contrary: those by Imhoof-Blumer and Gardner (as well as the updated version by A. Oikonomides),

by Lacroix, and by Ph. W. Lehmann, have all contributed important information. I understand that a study is in progress on the statues depicted by Athenian Imperial mints; preliminary results suggest—as far as I have been told—that only classical monuments appeared on their issues, a state of affairs which would differ from evidence we have already mentioned, which implied no such discrimination against Hellenistic and classicizing creations. I would rather extend a plea to the numismatists for more studies in depth concerning the reproduction of statuary on coins, bearing in mind the problems with which their colleagues specializing in sculpture are struggling.

Statistics on Individual Monuments

If we turn the argument around and look at copies not from the point of view of original location, but rather that of popularity, the Ephesian Artemis provides a good starting example. With almost one hundred replicas, it may rank, in fact, among the most frequently reproduced images of antiquity.

To be sure, as already mentioned, great variety in detail exists from copy to copy. There are also differences in quality and in size, the latter ranging from colossal to diminutive. Ephesos has yielded as many as fifteen examples in the round, four of them from the Prytaneion alone, and new finds are constantly being reported. Three more replicas come from elsewhere in Turkey, approximately thirty were found in the area of Italy and Yugoslavia, five come from Palestine and North Africa (two of them from Cyrene), only four come from Greece and its islands, including two from Kos, five are lost, and nine are on the art market or in various museums which do not indicate provenience.[12] Given the medium and the sanctity of the image, as well as the impossibility of taking casts or measurements over real clothing, we can be fairly confident that these various stone replicas convey only the general traits ensuring immediate recognition of this famous idol.

This surmise is confirmed by the various relief representations of the Ephesian Artemis: one from Italy and thirteen from Turkey, which include four from Ephesos. Since that sanctuary, as we can be sure, possessed the original cult image, all reproductions, whether in the round or in relief, should meet a high standard of recognition, if not of faithfulness. This consideration may be important in connection with another sculptural problem of difficult solution: that of the so-called Ephesian Amazons (plate 136).

Pliny's account on the competition among sculptors for the best statue of an Amazon to be set up at the Artemision is too well known to bear repeating in this context. Suffice it here to state that doubts on its reliability have recently been countered on the grounds that no local tradition of Amazons existed at Ephesos prior to the arrival of the famous statues by Pheidias and Polykleitos, and that only a mainland-Greek message could be conveyed by these fabled beings, since the Athenians had adopted them as symbol of their victory over the Persians in 490–480 B.C.[13] Before answering this specific point, let us review the evidence of the replicas, as conveniently summarized by Weber in her recent study.[14] Of the four types usually considered in connection with Pliny's passage, the Doria-Pamphilj statue can easily be dismissed: it is known exclusively from that single example and is likely to be a classicizing creation, a Diana, only approximately patterned after an Amazon and probably made in a Roman atelier.

The Mattei type is usually attributed to Pheidias, but a fourth-century date has also been proposed on stylistic grounds.[15] It is known through seven statues or torsos, none of them with pertinent head, although a head type has been suggested. Of these seven examples, one comes from Trier, but the others are all from Italy, two of them from Hadrian's Villa at Tivoli. There is also a high relief version of this type used almost in karyatid fashion in a villa of Herodes Atticus at Luku, but it should be considered a variant rather than a replica. One gem may have reproduced the original, but is now lost and known only through drawings; Weber has questioned its classical date.

The Capitoline Amazon type has been attributed to Polykleitos, but also to Kresilas, without compelling arguments for either side. It was probably better known than the Mattei, since it exists in nine statues or torsos (apparently all from Rome and Tivoli), two busts (probably both from Italy), ten heads (seemingly all from Italy, including one from Baiae), six gems, and, most importantly, one relief, which formed part of the stage decoration for the Ephesos theater. The Amazon was one of several images, including satyrs and other beings, set against piers supporting the pulpitum. Its appearance on an Ephesian building increases the probability that this specific type was known to the city and is therefore to be associated with Pliny's account.

The Lansdowne (Berlin/Sciarra) type is the most frequently copied of all the known Amazons. Eleven replicas exist, either complete or preserved as torsos; their provenience, when known, is consistently Rome or Italy. Six additional heads of the type were all found in Italy, as far as I can determine. Finally, there are two reliefs, and both come from Ephesos. One decorates another theater pier; the second—although found in a secondary context—originally belonged to the great altar in front of the Artemision.

The majority of modern scholars attributes the Lansdowne type to Polykleitos, except for those who believe that the Capitoline type is by the Argive

master and therefore give the Lansdowne to Kresilas. My suggestion that the type is classicizing and was possibly made in the Augustan period has met with no favor, and I have no new evidence to support my claim. In the context of our general topic, however, a few considerations can be added.

Among the reliefs on the theater piers, one more Amazon type is represented, although it is not duplicated in any extant statue in the round. If however, as we argued in the case of the Ephesian Artemis, a shared location requires that the relief replicas bear some relation to the iconography of the freestanding original, it stands to reason that a type corresponding to this fifth Amazon must have existed, although it has not come down to us in the round through the chances of preservation. To be sure, the carvers of the theater piers might have invented a new type to match the two they already had, for reasons of symmetry and of sheer numbers. Since, however, other beings formed part of the pulpitum decoration, there was no need to invent a new Amazon; moreover, the Mattei type should have been at hand, had it been part of the famous competition. As for the Lansdowne type, should the altar relief be conclusively shown to belong to the fourth century B.C., my contention would be demonstrably wrong. At present, and on grounds of style, I cannot exclude an Imperial date, perhaps during a phase of repairs to the altar, and we have already seen that classicizing creations could become so popular as to be reproduced repeatedly, singly or in combinations, in the round or even on coinage.

One more objection could be raised: whether or not a competition took place, whether the Amazons as we know them through the various types were dedicated at different times or at once, how could they be copied within their sacred setting? This is a real difficulty for our main theory on copying restrictions, as already acknowledged in other cases. To be sure, if the Lansdowne type was created in Roman times and on Italic soil (which would explain its great popularity there) a model could have been made before the original was released to Ephesos but this explanation would not account for the extant replicas of the true fifth- and—perhaps—fourth-century types. We can only assume that when the Artemision and its temenos underwent considerable change and redefinition under Tiberius, the occasion arose for such copying, but admittedly this is not a compelling explanation. The Baiae casts include some fragments of the more popular Amazons and may eventually throw some light on the occasion of their copying.[16]

Whatever the answer to this problem, I find it hard to believe that the Greek nationalism engendered by the Persian wars was responsible for the transference of the Amazon legend to Ephesos. Our earliest source connecting Artemis with the Amazons, Pindar (as quoted by Pausanias), is still not early enough to disprove political implications. Yet the famous Amazon types have not been openly wounded by Theseus and the Athenians—a context which would ensure Athenian overtones.[17] If no earlier representations of Amazons exist from Asia Minor, their occurrence in the *Iliad* proves knowledge of them in Anatolian territory, and they appear at Delphi as part of the decoration of at least one Ionic treasury, the Klazomenian, and perhaps of more. Were we able, moreover, to reconstruct in its entirety the multifigured parapet from the archaic Artemision, we might find there evidence of Amazonian presence. Historians and epigraphists tell me that transportation and implantation of myths by political action are improbable. Whenever a myth is connected with a site, even if only on the evidence of a late source, this is likely to reflect local and particular traditions, which have time and again been confirmed by subsequent finds of inscriptions or coins.[18] I shall therefore continue to believe that Amazons were dedicated at Ephesos not because of Athenian political allusions, but because they were deemed an appropriate subject for the sanctuary where they had been the first suppliants to seek asylum.

The above position is confirmed by another sculptural monument and an obscure version of the Daidalos/Ikaros myth connected with Ephesos. According to the encyclopedist Ampelius (8.18), in fact, Ikaros was buried at the Artemision. The sculptural monument is no longer preserved, but an inscribed base found in the gymnasium mentions both the father and the son, in a dedication to Artemis, Trajan, and the *demos* of Ephesos by a Roman magistrate active between 103 and 114.[19] Representations of Ikaros in freestanding sculpture are rare, perhaps because of the nature of the episode which lends itself better to pictorial renderings. Besides depictions on sarcophagi and classicizing reliefs, I know of only one Ikaros statue, in the Capitoline Museum, which Zanker has defined a classicizing creation recalling Polykleitan style, and the Imperial figure of Daidalos, in Hellenistic style, from Philadelphia/Amman.[20] The Ephesos monument acquires therefore greater importance, as indication that specific iconography could be invented to cater to local traditions.

To conclude this lengthy Ephesian discussion, and since the site has been named as a possible sculptural center of origin for many Imperial replicas from Asia Minor, we shall briefly review the evidence of its many statuary finds.[21]

Of classical works, there seems to be only "Lysippos's Eros" (see plate 91), after the bronze statue at Thespiai (?). All other extant "copies," even if in fifth- or fourth-century style, are either unparalleled elsewhere or, like the Polykleitan Diskophoros, can be considered variants or *imitationes*. One type, the so-

called Hera of Ephesos, has been dated to the second quarter of the fourth century, but it may be later and a local creation, since of the eleven known replicas, a second one was found at Ephesos and six more come from Asia Minor. A newly recognized example stood in the Demeter sanctuary at Cyrene, but may be a variant, and is the only one from North Africa.[22] Copies of the Hera Campana type and of the Munich Klio repeat Hellenistic types. Two statues of the Aphrodite Naples/Frejus (see plate 83) reproduce the Hellenistic variant with belt. Tritons, fountain satyrs, nymphs, and Aphrodites as fountain figures are generically inspired by Hellenistic types. A complex group with the Blinding of Polyphemos, made during the second half of the first century B.C., was reused in Flavian times for the nymphaeum of Pollio, but no detailed comments can be made because its final interpretation and publication are still pending.[23] Evidence for local copying may be provided by measuring mounds left on the rear of a Dionysos from the *Nymphaeum Traiani*, which in motif is said to follow the Tiber Apollo, albeit more animated in pose. Since I consider the Tiber Apollo a Roman creation, even this Dionysos can simply be an *imitatio* of a Roman prototype.[24]

Two final pieces may be mentioned to attest to the long life of Ephesian sculptural interests: one is a portrait of Sokrates of the so-called Lysippan type, dated to the Constantinian period, or even to the late fourth/early fifth century. Another is a bust of Menander, recognizable despite toga and *contabulatio*, found in the Thermae of Scholastikia in 1957 and of disputed date of manufacture, but probably Constantinian, thus made approximately six hundred years after the poet's death in 293/2 B.C.[25] This work is therefore further witness not only to the long life of the Ephesian workshops but also to the continued popularity of the man whose portrait could be reproduced time and time again, in ever "modernized" style.

That the Menander (see plate 43) was among the most frequently copied works in antiquity is shown by the more than sixty-three replicas now extant. Demosthenes (see plates 77 and 78) is almost a close second, with more than fifty-four covering a wide span of time. The popularity of such works lies in their subject, not in their artistry or the fame of their sculptor. The same applies to ideal compositions: the Crouching Aphrodite (see plate 34) or the Leaning Satyr (plate 137), of which well over a hundred are known since they were so well suited for gardens and elegant villas.

Ideal or formulaic bodies come next. They may initially have depicted a divinity, then been considered appropriate to represent either a deceased member of the family (if originally they showed Hermes, Demeter, Kore) or a living being (if formerly Aphrodite,

Artemis). Of these, only two types need be reviewed here: the so-called Large and Small Herculaneum Women (plate 138), from the two replicas now in Dresden found in 1706 at Portici, which gave the impulse for excavating Herculaneum. A study by H. J. Kruse, though purporting to consider only second-century A.C. replicas, gives a fairly comprehensive tabulation of the types—in 1968, with updating to 1975.[26] But more examples become known as excavations continue and new publications appear; many holdings in museum basements and magazines are still totally uncataloged. Yet Kruse could list, for the Large Herculanensis, 156 statues, 111 appearances on gravestones, and 32 on sarcophagi. For the Small Herculanensis, his numbers reached 128 for the freestanding statues, 75 occurrences on gravestones, and 4 on sarcophagi. If the two originals stood together, perhaps as Demeter and Kore, this connection is not always reflected by the copies, which appear singly and independently. Some sites have yielded only one of the two types; others repeat one of them in close juxtaposition, without ever including the second. Not only distribution, but even degree of preference vary, with the Small woman less popular than the Large in Asia Minor, the latter ignored in Delos but quite frequent in Yugoslavian territory.

Kruse would date the prototype of the Large Herculanensis shortly before 300 B.C., that of the Small somewhat earlier, after the Mantineia Base at the time of the last Attic gravestones.[27] Although the Large Woman at its most typical is veiled, the presence of the distinctive triangle of folds pulled by the right hand across the chest allows the inclusion of variants with bare head. A distant competitor, with only fifty-five replicas listed, is a Hellenistic Ceres type with long chiton, mantle drawn over the head and binding the right arm, but lifted by the left hand over the thigh of the free left leg. Kruse's distribution pattern emphasizes that the type, although known in western North Africa, is absent from Cyrenaica, but the Demeter Sanctuary at Cyrene has now produced a variant.[28]

In size, the Herculaneum women vary from over- to under-life-size, according to whether they are in the round or in relief. Much less known are the replicas in statuette format, which nontheless exist. They may have been ancestral images used from home *Lararia*, thus stressing that no real iconographic distinction was perceived between Greek and Roman art, if such Greek types could be adopted to represent revered forebears of Roman families.[29]

The male counterpart of the Herculaneum Women is of two types, but here statistics are still missing. Aside from the typical *togatus*, much better suited to represent contemporary Romans, the *palliatus* repeated a Greek prototype of man in himation, while the naked Doryphoros (see plate 13) or the Hermes

Richelieu (see plate 21), with chlamys, were usually chosen for more athletic portraits.[30] The oratorial type, with slight variant on the Aeschines/Lateran Sophokles statues (see plate 40), occurs on many gravestones, especially from Asia Minor, and is used in a variety of freestanding forms, from the idealized Eretria Youth and the headless Dioskourides (see plate 49) in Delos (138/7 B.C.) to the spectacular bronze version from the Sebasteion in Boubon, on which pressfolds and pattern acquire particular relief.[31]

Excavations of the Boubon structure suggest that the Sophokles body type was used for a portrait of Marcus Aurelius, obviously not in dramatic but in philosophical garb. The building, dedicated at the time of Nero, around 54, and then again at the time of Vespasian, contained statues, bases, and inscriptions reaching down to the period of Gallienus and Salonina. Besides Marcus Aurelius, also Nero, Poppaea Sabina, Nerva, perhaps Commodus, Septimius Severus, Julia Domna, Caracalla (twice), Gordian III, and Salonina were represented by bronze statues which have regrettably been dispersed through various collections by illicit diggers. The group, as painstakingly reconstructed by J. Inan, included not only draped, but also naked, figures, in general Polykleitan style and stance.[32]

No true statistics exist on the number of replicas of the Doryphoros used as a formulaic body, for a portrait head. Over 20 copies of the Spear-bearer as idealized statue exist, but the numbers must approximate one hundred, when portrait statues are included. The pratice begins in Late Hellenistic times and continues at least down to the time of Septimius Severus, an example being the impressive bronze from the Boubon Sebasteion. Even cuirassed statues of Constantine, although avoiding heroic nakedness, repeat the Polykleitan stance. Addition of a short chlamys bunched over the left shoulder does not detract from the total, Polykleitan effect. The two statues of Gaius and Lucius Caesar from Corinth exemplify the practice and demonstrate how a deceptive mirror-image effect can be obtained although the pose is simply duplicated.[33] The same comments apply to the mid-third-century statues in the Villa Doria Pamphilj (plate 139), where father and sons are distinguished purely by attire.[34] Nakedness carries the message of youth and heroization, especially within the modest Roman world. A figure depicted in Greek nudity next to a *togatus* implicitly expressed a specific concept to the contemporary viewer, which is however all but lost on a modern audience accustomed to thinking in terms of the Greek prototype.

From consideration of works known through a multiplicity of imitations, let us turn briefly to those sculptures preserved in single exemplar. If *Kopienkritik* is difficult in terms of recovering the appearance of a specific source of inspiration, assessment of the single monument is even harder. One such case is that of the Belvedere Apollo (see plates 96 and 97).

Formerly one of the most admired statues to come down from the classical past, this "pomaded" Apollo is now almost entirely neglected through changes in modern taste, although still generally attributed to the fourth-century Leochares. A recent exhibition in Rome (March 1982) has shown the marble with restorations removed, thus allowing assessment of the ancient formula. The god is in rapid motion to his right, but his head is turned back and his left arm, stretched out, splits the movement in two opposite directions. No true replicas of this statue are known: according to a recent study by Deubner the marble statuette in Arezzo is modern, and so is a marble head in Malmö. Two more marble heads cannot be proven to belong to the type, whose hairstyle is fairly common; to my mind, the spectacular Steinhauser head now in Basel is not only too poorly preserved but also too dramatic to belong to the same type.[35]

Deubner accepts however the comparison between the Belvedere statue and the Apollo on the Pergamon frieze; indeed he claims that the figure in the round has been altered from that prototype to the point of creating a contradiction in terms. While the Pergamon god stands with legs spread wide apart, in a shooting and fighting pose, his right hand extracting an arrow from the quiver, the Belvedere Apollo is in a stepping stance, although retaining his hair tied up for action, and looking back almost as if to follow an arrow just released from the bow. Since imperial coins of Phrygian Synaus, a site not far from Pergamon, show an Apollo comparable to the Gigantomachy figure, and a similar iconography occurs on the Lagina frieze, Deubner concludes that the prototype, far from being the Apollo by Leochares, is a statue which stood in Asia Minor, thus providing inspiration for the two architectural renderings. The Belvedere Apollo is a Roman modification of the type, which has changed the stance, thus turning a stationary into a moving pose, has added a chlamys, and has modified the right arm from selecting an arrow to holding an olive branch—a concept abandoned, according to Deubner, after the fifth century B.C. Whether this is the correct interpretation of the Belvedere Apollo should remain open, but I would agree that the statue, as it stands, is a Roman rather than a Greek creation, albeit in Greek style.[36]

Even more complex is the problem of the Attalid dedications, and in particular of the Suicidal Ludovisi Gaul (plates 140 and 141) and the Capitoline Trumpeter (see plates 32 and 33). A series of studies in recent years by Künzl, Wenning, and now by Coarelli and Özgan has reopened the question of setting and medium, although all scholars agree that, given their

size, these works could only belong to the time of Attalos I and to the dedications set up in Pergamon itself. This is not the place to discuss the entire issue, and I shall only summarize those points that have a bearing on our investigation of copies and Roman creations.[37]

The Ludovisi Gaul and the Trumpeter are both made in Asiatic marble, and they have always been considered copies of the bronze originals existing in single exemplar. A torso of a Gaul from Villa Hadriana, now in Dresden, in different marble but very close to the Capitoline Trumpeter, had been thought to copy another of the statues from the same monument, which had been visualized as set on the various steps of the round pedestal in the center of the Temenos of Athena at Pergamon. Objections to such reconstruction, in favor of a paratactic display on a long base, also present on the Pergamene citadel, had affected the Dresden Gaul as well, since two such similar statues would not have been conceivable in close proximity. Özgan has now solved this problem by suggesting that the Dresden Gaul and the Capitoline Trumpeter reflect one and the same statue. His photographs are indeed convincing, because they show the Dresden torso at a different angle from that of its present setting and thus highlight its similarity to the Conservatori figure.

Özgan goes however too far when he suggests that the Dresden torso is the original, and the Capitoline the Antonine copy, of the Attalid monument taken to Rome by Nero. That the emperor appropriated these statues from Pergamon is stated by Pliny, who then praises Vespasian for installing them in the Temple of Peace in public display (*NH* 34.84).[38] But Pliny mentions them in his section on bronzes: it is therefore obvious that the Dresden marble cannot be what Nero brought to Rome from Asia Minor. In addition, it would be hard to explain how the torso, from the Temple of Peace, could be moved to Hadrian's Villa, nor does the list of other possible Asiatic originals from Tivoli, even if correct, explain this difficulty. Finally, Özgan reconstructs a most complex marble group, technically impossible to visualize; to it he attributes what he considers other originals: the Dead Persian's head in the Terme Museum, contemporary with the Dresden torso, the Head A, (probably also Head B) at Fulda, with helmet appropriate for the leader of the Gauls and with technical details appropriate not for high relief but for a figure lying on the ground. The Ludovisi Gaul would reproduce (in later copy) one more element of the same monument, with the Galatian looking up at the riding king, whose presence, Özgan believes, is an essential part of the message.[39] A rampant horse and a rider high enough to catch the glance of the Suicidal Gaul are impossible to visualize *in marble,* thus invalidating this aspect of

the reconstruction, if more evidence were needed beyond that of the ancient source.

Yet a step forward has been made with the recognition that the Dresden Torso and the Capitoline Trumpeter copy one and the same prototype. Was this prototype in the Precinct of Athena at Pergamon or was it in Rome, accessible to copyists? Here Pliny's text presents a difficulty. He states that Nero brought to the capital works by Isogonos, Phyromachos, Stratonikos, and Antigonos. In the reasonable assumption that the Capitoline statue reproduces the Trumpeter by Epigonos cited by Pliny in a later passage, modern scholars have amended his previous text to read Epigonos instead of Isogonos. Yet when Pliny mentions Epigonos's Trumpeter and his fame, he gives us no inkling that the statue is in Rome, or that he knows where it is, much less that it commemorated Pergamene victories, and even whether the man is depicted dying.

The Asiatic marble of both the Capitoline and the Ludovisi statues has led Coarelli to suggest that they were made at Pergamon *before* Nero took the originals to Rome, and not in the second century, as usually held. Plausibly arguing that the monuments, now separated in two different museums, were found together, he suggests that they were copied from the Pergamene originals to honor Caesar's triumph over Gallia, between 46 and 44 B.C., with that recurrent Gaulish symbolism which the Romans used to celebrate their Celtic victories.[40]

But Coarelli goes farther. Noting the peculiar shapes of the Trumpeter's base and of that for the Ludovisi Gaul, he suggests that the two should be made to join, by removing the restored right arm of the Dying Trumpeter together with the corresponding portion of his pedestal. He then uses the diagram engraved on the Trumpeter's plinth to reconstruct the original Pergamene monument, once again attributed to the round pedestal, as a pentagonal composition culminating in the Ludovisi Gaul, with the Dying Trumpeter and two additional figures radiating from its base on the back, according to the planimetric sketch.

This daring reconstruction has only appeared within the limited format of a catalogue entry, and we should await the final publication before passing judgment. I shall risk, however, voicing some of my own considerations.[41]

Aside from the Isogonos/Epigonos difficulty, the Trumpeter's base, with its broken instrument and other details, requires a low placement to make its message entirely explicit; the Ludovisi Gaul needs to be seen from below, at a greater height, lest the bent arm cover the face. Another consideration is that the "eloquent silhouette" of the Trumpeter becomes severely obscured when the statue is joined to the Ludo-

visi group. The Trumpeter's head is almost tucked between the legs of the Suicidal Gaul, with an unpleasant, crowded effect, and the right arm of the dying man collides with the right leg of the suicidal warrior. To be sure, Coarelli argues that the Trumpeter's arm is restored; but even when the piece is removed at the break (although it seems to be of the same Asiatic marble, which a restorer in the Renaissance could hardly have obtained), what remains of the stump at the shoulder requires an inclination hardly different from that of the present restoration.

If the composition seems already compressed and confused by the joining of these two monuments, the effect would have been much worse when the two missing statues, postulated on the evidence of the diagram, were also present. Both the outline of the Ludovisi group and those of the single figures would seem diminished by such crowding, which could certainly have been avoided by making the round pedestal larger or different in shape. Although Coarelli believes that the dimensions of the Pergamene base would accommodate the bronze originals as he combines them, their high position, the telescoping inevitably caused by the setting, and the crowding would make for a less effective monument.[42]

I do not dispute that the two marble replicas were found together. I may even accept that they were joined at the base.[43] But I have difficulty in accepting the Ludovisi Gaul as a copy of a Greek work contemporary with the Capitoline Trumpeter.

Differences between the two have frequently been pointed out, and need not be discussed at length. I find it hard to believe that the raid on the Gaulish encampment suggested by the presence of the wife and by the suicide itself could allow for the contemporary presence of a dying trumpeter, who is most efficient on the battle field (I doubt that he could have been the sentry who failed, or attempted, to sound the alarm). The message of the Ludovisi Gaul, with his limp dead wife, invites commiseration and suggests that innocent female victimization which Roman war monuments repeatedly stress from Augustan times onward.[44] The twirling of the Galatian's cape implies rapid motion, yet the encumbering corpse would not justify or permit it. The wife's wound is not clearly visible.[45] Some blood, plastically rendered, drips from under the strap over the right arm, but such a wound could hardly kill. A short gash on the left side of the throat might perhaps be lethal, but no blood is there indicated, despite the wide area; paint could have supplied the proper effect, but one wonders why the difference in renderings, given the detail over the right arm.[46]

To these apparent incongruities others could be added: the strange, boneless effect of both faces, as contrasted with the pronounced zygomatic structure of the

Trumpeter and other heads of Gauls; the peculiar lack of integration of the wife's body, which remains almost attribual in its detached position—contrast instead the strict intertwining of Menelaos and Patroklos in the so-called Pasquino group.[47] These and other considerations lead me to suggest that the Ludovisi Gaul and his dead wife are Roman creations, in Pergamene style, added to some bona fide copies of the Attalid monument, in the same fashion in which, to an original Hellenistic core of Niobe and her daughter, more Niobid figures were added in later times, to form a more complex group within the very same Sallustian gardens from which the Gauls may come.[48]

Would the Romans, of whatever period, represent a Gaul in heroic nudity? Yes, I believe, if they composed in epic terms and Hellenistic style.[49] The Laokoon (see plate 30), the Sperlonga "Odyssey in Marble" suggest it. The relatively short range of dates possible for the Sperlonga sculptures—from the second century B.C. to the Flavian period—may cloud our judgment. It is therefore useful to recall that among the early finds from the Baths of Caracalla were listed the remains of an island with the feet of many figures on it and a boat approaching it, all in marble—a complex composition which creates its own landscape and was undoubtedly made for the spacious halls of the thermal complex.[50] A publication by Miranda Marvin stresses the great number of sculptures which must have adorned the Baths—over 150 if one includes a count of the niches on the general principle that an empty niche is not a viable Roman decorative concept. Some of these many works may have been reused from earlier context, but the sculptures at colossal scale, like the Punishment of Dirke (see plate 31)[51] and the Herakles Farnese (see plate 99), were undoubtedly created for the occasion. Marvin's study focuses also on the difficult iconography of a colossal male figure with heroic attributes and a dead child held by one ankle and flung over the man's shoulder. The ambivalent message conveyed by the monument, in which Marvin identifies Achilles and Troilos, would capture the Roman preference in sculpture, rather than the Greek concepts, thus suggesting that meaningful and ambitious epic groups could still be created in Caracalla's time.[52]

Even the colossal Flora Farnese, although not found within the thermal complex, reflects something of the same spirit.[53] We should desist from analyzing it in Greek terms, pointing out the apparent discrepancies. What would be anachronistic and illogical in a true copy is instead aesthetically justified once we "read" it with Roman eyes, without superimposing preconceived criteria on our judgment. What was once a useful method of approach—the research of the Greek model behind the Roman work—has been carried to its ultimate applications and has now ceased to

be valid. We should recognize its virtues, which have recaptured for us some lost Greek masterpieces, but it is time now to admit its faults, which prevent us from recognizing Roman art.

This next step is not going to be easy. Too many generations of students have been indoctrinated by Furtwängler's thinking, by Richter's and Bieber's attributions. Although some younger scholars are rapidly striding in the new direction, letting the "copies" speak for themselves, others can still write: "neither avarice nor neglect have the power wholly to obliterate the masterpieces of the past. . . . We ourselves are to blame for not perceiving them through the forms in which they still continue to exist among us." Yet how dangerous it is to look for a Greek model behind every work in classical style can be shown by the two examples with which I shall close my review.[54]

The first (plate 142), a series of heads, strikes us at first glance as recognizable. We can almost name the type of the Greek original which they copy. Yet they come from the Alexander Frieze made in 1822–38, with which Thorvaldsen commemorated Napoleon's triumphant entry in Rome in the earlier nineteenth century.[55]

The second example startled me when, in conjunction with the annual meeting of the Archaeological Institute of America in New Orleans, I had occasion to visit one of the old plantations nearby, called San Francisco. The structure, competently restored, had been furnished with period pieces that reflected colonial life at the turn of the eighteenth into the nineteenth century. In the four corners of the large dining room tall candelabra stood, each representing a lampadophoros kore in archaistic costume. The restorer, Mr. Samuel Dornsife, has informed me that they were made by Humphrey Hopper, an Irishman working in England, who produced the occasional portrait bust or memorial, but who specialized in sculptural light fittings, which he composed on a wire armature.[56] Although his inspiration may have come from classical models, it is more likely to have been derived from drawings and other intermediate sources than from true sculpture in the round; we can definitely exclude the possibility of direct copying and can appreciate his candelabra only as expressions of contemporary taste. If we can admit that Hopper may have imitated or emulated, but did not copy an ancient work, we should certainly give the same recognition to the many talented and active masters of Roman times.

Notes

1. The question could be reformulated in two parts: (*a*) were the Romans capable of exact copying, from an original, rather than just from casts or sketches which allowed a certain degree of freedom in reproduction? (*b*) did the Romans copy objects that existed in Rome? If, for instance, works by Lysippos or Pheidias were so famous, would the statues taken as booty to Rome be copied to supply replicas to other areas of the Roman world? It is the answer to the last question that seems to be negative, or at least impossible to formulate on the basis of present evidence. The one exception is discussed infra; statues made on Italian soil (e.g., the lychnouchos type—cf. the Sabouroff Youth discussed in chap. 7) and, of course, imperial portraits were certainly duplicated, but no certainty exists for the classical originals.

When our knowledge of marbles shall allow it, it may be useful to determine whether works in Italian marble were found outside of Italy proper, and specifically in Greece. That works in "foreign" marbles could have been carved in Rome is, however, clearly shown by the instance of two statues of Pan, from Lanuvium, now in the British Museum (Cat. 1606, 1607) signed by the same sculptor but made from different stones: J. Ward-Perkins, *BSR* 58 n.s. 35 (1980): 39 and n. 34.

2. Dacian ex-Lateran: Helbig[4] no. 1141 (E. Simon); cf. nos. 409 and 458, from the Forum of Trajan. The ex-Lateran Dacian was found in Via dei Coronari, in an area of marble workshops of Imperial date—but no more precise date is given by the sources. I am deeply indebted to Prof. James Packer for providing photographs and information on these statues.

3. See pp. 21–24 supra.

4. The dates of Antisthenes are a matter of speculation: 450–370 and 444–365 are both possible. See Richter, *Portraits* 2, pp. 179–81 and *Suppl.* 7.

5. Cf. supra, p. 22 and n. 62.

6. Stewart, *Attika,* pp. 8–12 and n. 28 on p. 28. Andreae, "Antisthenes." Because of a possible stylistic connection between Antisthenes' features and those of the Dead Giant in Naples, Andreae assumes that the Attalid dedications in Athens were made in part by the same master, around 159 B.C., and coincide with those mentioned by Pliny (*HN* 34.84). Stewart connects Phyromachos with the earlier dedications, by Attalos I, and thus dates the portrait ca. 200 B.C. This question is, however, irrelevant for our specific inquiry.

7. *AA* 1966, pp. 472–73, fig. 51; Richter, *Suppl.* to *Portraits,* fig. 1055a (p. 7, no. 9); she also mentions the Ostia base. Stewart, *Attika* (supra, n. 6), states that eleven replicas of the head are known, although Richter has a total of nine even after the Pergamon addition. Stewart perhaps accepts as true portraits of Antisthenes some heads that Richter considers only related.

8. The type appears not only on Bithynian but also on Paphlagonian coins: cf., e.g., *Museo Nazionale Romano,* pp. 141–44, no. 100.

9. R. Fleischer, *Artemis von Ephesos und verwandte Kultstatuen aus Anatolien und Syrien,* EPRO 35 (Leiden, 1973); supplementary lists, by the same author, in *Studien zur Religion und Kultur Kleinasiens,* Festschrift F. K. Dörner (Leiden, 1978), vol. 1, pp. 324–74. For the practice of dressing Artemis at Ephesos see also R.

Fleischer, "Eine bekleidete Nachbildung der Artemis von Ephesos," *ÖJh* 52 (1978–80): 63–66.

10. Fleischer, *Artemis von Ephesos,* p. 405; cf. also pp. 39–46 for specific discussion of the coinage.

On the freedom of die cutters in imperial Athens, however, see M. Thompson, *Hesperia Suppl.* 20 (1982): 163–71. She states that, from Hadrianic to Herulian times, even famous statues and buildings were rendered with varying details and poses within the life span of the same cutter or the same die.

11. Fleischer's maps I and II occur at the end of the book; cf. however p. 136: "Eine verbreitungskarte von Münzbildern in der Art der ephesischen Göttin . . . gibt somit nicht die Verbreitung des ephesischen Kultes an, sondern zeigt in erster Linie das Gebiet, in dem man den Typus der Artemis Ephesia für verwandte epichorische Gottheiten verwendete."

12. My list, which does not add up to one hundred, but does not take into account terra-cotta figurines or other forms of reproduction, is based on the two works by Fleischer and on the mention of recent finds, e.g., in the *AJA* News Letters from Asia Minor.

13. Pliny *NH* 34.53. For the initial doubts see Ridgway, *AJA* 78 (1974): 1–17; cf. also *Fifth Century Styles,* p. 244, no. 5, for an update of the issue with recent bibliographical references. Opposition to the theory has come from many fronts, but see especially P. Devambez, *CRAI* 1976, pp. 162–70, *RA* 1976, pp. 265–80, and, most recently, *LIMC* 1 (1981) s.v. *Amazones,* esp. pp. 640, 642–43.

14. Weber, "Amazonen." See also her addendum in *JdI* 93 (1978): 175–83 on the head type of the Mattei Amazon. Weber's article has been critically reviewed by T. Dohrn, *JdI* 94 (1979): 112–26.

15. My main reason for lowering the date of this type was the torsional movement inherent in the pose. Recently, E. B. Harrison has suggested that the shape of the head is closer to early fourth- than to fifth-century renderings: "Two Pheidian Heads: Nike and Amazon," in *The Eye of Greece* (supra, chap. 4, n. 32), pp. 53–88, esp. pp. 70–76, where the Mattei Amazon is dated ca. 370 B.C.

16. They may also help gain a more faithful idea of the originals: cf. *Abgüsse,* pp. 31–35 and esp. p. 33 for the statement that none of the marble replicas gives an exact reproduction of the garments of the originals. The prototype is altered in a distinctive manner which makes the copies comparable to Roman portrait statues.

17. At least one source, albeit late (Tacitus *Ann.* 3.61–63) tells us that the Amazons had sought asylum at the Altar of Artemis at Ephesos when fleeing from Dionysos and then again from Herakles. If this myth was current at Ephesos, the wounds of the Amazons would have been associated with these two epic battles.

18. I am deeply indebted to Professor Kent Rigsby for giving me the benefit of his opinion on the subject, in the light of his specialized research on the right of asylum. To him I owe also knowledge of the Ephesian base connected with the myth of Ikaros and Daidalos, for which see infra.

19. See *ÖJh* 1 (1898) Beibl. col. 76 (b); *ÖJh* 39 (1952): 45, fig. 11; Manderscheid (supra, chap. 2, n. 60) p. 87, n. 167.

20. Zanker, *Klassizistische Statuen,* pp. 23–24, no. 20, figs. 23.5–6. Philadelphia/Amman monument: H. Möbius, *JdI* 68 (1953): 93–101, dated Severan or Antonine.

21. This information is primarily drawn from *Ephesos, Führer,* and therefore does not take into account more recent finds, nor the sculptures in the Vienna museum, from the early excavations. Among the former, note the replica of "the diskophoros by Polykleitos," R. Fleischer, *ÖJh* 52 (1978–80): 1–9, but cf. also Ridgway, *Fifth Century Styles,* pp. 215–16, no. 2. Among the latter, besides the sphinxes-and-Theban-Youths discussed in chapter 4, see also the bronze Apoxyomenos which S. Lattimore dates to the early third century B.C.: *AJA* 76 (1972): 13–16. It is still debated whether the statue is an original or a copy, perhaps a direct overcasting from the original. A copy of the Myronian Diskobolos is cited by Vermeule, *Sculpture and Taste,* p. 8. See also Linfert, *Kunstzentren,* pp. 52–60.

22. Hera of Ephesos: see discussion in Kruse, *Weibliche Gewandstatuen,* p. 118 and n. 165 on pp. 437–38 with the list of replicas; for the Cyrene variants see Kane (supra, chap. 7, n. 72), pp. 93–96, nos. 20–21. The Ephesos replica (inv. 1581): *Ephesos, Führer,* pp. 52–53. For a replica from Side see Inan, *Side,* pp. 50–53, no. 11.

23. Even the extensive discussion of the composition by B. Andreae in *Festschrift für Frank Brommer* (Mainz, 1977), pp. 1–11, announces further treatment in a supplement to the *ÖJh* ("Korrekturzusatz," p. 11). Andreae dates the group in Augustan times at the latest, a date lower than that proposed in *Ephesos, Führer,* p. 36 Pollio's Nymphaeum reused the sculptures in A.D. 93.

24. Dionysos: *Ephesos, Führer,* pp. 30–31, inv. 769; *ÖJh* 44 (1959) Beibl. 333, fig. 178; face added in 1966, *Bustan* 9/3–4 (1968) 92 fig. 8 (*non vidi*).

Prof. E. Gazda warns me that measuring mounds cannot be taken as firm proof of local manufacture unless the marble too is from a local source; since we have evidence that sarcophagi were sometimes shipped in unfinished state, this practice may have obtained also for "copies," at least on occasion.

Tiber Apollo: Ridgway, *Fifth Century Styles,* p. 238 and n. 17, bibliography on p. 248.

25. Sokrates: *Ephesos, Führer,* pp. 68–69, inv. 745.

Menander: *Ephesos, Führer,* pp. 13–15, fig. 1, inv. 755.

26. Kruse, *Weibliche Gewandstatuen;* Large Herculanensis: pp. 41–67 and Catalogue, pp. 260–93. Small Herculanensis: pp. 68–69 and Catalogue pp. 294–340; see also Linfert, *Kunstzentren,* pp. 57–58.

27. Kruse, *Weibliche Gewandstatuen,* pp. 41–42 and n. 52; pp. 68–69 and n. 63. S. Karousou, *AthMitt* 84 (1969): 151, retains the same relative chronology and considers the Large Herculanensis the creation of a North Peloponnesian master, the Small that of an Attic, post-Praxitelean sculptor.

28. Kruse, *Weibliche Gewandstatuen,* pp. 3–40, Catalogue, pp. 229–59. For the Cyrene statue (which presents slight modifications from the standard type) see Kane (supra, chap. 7 n. 72), pp. 66–69, no. 10; D. White, *LA* 8 (1971): 100–1, pl. 39a.

29. I am much indebted to Dr. Eugenio La Rocca, who showed me such statuettes in the storerooms of the Conservatori Museum.

30. Palliatus: see Bieber, *Copies,* pp. 129–47.

Hermes Richelieu: latest discussion with previous bibliography: *Munich Catalogue,* pp. 283–89, no. 27. The Eretria Youth is also briefly discussed under that heading.

31. For Asia Minor gravestones see the extensive corpus by E. Pfuhl and H. Möbius, *Die ostgriechischen Grabreliefs* (Mainz, vol. I, 1977; vol. II, 1979), passim.

On the Sebasteion in Boubon see Inan and Jones, "Bronzetorso," and for the Lateran-Sophokles replica esp. pp. 281–82, no. 10, pl. 89. Cf. also supra, chapter 3 and n. 14.

32. On the dispersal of the group from Boubon, beside Inan and Jones, see also C. C. Vermeule in *Eikones* (Festschrift H. Jucker, *AntK BH* 12, 1980), pp. 185–90.

33. Gaius and Lucius Caesar from Corinth: Ridgway, *Hesperia* 50 (1981): 432 and bibliography in nn. 39–40.

34. Villa Doria–Pamphilj portraits: best illustrated by H. von Heintze, *AntP* 1 (Berlin, 1962): 7–32. Note that her identifications have not been generally accepted; it is also suggested that the three statues depict the same person under different aspects or for different functions. For our purposes, these different identifications are irrelevant.

35. On the success of the Belvedere Apollo since its discovery see Haskell and Penny, *Taste,* pp. 148–51, no. 8. O. R. Deubner, "Der Gott mit dem Bogen," *JdI* 94 (1979): 223–44; see also J. Frel, *GettyMusJ* 1 (1974): 57–60, fig. 8 and n. 31. C. M. Havelock, *Hellenistic Art,* 2d ed. (New York and London, 1981), p. 124, no. 91, believes that "an early second-century date [is] quite possible."

36. To be sure, the statue could also be integrated with an arrow, not an olive branch, in the right hand, thus lessening the contradiction of a simultaneously warring and peace-offering image: G. Daltrop, *RendPontAcc* 48 (1975–76): 127–40.
A late date for the statue may also be suggested by the shape of its sandals, which K. E. Dohan tells me seem Roman, or at the earliest Hellenistic. Since, however, copyists may have taken liberty with their reproductions, and no comparison with other copies can be made, the matter cannot be settled on this basis. Note, however, that the Baiae casts preserve a sandal of a very similar shape, which has been dated by comparison with the Belvedere Apollo: *Abgüsse,* pp. 46–49. Proper assessment of the footwear would be of considerable importance not only for the date of the Apollo, but also for that of the Baiae collection, whose range is at present fixed as spanning only from the severe to the late classical periods.

37. E. Künzl, *Die Kelten des Epigonos von Pergamon* (Würzburg, 1971). R. Wenning, *Die Galateranatheme Attalos I* (Berlin, 1978). Coarelli, "Grande Donario." R. Özgan, "Bemerkungen zum grosser Gallieranathem," *AA* 1981, pp. 489–510.

38. Note, however, that Gros, "Vie et mort," considers Pliny's statement purely in praise of the Flavian emperor, but doubts that any statue (except perhaps the bronze Ganymede by Leochares) could have been taken from the *Domus Aurea.*

39. Özgan, *AA* 1981, p. 498.

40. Coarelli, "Grande Donario." A more extensive publication by the same author is forthcoming. Since both the Dying Trumpeter and the Ludovisi Gaul were in the Ludovisi Collection by 1623, Coarelli convincingly suggests that they were found together in the Horti Sallustiani, which have yielded many Greek originals as well as Roman copies and adaptations. For Roman commemorations through depictions of Gauls see supra, chapter 5, p. 50 and n. 7.

41. Preliminary comments along these same lines were also included in a lecture delivered at a symposium in Rockford, Illinois, and at De Kalb University, De Kalb, Illinois, on April 25, 1981. See *ArchNews* 11 (1982): 85–104.

42. If the Attalid group (and not a statue of Athena) stood originally on the round pedestal, it was probably removed from it when Augustan trophies were set up on the lower ring of the base together with a new inscription. This reuse of the pedestal might have allowed the making of copies. But where did the statues stand until Nero removed them?

43. I must admit that my faith in this reconstruction, engendered by the published drawings, has been somewhat shaken by an examination of the casts in May, 1982, kindly allowed to me by Dr. Coarelli and by Dr.ssa M. L. Morricone Matini at the Museo dei Gessi of Rome University.

44. Women as prisoners appear at the foot of Roman trophies as early as the reliefs of the Arch of Orange, dated between A.D. 10 and 26–27: R. Amy et al., *L'Arc d'Orange* (*Gallia* Suppl. 15, 1962): 80 and pls. 19–20 for drawings of the short faces (E and W) of the arch on which the women appear. See also the brutal treatment of women on the exergue of the Gemma Augustea.
To be sure, one of the sculptors connected with the Attalid dedications, Epigonos, is said by Pliny (*NH* 34.88) to have "surpassed others with . . . his Infant pitiably caressing its slain mother." Whether or not Pliny's statement is to be connected with the Attalid dedications (and indeed it occurs at some remove from the previous mention of the Pergamene monuments, *NH* 34.84), the subject seems emotional enough to rank with the dead wife of the Ludovisi Gaul. But this is the only mention of the work and Pliny might have "read" the composition with Roman eyes. The Amazon in Naples, which supposedly was once joined to a child according to an early drawing, fits so well, in scale and medium, as well as subject and style, with the Giant, Persian and Galatian, that it can only be an Amazon, and therefore unlikely to have been shown as a mother. Some authors, moreover, believe that the child was mistakenly transferred to the Amazon from another statue: for a discussion of this problem, with refs., see Ridgway, *Classical Sculpture,* Catalogue of the RISD Museum of Art (Providence, R.I., 1972), pp. 92–94, no. 36.
Be that as it may, it seems fair to state that female victimization by war was an artistic *topos* much more popular with the Romans than with the Greeks.
Note in addition that the Great Attalid Monument commemorated the battle at the Kaikos River, when the Gauls moved forth from their settlements to meet the Pergamene army half way in a surprise encounter. Yet the Ludovisi Gaul kills his wife as if he were the victim of a surprise attack.
Of even greater significance for my theory may be the very concept of suicide, which is much more common among Germans than among Kelts. Beside the famous episodes depicted on the Column of Trajan, including Decebalus's suicide, note Plutarch *Life of Marius* 27.1–4 (about the Cimbri), and Florus 1.38.17. For women and children stationed immediately behind the German battle line see Tacitus *Germania* 7.3–8.1. I owe these references to Prof. John Morgan.
Even the concept of pity for the noble barbarian is unfamiliar to the Greeks, but is widespread in Rome from the time of the Column of Trajan onward, in the visual arts as well as in literature.

45. For calling this point to my attention I am indebted to Dr. Ph. Fehl, who saw with me the Ludovisi collection in the Terme on March 8, 1982.

46. The plastic drops begin above the line of the restored portion of the arm, and match those under the blade of the Gaul's sword plunged into his chest. This is the only wound mentioned in the Helbig[4] entry, which does not explain the gash in the neck.

47. Note, moreover, that the rear view of the Ludovisi group is aesthetically unsatisfactory, and even the side views are not all successful; contrast the Capitoline Gaul, which produces an effective composition from all sides and could satisfactorily have been viewed from the rear.

48. This statement is not to deny that a special Roman event might have been commemorated by the new grouping, and that the result might have been entirely "Roman" in spirit and composition. The case of the Laokoon is instructive on this point.

49. It can also be argued that nudity in a Gaul represents a realistic trait, since the Kelts often went into battle nude or wearing only a belt. That as late as the second century after Christ this conception prevailed among the Romans is shown by a series of lead figurines meant as appliqué, from Velia, now in Salerno: *AA* 1956, cols. 337–46, figs. 96–103, and footnotes 184–92 with many parallels. Note in particular fig. 101: a young barbarian on foot, shown entirely naked except for his sword strap, around his waist.

50. This piece is known through a description by Flaminio Vacca, repeated by Lanciani; see Vermeule, *Sculpture and Taste,* p. 109, 4A; Marvin, *AJA* 87 (1983): 347–84, esp. p. 353.

51. The relationship of the Farnese Bull (The Punishment of Dirke) from the Baths of Caracalla to the marble group with the same subject mentioned by Pliny is still unclear. For recent discussion of the monument and its prototypes see, e.g., G. Gualandi, *ASAtene* 54 n.s. 38 (1976 publ. 1979): 56–61, no. 15; L. B. van der Meer, *BABesch* 52–53 (1977–78): 66–68.

52. Marvin, (supra, n. 50) pp. 358–63, pls. 48–49, figs. 6–11, ills. 5–6; cf. E. Künzl, *Frühhellenistische Gruppen* (Cologne, 1968), pp. 94–97, fig. 12.

53. Flora Farnese: Haskell and Penny, *Taste,* pp. 217–19, no. 41; their concluding statement is that the statue "is now displayed as a Roman copy of a Greek statue of Aphrodite of the fourth century B.C." Why this assessment is surely incorrect need not detain us here, given the highly eclectic character of the figure.

54. The quotation is from J. Dörig, *Onatas of Aegina* (Leiden, 1977), p. ix.
My point could be demonstrated just as easily with a discussion of the Egyptianizing statues from Villa Hadriana, which have already been mentioned supra, chapter 5, n. 25. The illustrations included in A. Roullet, *The Egyptian and Egyptianizing Monuments of Imperial Rome,* EPRO, vol. 20 (Leiden, 1972), e.g., pl. 87, no. 100 (Antinoos) or pl. 114, no. 139, clearly show the interest in movement, the temporary stance of the figures, the rounded contours and overly mannered drapery that go with contemporary taste and only remotely combine with the Egyptian forms to suggest an African derivation. Certainly no true prototype was copied for these works. Somewhat the same picture results from the world of painting: cf. M. de Vos, *L'Egittomania in pitture e mosaici romano-campani della prima età imperiale,* EPRO, 84 (Leiden, 1980), who stresses the free interpolations of Campanian artists. This lack of faithful copying is readily accepted in this sphere of Roman art, and it is surprising that the same cannot be done for the question of imitation of Greek models. Yet Egyptian imitation was carried to the point of utilizing Egyptian stones and transcribing (or imitating) hieroglyphic inscriptions. But this topic is too large to be treated in this context, and can only be mentioned here in footnote. Suffice it to point out that Egyptian booty was repeatedly taken to Rome, and that obelisks and other Egyptian features were constantly under the eyes of the Romans—as much as the Greek antiques. The presence of Egyptian sculptors in Rome has also been postulated on good grounds.
The same kind of eclecticism and Roman message prevailed in Roman silver plate. I am indebted to Mr. Jon Van de Grift, who has let me read an advance copy of his manuscript on the Berthouville Centaur Scyphi, where he comes to comparable conclusions in terms of models and iconography. He also argues that the two silver vessels should be dated to the Domitianic period. For a Hadrianic/Antonine statuette from England in Hellenistic style see supra, chapter 1, n. 40.

55. See *Bertel Thorvaldsen* (Ausstellung) (supra, chap. 7, n. 1); pp. 174–75 illustrate the heads, entered as cat. no. 47. The Alexander Frieze and its vicissitudes are discussed on pp. 81–83.

56. The entry on Hopper in R. Gunnis, *Dictionary of British Sculptors 1660–1851²* (London, 1968), p. 209, suggests a sculptor of greater importance, who eventually received a silver and then a gold medal for his work. Gunnis does however mention that Hopper, born in 1767, entered the Academy late, and that he made one light fixture. Mr. Dornsife suggested that the latter production was more extensive than the *Dictionary* seems to imply.

Topographical Index of Greek Sculptures and Other Works of Art in Rome, Not All Necessarily Booty*

Apollo (Sosianus), Aedes
Apollo of cedar wood from Seleukia (uncertain which Seleukia)
Apollo by Timarchides
Apollo and Nine Muses by Philiskos
Leto, Artemis, Apollo
Niobe and her children, either by Skopas or by Praxiteles (Amazonomachy pediment)

Apollo Palatinus, Aedes
Apollo by Skopas (from Rhamnous?)
Leto by Kephisodotos the Younger
Diana by Timotheos (head restored by Avianus Evander)
Apollo Comeus from Seleukia on Tigris (after A.D. 165, L. Verus)
Akroteria by Boupalos and Athenis of Chios
Central akroterion: Sun chariot
In front of Temple, around altar, four bulls by Myron (or only cow ?)
 (inside temple, tripod table with Greek inscription, dedicated by Titus and Vespasian since Library burnt in Neronian fire)

Arcus Octavii
Marble quadriga with Apollo and Diana, from single block of marble, by Lysias

Bibliotheca Templi Divi Augusti
Apollo Temenites (colossal) from Syracuse (Suet. *Tib.* 74), (perhaps the same as Pliny's Tuscan Apollo)

Capitolium (area capitolina)
Bronze Apollo by Kalamis, from Apollonia Pontica (ca. 13 m high)
Agathos Daimon and Agathe Tyche, by Praxiteles, from Greece
Sitting Herakles by Lysippos, from Taras (colossal)
Juppiter Imperator, from Macedonia
Zeus by Myron, from Samos (once in group with Athena and Herakles which were returned by Augustus; naiskos built for the Zeus)
Two colossal bronze heads (1 by Chares, origin unknown; 1 by ——discus)
Apoxyomenos probably from Bithynia
Bronze Zeus Keraunios and Athena, from Syrian Antioch
Bronze Athena by Euphranor (Minerva Catuliana)—at foot of hill

Concordia, Aedes
Bronze Asklepios and Hygieia, probably from Pergamon, by Nikeratos

*This list, which does not include paintings, has been derived from Pape, "Kriegsbeute" (esp. pp. 143–93), and from Pollitt, "Impact," pp. 170–72.

Bronze Apollo and Hera by Baton
Bronze Ceres, Juppiter, Minerva by Sthennis
Bronze Leto with infant Apollo and Artemis, by Euphranor
Bronze Ares and Hermes by Piston
Hestia from Paros, brought by Tiberius returning from Rhodes
 (Augustus dedicated four obsidian elephants, Livia gave the sardonyx from the ring of Polykrates)

Curia Julia
Victoria from Taras set up as akroterion
Egyptian booty

Domus Titi (Titus Flavius Vespasianus)
Laokoon, by Rhodians Hagesandros, Polydoros and Athanodoros
Bronze Astragalizontes by Polykleitos (in atrium)

Felicitas, Aedes
Bronze Aphrodite by Praxiteles (burnt in fire under Claudius)
Marble Thespiades, from Thespiae
Outside Temple—bronze statues by Praxiteles (Muses ?)

Fortuna Huiusce Diei, Aedes
(two temples with same name, one on Palatine, one in Campus Martius)

Bronze Athena by Pheidias (on Palatine)
Two statues by Pheidias, wearing *pallium* (on Palatine)
Bronze statues of seven naked men and one old man, by Pythagoras of Samos (on which of two temples?) Seven against Thebes?

Forum Agustum
Ivory Athena by Endoios, from Tegea (probably balanced by ivory Apollo)
 (also, rows of statues of *summi viri*, copies of Erechtheion korai in architectural function)

Forum Boarium
Bronze bull of Aiginetan alloy, from Pergamon (?)

Hercules Musarum, Aedes
Statues of Muses (five?) and actor as Herakles (?) from Ambrakia

Hercules Pompeianus, Aedes (Circus Maximus)
Bronze Herakles by Myron

Hercules Victor, Aedes
Base with dedications by L. Mummius (after sack of
 Corinth)
 (possible cult images by Skopas Minor—Coarelli)

Honos et Virtus, Aedes
Many works of art, but little remaining by Livy's time (last
 quarter of first century B.C.)
Globe of Archimedes

Horti Luculliani
(mentioned by Plutarch as one of richest in Rome—
 Imperial possession)

Horti Serviliani
Flora, Triptolemos, Ceres by Praxiteles
Seated Hestia (Vesta) surrounded by two *lampteres*
 (= Lychnouchoi?) by Skopas (probably Minor)
Apollo by *caelator* Kalamis (same sculptor?)
Pyctae (pugilists) by Derkylides
Portrait of Kallisthenes, by Amphistratos

Janus, Aedes
Marble Janus pater, from Egyptian booty, rendered dark
 by gilding, either by Skopas or by Praxiteles

Juppiter Optimus Maximus Capitolinus, Aedes
Nixi dii, three statues of kneeling birth helpers
Silver vessels decorated by Mentor (burnt before Pliny's
 time)
 (also Myrrhinian vases, finger rings collection of Mithri-
 dates; columns from Athenian Olympieion)

Juppiter Tonans, Aedes
Juppiter in Delian bronze (= Juppiter Tonans by Leo-
 chares) burnt in A.D. 80 and cult image replaced (and
 given mantle)
Dioskouroi by Hegias (in front of Temple)

Mars, Aedes (in Circo Flaminio)
Mars and Venus by Skopas, the latter "better than that by
 Praxiteles" (Coarelli: Skopas Minor) Colossal

Mars Ultor (in Forum Augusti)
Two supports from tent of Alexander the Great (statues?)

Monumenta (Bibliotheca) Asinii Pollionis
Maenads, Thyiads, karyatids and sileni, by Praxiteles
 (Hellenistic?)
Venus by Kephisodotos (the Younger)
Canephorae by Skopas (the Younger) and *lampteres*
Centaurs carrying nymphs, by Arkesilaos
Thespiades (Muses? copies of statues from Thespiae?) by
 Kleomenes
Okeanos and Juppiter, by Antiochos (Heniochos?)
Appiades by Stephanos

Hermerotes, by Tauriskos from Tralles
Juppiter Xenios by Papylos
Zethos, Amphion, Dirke and the bull from a single block,
 by Apollonios and Tauriskos, from Rhodes (from the
 same stone?)
Liber Pater (Dionysos) by Eutychides

Monumentum Catuli
(monuments not mentioned specifically, but considered one
 of important collections; decorated with Cimbrian spoils;
 Greek statues from Carthage)

Neptunus, Aedes (Circus Flaminius)
Marine Thiasos by Skopas (Neptune, Thetis, Achilles,
 Nereids, *alia marina*)—Skopas Minor?

Pax, Templum (Forum)
Portrait of boxer Cheimon by Naukydes, from Argos
Works from Domus Aurea, brought here by Vespasian:
 Ganymede and Eagle by Leochares, Galatian monument
 from Pergamon
Heifer by Myron (?)
Marble Venus by unknown master

Porticus Metelli—replaced by Porticus Octaviae
Temple of Juno Regina, with cult image by Dionysios and
 Polykles (one or two?)
Juppiter in Temple of Juppiter Stator (either by Pasiteles,
 or by Polykles and Dionysios, sons of Timarchides)
Juno by Timarchides (?)
Marble Venus by Pheidias
Eros by Praxiteles from Thespiai
Pan and Olympos fighting, by Heliodoros
Venus washing, by "Doidalsas" (?)
Aphrodite standing, by Polycharmos
Venus of Philiskos
Artemis by Kephisodotos, son of Praxiteles
Asklepios, by Kephisodotos, son of Praxiteles
Statues by Pasiteles (*not* Praxiteles)
Granikos Monument, by Lysippos (Porticus Metelli)

Porticus Pompei and Porticus ad Nationes
Statues of fourteen defeated Nations
Famous women (statues)
 (Attalid carpets, interwoven with gold)
Herakles Melqart from Carthage

Regia
Two supports from Alexander's tent (cf. Mars Ultor) in
 front of it

Rostra
Bronze Hercules Tunicatus (with three inscriptions for
 rededications)
Sun dial from Katane

Saepta Julia
Marble group of Pan and Olympos
Marble group of Chiron and Achilles

Thermae Agrippae
Bronze Apoxyomenos by Lysippos
Fallen Lion from Lampsakos, by Lysippos (between stagnum and Euripus)

Venus Genetrix
Cult statue by Arkesilaos
Gold statue of Kleopatra, from Egypt

Location uncertain
Diver Hydne, from Delphi
Mikythos's dedications from Olympia (by Dionysios and Glaukos of Argos?)
Odysseus by Onatas, from Olympia
Herakles by Polykleitos
Amazon by Strongylion (statuette?)
Puer Bruti by Strongylion
Bonus Eventus by Euphranor
Argonauts by Kydias
Apollo, Poseidon, by Praxiteles
Alexander puer by Lysippos (gilded by Nero)
Labors of Herakles by Lysippos, from Alyzia
Autolykos, founder of Sinope, by Sthennis

Plates

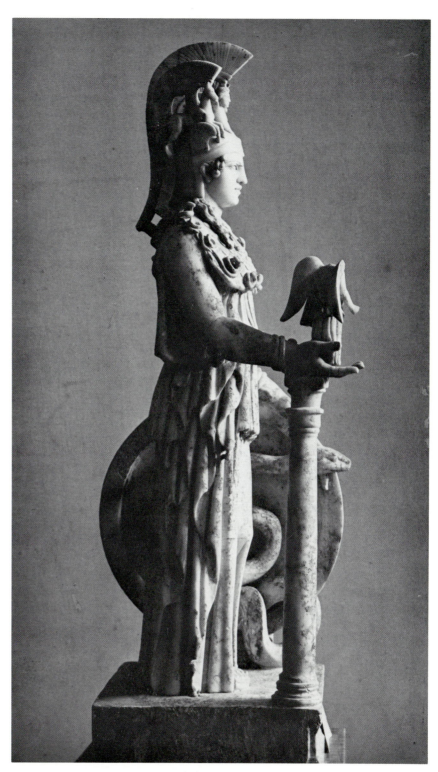

Pl. 1. Varvakeion Athena, small-scale reproduction of Athena
Parthenos. Athens, National Museum. (*Postcard.*)

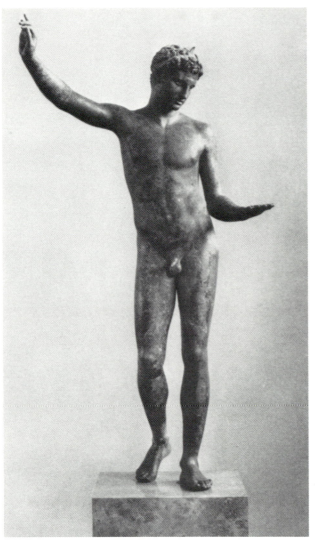

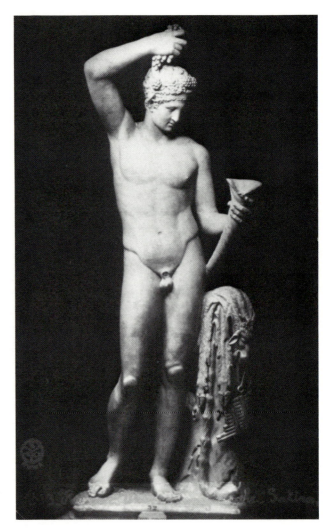

Pl. 3. Wine-pouring satyr, Roman marble copy after a bronze original. Rome, National Museum. (*Postcard.*)

Pl. 2. "Marathon Boy," bronze original, fourth century B.C. Athens, National Museum. (*Postcard.*)

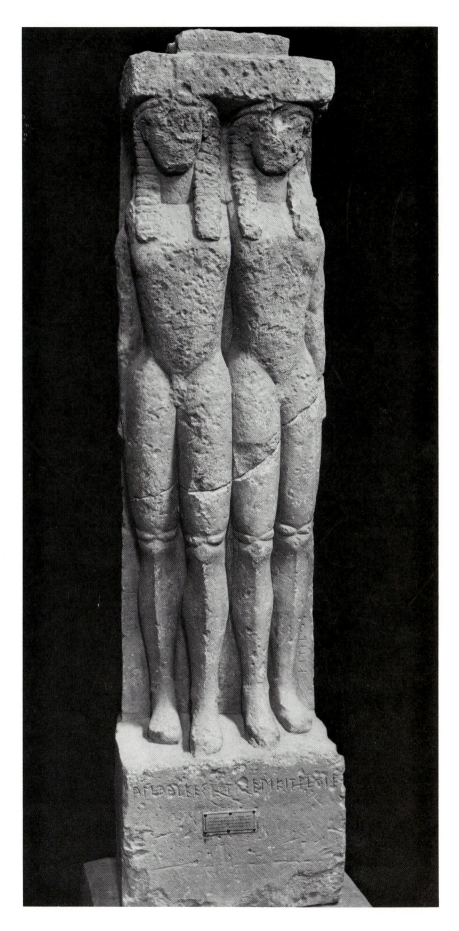

Pl. 4. "Dermys and Kittylos," original of
the early sixth century B.C. Athens,
National Museum. (*Alinari*.)

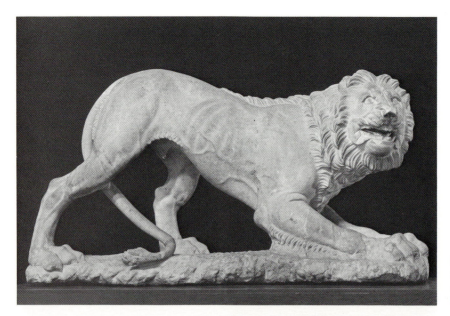

Pl. 5. Funerary lion to right, Inv. no. 1917.225, ca. 300 B.C. Wadsworth Atheneum, Hartford, Conn. (*Courtesy Wadsworth Atheneum.*)

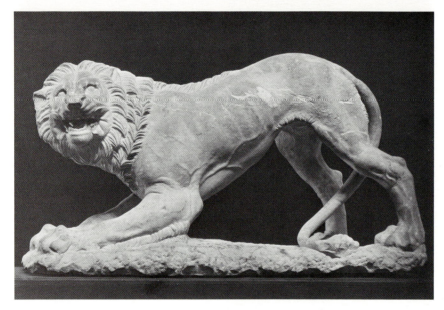

Pl. 6. Funerary Lion to left, Inv. no. 1917.224, ca. 300 B.C. Wadsworth Atheneum, Hartford, Conn. (*Courtesy Wadsworth Atheneum.*)

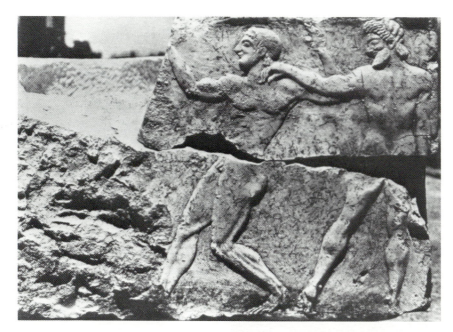

Pl. 7. Relief base, side with ball-playing scene. Inv. no. P 1002. Athens, Kerameikos Museum. (*After* AthMitt *78 [1963], Beil. 66.*)

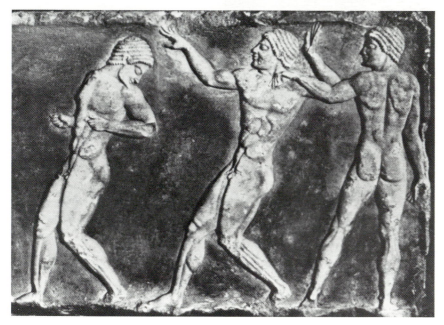

Pl. 8. Ball-player base, Inv. no. 3476, detail. Athens, National Museum. (*After* AthMitt *78 [1963], Beil. 66.*)

 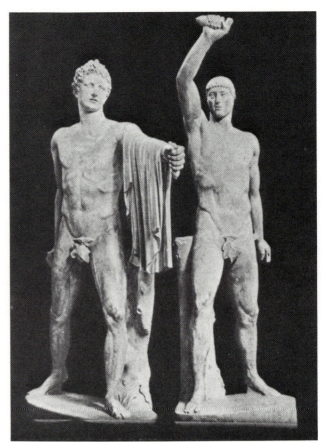

Pl. 9. Double relief of Athena, no. 82. Athens, National Museum. (*Postcard.*)

Pl. 10. Tyrannicides by Kritios and Nesiotes, Roman copies after bronze originals of 477 B.C. The head on Aristogeiton is ancient but not pertinent, Harmodios's arm is wrongly restored. Naples, National Museum. (*Postcard.*)

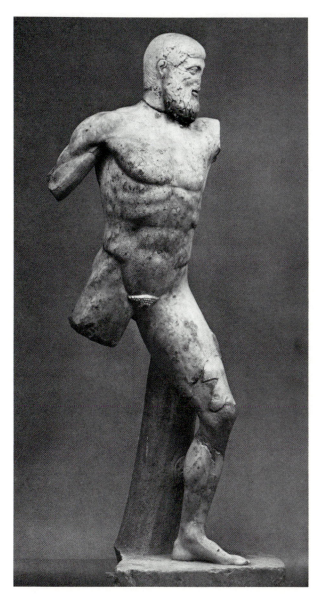

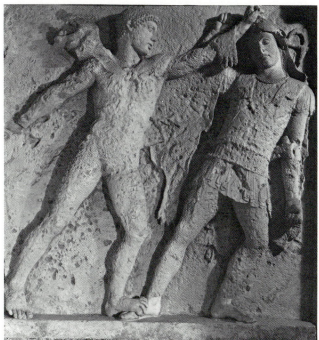

Pl. 12. Metope of Herakles and the Amazon, from Temple E at Selinus. Herakles' pose compares to Aristogeiton's, his head to Harmodios's. Palermo, National Museum (*A. Frantz.*)

Pl. 11. Aristogeiton, Roman copy of bronze original. Rome, Conservatori Museum. (*DAI Rome.*)

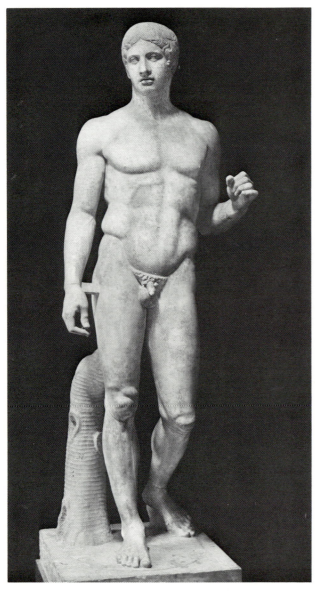

Pl. 15. Stele of warrior echoing Doryphoros by Polykleitos, original of the fifth century B.C. Cyrene Museum. (*Courtesy Libyan Inspectorate of Antiquities.*)

Pl. 13. Doryphoros by Polykleitos, Roman copy from Pompeii, after bronze original. Naples, National Museum. (*Alinari.*)

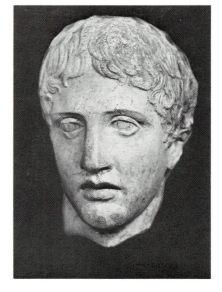

Pl. 14. Head of Doryphoros, marble copy of bronze original. Corinth, Archaeological Museum. (*Stournaras.*)

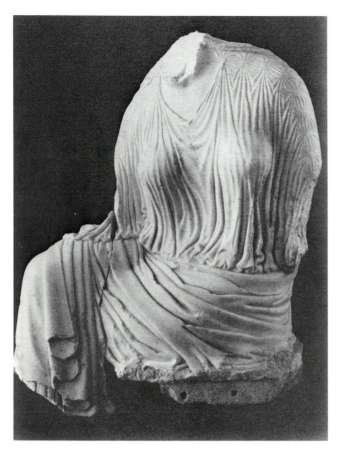

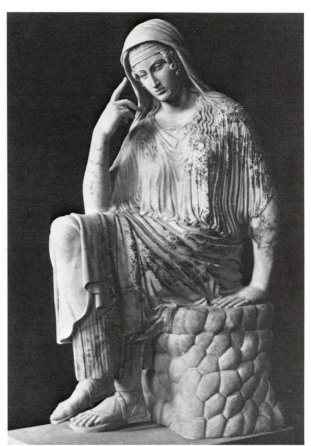

Pl. 16. "Penelope" from Persepolis, original of the fifth century B.C. Teheran Museum. (*Oriental Institute of the University of Chicago*.)

Pl. 17. "Penelope," Roman copy of Greek original. Rome, Vatican Museums. (*Alinari*.)

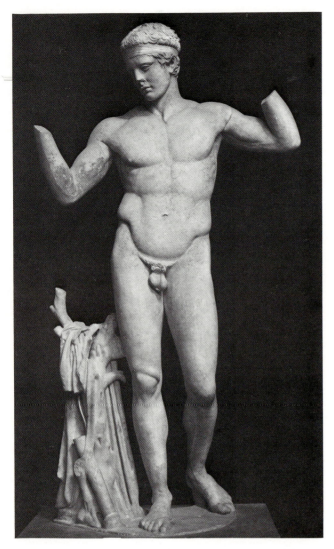 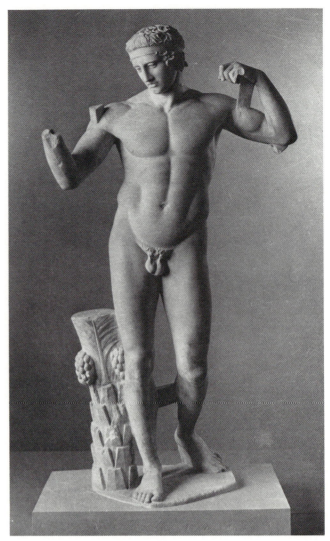

Pl. 18. Diadoumenos from Delos, Roman copy of bronze original of the fifth century B.C. Athens, National Museum. (*Alinari.*)

Pl. 19. Diadoumenos, Roman copy of bronze original integrated with casts taken from Delos Diadoumenos. New York, Metropolitan Museum of Art. (*Courtesy of the Metropolitan Museum.*)

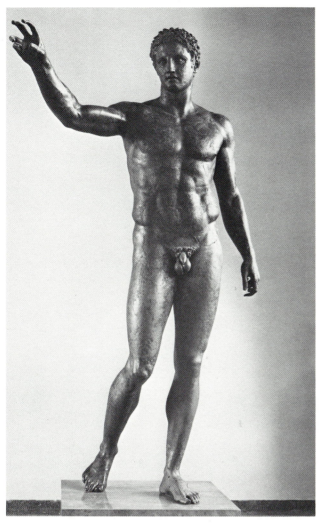 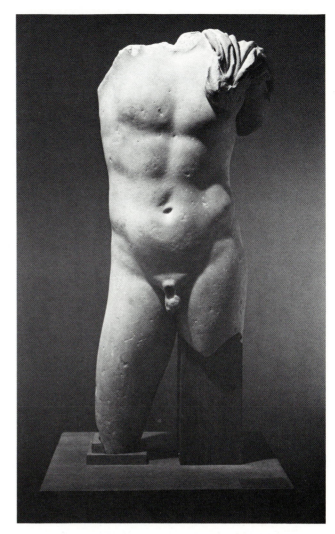

Pl. 20. Youth from Antikythera wreck, bronze original of the fourth century B.C. Athens, National Museum. (*A. Frantz.*)

Pl. 21. "Hermes Richelieu" type. Roman copy, possibly used for a portrait of Antinoos. Museum of Art, Rhode Island School of Design, Providence, R.I. (*Courtesy of RISD Museum.*)

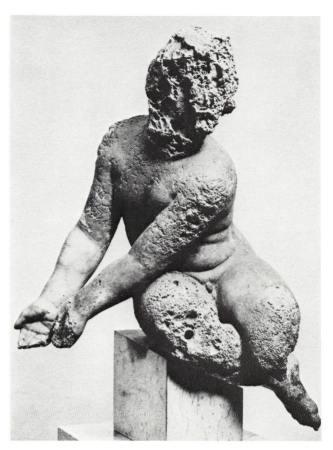

Pl. 23. Satyr recovered from Mahdia shipwreck, Hellenistic. Tunis, Bardo Museum. (*After W. Fuchs,* Der Schiffsfund von Mahdia *[Tübingen, 1963], pl. 62.*)

Pl. 22. Aphrodite Knidia by Praxiteles, Roman copy after marble original of the fourth century B.C. Rome, Vatican Museums. (*Bryn Mawr College.*)

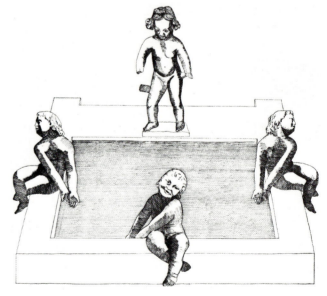

Pl. 24. Reconstruction of fountain ornaments with figures copying same prototype as Mahdia satyr. Roman period. Sperlonga. (*After B. Andreae,* RömMitt *83 [1976]: 295, fig. 1.*)

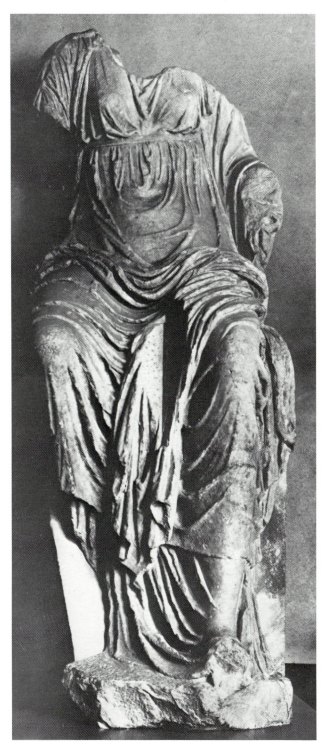

Pl. 25. Seated goddess from Amiternum, Abruzzi, Hellenistic original. Boston, Museum of Fine Arts. (*R. Carpenter Collection.*)

 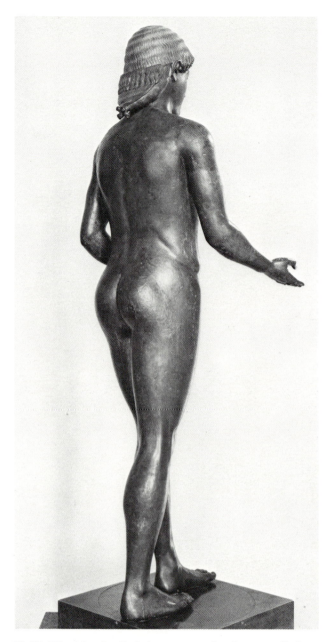

Pl. 26. "Piombino Apollo," bronze original of the first century B.C. imitating archaic prototypes. Paris, Louvre. (*D. Widmer.*)

Pl. 27. "Piombino Apollo," three-quarter view from rear. Paris, Louvre. (*M. Chuzeville, Paris.*)

Pl. 28. "Piombino Apollo," feet seen from
below (round knob is modern fastening).
Paris, Louvre. *(Institute Mainini,
Laboratory of Louvre Museum.)*

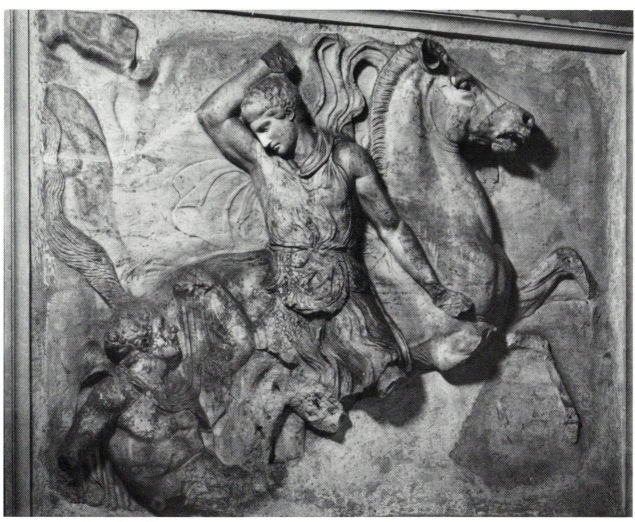

Pl. 29. "Albani Relief," Greek original of the fifth century B.C.
Rome, Villa Albani. *(Anderson.)*

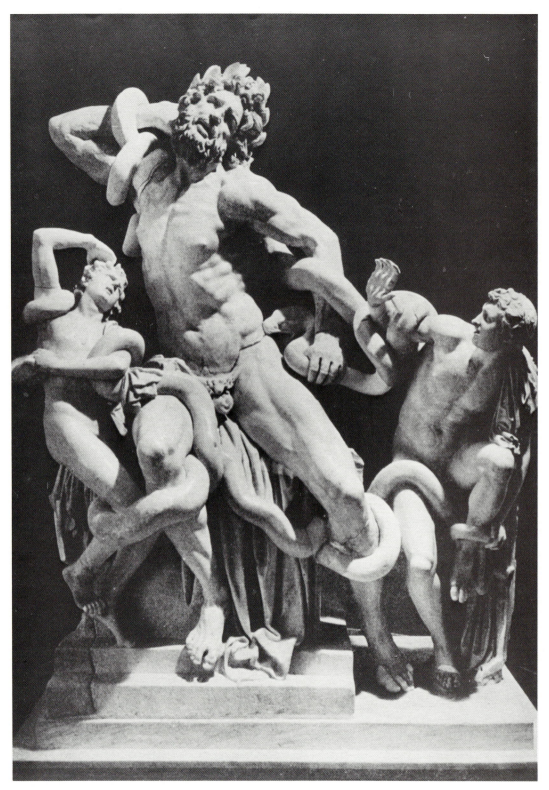

Pl. 30. Laokoon by Hagesandros, Polydoros, and Athanodoros of
Rhodes, modern integrated cast of marble group of Flavian period
after possible Hellenistic prototype (?). Rome, Vatican Museums.
(*After F. Magi,* Il ripristino del Laocoonte *[Città del Vaticano,
1960], pl. 44.*)

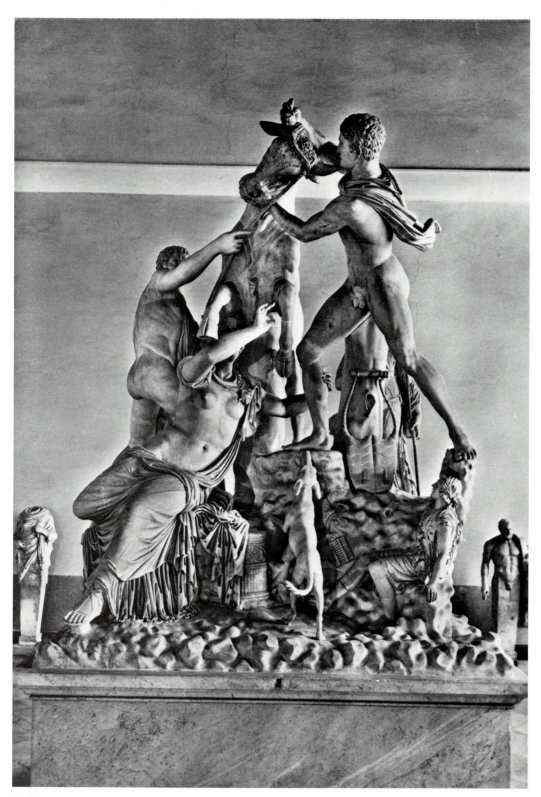

Pl. 31. "Toro Farnese"—the Punishment of Dirke. Marble group
of the time of Caracalla, after original of the second/first century
B.C. (possibly in bronze). Naples, National Museum. (*Postcard.*)

Pl. 33. "Dying Trumpeter," detail of head. Rome, Capitoline Museum. (*Postcard.*)

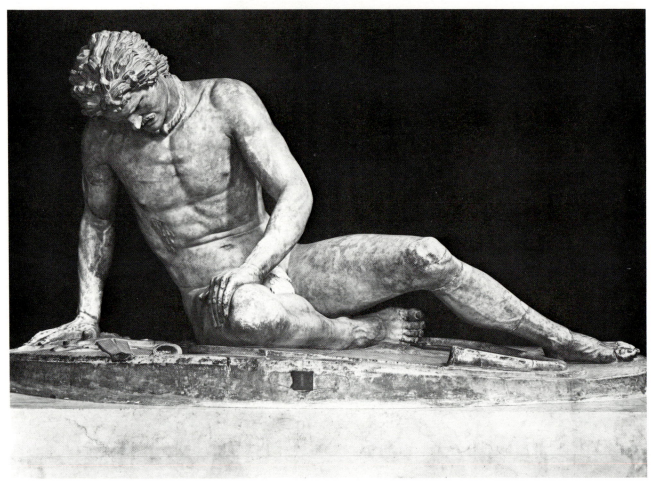

Pl. 32. "Dying Trumpeter," marble copy after bronze original (by Epigonos?) of Hellenistic date. Rome, Capitoline Museum. (*Alinari.*)

60750

Pl. 34. "Crouching Aphrodite" type, marble replica of Hellenistic
(bronze?) original. Rome, National Museum. (*Postcard*.)

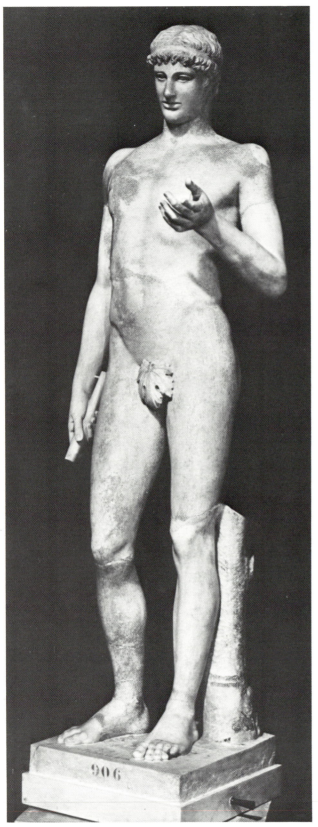

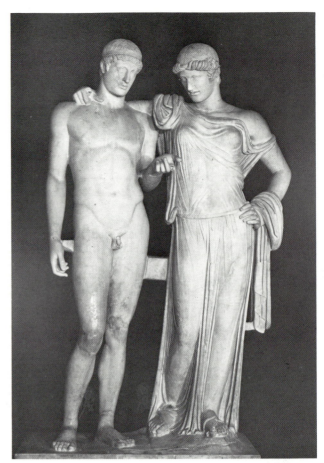

Pl. 36. "Orestes and Elektra" group; the male figure duplicates Stephanos Athlete, the female figure echoes a Hellenistic version of the Aphrodite Naples/Frejus type. Naples, National Museum. (*Courtesy Naples National Museum.*)

Pl. 35. "Stephanos Athlete," Late Hellenistic creation known in many replicas. Rome, Villa Albani. (*Bryn Mawr College.*)

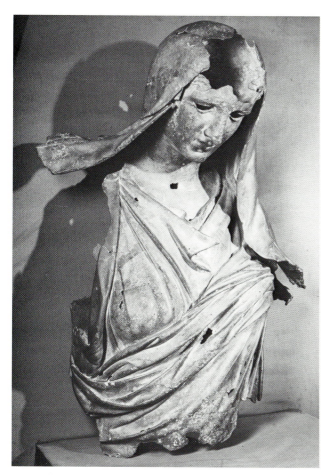

Pl. 39. "Lady from the Sea," drawing of component parts by R. De Puma.

Pl. 38. "Lady from the Sea," Greek original of the early third century B.C. Izmir Museum (*K. Dimler.*)

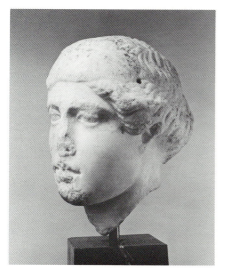

Pl. 37. Female head, possibly from pediment, retaining holes of measuring process (one visible before left ear). Greek original of the fifth century B.C. Museum of Art, Rhode Island School of Design, Providence, R.I. (*Courtesy RISD Museum of Art.*)

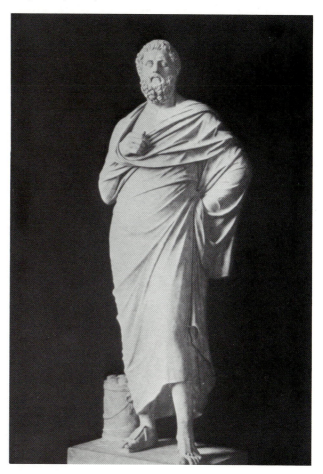

Pl. 40. Sophokles, Lateran type, marble copy after bronze original of the fourth century B.C. Rome, Vatican Museums. (*Postcard.*)

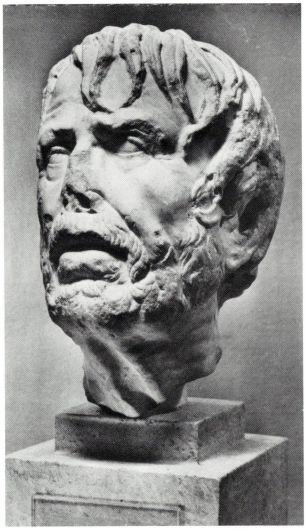

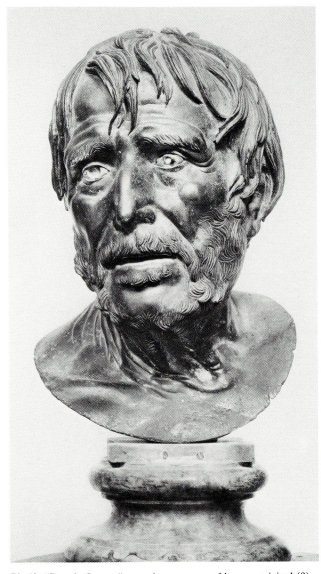

Pl. 41. "Pseudo-Seneca" type (Hesiod? Ennius?), replica in Bardo Museum, Tunis. (*Postcard.*)

Pl. 42. "Pseudo-Seneca" type, bronze copy of bronze original (?) from Villa of Pisoni, Herculaneum. Naples, National Museum. (*DAI Rome.*)

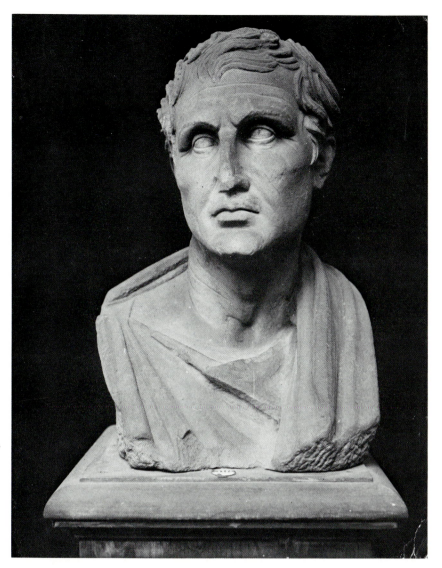

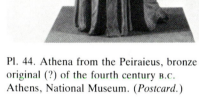

Pl. 44. Athena from the Peiraieus, bronze original (?) of the fourth century B.C. Athens, National Museum. (*Postcard.*)

Pl. 43. Menander, marble copy after seated statue by Kephisodotos and Timarchos, sons of Praxiteles, third century B.C. replica in Venice, Seminario Patriarcale of S. Maria della Salute, from Athens. (*Bryn Mawr College.*)

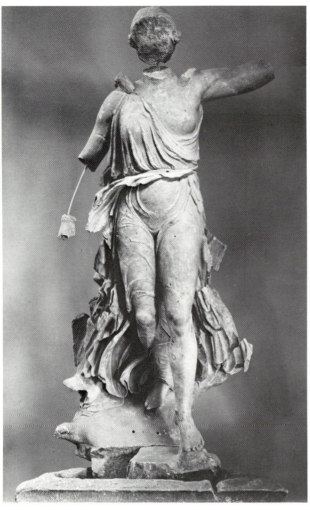

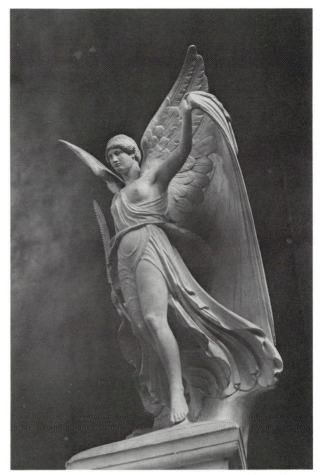

Pl. 46. Nike of Paionios, reconstruction. (*Mary H. Swindler Collection, Bryn Mawr College.*)

Pl. 45. Nike by Paionios, Greek original of the fifth century B.C. Olympia Museum. (*DAI Athens.*)

Pl. 47. Herm of head comparable to Nike of Paionios. Rome, Vatican Museums. (*After R. Carpenter,* The Sculpture of the Nike Temple Parapet *[Cambridge, Mass. 1929], pl. X.2.*)

Pl. 49. Statues of Kleopatra and her husband
Dioskourides, in Delos. (*Postcard.*)

Pl. 48. The emperor Claudius as Juppiter from Lavinium. Rome,
Vatican Museums. (*Bryn Mawr College.*)

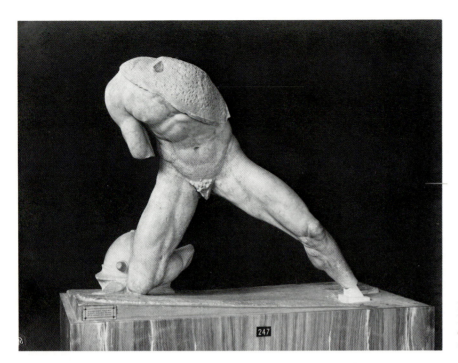

Pl. 50. Fighting Gaul by Agasias, from Delos, commemorating Marius's victories of 101 B.C. Athens, National Museum. (*Bryn Mawr College.*)

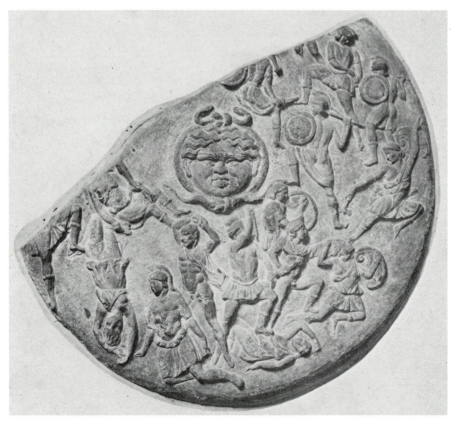

Pl. 51. Strangford Shield, Roman adaptation of the shield of the Athena Parthenos in Athens. London, British Museum. (*British Museum [Bryn Mawr College collection].*)

Pl. 52. Head of Triton from Odeion of Agrippa, imitating
Poseidon from the West Pediment of the Parthenon. Antonine
period. Agora of Athens. (*ASCSA postcard.*)

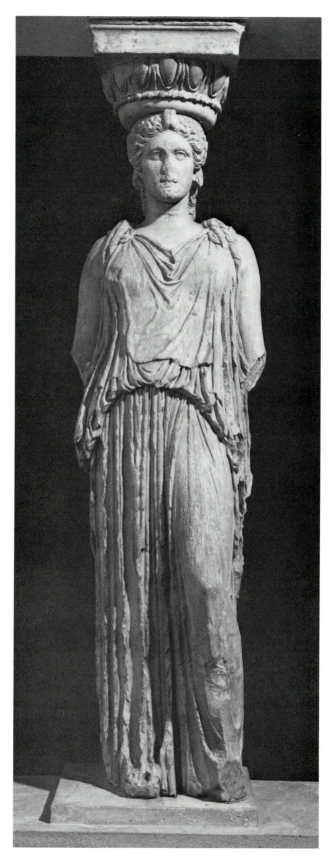

Pl. 53. Karyatid from the Erechtheion in Athens, Greek original of
the fifth century B.C. London, British Museum. (*British Museum.*)

Pl. 54. Nike Balustrade, several fragments. Original reliefs of the
fifth century B.C. Athens, Akropolis Museum. (*Postcard.*)

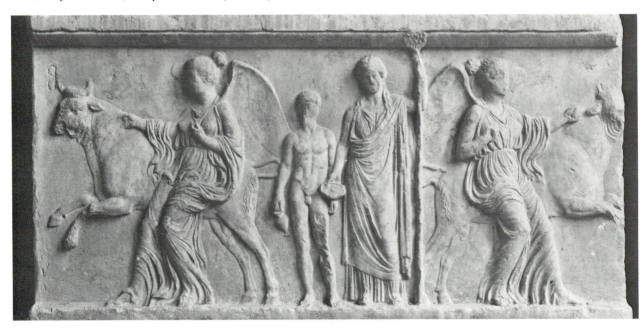

Pl. 55. Neo-Attic relief adapting motifs from the Nike Balustrade.
Athens National Museum no. 3497. (*Athens National Museum.*)

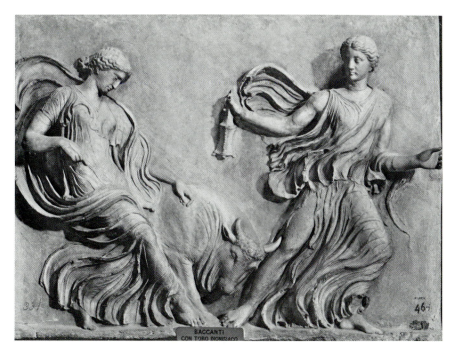

Pl. 56. Neo-Attic adaptation of motifs from the Nike Balustrade.
Dresden, Albertinum Museum. (*Bryn Mawr College.*)

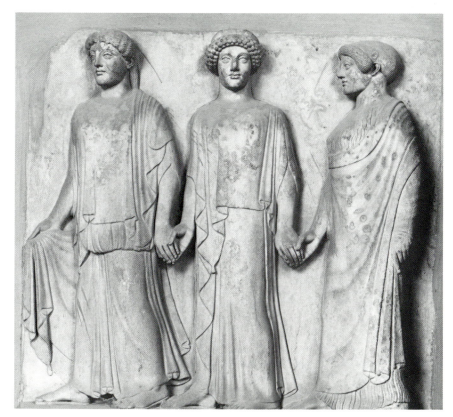

Pl. 57. Neo-Attic relief with Three Graces by Sokrates. Rome,
Vatican Museums. (*Anderson.*)

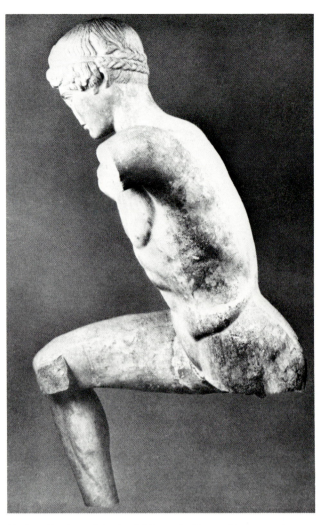

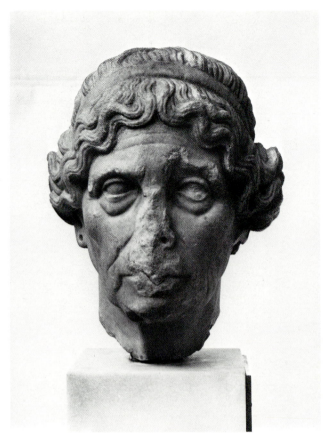

Pl. 59. So-called Lysimache, London, British Museum. (*British Museum.*)

Pl. 58. "Charioteer" in classicizing style. Rome, Conservatori Museum. (*Brunner & Co.*)

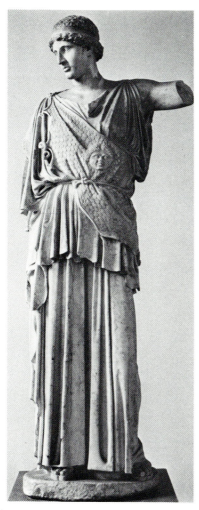

Pl. 60. So-called Athena Lemnia,
Dresden, Albertinum. (*Kim Hartswick.*)

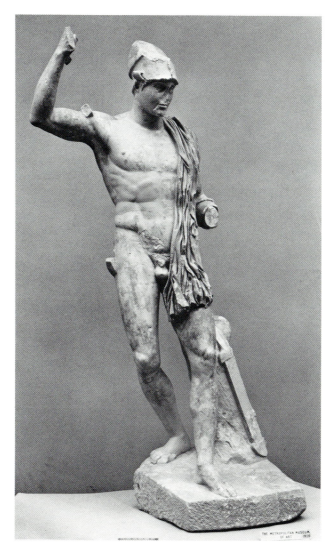

Pl. 61. So-called Protesilaos, after Greek bronze original of the
fifth century B.C. Metropolitan Museum of Art, New York.
(*Metropolitan Museum of Art.*)

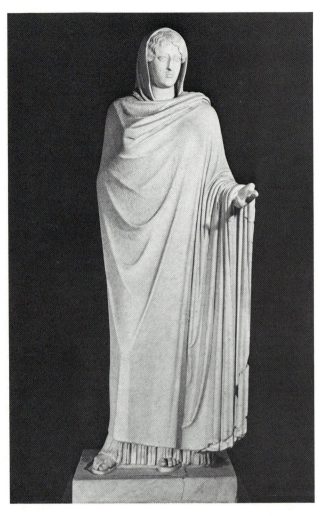

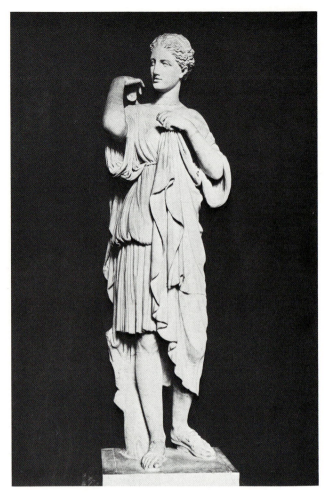

Pl. 63. Artemis from Gabii, Paris, Louvre. (*Postcard.*)

Pl. 62. So-called Aspasia/Sosandra, marble replica after an original of the fifth century B.C. From Baiae, Naples, National Museum. (*National Museum, Naples.*)

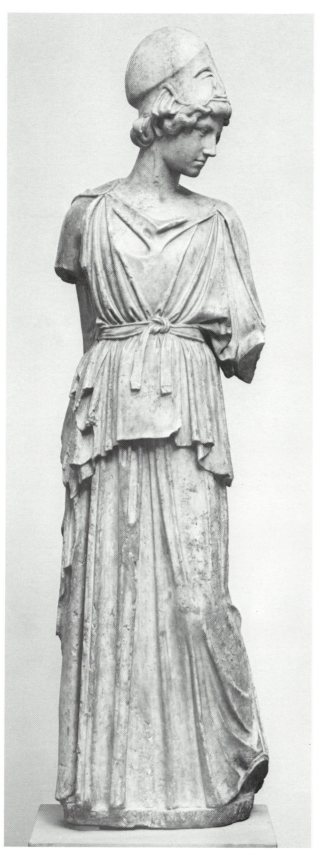

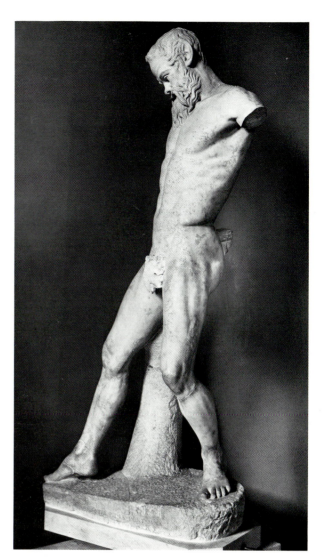

Pl. 65. Marsyas ex-Lateran, attributed to Myron. Rome, Vatican Museums. (*Vatican Archives.*)

Pl. 64. Frankfurt Athena, attributed to Myron. Frankfurt, Liebighaus. (*G. Busch-Hanck.*)

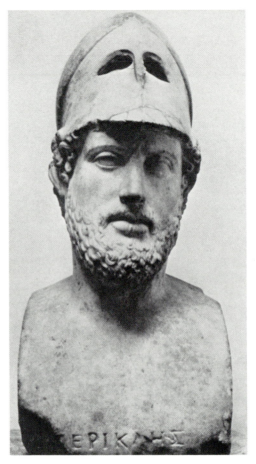

Pl. 66. Herm of Perikles, Rome, Vatican Museums. *(Alinari.)*

Pl. 67. Herm of Perikles, London, British Museum. (*Postcard.*)

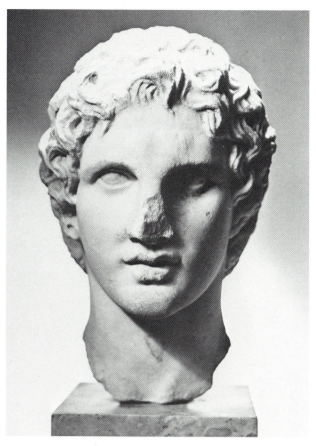

Pl. 68. Portrait of Alexander, from the Athenian Akropolis.
Roman copy of fourth-century original (?). Athens, Akropolis
Museum. (*Postcard.*)

Pl. 69. Xenokles Base, Akropolis Museum
inv. no. 402a. Athens, Akropolis.
(*Courtesy Prof. E. B. Harrison.*)

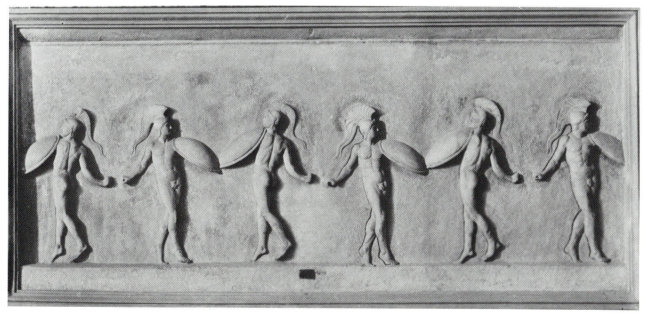

Pl. 70. Neo-Attic replica of the Xenokles Base. Rome, Vatican
Museums. (*Bryn Mawr College.*)

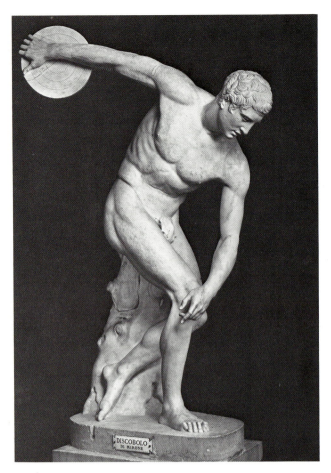

Pl. 71. Diskobolos by Myron, Roman copy of bronze original of the fifth century B.C. Rome, Vatican Museums. (*Bryn Mawr College.*)

Pl. 72. Apollo Kitharoidos, considered the Apollo Patroos by Euphranor. Greek original of the fourth century B.C. Athens, Agora Museum. (*A. Frantz.*)

Pl. 74. Sorrento Base, short side with Palatine Triad (the Apollo should reproduce a statue by Skopas taken from Rhamnous). Sorrento Museum. (*Courtesy G. De Cecilia.*)

Pl. 73. Statuette of Apollo Kitharoidos, probably after the Apollo Patroos by Euphranor. Athens, Agora. (*Agora Excavations.*)

Pl. 75. Statuette of "Rhodian Aphrodite" type, Corinth Museum. (*Courtesy Corinth Excavations.*)

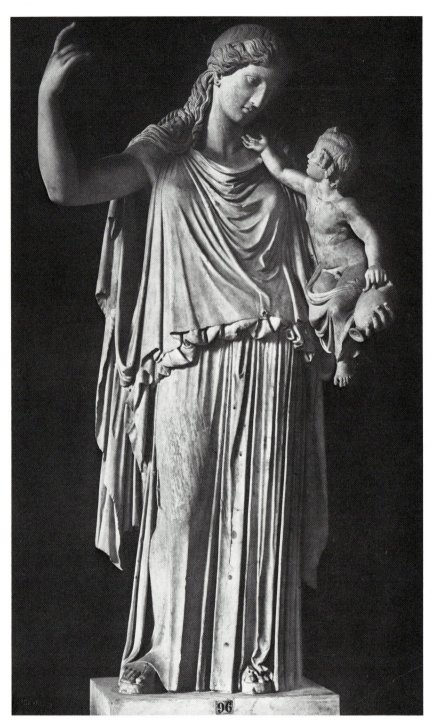

Pl. 76. "Eirene and Ploutos," Roman copy of bronze original by Kephisodotos, ca. 370 B.C. Munich Glyptothek. (*Munich Glyptothek.*)

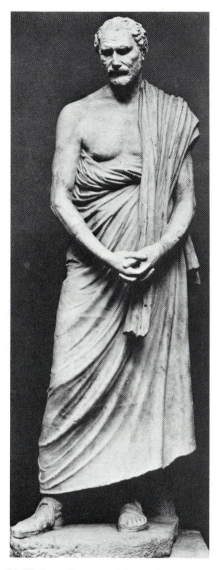

Pl. 77. Portrait statue of Demosthenes, Roman copy of bronze original by Polyeuktos in 280 B.C. Ny Carlsberg Glyptotek, Copenhagen. (*Courtesy Ny Carlsberg Glyptotek.*)

Pl. 78. Portrait of Demosthenes, Roman replica. The Art Museum of Princeton University. (*Courtesy Princeton Art Museum.*)

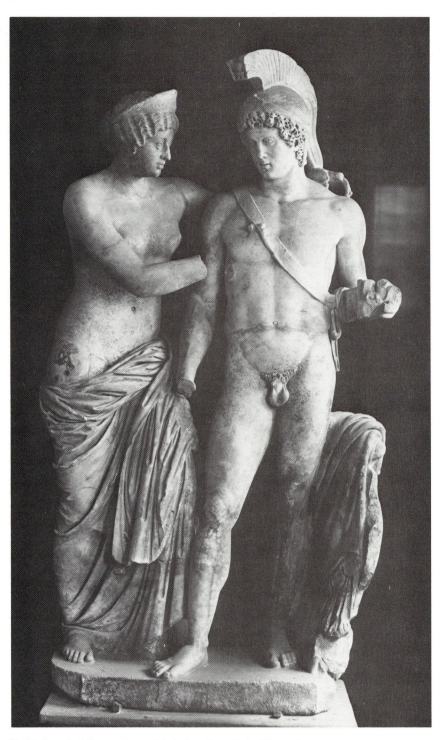

Pl. 79. So-called Commodus and Crispina, from Ostia. The male
figure utilizes the body of the Ares Borghese type. Ostia Museum.
(*Moscioni.*)

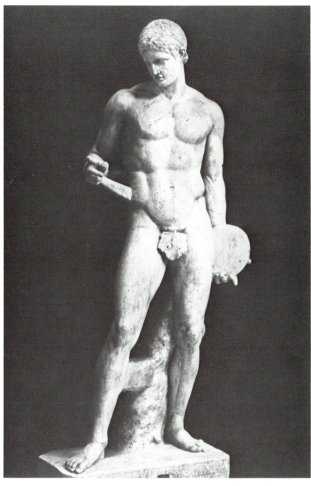

Pl. 80. So-called Diskobolos by Naukydes, Roman copy after bronze original of the late fifth/early fourth century B.C. Rome, Vatican Museums. (*Bryn Mawr College.*)

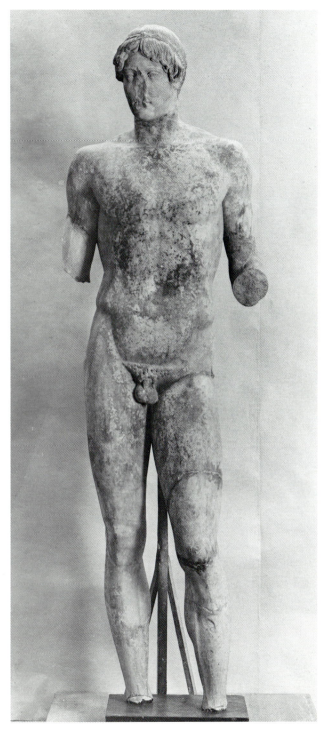

Pl. 81. Omphalos Apollo type, name piece, from Theater in Athens. Roman copy of bronze original of the fifth century B.C. Athens, National Museum. (*DAI Athens [Hege].*)

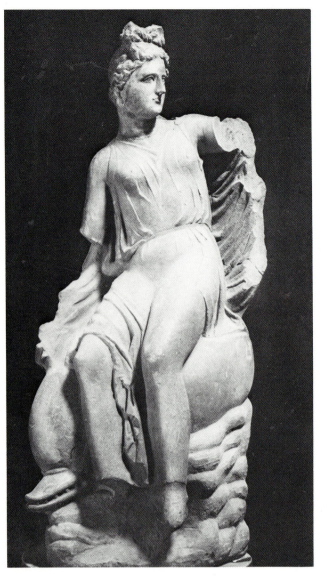

Pl. 82. Nereid on a Dolphin, after akroteria in Athens of the fifth century B.C. Venice, National Museum. (*After* EA *2454.*)

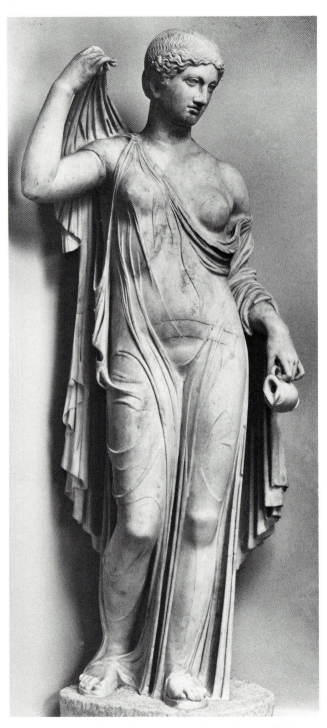

Pl. 83. Aphrodite Naples/Frejus type, replica in Holkam Hall. (*Courtesy Forschungsarchiv für römische Plastik, Cologne.*)

Pl. 84. Heads from Hekataion, Boston Museum of Fine Arts.
(*Boston Museum of Fine Arts.*)

Pl. 85. Hekataion, Corinth Museum.
(*Courtesy Corinth Excavations.*)

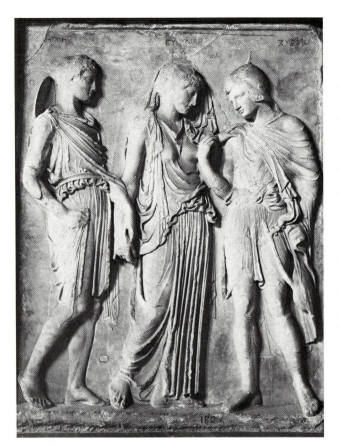

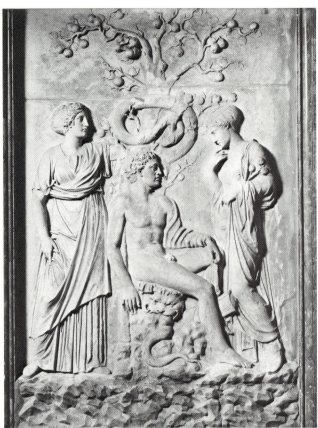

Pl. 86. Orpheus, Eurydike, and Hermes, one of so-called Three-Figure Reliefs. Naples, National Museum. (*Alinari.*)

Pl. 87. Herakles and the Hesperides (or Herakles between Hera and Aphrodite, "at the crossroads"). Rome, Villa Albani. (*DAI Rome.*)

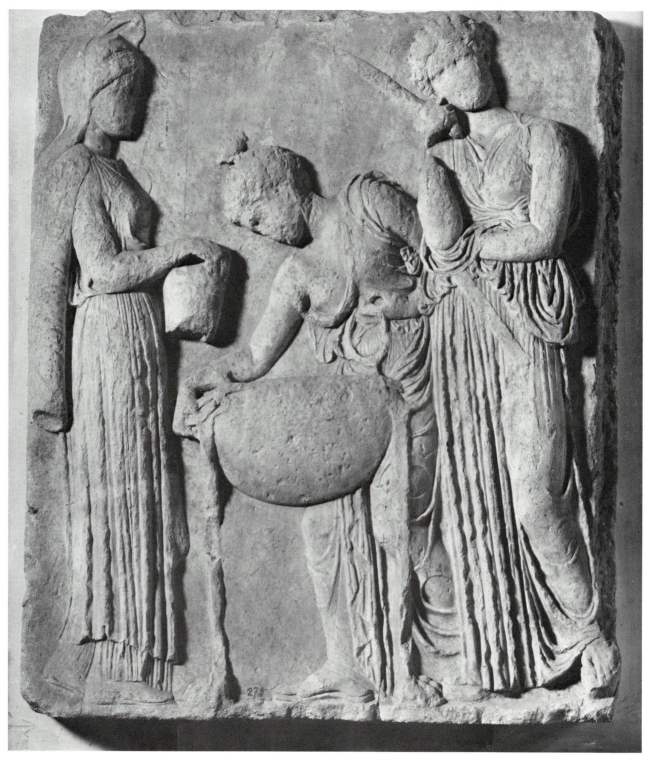

Pl. 88. Peliads Relief, Rome, Vatican Museums. (*Anderson.*)

Pl. 89. Aphrodite of Arles type, from Athens Theater. Athens, National Museum. (*DAI Athens.*)

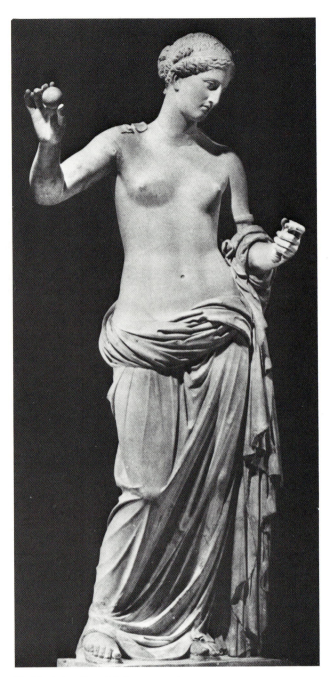

Pl. 90. Aphrodite of Arles, name piece, from theater in Arles. Paris, Louvre. (*After* TEL *III.*)

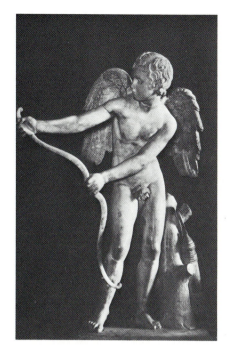

Pl. 91. So-called Eros by Lysippos, replica
in the Capitoline Museum, Rome.
(*Museum postcard.*)

Pl. 92. Nemesis by Agorakritos, Roman replica of cult image in
Temple of Nemesis at Rhamnous. Ny Carlsberg Glyptotek,
Copenhagen. (*Courtesy Ny Carlsberg Glyptotek.*)

Pl. 93. Statuette of Poseidon, echoing
Lateran Poseidon type. Hellenistic bronze
original, from Pella. Pella Museum.
(*Museum postcard.*)

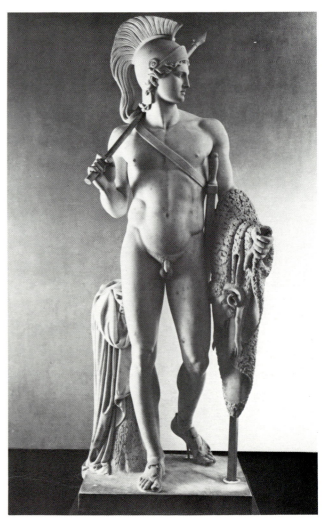

Pl. 95. Thorvaldsen's "Jason," Copenhagen, Thorvaldsen Museum.
(*Museum postcard.*)

Pl. 94. Tyche of Antioch, after bronze (?)
original by Eutychides, of the Early
Hellenistic period. Roman replica in the
Vatican Museums, Rome. (*Bryn Mawr
College.*)

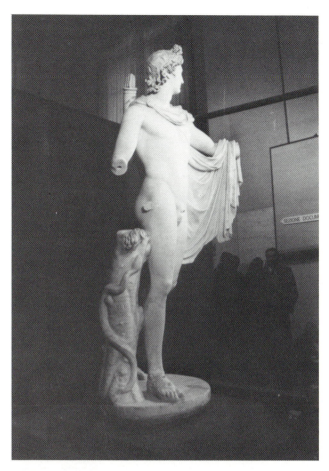 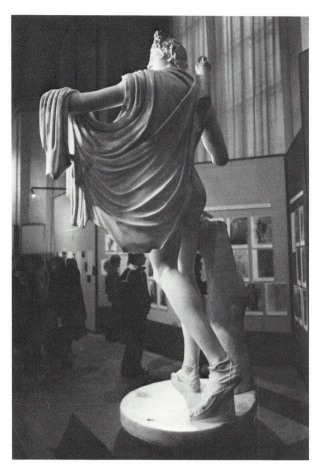

Pl. 96. So-called Belvedere Apollo, usually attributed to Leochares, during recent display without restorations. Rome, Vatican Museums. (*Courtesy Cok-Escher.*)

Pl. 97. Belvedere Apollo from the rear, Rome, Vatican Museums. (*Courtesy Cok-Escher.*)

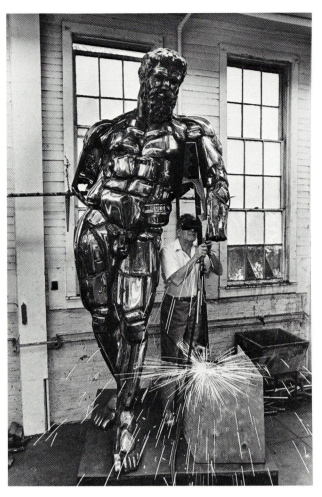 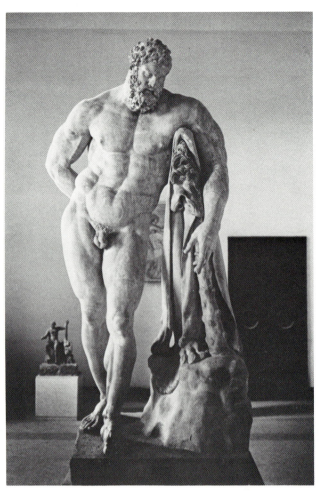

Pl. 98. "Farnese Hercules II" by Jason Seley, Cornell University, Ithaca, N.Y. (*Jon Reis photo courtesy Prof. P. Kuniholm.*)

Pl. 99. Herakles Farnese, replica from Baths of Caracalla in Rome. Naples, National Museum. (*Courtesy Prof. M. Marvin.*)

Pl. 100. Hermes, of ideal type. Hispanic Society of America, New York. (*Courtesy Hispanic Society of America.*)

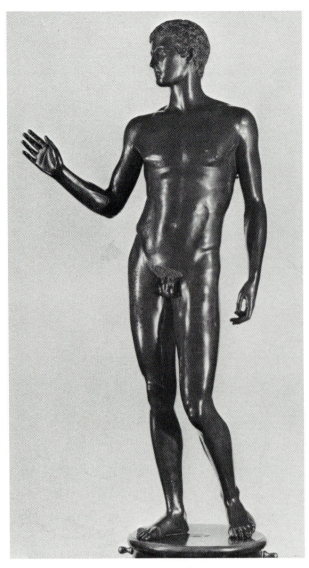

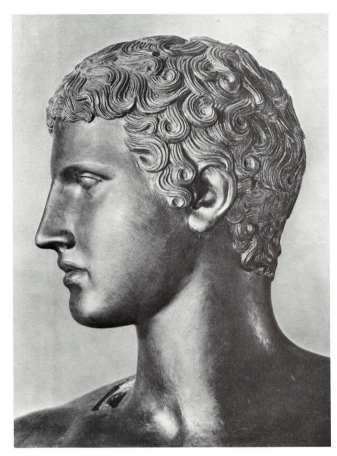

Pl. 102. Magdalensberg Youth (Hermes). Vienna, Kunsthistorische Museum. (*Museum postcard.*)

Pl. 101. Magdalensberg Youth (Hermes). Vienna, Kunsthistorische Museum. (*Museum postcard.*)

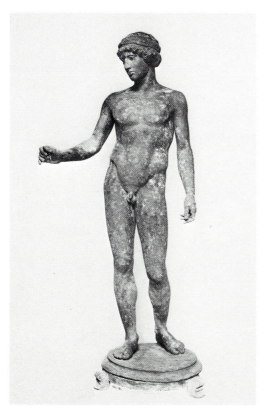

Pl. 103. Lychnouchos from Pompeii.
Naples, National Museum. (*National
Museum, Naples.*)

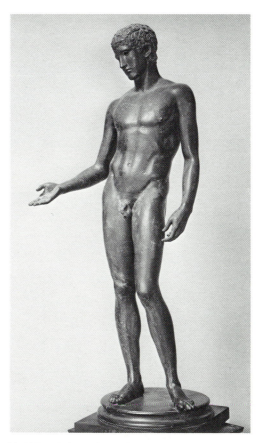

Pl. 104. "Idolino," front view. Florence,
Archaeological Museum. (*Alinari.*)

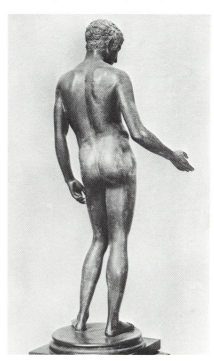

Pl. 105. "Idolino," rear view. Florence,
Archaeological Museum. (*Museum
postcard.*)

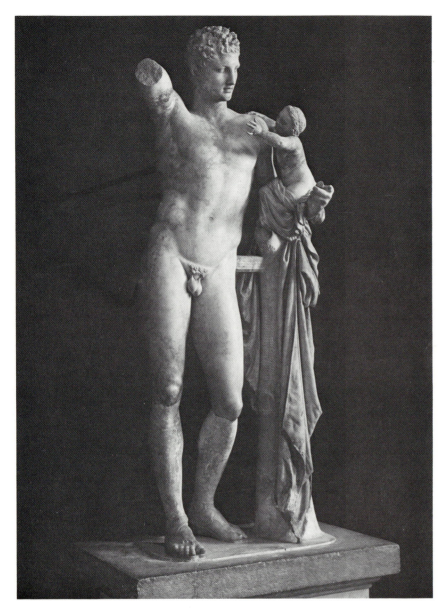

Pl. 107. Hermes of Olympia, head profile. Olympia Museum. (*Sphinx.*)

Pl. 106. Hermes of Olympia. Olympia Museum. (*Alinari.*)

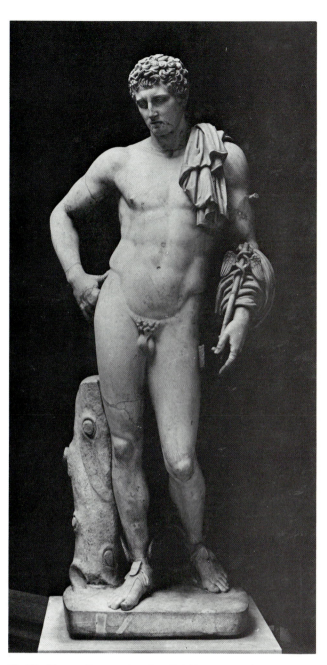

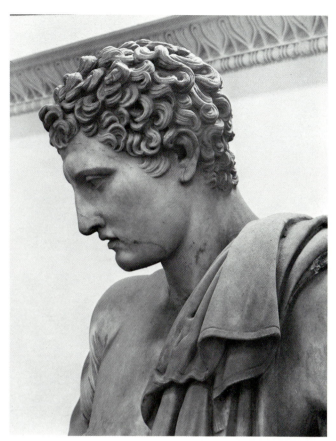

Pl. 109. Hermes Farnese, head profile. London, British Museum.
(*Bryn Mawr College.*)

Pl. 108. Hermes Farnese, London, British Museum. (*Bryn Mawr College.*)

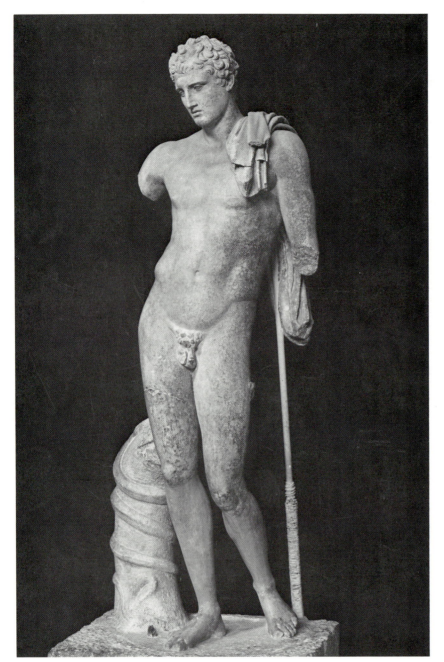

Pl. 111. Hermes of Andros, profile.
Athens, National Museum. (*Postcard.*)

Pl. 110. Hermes of Andros. Athens, National Museum. (*Postcard.*)

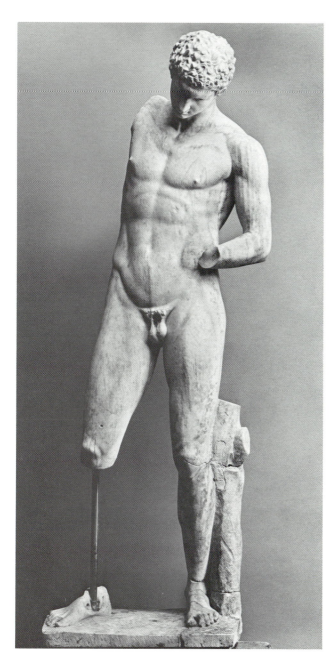

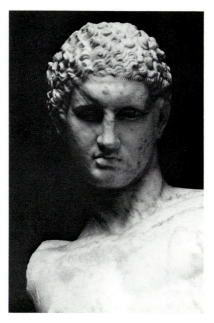

Pl. 113. Oil-pourer, head. Munich
Glyptothek. (*Courtesy Prof. A. Stewart.*)

Pl. 112. Oil-pourer, Munich Glyptothek. (*Courtesy Prof. A.
Stewart.*)

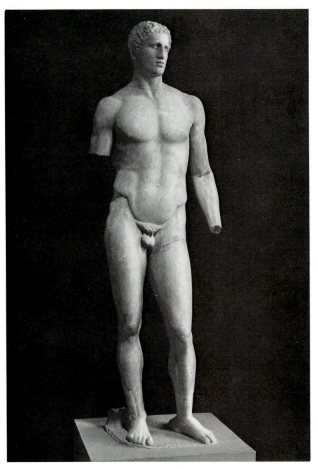

Pl. 114. Agias, from Daochos's Thessalian dedication (after Lysippos?) Delphi Museum. (*Alinari.*)

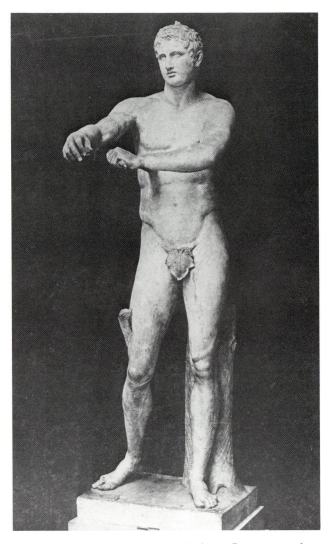

Pl. 115. Apoxyomenos, attributed to Lysippos, Roman copy of bronze original. Rome, Vatican Museums. (*Bryn Mawr College.*)

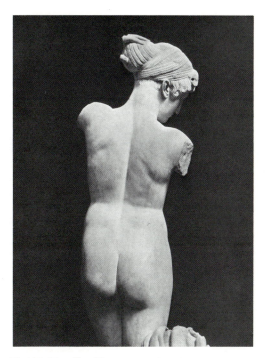

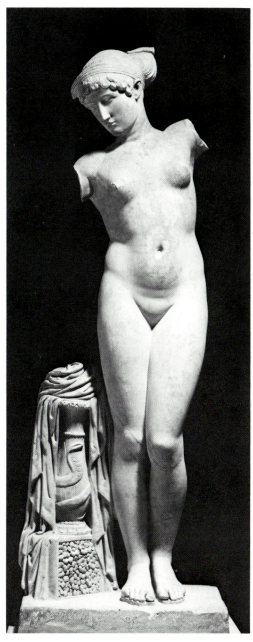

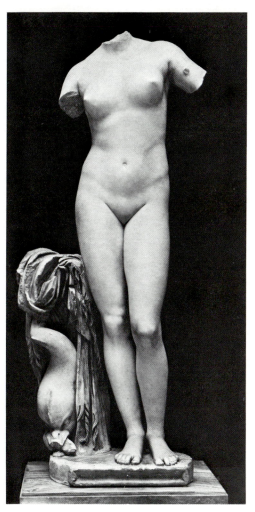

Pl. 120. So-called Jason ("Sandalbinder") type; unfinished replica from the Athenian Akropolis. Athens, Akropolis Museum. (*DAI Athens.*)

Pl. 119. So-called Jason ("Sandalbinder") from Perge. Antalya Museum. (*Courtesy Prof. J. Inan.*)

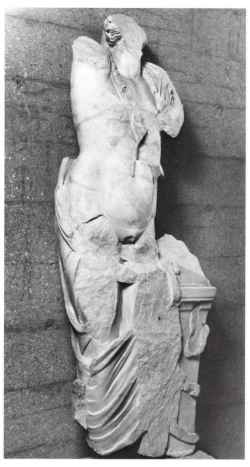

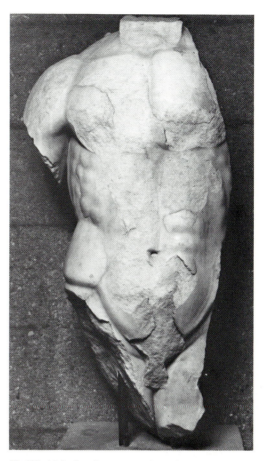

Pl. 121. Apollo Kitharoidos, perhaps from Aphrodisias. Corinth Museum. (*Courtesy Corinth Excavations.*)

Pl. 122. Naked male torso, perhaps from Aphrodisias. Corinth Museum. (*Courtesy Corinth Excavations.*)

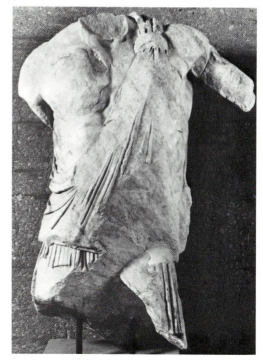

Pl. 123. Draped male torso, perhaps from Aphrodisias. Corinth Museum. (*Courtesy Corinth Excavations.*)

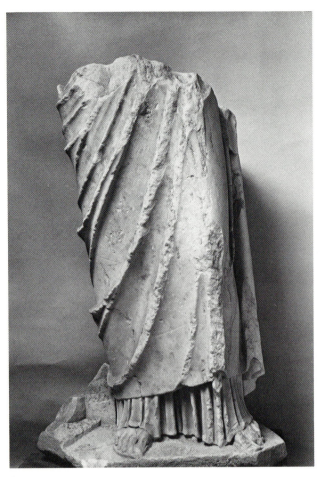

Pl. 125. Fragmentary Nemesis. Corinth Museum. (*Courtesy Corinth Excavations.*)

Pl. 126. Statue of Kore dedicated by Helbia Timareta, Sanctuary of Demeter and Kore, Cyrene. (*Courtesy University Museum of the University of Pennsylvania Excavations.*)

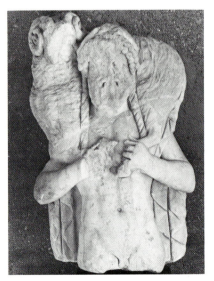

Pl. 124. Archaistic Kriophoros. Corinth Museum. (*Courtesy Corinth Excavations.*)

Pl. 128. "Corinth/Conservatori type," side view. Corinth Museum. (*Courtesy Corinth Excavations.*)

Pl. 127. Female figure, "Corinth/Conservatori type." Corinth Museum. (*Courtesy Corinth Excavations.*)

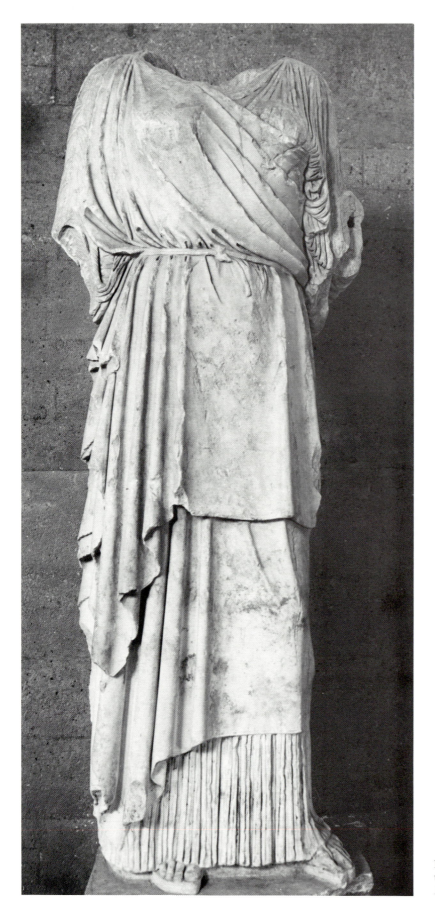

Pl. 129. Female figure, "Corinth/Mocenigo type." Corinth Museum. (*Courtesy Corinth Excavations.*)

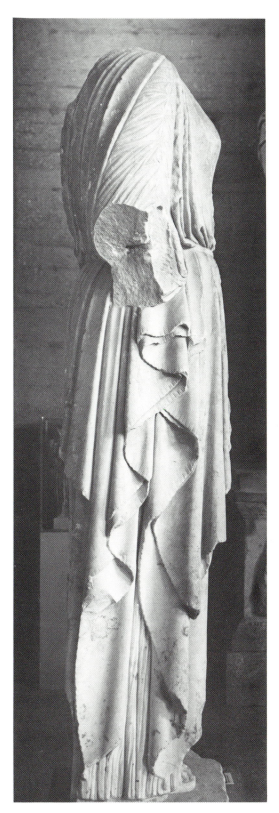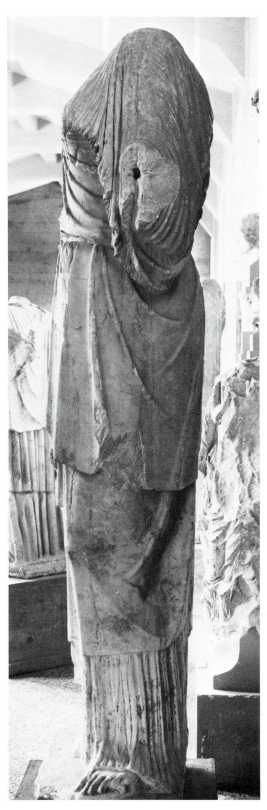

Pl. 130. "Corinth/Mocenigo type," right
side. Corinth Museum. (*Courtesy Corinth
Excavations.*)

Pl. 131. "Corinth/Mocenigo type," left
side. Corinth Museum. (*Courtesy Corinth
Excavations.*)

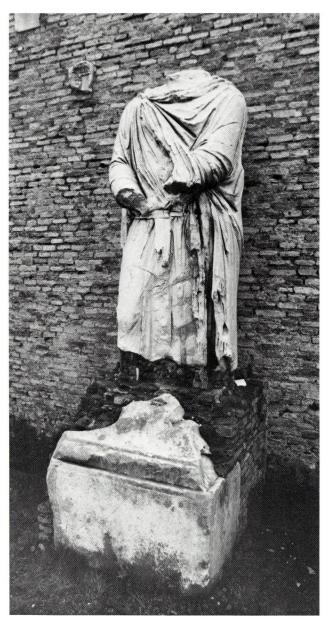

Pl. 132. Dacian Prisoner, unfinished replica. Rome, Vatican Museums. (*Courtesy Prof. J. Packer.*)

Pl. 133. Dacian Prisoner from the Forum of Trajan. Rome. (*Courtesy Prof. J. Packer.*)

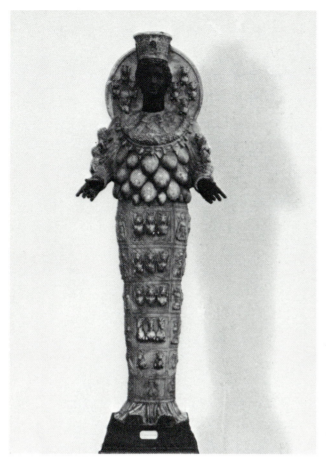

Pl. 134. Artemis of Ephesos, replica in Naples, National Museum.
(*Museum postcard.*)

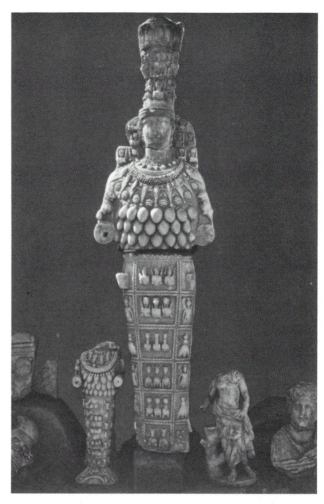

Pl. 135. Artemis of Ephesos, various replicas in Selçuk Museum.
(*Museum postcard.*)

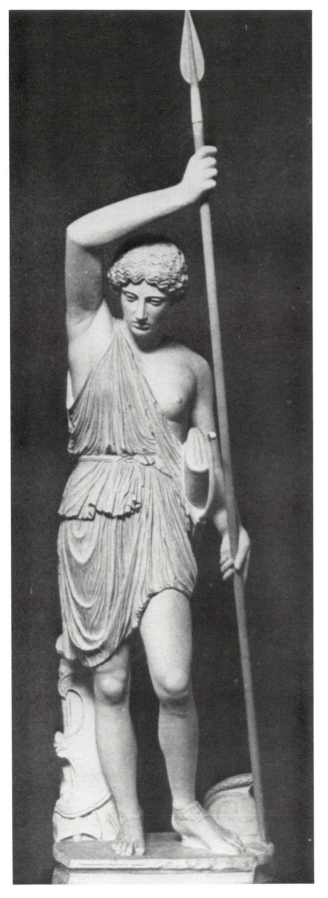
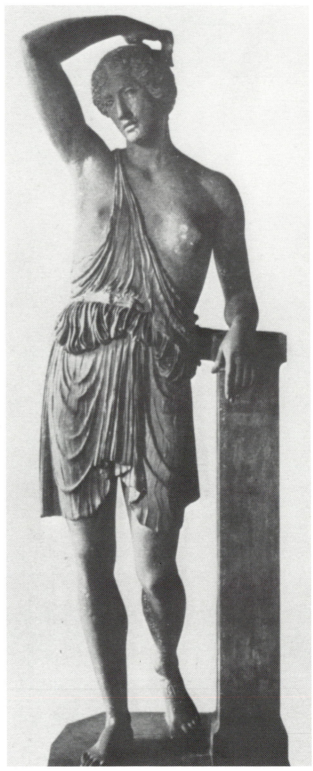

Pl. 136. The Ephesian Amazons. From left to right: Mattei type, Lansdowne (Berlin) type, Capitoline (Sosikles) type, Doria Pamphilj statue. (*After G. Becatti,* Problemi Fidiaci *[Milan and Florence, 1951], pl. 95.*)

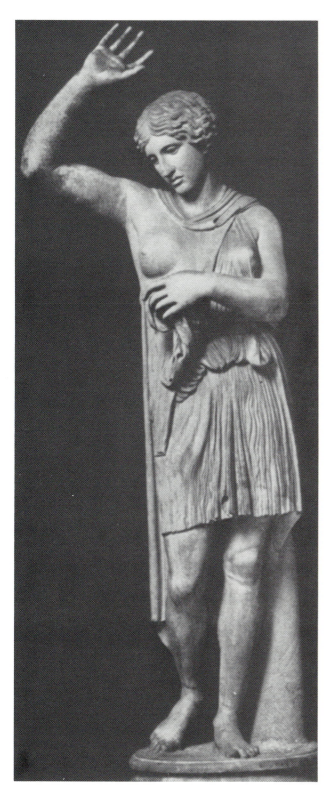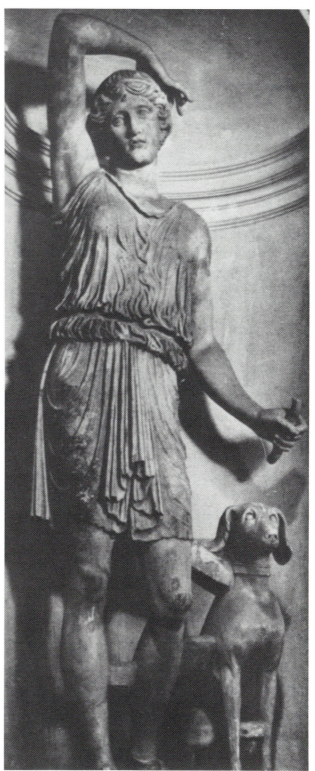

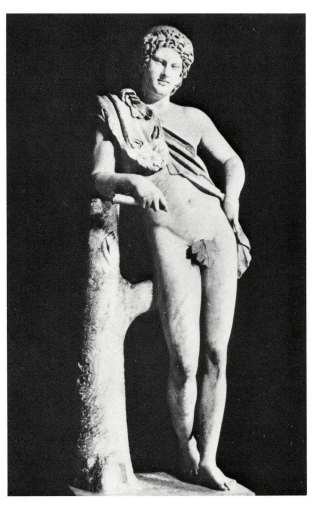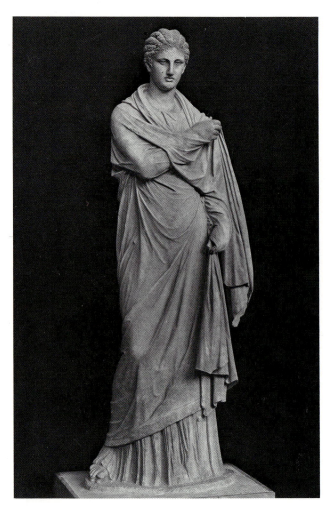

Pl. 137. Leaning Satyr (Anapauomenos) usually attributed to Praxiteles. Replica in Rome, Capitoline Museum. (*Museum postcard.*)

Pl. 138. "Small Herculanensis" type, Athens, National Museum. (*Alinari.*)

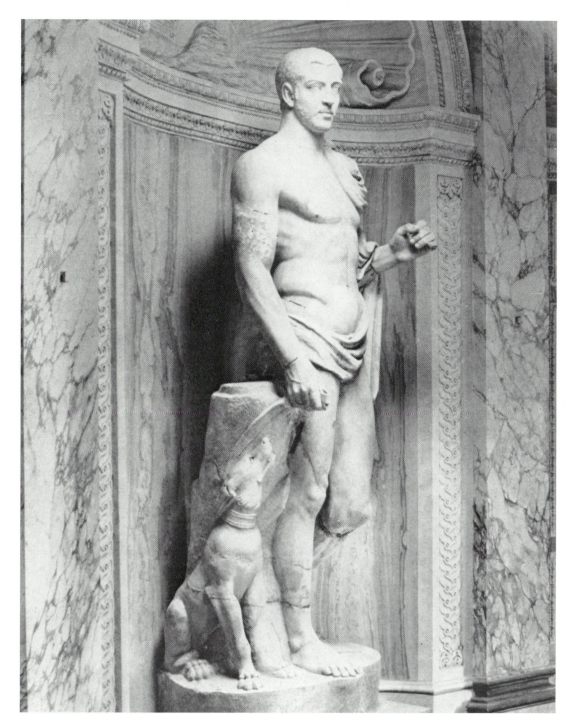

Pl. 139. "Hunter" once in group with a togatus and other male
figure, as replica of the Doryphoros body type (possibly T. Fulvius
Iunius Macrianus, son of M. Fulvius Macrianus). Rome, Villa
Doria Pamphilj. (*DAI Rome.*)

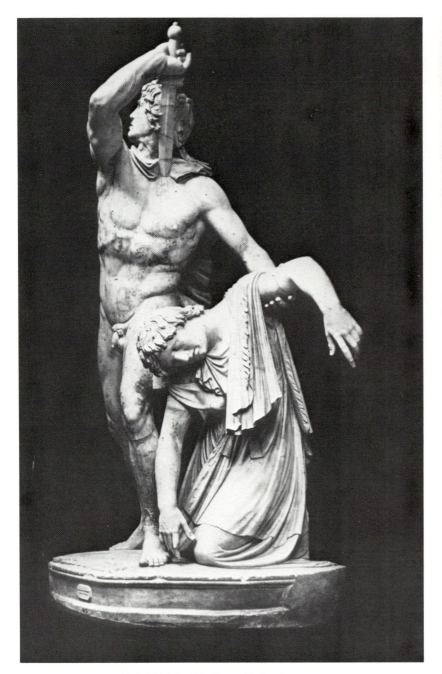

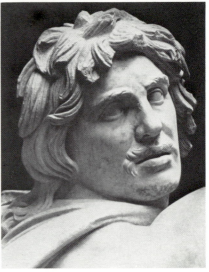

Pl. 141. Ludovisi Gaul, detail of face.
(*After Anderson.*)

Pl. 140. Ludovisi Gaul ("Suicidal Gaul"), Rome, National
Museum. (*Bryn Mawr College.*)

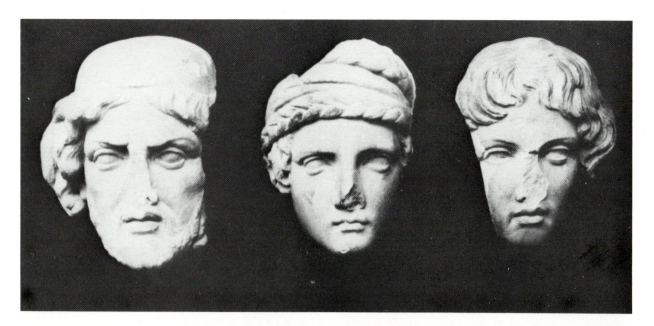

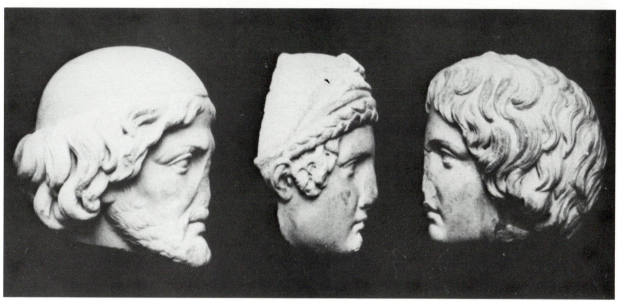

Pl. 142. Heads from the Frieze of Alexander's entry into Babylon.
Thorvaldsen Museum, Copenhagen. (*After* Bertel Thorwaldsen—
Ausstellung Köln, 1977, *Cat. no. 47, p. 174.*)